The Photographic
Encyclopedia
of
ROSES

Text
Peter Harkness

Design
Michael Morey

Commissioning Editor
Andrew Preston

Publishing Assistant
Edward Doling

Editorial
Gill Waugh

Production
Ruth Arthur
David Proffit
Sally Connolly
Andrew Whitelaw

Director of Production
Gerald Hughes

Director of Publishing
David Gibbon

CLB 2423
© 1991 Colour Library Books Ltd, Godalming, Surrey, England.
All rights reserved.
Colour separations by Advance Laser Graphic Arts, Hong Kong.
Printed and bound in Italy by Fratelli Spada, SpA.
ISBN 0 86283 860 6

PREVIOUS PAGE: 'PAUL SHIRVILLE'

The Photographic
Encyclopedia
of
ROSES

CLB

Colour Library Books

CONTENTS

'MALCOLM SARGENT'

foreword

Roses have filled my working life. When after nearly forty years the time came for my wife and I to retire, we thought we would have the chance at last to embark on all those projects that the routine of daily toil inhibits, such as visiting distant lands, walking Offa's Dyke, seeing a Test Match through from start to finish, exploring the family tree … and by no means least, having the opportunity to care for our own garden properly instead of looking after everybody else's.

Barely a week had passed when the invitation came for me to write this book, and the opportunity was a challenge. To it I could bring the stored experience of forty years, gained from seeing roses in many lands, talking to their guardians, judging their performance. One point worried me, the fact that there have been so many books on roses: how could another one be justified? What more could anyone wish or need to know?

It was then that I thought of all the hours and days spent answering people's queries. Those received in the office, by letter and by telephone, would probably fill a small room, and perhaps as many more had been posed at social occasions, or after talks to clubs, or when dining out, or in the church porch after service. For it seems that at almost any kind of random gathering, if someone thought to know about Roses is on hand, questions follow.

Clearly the need for information still exists. My object in this book has been to answer many of the questions people ask, and to do so in a readable and entertaining way, avoiding technical language but not dodging the essentials. It includes a brief survey of rose history, telling how the lovely garden roses of today have evolved from their wild ancestors, and detailed descriptions are given of nearly seven hundred roses, chosen for their merit or importance in rose history.

Illustrations are used lavishly throughout the book to show many of the roses described. These have been selected with care to ensure that they are good representations of the roses and pleasing to the eye.

Finally, a word about my family's involvement in the world of horticulture. This started in the 1870s, when Robert and John Harkness sowed four pennyworth of wallflower seed, and astonished their relations by making £2 from the plants they sold. In the 1990s the fifth generation holds the reins. Along the way, and thanks to the cooperation of a loyal, hardworking staff – and long-suffering wives – many of the targets rose growers set themselves have been achieved, notably forty-one national championships and, more recently, Chelsea Gold Medals in several successive years. Jack Harkness began our breeding work in 1961, and more than four hundred international prizes have been won since then for new varieties. Jack has also written several books, following in the footsteps of old John, whose *Practical Rose Growing* of 1889 was great value at one shilling plus twopence postage – or sevenpence ha'penny post free if you would take a shop soiled copy!

Between the older and the younger generations came Bill and Ena Harkness, Bill being responsible for the greater number of those championships during his forty years in charge which ended with his death in 1959, and Ena a flower arranger of international note. While I was at work on the first chapter of this book, Ena passed away. It seemed like the end of an era. In his address, the vicar spoke in words that are pertinent to all lovers of the rose: "On one occasion Ena told me how Bill had shared with her his belief that God was a God of gentle laughter, and how she found this helpful and real. The image of God enjoying his creation is a very natural image, and especially so for those involved with flowers and gardening; for if there are things we can enjoy, I'm sure God enjoys them too, and wants us to share in that joy also."

Two of Jack's creations bear our daughters' names, Anne and Rosemary, which were named to mark their coming of age. Both are lovely girls (and lovely roses too!) and my dedication is to them.

PETER HARKNESS
Letchworth Garden City

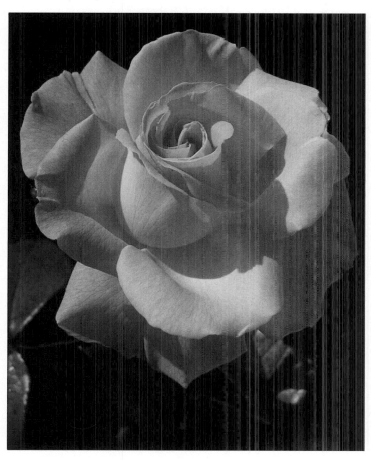

'ROSEMARY HARKNESS'

PART ONE

a brief history

growing roses

a brief history

The beauty of a rose has gladdened the eye and captivated the heart since the dawn of recorded history. Just how the simple wild roses of the natural world have developed into the complex hybrids of today is a fascinating tale, involving gardeners and plant lovers of diverse ages and distant lands. It is, considering the sweet and guileless nature of its subject, a surprisingly complicated story. Explaining how the rose has got where it is today is rather like setting out to do a jigsaw for which there is no agreed number of pieces, and where one or two vital ones appear to be missing.

What *is* a rose? Let us imagine we have landed on planet Earth from outer space, and are observing its creations with fresh eyes. All around us there are plants in flower to advertise their presence – not to give us enjoyment, much as we may wish to think so, but in order to attract insects or other agents to achieve pollination. A friendly botanist comes by, and starts to explain the rules whereby he classifies the plants. Even we newcomers can observe that some have flowers, and some, like ferns and mosses, do not. Next he points out the way the plants bear seed. When the seeds are formed, some plants house them in a pod or casing, and other plants do not. From their hips it is plain to see the roses are plants that keep their seeds protected. After this the points that distinguish the families of plants from one another become more technical, and the botanist, unless he has the gifts of a David Bellamy, will probably lose his audience. Suffice to say that certain plants are grouped together by their general character as being "Rosaceous".

The rosaceous plants, or Rosaceae, are a very wide family indeed. They would make a glorious fruit salad, with apples and pears, peaches and cherries, blackberries and raspberries, apricots, strawberries and plums, almonds for dessert and sloes to flavour the gin. Among familiar garden plants they number roses, hawthorns, geums, cotoneaster, rowan trees, potentillas and many more. In all, about ninety kinds of plant are termed rosaceous.

There are general features that distinguish the plants we call roses from the apples, the strawberries and the rest. Among these features are the prickly stems, the way the leaves grow, the form of the hips, and the ability of the plants to interbreed. At the end of the day, all the plants that seem to qualify as belonging to this more close-knit family are classed as being of the Genus ROSA, which is simply a way of saying in Latin that they are of the race of roses. Each different kind of rose within the Genus is called a Species, and as there are several score species of roses, each one is given its own species or "specific" name, again in Latin, to distinguish it from others of its race. Latin is used because it has long been regarded as a language of international understanding. It is customary for the names of species to be printed in italics, and for the race name ROSA to be shortened to R. Thus two wild roses commonly found in Britain, and popularly known as the Dog Rose and the Field Rose, are correctly termed *R. canina* and *R. arvensis* respectively.

The oldest roses known have come down to us as fossils, where, by a rare miracle of nature, minerals have replaced the delicate cell tissue of the living plant. They consist of very fragmentary remains, usually of leaflets, pieces of stem or prickles. In a few instances it has been possible to match them quite closely with species still existing. The German rosarian Gerd Krussmann listed twenty-six such fossils, though not

ROSA ARVENSIS (FIELD ROSE)

all can be with certainty identified as roses. The first was found in Austria in 1848, being a prickle with a piece of stem. (It is tempting to write 'thorn' instead of prickle, but according to the laws of botany the armaments of rose stems are not true thorns.) Several more fossils have since been found in Europe, in Germany, Czechoslovakia, France and Bulgaria; also in California, Colorado, Oregon and Alaska in the USA, and in Japan and China, including from the latter what is thought to be *R. rugosa*, a species still to be found around its coasts today. The majority of the finds have been in deposits from three to twenty million years old. No doubt more will come to light as time goes by, or be recognised for the first time for what they are.

Whether present-day wild roses are direct descendants from the fossil traces is impossible to say with certainty. The species of today do still grow in the same regions of the world. Their overall extent stretches right across the northern hemisphere, circling the pole from Siberia westwards to Alaska, embracing most parts of north and central Asia, pockets of India and Arabia, virtually all of Europe, parts of northern Africa, touching Iceland and extending over North America as far south as northern Mexico. No wild rose has ever been discovered south of the equator, unless it had been taken there by man. A possible explanation of this surprising fact is that rose seeds benefit from cool conditions to enable them to germinate, and the equatorial belt may have proved too great an obstacle. It still remains astonishing how well the race of roses has adapted to the diverse environments its geographical spread reveals, from the chill of the Arctic tundra to the heat of Arizona, from the swamps of Carolina to arid mountains in the Yemen, from windswept Hebridean

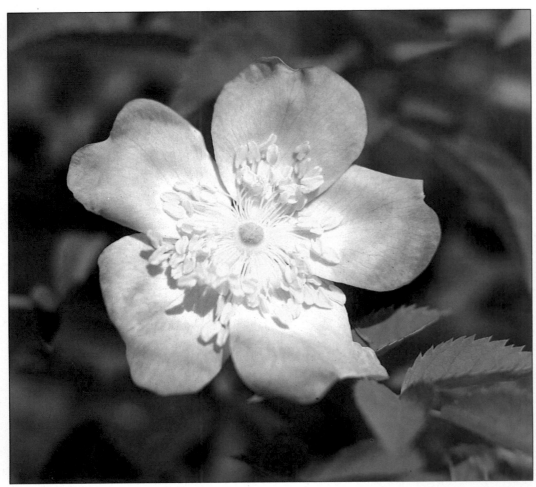

PREVIOUS PAGES: 'CHARLES DE MILLS' *ROSA CANINA* (DOG ROSE)

shores to steamy forest valleys in Nepal. These it is fair to say are among the exceptional performers. The habitats preferred by most rose species are well drained sites, often in upland country where competition from other vegetation is not too great, enabling the roses to obtain their share of light and moisture. We may speculate on the purpose of the prickles. Were they to enable roses to clamber towards the sunshine, supported by the other plants of field and forest? Or were they a defence against being eaten? Or do the prickles protect the stems from dehydration, conserving moisture within their horny sheath? It's noticeable that garden roses produce pricklier stems in periods of drought, and that roses of arid regions are particularly bristly. Maybe all three factors play a part.

Among roses that have adapted successfully to unkind environments is the Swamp Rose, *R. palustris*, found in marshy ground from Eastern Canada to

ROSA STELLATA MIRIFICA

ROSA RUGOSA, A SPECIES FROM EAST ASIA.

Florida. The lustrous leaved *R. nitida*, from N. America, is another one that thrives in acid, boggy soil. Very different is the habitat of *R. stellata*, found high and dry in the mountains of New Mexico, and considered to have the smallest leaves of any wild rose, carrying only three leaflets each of half an inch. It makes a wiry thicket some fifteen inches high, and is covered with a furze of fine hairs, presumably for protection against extremes of heat and cold. Contrast this with the luxuriant growth of *R. sinowilsonii*, whose almost smooth red stems rampage for up to fifty feet among the neighbouring plants in southwest China, blanketing them beneath a canopy of enormous purplish leaves.

Or with *R. acicularis*, the Circumpolar Rose, cheering the pallid Arctic summers with its bright pink scented flowers.

R. acicularis has another claim to fame. Of all roses, it has the largest number of chromosomes. Chromosomes are the microscopic rod-like bodies in the nucleus of each cell. The word chromosome means "coloured threads", and they are so described not because they are naturally coloured, but because when subjected to a complicated process they absorb colouring matter, and in that way can be studied. In roses, chromosomes occur in multiples of seven, and many species, including those thought to be most primitive, have fourteen. If one species has more chromosomes than another, it is thought likely to be later in development, and indeed better adapted to the area it inhabits – what in a human context we might describe as more sophisticated. It is therefore tempting to think that if we can establish where the species are growing, and plot their chromosome numbers, we may be able to discover the heartland whence all Roses spread. The exercise cannot be conclusive but results

suggest that eastern Asia is the rose's original family home, migrants having travelled from there to give the species distribution that we see today. For what it is worth, a survey shows that some 48 species are peculiar to China, about 42 occur in other parts of Asia in addition to the Chinese ones, 32 are found in Europe, about 7 in North Africa, half a dozen in parts of the Middle East, and 26 in North America. That adds up to 161, but as several occur in more than one region, the true number of species is less than that.

Indeed, nobody can be sure how many of them there are. Some were being discovered in the early part of the twentieth century, and it is possible that more may lie unregarded and unrecognised in remoter parts

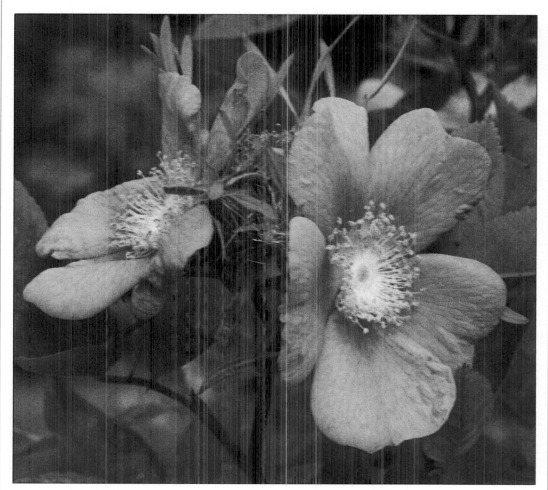

ROSA PALUSTRIS (SWAMP ROSE)

ROSA PERSICA

ROSA ROXBURGHII NORMALIS

of China and central Asia, where geography and politics continue to prevent thorough investigation. Even species that are known and grown are the subject of controversy. The arguments arise because several are so similar that they can be considered variations on a theme rather than plants of separate identity. Due to environmental difference, or through groups of plants becoming isolated from each other, minor adaptations may become pronounced, leading to conundrums for the botanist. *R. salictorum* is nearly spineless, and *R. woodsii* is similar except that the stems are prickly. At what point should they be considered cousins, rather than allowed the closer relationship of sisters? Some species have been grown in cultivation from seed collected in the wild, and there can be no absolute certainty that such seed is true, particularly if verifiable access to the parent stock cannot be repeated due to its remoteness. One botanist gives a species count of "over 100", another admits "some 150". Much depends on how botanists approach their task, and one worthy claimed to discern more than one species on the same plant! One author was driven to say of *R. henryi* that it was "in complete confusion with *R. gentiliana*, whether identical or not, existent or not".[1]

As examples above have shown, botanists are apt to bestow awkward names on the pretty wild roses of creation. Botanists look for differences in the structure of the plant, rather than considering, as gardeners do, the colour of the flower, growth habit and general good behaviour as an ornamental plant. Before moving on to these more endearing aspects, it is right to note work the botanists have done. Alfred Rehder in 1949 devised a classification of all wild roses into four subgenera (or sub-families), and with modifications his system is still followed. Explanations of the alarming-looking names appear in brackets:

HULTHEMIA (taking its name from Van Hulthem, a Dutch botanist) There is only one species in this sub-family, *R. persica*, which is deep, bright yellow with a red eye, a beautiful rarity growing from Iran to Pakistan.

HESPERRHODOS (Greek meaning "Western Roses") This group has three members, one blush, two a striking purple, and is so named because it occurs only in the Western Hemisphere, in S & W USA.

PLATYRHODON (meaning "Flaky Rose" because the bark peels off in layers when old) Found in China and Japan, and represented in this book by the pink *R. roxburghii*.

The above are curiously different from other wild roses, appearing more primitive in form, like country cousins many times removed. The remainder, constituting the overwhelming majority, belong to the sub-family ROSA (Latin for "Rose"). And these are so numerous that they are split into ten sections like this:

1　PIMPINELLIFOLIAE (meaning it has leaves like a salad plant which in English is called burnet, and in Latin *pimpinella*) There are about a dozen species which between them span Europe and Asia, and include the brightest yellows (all in Asia) as well as cream, pink and purple shades. They are all early summer flowering.

2　GALLICANAE (meaning "French") The people of France had the good sense to adopt the pinky-red *R. gallica*, which is arguably the greatest success story in the rose world. Summer flowering.

3　CANINAE (with reference to "dogs", perhaps because the thorny nature of these roses put the ancients in mind of canine teeth; their prickles can certainly savage skin and clothing if handled without care) This is a big group of some 30 species, most of them light pink, in Europe, North Africa and Western Asia, but

1　Jack Harkness, *Roses*, Dent 1978.

ROSA PIMPINELLIFOLIA (BURNET OR SCOTCH ROSE)

ROSA MULTIFLORA CATHAYENSIS, A NATIVE OF CHINA.

not native to North America or Eastern Asia. All are summer flowering.

4 CAROLINAE (from Carolina USA) The half dozen species are confined to North America, in deepish shades of pink. All are summer flowering.

5 CINNAMOMEAE (named after a species claimed by early rosarians to have cinnamon fragrance, which is hard to detect now; they seem to have had imaginative noses in those days) This is the largest group, with 50 or so species, found mainly in Eastern Asia, in white, shades of pink, purple and red, and (in pink only) in Europe and North America. It includes the very hardy *R. rugosa* in both white and purple, important because it gives a good show of colour through summer and autumn. The rest bloom in summer, with a few giving the odd late flower.

6 SYNSTYLAE (from Greek meaning "fused pillars" because of the way the threadlike styles cling together like a little pillar in the centre of the bloom) There are about two dozen of these, mostly vigorous climbers in white, cream and blush. Nearly all occur in Eastern Asia. Among the few found further west is *R. arvensis*, or the Field Rose, often mistaken for the Dog Rose when encountered by walkers in the English countryside. Only one member of this group is found in North America. It is a deeper pink than all the rest, and is called *R. setigera* or the Prairie Rose. All are summer flowering only.

7 CHINENSES ("Chinese") This sub-family only boasts two members, but their importance in the story of our garden roses cannot be overstated. *R. chinensis spontanea* has forms which carry differently coloured flowers on one and the same plant. The other, *R. gigantea*, has large, silky petals in blush, pale yellow or light pink. Thus they both show variability in their behaviour. They flower over a very long period from summer to late autumn. As the name suggests they are of Chinese origin, though for many years the sub-family was known as INDICAE, meaning "Indian", because western botanists first gained knowledge of them through gardens in Calcutta.

8 BANKSIANAE ("Banksian"), a distinctive and beautiful white Chinese garden climber was named after the wife of Sir Joseph Banks, then in charge of Kew Gardens, ca. 1807, and yellow forms were subsequently found. They flower very early in the summer.

9 LAEVIGATA (meaning "polished smooth", with reference to the glossy leaves) *R. laevigata* is the only member of its sub-family. It is creamy white, grows in China and flowers early in the summer.

10 BRACTEATAE (meaning "the roses with bracts", bracts being leafy growths unusually close to the flower) Other roses have bracts, too, but they are especially noticeable in *R. bracteata* and *R. clinophylla*, the only species in this sub-family. Both are creamy white and in their native Southeast Asia the leaves are evergreen. Their flowers are borne over an extended period, late spring to autumn.

From this brief summary of the four groups and ten sub-families we can draw the following conclusions:

1 Deep yellow roses are found growing wild only in Asia
2 Deep red roses are found growing wild only in China
3 There are very few roses that will keep flowering right on through summer and autumn, and they are all to be found in the eastern regions of Asia.

When we observe our garden roses with their wide range of hues – all shades of red, pink, salmon, orange, yellow, with cream and white, bicolours, multicolours, lilacs, purples, and even greens and browns – it is easy to overlook the fact that in nature the predominant colours are very pale. More than half the wild rose species are white or blush pink, a further sixth are medium pink, and with the pale yellow shades these account, in percentage terms, for over 77% of the total. Deeper pinks account for a further 16%, leaving just a handful of varieties in the more vivid hues of deep yellow, purple, scarlet and crimson.

The scene is now set for the story that follows, of how the rose has developed into the garden favourite of today. All the cast are in place, but they are literally as nature made them, like raw materials waiting to be found and take their place as the plot unfolds. And although they are available, waiting in the wings, it will take many centuries to seek them out. How that has happened is our next theme.

When and where was the rose first cultivated? As with many aspects of the story, deductions have to be made, based on what slender evidence there is. It seems reasonable to think that wherever early civilisations were most advanced, a society capable of settled living and the pursuits of leisure would soon find in the rose a desirable companion. As one writer puts it, "It might almost be said that the rose is an index

ROSA BANKSIAE LUTESCENS

of civilisation."[2] Then, as now, the qualities of the flower – its beauty, fragrance, value for decoration and depiction in all kinds of ways – compel human notice, but because civilisation's progress has been a stop-and-go affair, the development of the garden rose is a complicated story, involving peoples separated by geography, race and time. Graham Thomas has summed it up beautifully: "The resulting confluence has been like the uniting of two great rivers, determined by the flow of civilisation crossing from east to west and back again and from north to south with reverse traffic likewise".[3]

Because there are grounds for thinking that China witnessed the earliest cultivation of garden plants, to Chinese roses goes the honour of beginning this account. Gardening is said to have started under Chin-Nun (2737-2697 BC). A specific mention of roses comes from Confucius (551-479 BC) who recorded that many were planted in the Imperial gardens, and by the time of the Han dynasty Emperor Wu Di (140-86 BC) there were extensive ornamental parks for his household and his counsellors to enjoy, in the interludes between waging war on their neighbours and extending the Great Wall. A story has come down which tells of one such day when the Wu Di was at peace among his roses in his capital Chang'an. He brought his concubine Li Juan to the imperial garden to enjoy them in full bloom. "These flowers," said the Emperor "are as beautiful as your smile". "And can you buy a smile?" she asked, jokingly. "Indeed I can", replied Wu Di. "Then offer me a hundredweight of gold, and I will prove it to you." The Emperor complied, and ever afterwards the Rose of Chang'an was called 'Mai Xiao', which being interpreted means "buy a smile".

Chang'an was the starting point of the so called "Silk Road" and under Wu Di and his immediate successors Chinese influence towards the west was greatly extended. Trade missions were sent to Persia, developing a sophisticated export trade with China's western counterpart, Imperial Rome. An indication of its extent is a complaint of Pliny the Elder (23-79 AD) concerning extravagant expenditure on Chinese silks. Alongside such exotica we may assume that traffic in spices, herbs, medicinal and fragrant plants found markets too, and we may reflect on the effect on world history, let alone the story of the rose, had these two mighty economies of east and west continued to develop in tandem. The Dark Ages intervened, bringing intermittent chaos to both regions, and many centuries passed before China was drawn again, and reluctantly at that, into lively commerce with the western world.

Throughout those years of isolation the tradition of flower growing was maintained, despite population pressures that forced the closure or reduction of many of the larger parks. The growth of Buddhism, with its stress on the value of the contemplative life, encouraged small flower gardens as places for spiritual refreshment. We get the flavour of the times from what the poet Hsieh Lung-yin wrote of his own country retreat in 410 AD: "I have banished all worldly care from my garden … I have dammed up the stream and built a pond. I have planted roses in front of the windows, but beyond them appear the hills." The garden of Lo-yang was celebrated for its roses, forty-one varieties established there being described in the time of the Sung dynasty (960-1276 AD). Among botanical drawings and paintings of that era is the one of the species *R. rugosa*, in Chinese 'Mei kuei'. This in itself is not surprising, since that rose's natural home is Northeast Asia, but it is very significant because *R. rugosa* shares two unusual qualities with Chinese garden roses, being repeat-flowering, and variable in colour. Whether or not *R. rugosa* was an actual parent of Chinese garden roses (and to the ones I know it bears no outwardly obvious resemblance), its example in showing what roses can be capable of must have informed the minds of gardeners

2 E.A. Bunyard in *Old Garden Roses*, London 1936.

3 In his foreword to Hazel le Rougetel's *A Heritage of Roses*, Unwin Hyman 1988.

ROSA RUGOSA ALBA

'VIRIDIFLORA', 'LÜ E' OR GREEN ROSE

looking for improved strains. Undoubtedly most varieties being grown were garden forms, not wild species, and were the consequence of centuries, perhaps millenia, of cultivation and selection.

Lists of ancient Chinese roses dating up to about 1850, that is before their development could be influenced by western hybrids, reveal the fruits of this long selection process. The colours include white, all shades of pink, light to medium yellow, apricot, scarlet, crimson and purple, with bicolours of scarlet/white, white/pink, pink/apricot, peach/yellow, pink/red, pink/scarlet and white/lilac. There is a curious green rose also, 'Lü E' which means 'Green Calyx' but this hardly counts as a flower colour, the "petals" being modified leaves. The list contains Moss roses, habits that are dwarf, spreading, upright and climbing, petals numerous and few, and of varying shapes and textures, and fragrances whose descriptions range from slight to sweet, heavy and "Tea". As if all this were not enough, many of the varieties grown bloomed not in summer only, but in repeated cycles of growth and flower until seasonal change in temperature forced them into dormancy. These were the garden roses of the Orient that would in the fullness of time enchant and astonish westerners by their beauty and diversity.

The heartland of western culture is traditionally thought to lie in Mesopotamia, the level plain "between the rivers" in what today we call Iraq. Here, a little over 5000 years ago, a pattern of settled agriculture evolved to support sizeable urban populations. The earliest probable reference to roses comes from a Sumerian clay tablet inscribed with cuneiform writing found during excavations by Sir Leonard Woolley among royal tombs at Ur. The creators of the tombs hoped to ensure safe passage to new worlds for their late rulers, providing sacrificial soldiers, handmaidens and oxen as well as food, gems and toilet items. Among the last of these, rosewater came to be highly prized, and the use of roses in that connection is the most likely explanation of the reference at this early date, around 2000 years BC. The builders of the tombs put all the effort and ingenuity of which they were capable to clothing the mortal with immortality. The clay tablets with their prosaic records have proved the true imperishables.

The Akkadians under Sargon (2371-2316 BC) led a conquering army six hundred miles westwards into Turkey and he brought back "foreign trees, vines, figs and roses" to grow in his own land; unfortunately authorities cannot agree whether this was in truth a reference to roses or to some other plant, but it shows that the distribution of plants was practised, and that their possession was a social cachet. Tiglath-Pileser of Assyria (c.1100 BC) also left records of his active interest in plants, and how he had brought to the parks of his own land trees that none of his forefathers possessed. Later kings extended these parks to grandiose dimensions, with all types of flowers and herbs, and water gardens covering five acres, but no specific reference to roses has been discovered.

There is no evidence that the early Greeks went in for ornamental gardens, perhaps because wild flowers were so plentiful in their natural landscape. Mention is made of rosewater and rose-scented oil, adding weight to the view that the rose was treasured for its fragrance and cleansing and cosmetic properties long before it was used in other ways; rose oil being in its day "even more valuable than gold".[4]

The most valuable source of rose fragrance at this period without any doubt was *R. gallica*. A strong case can be made for this as the longest running favourite of all time. It is a warm reddish, sometimes purplish, pink, so deep that in a rose world lacking crimson scarlet tones it could be considered "red", and receive such synonyms as *R. rubra* and 'Red Rose of Lancaster'. Its commercial value is due primarily to the ability of the petals to retain and even intensify their fragrance after drying, but also to the fact that the plant grows neatly and compactly (unlike many wild roses), bears a good number of blooms over several weeks, and will tolerate varying types of soil. It will also sucker readily so stock can easily be increased. It comes therefore as no surprise to find *R. gallica* described as being known to Medes and Persians by 1200 BC, a strong candidate for the rose depicted on a famous fresco at Knossos in Crete (1500 BC?), grown by Greeks and Romans, taken to Spain by Moors, to France by Crusaders and thence to England to become the badge of royalty and, in stylised heraldic form with five distinctive flat-edged petals, the national flower.

When a rose is widely cultivated new forms are likely to arise, and what is more important for our story, they will be noticed, since the plants, especially at flowering time, will be under constant observation. The most probable variations will be in petallage and colour. Species roses almost invariably have five petals in the flower, and *R. gallica* is no exception when growing in the wild. Five petals evidently provide a satisfactory pattern to guide pollinating insects towards their hoped-for reward of nectar, and as successful pollination is the key to long-term survival, chance blooms with extra petals have a built-in disadvantage in the evolutionary process. It is very different when a

4 G.S. Thomas, *Shrub Roses of Today*, Dent 1974.

rose comes under cultivation, for now the human eye can select the stem that bears the chance bloom, and the human hand can propagate it by cuttings or by other means. A similar process of selection operates if a significantly different flower colour is observed. In this way cloned plants, i.e. raised from the same original piece of vegetation, can be produced and multiplied. They may be sufficiently distinct to become famous in the locality and become known in time as 'The Rose of So-and-So'.

It follows from all this that when Herodotus (c.485-425 BC) encountered and admired a strongly scented "rose with sixty petals" which ex-King Midas of Phrygia had brought westwards to Macedonia, we can respect the view, although we have no way of proving it, that this may have been a full-petalled clone of *R. gallica*. And when Pliny (23-79 AD), listing the rose varieties of the western world, describes 'The Rose of Praeneste' (near Rome) 'The Rose of Miletus' (SW Turkey) and 'The Rose of Pangaeus' (NE Greece), scholarly opinion can hold that all three are *R. gallica* variants. Indeed, Pliny's comment on the last named is revealing: "The natives transplant it, improving the variety by mere change of place".

What of the other roses itemised in Pliny's Natural History? His 'Rose of Campania' (30 miles north of Naples) is described as having bright green or bluish foliage and white, scented flowers, and that fits very well with what we call the Alba roses; "alba" being Latin for white. The original Alba rose was not a true wild rose, and probably originated as a natural hybrid between two different species. This can happen if the two are sufficiently close neighbours for an insect to take pollen from one and carry it to the other. In this way cross-pollination can occur. In nature the chances of an accidental species hybrid establishing itself in competition with established neighbours are very small, because nature does not cosset the extraordinary, and existing plants are not disposed to yield their territory. The hybrid's chances of survival become greatest if

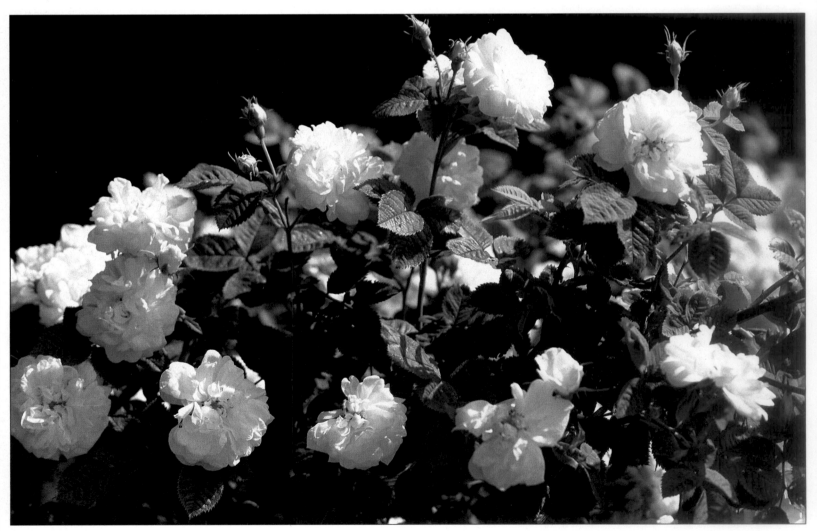

ROSA X ALBA, 'MAXIMA' OR 'WHITE ROSE OF YORK'

THE *RUGOSA* HYBRID 'HARVEST HOME'

Bulgaria for making rose oil, which the Bulgars say a Turkish merchant introduced before 1700. No doubt they are related, more than that one cannot say.

Finally we come to the last on Pliny's list, and another mystery. The 'Rose of Cyrene' is commended for its fragrance and is used to make an ointment. Gerd Krüssmann equates this with a late blooming scented climbing species, R. *moschata*, but prudently adds a question mark.[5] R. *moschata's* history is a tangle of question marks along the way. If it was known to the Classical World, as asserted by rose writers whose confidence masks the lack of evidence, it must have been brought in from the east; that is very possible, but we do not know for certain.

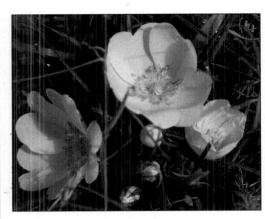

ROSA PIMPINELLIFOLIA

the human eye takes note of something new and strange, not necessarily a flower or plant but maybe just an oddly shaped hip, and then human skills come into play. In her small town garden in the 1970s, Mrs Rock of Hitchin noticed an unusual hip on her 'Scabrosa' rose; seed germinated, an award- winning new variety came from it, and when it was commercialised a neatly appropriate name was chosen: 'Harvest Home'. What works for an English gardener in our own day could work equally well for a Crimean one two and a half thousand years ago. Certainly no observer seeing the Alba rose for the first time could miss the distinctive qualities of the successful hybrid, standing tall and strong, with a greyish cast to the green of the leaf, and sweet, delightful fragrance. In course of time, as with the Gallicas, more fully-petalled (or "double") blooms appeared, as well as blush pink forms, and were selected to be grown on as new varieties, with names evocative of happenings far from their land of origin: 'White Rose of York', 'Jacobite Rose', 'Bonnie Prince Charlie's Rose', 'Maiden's Blush' – and its saucier French counterpart, 'Cuisse de Nymphe Emue', or "thigh of startled nymph".

Because it is not a true species, the Alba rose should according to the rules of botany be written R. *x alba* rather than R. *alba*. The most informed guess as to its parentage gives a rather charmless white rose with few prickles as the pollen parent *(R. coriifolia froebelii)* and the more familiar R. *canina* as the bearer of the hip. In this way the tremendous vigour and hardiness of Britain's most noticeable hedgerow rose was injected into varieties fit for cultivation, though it has to be said that the genes of R. *canina* have contributed little fresh in all the intervening years.

Four further roses on Pliny's list need to be considered. One is his 'Spineola' meaning "prickly" which he dismisses as "the least prized, having very many, but very small petals". It sounds like a lowly Burnet Rose, or R. *pimpinellifolia*, forms of which are common and widespread. His 'Coroniola' is described as being suitable for garlands worn about the head, and its identity is not certain; the 'Evergreen Rose', R. *sempervirens*, found around the Mediterranean and perhaps the earliest climbing rose in cultivation has been suggested. Next to consider is the 'Rose of Trachys' (Northwest Turkey), deepish pink, which some say is "the Damask Rose" whatever that may be, for no true species of that name exists. The best guess

to date, based on botanical analysis, is that this rose is yet another natural hybrid, in which the ubiquitous R. *gallica* has played hostess to the pollen of R. *phoenicia*, a sprawling species bearing clusters of white flowers found in the wild from Lebanon to Turkey. The outcome of such a cross could well be a deepish pink of somewhat lanky habit, a description fitting a centuries-old variety known as 'Kazanlik', extensively grown in

To summarise the roses of the western world as we did for those of the east, we find at this early date a more limited range of colour – white, pink shades from blush to reddish and purplish pink, but no yellow more telling than the pale cream of the spiny little Burnet rose, and no deep red or scarlet. There are grounds for

5 G. Krussmann, *Roses*. Timber Press 1981.

'KAZANLIK' OR 'TRIGINTIPETALA'

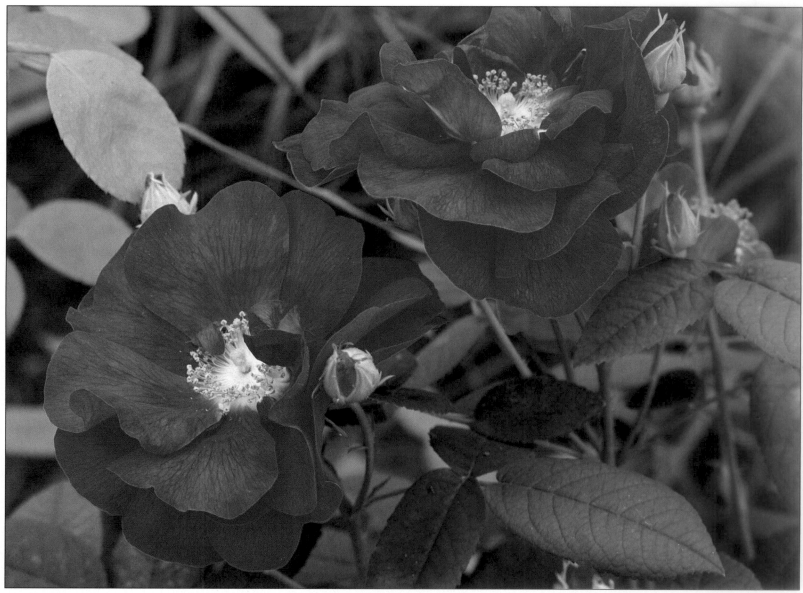

ROSA GALLICA OFFICINALIS, 'APOTHECARY'S ROSE' OR 'PROVINS ROSE'

regarding the western roses as being not so amenable to garden cultivation as those of the Chinese, being in general extra vigorous, apt to sucker freely, and bearing the flowers abundantly but for a shorter season. That they were grown in Greek gardens is evident from comments by Demosthenes (384-322 BC), from references to "Gardens of Adonis" specifically for roses, and most notably from the works of Theophrastus (?372-287 BC). He was a pupil of Aristotle, wrote a treatise including detailed notes on rose care, and in his will he left his garden to his friends. Perhaps the largest private garden belonged to Epicurus (341-270 BC), whose name endures in our language to describe one who holds that the highest good is pleasure; he created his garden in pursuit of that pleasure and ensure a constant supply of fresh rose petals.

The Romans, too, used roses in their gardens, set out in formal fashion with hedges surrounding individual bushes in small beds. Pliny the Younger (?62-112 AD), nephew of Pliny the Elder, described how his "inward circular walks (for there are several), enjoying an open exposure, are perfumed with roses".[6]

The demand for rose petals by Greeks and Romans on an increasingly lavish scale, for use domestically, in religious rites, for medicines, and to sweeten odours, could only be satisfied by commercial growing. Major sources were Praeneste, near Rome, and the city of Paestum (60 miles south of Naples), which was the focus of a huge flower market and where nursery techniques extended the blooming season. When domestic supplies were unavailable, flowers would be shipped from elsewhere in the empire, notably from the Nile delta and from Carthage, involving, wind and weather permitting, a six day journey.

6 Quoted from R. King, *The Quest for Paradise*, Mayflower 1979.

With the collapse of imperial Rome and the disruption of civilised societies, the history of the rose in Europe becomes shadowy and vague. Stray references show they continued to be used in practical ways as well as cherished for their beauty. No doubt the monastic movement, giving rise to self-supporting communities of monks and nuns, with times for contemplation and garden areas to tend, helped preserve cultivated varieties from being lost, especially those valued for medicinal, cosmetic and culinary use. In sixth century Paris, Childebert I laid out a rose garden for his queen. The emperor Charlemagne (742-814) issued a directive for planting flowers in gardens, with lilies followed by roses heading a long list. At St Gallen in Switzerland a 9th century monastery plan made specific provision for a rose bed in the garden, where doubtless the old classical roses "red and white" – R. *gallica* and R. *x alba* – would find their place. We would give a lot to know just what was growing in the nunnery cloister of England's Romsey Abbey, which William Rufus (c.1056-1100) sought to enter in hopes of seeing the youthful Lady Matilda, on the excuse that "he only wanted to admire the roses and other flowering plants". For special occasions in medieval times, branches from wild roses in the countryside would be sought out to adorn fencing and thus create arbours. The Sweet Brier, R. *eglanteria* (Shakespeare's 'Eglantine'), with pretty pink flowers and apple-scented foliage, would be excellent for such a purpose, and as it is said to have been cultivated in England at this period, no doubt gardens too were raided then, much as today's flower arrangers take the secateurs to the purple foliaged 'Rubrifolia' for its decorative value. Permanent arbours were created by planting roses outside castle walls when it became safe to do so, and the castle orchard in the *Roman de la Rose*, where a

suitor sets out to win his love, is filled with "sweet-scented roses red and pale".

The red rose as we have seen is R. *gallica*. A form of this, the 'Apothecary's Rose', or R. *gallica officinalis*, with petals of fine reddish pink colour, is said to have been brought back from the Crusades to Provins, 40 miles from Paris. It was certainly in cultivation as the 'Provins Rose' around 1310, and continued for centuries to be used for perfumes, conserves, and, as the name implies, by pharmacists. In its day it was rated highly for treating "disorders of the head, eyes, gums, heart and stomach" and was being grown in Surrey for its medical properties as late as the mid 1800s. It was and still is a fine garden rose. There is a story that in the early days an English prince, the Earl of Lancaster, brought it from Provins to England and adopted it as his badge, to become the red rose of the royal house.

Such picturesque accounts give few clues to the rose historians as they seek to establish facts and chart their subject's progress. Not until the sixteenth century, when the Renaissance has brought in its train a renewed spirit of enquiry, do botanical lists of the sort drawn up by Pliny again appear. They contain surprises. The source of some of those surprises lies in countries of the nearer east, to which now we turn, and not before time.

Persia may well have been the cradle from which rose growing developed in the west. The art of obtaining rose water was known from very early times, and fragrant roses were grown extensively for that purpose. Some idea of the scale of rose water production may be gauged from reports that annually from 810 to 817 AD the province of Faristan was required to pay a tribute of 30,000 bottles to the Caliph of Baghdad, and that the export trade extended as far as China, India, Egypt, Morocco and Spain. Moslem influence encouraged

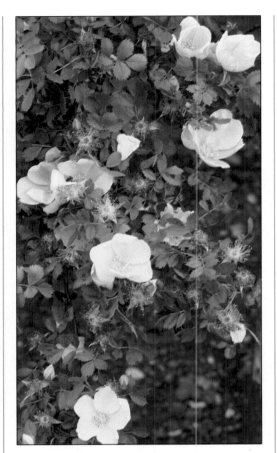

ROSA FOETIDA OR 'AUSTRIAN YELLOW'

the art of creating gardens in the inner courtyard of one's home, with a fountain playing in the centre and shallow pools of water; these gave beautiful effects when the roses were reflected in them, especially as the plants were allowed to grow to their full extent. By planting different varieties near together, and being observant of any novel feature, the Persian gardeners, like their counterparts in east and west, obtained new forms. We read of red, white, pink, purple and bicolours being grown; of a double white R. *moschata* smelling of camphor; and then, in the twelfth century, comes mention of 'The Yellow Rose of Asia'.

As noted earlier, only in Asia are wild, deep yellow roses to be found. They are three in number, R. *persica*, R. *ecae* and R. *kokanica*. In view of their desirable potential for bringing a new colour to a favoured garden plant, it may seem strange that so many centuries elapsed before they came to notice in the wider world. There are, however, reasons to account for this. R. *persica* has, in addition to its vivid yellow colour, a rich scarlet 'eye' at the petal base, which is a feature unique in roses. It is almost impossible to grow except from seed, and, having pollen of low fertility, it does not produce much seed of its own to harvest, let alone show willingness to hybridise with other roses. It spreads by suckering freely, and though so common in its native habitat that its stems are harvested for fuel, it often fails elsewhere. R. *ecae* is found on rocky hillsides in regions of central Asia remote from fanciers of the rose, and only as late as 1880 was it botanically recorded. It too extends its range by producing suckers in its difficult terrain, where it demands dry and sunny sites. R. *kokanica* also suckers and has much in common with the last-named, being well adapted to its own conditions but not easily satisfied outside them, and prone to lose its leaves through blackspot.

From one of these roses, it seems, 'The Yellow Rose of Asia' sprung, showing a brilliance of colour in its five big petals that only they could give. R. *persica*, though the handiest geographically, has to be ruled out. Of the others R. *kokanica* seems more likely. If so, it is the progenitor of all the gaudy yellows and flamboyant bicolours among the modern roses, extending nature's bounty to the future delight not only of human beings but also of blackspot spores, in the even-handed generous way that nature does so well.

'The Yellow Rose of Asia' was first called R. *lutea*,

meaning yellow, but later this was changed to R. *foetida*. As that name implies, scent is not its strong point, and indeed has been compared to that of "the leaf maggot found in soft fruit". Because of its inability to produce good seed and difficulties in propagation, it spread slowly from its heartland, and appears to have been grown in Africa before reaching Europe, which it entered via the Moors in Spain. In Tripoli a bicolour form was being widely grown, now known as R. *foetida bicolor*, with vivid, orange-red replacing the yellow pigment inside each of the five petals. It must have been a flash of brilliance to witness, if only for a day or so in that hot desert sun. Both sorts were being grown by keen rosarians all over Europe by the year 1600.

Another mystery was coming out of Persia to puzzle rose historians. In 1551 Dr Nicholas Monardes from Spain wrote a treatise on the roses of Persia and Alexandria, saying that the 'Damask Rose' had only been grown in Spain for about 30 years, but for longer than that in Italy, France and Germany. Richard Hakluyt (c 1552-1616) credited Dr Thomas Linacre (c 1460-1524), founder of the Royal College of Physicians, with its introduction from Italy into England. The puzzle arises from the fact that the 'Damask Rose' was one of those few varieties famous in Classical times referred to earlier, that hybrid of R. *gallica* x R. *phoenicia* so valued for its scent, which had been established for centuries all over Europe and the Near East, notably in Syria where rosewater production was conducted on a large scale, and where doubtless the name 'Damask', meaning "from Damascus", derives. The answer to this puzzle, according to geneticist Dr C.C. Hurst (1870-1947), lies in the fact that there are two different 'Damask Roses'. The earlier one is as stated above, but the later one has very different properties, being not so fragrant, but *having the ability to give some autumn bloom*. The amount of Autumn bloom is not great, just a token spray here and there of deep pink, crinkly-petalled double flowers on long, arching stems. Nevertheless, for an age when no other roses flowered beyond mid-August, even a token offering in the period September to November was sensational. The

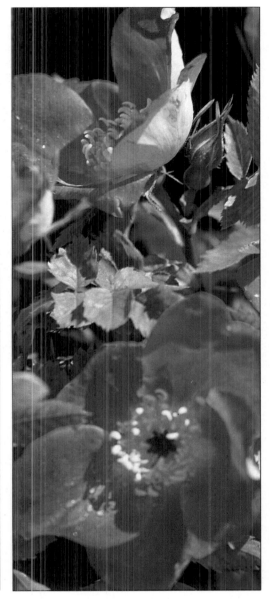

ROSA FOETIDA BICOLOR OR 'AUSTRIAN COPPER'

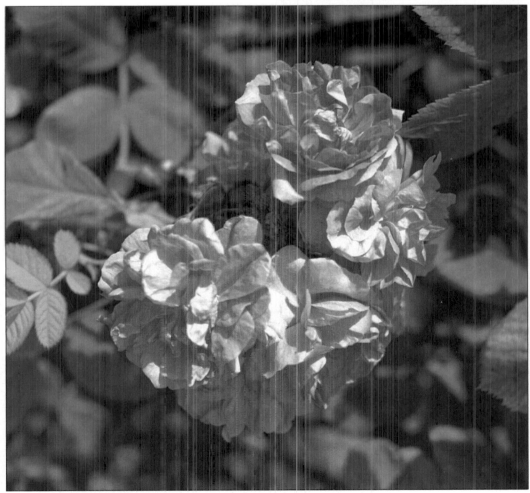

'QUATRE SAISONS' OR 'AUTUMN DAMASK'

supposed parentage of this repeat-flowering 'Damask Rose' is *R. gallica x R. moschata*, and although *R. moschata*, a Climber, bears its scented white flowers later in summer than other species, it is still genetically unlikely for two once-flowering parents to produce anything other than a once-flowering offspring. Perhaps the bees concerned could tell a different story. The rosarians of Europe (perhaps anticipating Oscar Wilde's view that "it is better to take pleasure in a rose than to put its roots under a microscope") did not have to worry about genetics. They planted the new rose and conjured up new names for it. 'Autumn Damask' is a fair description, but in France enthusiasm got the better of accuracy, and the variety is there called 'Quatre Saisons' ('Four Seasons') to this day. Botanists call it *R x damascena* 'Bifera', the twice-bearing Damask.

Books on rose history will tell you in confident prose that the 'Autumn Damask' was known to Greek and Roman, that it was grown at Paestum and blasted at Pompeii. If that is so, where was it in all those years up to 1500? Such an outstanding garden plant would have left some trace in the course of eleven centuries. Nor is it easy to see how it could have been cultivated in Classical times and subsequently lost. In my experience it is the kind of rose that overgrows its neighbours and soldiers on for ever. Maybe the Persian poet Farid-ud-din-Attar, when he wrote these lines seven hundred years ago, had a variety such as this in mind: "In the rose bed, mystery glows; the secret is hidden in the rose".

Mention has just been made of R. *moschata*, and although that, too, has its mysteries, in the present context, that of Persian roses, the story is straightforward. During the 1500s it found its way to Europe. Thomas Cromwell (c 1485-1540) is said to have brought or sent the first plants to England from Italy, where he spent several years as a young man, absorbing its Renaissance culture before coming home to serve king Henry VIII. As commercial agent to a Venetian merchant house, he was well placed to ship plants home to England. Another source suggests it arrived from Spain in 1521 – and both stories could be true. It was growing in Augsburg by 1565 and by 1600 rosarians everywhere were able to appreciate its unique qualities. It was the only late bloomer apart from its fellow traveller 'Autumn Damask', the only garden-worthy Climbing rose, and the blooms, which varied from single to double in their petal count, maintained a cool, fresh appearance as they opened out. *R. moschata* is also remarkable for the curious derivation of its name, which translates as 'Musk Rose', from Persian *mushk* and Sanskrit *mushka*, meaning scrotum, repository of the musk deer's alluring scent, an imitation of which each flower in the cluster yields so pervasively on late summer evenings.

Having acquired four oriental treasures for the rose world, namely the first deep yellow, the first bicolour, the first garden-worthy Climber and the first Autumn bloomer, it is nearly time to return to Western Europe and catch up with what has been happening there. We pause only to consider that Persian influence was not confined to western channels, but extended, and very strongly, towards the east. In India the Mogul emperors were great builders, and gardens were included in their forts and pleasure palaces. They had family links with Persia and employed Persian architects. Of Babur, the first emperor (1526-30) it is recorded that when he was laying out a garden in Agra he "planted roses and narcissi regularly and in beds corresponding to each other". Jahangir (1605-27) and his wife Nur Jehan established many gardens, and close to his last resting place roses were planted either side of a canal, so that they would be more effective in reflection. His was a most versatile rose-loving family, for his father-in-law's tomb anticipated ground cover roses of today, using bushes so planted that their stems would bow over "to break the hard edges of the stonework", and his wife, Nur Jehan, is often said to have discovered rose oil or attar, through observing a film of oil upon the water's surface. The emperor's

'NUR MAHAL'

memoirs tell a different story, giving the credit to her mother:

> This 'itr is a discovery which was made during my reign through the efforts of the mother of Nur-Jehan Begam. When she was making rose-water a scum formed on the surface of the dishes into which the hot rose-water was poured from the jugs. She collected this scum little by little; when much rose-water was obtained a sensible portion of the scum was collected. It is of such strength in perfume that if one drop be rubbed on the palm of the hand it scents a whole assembly, and it appears as if many red rosebuds had bloomed at once. There is no other scent of equal excellence to it. It restores hearts that have gone and brings back withered souls. In reward for that invention I presented a string of pearls to the inventress[7]

[7] tr. H. Beveridge, quoted from B.P. Pal, *The Rose – its Beauty and its Science*, Arrowsmith 1987.

This makes a nice story but is not to be taken at face value. Jahangir caused many books to be written concerning his family's deeds, and while the event may be based on fact, the process of making attar was known to the emperor's Persian kinsfolk centuries before.

It was during that same Jahangir's reign that an envoy was sent to his court from James I of England, a reminder that even at that early date such extensive journeys could be planned. It is small wonder that from now on there is a rapid acceleration in the development and dispersal of the rose throughout the known world.

A direct reference to this process occurs in a book of 1561 by Konrad Gessner (1516-1565) of Zurich, under the heading "Hedgeroses": "Alexandrian, Persian or Damascene, mostly flesh pink, were formerly quite rare with us, but now we have them in quantity in these pink tones. These roses were often brought to us by Italians, French, Germans etc In our case it is now about thirty years since we became aware of them."

Gessner was one among several writers whose rose lists become increasingly helpful. One of them was Clusius, or Charles de l'Ecluse (1525-1609) of Arras, who travelled via Hungary to Turkey and is credited with introducing R. *foetida* into northern Europe. On his travels he visited an exhibition in Vienna, where, displayed in the entry from Constantinople, he admired a fine paper model, no doubt after the manner of that traditional eastern art which continues to this day. The model showed a garden, and admiration grow to excitement when Clusius saw it contained a yellow rose with many more than the customary five petals. His enquiries bore fruit, albeit slowly, for this rose proved a bad traveller, but at last, in 1601, he received it in his native Holland. It was known as R. *sulphurea* (from the medium yellow colour) or R. *hemisphaerica* (because the flattish top gives the bloom, seen from the side, the shape of half a sphere), and the second of these names eventually found favour. Both flower and plant proved a disappointment, because the many-petalled blooms refused to open in cool or wet conditions, and the plants were very difficult to propagate and liable to die in hard winters. Indeed, attempts to introduce it into England, begun in 1622, did not achieve lasting success until 1695. It was suitable in warmer climes, and grown extensively for cut flowers in France and Italy. The

ROSA X CENTIFOLIA, CABBAGE ROSE OR PROVENCE ROSE

'TUSCANY SUPERB'

ROSA X CENTIFOLIA CRISTATA, 'CRESTED MOSS' OR 'CHAPEAU DE NAPOLEON'

sensational novelty of a double yellow rose outweighed the drawbacks, which also included a droopy neck and unappealing habit.

The earliest comprehensive list of roses being grown in England comes to us from John Gerard (1545-1612), who includes the 'Great Holland' or 'Province' rose. Today it is called 'Provence' or sometimes R. *x centifolia* or 'Cabbage Rose'. Holland is thought to be its place of origin. It is deep rose pink, a very rich colour, with many large petals, though not as many as a hundred, which the name 'Centifolia' suggests, and is one of the most sweetly fragrant roses known. Probably it has *R. gallica* parentage, mixed with 'Damask' or other varieties or species, and was developed by observant gardeners from the later fifteenth century onwards. It proved a wonderful rose for growers, flower arrangers, perfumers, painters and as a decorative motif for all manner of objects, from French porcelain of the eighteenth century to biscuit boxes of the twentieth. It also showed great versatility as a parent of new forms, and a whole class of 'Centifolia' or 'Provence' roses came into being, some being dwarf growers, some white, some having curious furry growth over the buds and stems (which came to be called 'Moss' roses, or in Latin *R. x centifolia muscosa*), and one with tufted growths on the bud, named the 'Crested Moss' or *R. x centifolia cristata*, or, in France, 'Chapeau de Napoleon'.

R. gallica also proved capable of surprises. In addition to the increase in petallage, the *officinalis* variety mutated in the early seventeenth century, so that some of the pinky red colour was missing, resulting in a bizarre striped red and white effect; this rose is often misnamed 'York and Lancaster', and an acceptable extra name, 'Rosa Mundi', meaning "rose of the world", appears charmingly misspelled as 'Rose of Monday' in eighteenth century bills.

Also very popular at that period was 'Tuscany', probably the same as the rose called 'Double Velvet'. The first name gives a clue to the likely place of origin, the second indicates the effect of sun lighting up the petals, which appear like a beautiful, textured, rosy-purple velvet. Perhaps this intense colour came through a fine selected form of the Alpine Rose, R. *pendulina*, which is capable of giving rich purple-red flowers, crossed with a *R. gallica* variety. There was no deeper

red to be found in Europe, but in truth maroon-purple tones soon spoiled the illusion of redness once the flowers were past the earliest stage.

Allowing for some hybrids whose qualities are less outstanding, and for a few additional species, such as the handsome bright pink R. *virginiana* which reached Europe from America in 1724, the roses

described up to this point constitute the gene pool of the western world up to 1750. There are yellows and a bicolour, but they are apparently sterile and difficult to grow; there are many excellent pinks and whites, vigorous and fragrant, but only the 'Autumn Damask' can be relied on for late season bloom; the crimson purple 'Tuscany' and bizarre 'Rosa Mundi' show promise of what further gifts the genus ROSA may yet provide. That promise is soon to be fulfilled.

The focus of our story moves, once again, to the east; further this time than Persia and India, though their role is still significant. Within the period 1750 to 1910 a succession of varieties from China found their way to the west and made an impact on so many aspects of rose cultivation that their importance can hardly be overstated. The story is, like so many phases

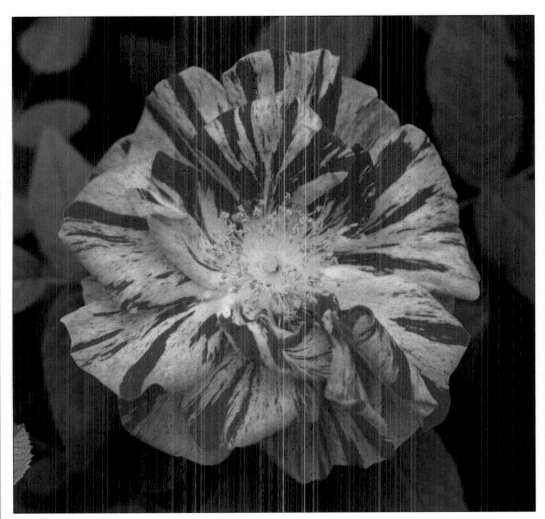

ROSA GALLICA VERSICOLOR OR 'ROSA MUNDI'

ROSA MULTIFLORA CARNEA

two or three visits a month were allowed to foreigners, and a fee of $8 per day was charged.[8] Even so, a wide range of Chinese horticultural produce could be observed, and the fact that the plants were in pots was a great advantage to purchasers from far away. They could be bought in tubs, or sewn in cloth with soil at the roots, or in specially designed glass cases. Even so, losses were tremendous. John Livingstone of the EIC recommended repotting in better soil, and then growing on in Macao before risking the hazards of a long sea voyage.

Among the first rose novelties discovered was a vigorous Chinese climber "Golden Cherry" (so called from its hips) and a rambler "Powderpuff Rose" (from the big trusses of white flowers smothering the plant in summer). The west was very short of climbing roses, and welcomed these in the 1700s. The second one became very popular, but the first, whose waxy white flowers with their large petals and gold stamens looked so beguiling in South China, proved too tender for northern Europe. The Chinese names were also more beguiling than those the botanists bestowed: the tender one became R. *laevigata*, and the tough one R. *multiflora cathayensis*. A flesh pink sister of the last-named, the Chinese 'Lotus Rose', found its way to England in 1804, to become R. *multiflora carnea*.

In 1791 a mission to Peking was arranged by the government in Britain, to seek a relaxation of the controls on traders. It was led by Lord Macartney, whose Secretary, George Staunton, received permission to collect plants from the adjacent coastal regions. The party included two gardeners, which was just as well, for the plants they carried away were the mission's only useful consequence. Among those plants was a third new Climber, R. *bracteata*, named for the decorative, tiny leaf structures (bracts) around the flowers, which are large, white with a silky look and having orange-yellow stamens; in the words of one commentator, "aristocratic and altogether splendid". It was introduced into Britain as the 'Macartney Rose' in 1793, and not long afterwards into the USA, where in the milder southeast it grew as a wild plant so extensively as to make itself a nuisance, and receive the less aristocratic appellation 'Chickasaw Rose'.

It is possible that an ancient Chinese garden rose, 'Old Blush' also accompanied Macartney home to England, though it had reached Europe earlier. This has many names, 'Common Blush China', 'Parson's Pink' and 'Old Pink Monthly' among them. The last gives the clue to its real importance, for it flowers not in summer only, but in repeated cycles of growth and bloom, being, in other words, remontant. (Remontant is a French word that means "coming up again", and is used of roses in preference to the clumsy "repeat-flowering" and the misleading "continuous-blooming".) It took so well to the British climate that we are told "it was in every cottage garden" by 1823, giving colour from June to late Autumn, until nipped by winter frost. Today anyone can see how very closely its ensemble of neatly formed double flowers on compact plants parallels that of a modern cluster-flowering Floribunda, especially in respect of the shiny, pointed foliage. The eye is no deceiver, for 'Old Blush' has proved a potent ancestor of much that is best in the twentieth century rose.

Around the year 1790, a captain in the East India Company obtained a rose of Chinese origin in Calcutta, which he brought to England and presented to an EIC Director, Gilbert Slater. This became known as 'Slater's Crimson China', having a crimson tone of richness and intensity not seen before in roses of the west. Like 'Old Blush', it was remontant, so much so that in America some called it the 'Daily Rose', and even the botanists conceded the point, with the title R. *chinensis* 'Semperflorens', "the ever-blooming China Rose". As an ancestor of modern roses it ranks in importance with 'Old Blush', but in the garden proved less tolerant of hard winters.

8 See *A Heritage of Roses* op. cit. where she describes her rediscovery of the site in 1981.

of rose history, both fascinating and confusing. The confusion arises in part because cultivated forms were often known before the species responsible for them had been discovered, and in part from the desire of China's rulers to maintain their cultural and political isolation. To them the westerners were barbarians, and fraternisation beyond the limits necessary for trade was not encouraged. Plant hunters, especially in the earlier years, suffered frustrating restrictions in their attempts to achieve their goals.

In 1698, a charter was granted to "the English Company trading to the East Indies", which was soon to become famous as the East India Company, purveying all kinds of artefacts and merchandise to and from the Far East. The activities of its agents in China were grievously restricted, to an area of only some 1000 x 500ft. in the city of Canton (now Kwangchow), up the Pearl River estuary from Portuguese Macao where they resided. Much has been written of the gardens near Canton known as "The Flowery Land" or "Fa Tee" in Chinese. Here flowers and a succession of potted plants in bloom were on sale all the year round, though access to non-Chinese was limited. Hazel le Rougetel records that by 1819 only

'OLD BLUSH' OR 'PARSONS PINK'

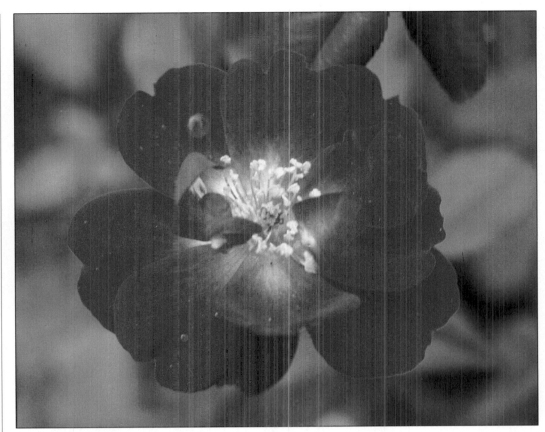

ROSA CHINENSIS SEMPERFLORENS OR 'SLATER'S CRIMSON'

Slater's rose came via Calcutta, where the Botanic Gardens played host to many Chinese roses. In 1793 Dr William Roxburgh was appointed Superintendent. He organised the collection of new plants and a team of artists to depict them, and took care of new items sent by ship from China. A pretty pink rose that bears his name, R. *roxburghii*, also called the 'Chestnut Rose' because the hips are bristly like a chestnut's casing, was obtained from Canton in 1814, and sent to England where it first bloomed in 1824. Only four years later it reached the USA.

John Reeves, a Tea inspector with the EIC, was a keen rosarian. He bought plants at Fa Tee on behalf of others, and among them was a scented, blush-pink, large-petalled rose which bloomed about 1809 in the garden of Sir Abraham Hume in Hertfordshire, and came to bear his name as 'Hume's Blush Tea-Scented China'. It was not a perfect rose for the English climate, being tender and thin-wooded. From the same Chinese source John Parks brought home in 1824 what appeared to be a pale yellow sister of the blush one, which came to be called 'Parks' Yellow Tea-Scented China'. It shared its sister's failings. What the Tea roses lacked in garden-worthiness they made up for in the graceful shape of their young flowers, and the silky texture of their large petals, qualities which they were soon to pass on to uncountable descendants. Their "Tea fragrance" is like the delicate aroma of a choice China tea.

John Parks was an example of a new breed of professional botanists, commissioned to search out specific items by a sponsor or employer. His brief, from the Royal Horticultural Society, had been to search for a yellow climbing rose, admired by visitors to Calcutta who learned it had been imported from Canton. A white form of the rose had earlier been found by William Kerr, sent out from Kew, and named for the Director's wife as 'Lady Banks' Rose' or R. *banksiae*. Parks succeeded, and his R. *banksiae lutea* or 'Yellow banksian', with pretty pendant sprays of yellow rosette flowers remains one of early summer's chief delights, seemingly unchanged since he brought it home on the Eastindiaman *Lowther Castle* in 1824.

War between Britain and China broke out in 1839, following the destruction of chests of opium illegally imported by the English merchants. By the Treaty of Nanking in 1842, the traders gained a landhold in Hongkong and access to five Chinese ports. These conditions should have made plant finding easier, but Robert Fortune, working for the Royal Horticultural Society, found himself obliged to dress as a Chinese, shave his head and wear a pigtail to fulfil his task. His many acquisitions included winter-flowering jasmine, and three beautiful but tender climbing roses, among them 'Fortune's Double Yellow' in 1844. His often-quoted account of its discovery, taken from his *Three*

ROSA BANKSIAE LUTEA OR 'YELLOW BANKSIAN'

ROSA HUGONIS OR 'THE GOLDEN ROSE OF CHINA'

ROSA CAUDATA HIPS

Years Wandering in China (London, 1847), captures something of the excitement experienced by plant hunters of those times:

> On entering one of the gardens on a fine morning in May, I was struck with a mass of yellow flowers which completely covered a distant part of the wall. The colour was not a common yellow, but had something of buff in it, which gave the flowers a striking uncommon appearance. I immediately ran up to the place and, to my surprise and delight, found that it was a most b*eautiful new double yellow climbing rose* Another rose, which the Chinese call 'Five Coloured', was also found Sometimes it produces self-coloured blooms, being either red or French white and frequently having flowers of both on one plant at the same time – while at other times the flowers are striped with two of the colours."

The second variety sounds like one already brought to England in 1817 and known as 'Seven Sisters' or R. *multiflora platyphylla*. This was at least the third variation on *R. multiflora* from the Far East, and it was some years before *R. multiflora* itself, the species parent, was introduced to Europe, having been discovered both in its normal rambling form and as a bush. My brother Jack comments on it as follows: "One of the least attractive of wild roses, but one of the most generous and amazing parents."[9]

This serves to remind us that most Chinese roses sent westwards had been garden forms, not wild roses. After 1860 political events eased access to the interior, and then the native roses began to yield their secrets. One was the climber *R. gigantea*, whose pale, silky-looking flowers with refreshing tea scent marked it out as one of the progenitors of the Teas. It was first seen

in 1888. Their other presumed ancestor proved more elusive, having been recorded in 1885 and then not found for nearly a hundred years.

Among the seekers after species was E.H. Wilson, whose many finds earned him the soubriquet "Chinese Wilson". One of them must greatly have pleased his wife, for he named a creamy white climber after her, as R. *helenae*. His haul included items which would prove garden-worthy in their own right, like the grey-foliaged R. *murielae* and the ferny-leaved R. *willmottiae*, and R. *moyesii* and R. *davidii* with magnificent scarlet hips.

The last two commemorate Christian missionaries, who were now allowed to evangelise in China. The Rev. Hugh Scallan, also known as Father Hugo, noticed a pretty yellow species and sent seeds to Kew, giving rise to R. *hugonis*, introduced in 1908. An Italian pastor found R. *caudata*, bearing wonderful bright red hips

'MUTABILIS', WHICH HAS PETALS THAT CHANGE COLOUR.

9 *The Rose*, op. cit.

hanging down in bunches. Abbe Soulie found another grey foliaged plant, *R. soulieana*, and a formidable looking species whose name, *R. sericea pteracantha*, refers to its huge, winged thorns, glowing red when caught by the sun.

These discoveries were made between 1890 and 1910, and at some time in that period a very strange Chinese rose turned up in Italy, having the unique property of changing the colour of its flowers from yellow through buff pink to slate purple. It is known as 'Mutabilis', and how or when it came from China remains a mystery. In 1906 and 1909 the American Frank N. Meyer found two superb yellows, the first "in the garden of a mandarin" with many-petalled flowers, and the other similar in habit, but a brighter colour, and with flowers of five petals. Both are lovely garden plants in their own right, as R. *xanthina* and *R. xanthina spontanea* (or 'Canary Bird').

Japan, like China, had for centuries given little encouragement to foreigners, but three roses found there are important to our story. The first was R. *rugosa*, already referred to as a tough, long-flowering plant, first sent to Europe in 1796. The second came to notice in 1861, when a German visitor, Dr Max Wichura (1818-1866) saw a white rose with leaves of shining brightness trailing over the rocky banks of a stream. This became *R. wichuraiana* in his honour and, with its similar Chinese sister *R. luciae*, provided valuable genes for future hybridists. The third item was of more immediate use, being a spectacular red rambler with the local name of 'Cherry Rose'. It was seen in a Tokyo garden by Robert Smith, a professional engineer, who sent it to a friend in Scotland. Called the 'Engineer's Rose', it was exhibited in England in 1890, and marketed as 'Crimson Rambler' in 1893, creating such a sensation that in order to see it Queen Victoria is said to have paid a special visit to Slough.

For western horticulturalists, the roses just described must have appeared the best gifts from the east since the coming of the Wise Men. Among their

ROSA XANTHINA SPONTANEA OR 'CANARY BIRD'

most precious assets are length of flowering period, ability to mutate, attractive foliage, rich diversity in habits of growth and forms of flower, new shades of colour, and, not least, their overall loveliness.

Because of this bewildering profusion of new things, it becomes impossible to give a clear and logical account of rose developments through the nineteenth century. Great gardens were established. The most notable was at Malmaison near Paris, where the Empress Josephine (1763-1814) sought to make a collection of every known rose, and had assembled 250 varieties by the time she died. With so many

different roses in proximity to one another, it was natural that some would readily cross-pollinate, but sadly for posterity no registrar was there to keep a record. The situation in the middle of the century brought this lament from a visitor to a nursery in France: "Beds of thousands of seedlings without a tally amongst them; the hips gathered promiscuously and the seed sown without any reference to the plants from whence they have come..."

While allowing that many details are unknowable, it is reasonable to set out the likely sequence of events, based on research, conjecture and such evidence as has survived:

ROSA XANTHINA

'BOURBON QUEEN'

'MME ISAAC PEREIRE'

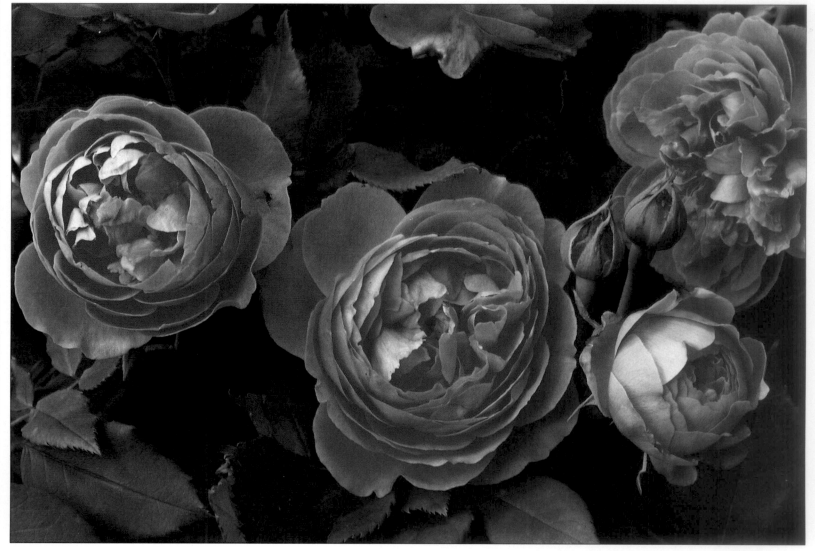

'REINE VICTORIA'

A rose appears in Italy a little before 1800. It is admired for its light red tone which reminds some observers of a China rose, but grows like a European one. Can this be the first cross between east and west, between an imported red China and a resident Gallica or Damask? In England, grown on and greatly treasured, it is named 'Duchess of Portland'. In rose history, it becomes the prototype of the Portland Roses, most of them pink or red, with short stemmed blooms on leafy, shrubby plants, and sometimes an autumn crop of bloom. As many as 150 Portlands were on offer in their heyday, but by 1850 only a few were grown. The Portland genes, combining the eastern ones for redness and extended flowering with the western ones for hardiness and vigour, had meanwhile crossed with other strains to create better roses in their place.

The improbable setting for the next significant union between roses of east and west was the Indian Ocean's Ile de Bourbon, now called Reunion, a colony of France since 1642. Roses are used there as hedges to make pleasing and practical field boundaries. A popular one is 'Quatre Saisons', the long-flowering Damask rose, in its deeper, reddish pink form. Plants of 'Old Blush', the most dependably remontant rose, are imported for similar use. In 1817 a strange plant was noticed, apparently a self-sown seedling of the two, and seeds from that were soon on their way to

Paris. Whatever the truth about the parents, there is no doubting the quality of their descendants. The best one flowers on through summer and autumn, bearing clusters of pink to reddish-purple blooms, on sturdy, vigorous plants. It became the first Bourbon Rose, honouring its place of origin as well as the French royal house, and transmitted to many of its heirs delightful fragrance from the Damask genes. One early fragrant Bourbon was the red 'Gloire des Rosomanes' in 1825, and from then until 1880 many varieties were brought out, mostly raised in France, of which today the best known survivors must be 'Zéphirine Drouhin', 'Mme. Isaac Pereire', and 'Reine Victoria', all various shades of pink, and 'Boule de Neige', white as the name suggests. Some Bourbons need a warmer, drier climate than Britain offers, to enable the silky petals to open fully. The full, rounded flowers of the blush 'Souvenir de la Malmaison' and rose pink 'Louise Odier' are better appreciated in such conditions.

It is clear from the above that French growers played a prominent role in rose developments at this period. Another Frenchman was involved in the third important union of genes from east and west. Louis Noisette of Paris had a brother, Philippe, in business as a florist in South Carolina, USA, to whom he sent 'Old Blush'. Philippe passed it on to his neighbour, a rice farmer called John Champney. Champney had many

'ZÉPHIRINE DROUHIN'

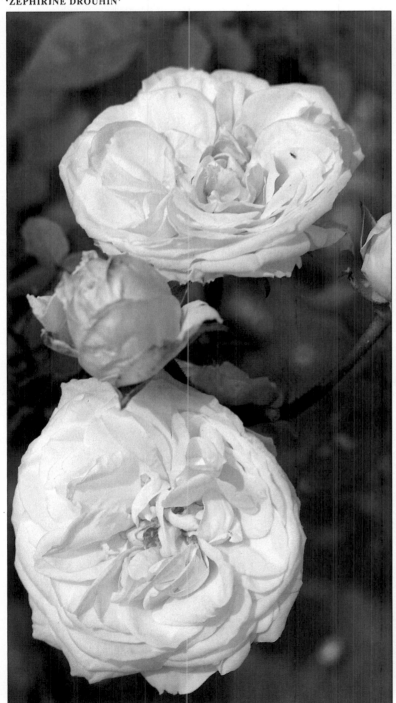

'SOUVENIR DE LA MALMAISON'

'BOULE DE NEIGE'

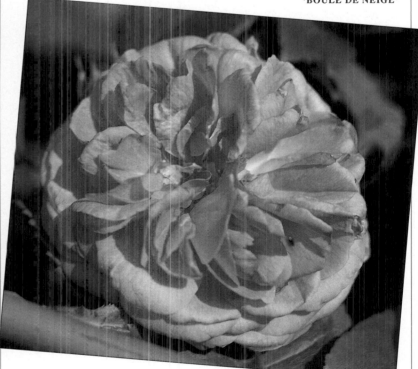

'LOUISE ODIER'

roses, including R. mos*chata*, or 'Musk Rose', the scented white late flowering climber. Around 1802 one of these produced a hip, evidently pollinated by the other. From it came a summer-flowering seedling, scented like the Musk Rose, of semi-climbing habit, pink in colour, and such a pretty thing that everyone admired it, and it is on sale as 'Champney's Pink Cluster' to this day. Philippe Noisette raised some promising seedlings from it, and sent them in 1817 back to brother Louis in Paris, who swiftly introduced the best of them, known today as 'Blush Noisette'. This was a sturdy bush, with pink flowers, and, most important of all, it was remontant. The whole episode illustrates a principle in breeding roses, that if a repeat-flowering rose and a once-flowering one are hybridised, the immediate offspring will be once-flowering; but in the next generation, remontancy can be attained.

The Tea-scented roses, being themselves remontant, were natural subjects for the breeder. Attempts to cross the pink one with the Gallicas were successful, though in line with the principle just mentioned, they were non-remontant, and as they tended to be sterile, further progress down that line was halted. When in 1824 'Park's Tea-Scented Yellow' made its debut, breeders tried again, and with more

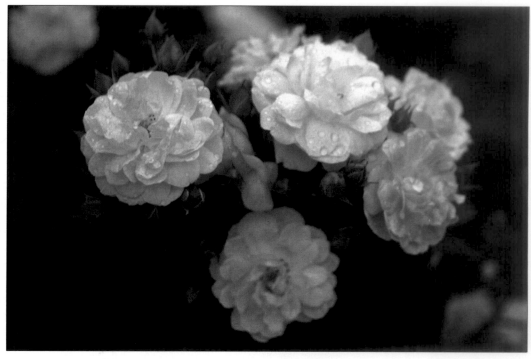

'CHAMPNEY'S PINK CLUSTER'

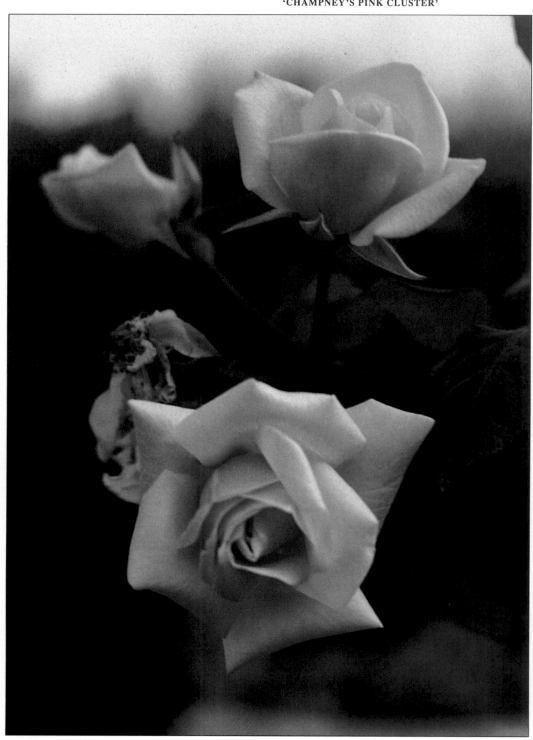

'SAFRANO'

success. By 1830 twenty-seven Teas were on the market. They were crossed with the cream of everything the rose world had to offer, with Bourbons, Noisettes, Chinas, Portlands and older groups besides. One of the prettiest in the early days was 'Safrano', from France, in 1839, with pale buff flowers of elegance and beauty, the long, silky petals giving a high centre to the buds and younger flowers. The older garden roses were often cup-shaped, with flat, low-centred blooms. If they were full-petalled, the arrangement of those petals was lacking symmetry. The gift of the Teas was their revelation that a large flower could be refined, both in shape and petal texture. Decades were to pass before this rose became the accepted public image, and 'Safrano' was an important signpost on the way. Bush Tea roses generally proved tender, so that they suffered in harsh British winters. They are best grown under glass, or in a milder climate. It is estimated that nearly 1400 were commercialised all told, but very few survived competition from the Hybrid Teas after 1900. Those still grown today are mostly derived from crosses with Noisettes, like the famous 'Gloire de Dijon', 'Alister Stella Gray', 'William Allen Richardson', all buffish-yellow, and the white 'Mme. Alfred Carrière'.

A number of remontant roses were introduced which were catalogued as 'Hybrid Chinas'. In appearance they resembled Chinese garden roses, owing less to western genes; indeed some were doubtless forms or seedlings of completely Chinese origin. Among them 'Agrippina', also called 'Cramoisi Supérieure', has been an enduring favourite, with flowers of that rich, deep, scarlet crimson so new to the Europe which welcomed its introduction in 1832. Another popular red was 'Gloire des Rosomanes', which would shortly pass valuable genes for vigour and remontancy to its descendants.

Among the variants from China a miniature form was found, like a 'Slater's Crimson' very much reduced in scale. Its source remains obscure, some saying it was a seedling in an English nursery, others that it came via Mauritius, but it was patently of Chinese origin. From it were derived the Fairy Roses or Miniatures, which became very popular for growing in small spaces and in containers, as their remontancy made them splendid garden value. Sixteen sorts were on offer from one grower in 1836. Pre-eminent was the light red 'Pompon de Paris'. These Fairy Roses were the cheapest of all to buy. British gardeners were being offered them at 3s 6d per dozen, carriage paid, in 1884. Later they fell out of favour but were revived after Colonel Roulet found a pretty red specimen on a farmhouse window sill in Switzerland in 1917. Breeders in Holland, Spain,

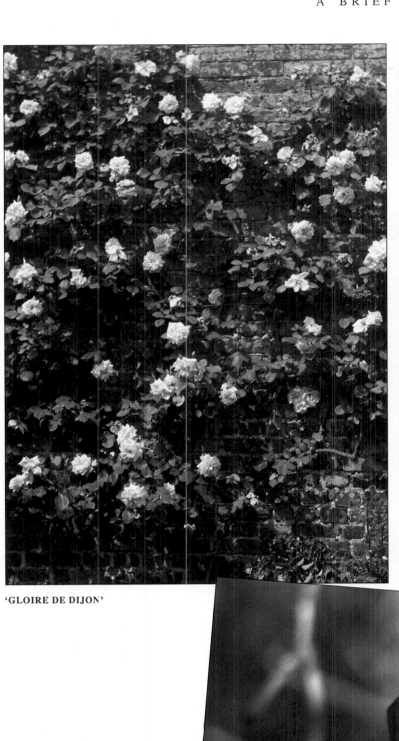

'GLOIRE DE DIJON'

'ALISTER STELLA GRAY'

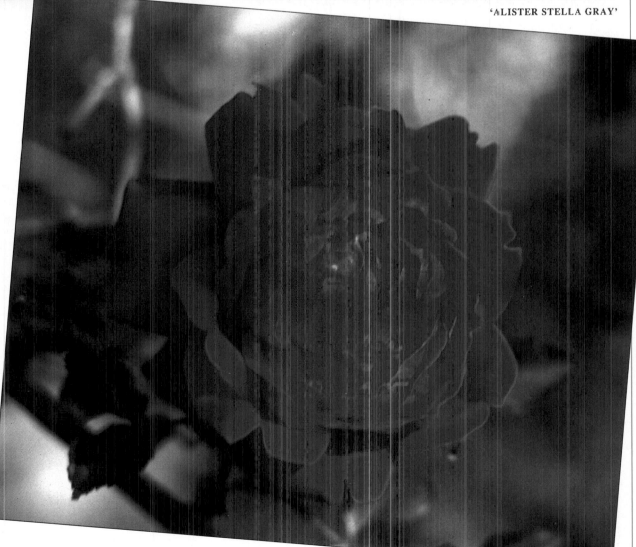

'AGRIPPINA' OR 'CRAMOISI SUPÉRIEUR'

'BABY MASQUERADE'

Germany, France and the USA have been especially active in the twentieth century, bringing in new colours, and flowers whose petals range from the original five to over a hundred. Among the best are 'Stacey Sue', (pink), 'Starina' and 'Orange Sunblaze' (bright red), 'Colibri 79' (deep apricot), 'Pandora' (white), 'Blue Peter' (lilac), and, for those who like mixed colours, 'Little Artist' (red/white) and 'Baby Masquerade' (yellow/pink), though that one may grow rather tall.

We now leap back in time two centuries to see what other forms of rose have still to be accounted for. Before the advent of the Miniatures, the lowliest roses for the garden were the Scotch (or Burnet) ones, prickly, freely suckering, fleeting in flower and hardy, and very ready to produce new colours in their seedlings, which might give flowers of white, cream, pink, purplish-red, or yellowish shades, or veined or mottled combinations of them. A few were being offered from the 1750s, but nurserymen in Perth, Glasgow and elsewhere, sensing a potential market for such novel types of rose, intensified the search for better forms. Eventually several hundred Scotch roses were on offer, and the vogue reached its peak around 1830. Then they were so decisively supplanted by remontant newer roses, that today only a handful can be found. Of these, 'Scotch Yellow', with double flowers, is an arresting sight in its week or two of summer glory, especially in northern Britain. Of the rich purple 'William III' it has been said that "anyone fortunate enough to own this will surely consider it one of the dearest treasures of his garden".[10]

10 J.L. Harkness, op. cit.

'STARINA'

'PANDORA'

'STACEY SUE'

'LITTLE ARTIST'

'LITTLE WHITE PET'

Scotland was the venue for another short-lived race, the Ayrshire Roses, introduced by Scots nurserymen from the 1830s onwards. They used the white trailing *R. arvensis*, the 'Field Rose' common in hedges and dappled woods, and from it raised some sixty seedlings. John Harkness in 1898 recommended them for their hardy constitution, and "for covering rough banks, running up old trees, forming archways, festoons, etc.", but very few are extant today.

Longer lived are the *R. sempervirens* (or 'Evergreen Rose') ramblers raised by Jacques, gardener to the Duc d'Orléans, later King Louis Philippe of France. From 1824 to 1832 he raised some 40 hybrids, of which 'Félicité Perpétue' (white) and 'Adélaïde d'Orléans' (light pink) are still grown today, a tribute to their gracefulness and stamina. In 1879, a dwarf rose, 'Little White Pet', was introduced in the USA. It is a precise replica in bush form of 'Félicité Perpétue', with the added advantage that it is remontant. If it came about as a sport, or natural freak of nature, that gives ground for thinking that the ability of a rose to repeat its flower might have originated through once-flowering climbers sporting in this way. The energy not then needed to make extensive growth could instead be channelled into flower production. Others think this explanation will not do, and suppose some little China rose must have been on a spree in M. Jacques's nursery.

A small group of once-flowering climbing roses originated in France in the nineteenth century. No two accounts agree, but John Fisher[11] credits the parentage

11 In *The Companion to Roses*, Viking 1986.

'FÉLICITÉ PERPÉTUE'

to a rose from China crossed in France with one *(R. blanda)* from Canada, about as far as one can go in proving Kipling wrong when he said "east is east and west is west and ne'er the twain shall meet". Henri Boursault is credited with their origin, and they are called the Boursault Roses. They are pink or red, with smooth stems, bloom early and then play genial hosts to blackspot. A beautiful one that is still grown is 'Mme. de Sancy de Parabère', a pleasing, mauve-tinted pink, probably introduced about 1845.

Two years before then an important event occurred with the recognition of a new group of roses. These were Hybrid Perpetuals. In origin they were a bit of nearly everything, with genes of Gallica, Damask, Portland, Bourbon, Tea and Hybrid China all playing their part. That justifies the "Hybrid" in their name, but perpetual in the modern sense they certainly were not, for while many gave some autumn bloom, others were rather shy. The explanation is that a few early nineteenth century hybrids were called Perpetuals, and they included parents of the new group. Most famous among them was 'Rose du Roi', from France in 1812, with large, fragrant flowers of bright red shaded violet. Nurseryman Thomas Rivers recommended it for "every

'BLUSH BOURSAULT'

'BARONNE PRÉVOST'

'MME. DE SANCY DE PARABÈRE'

gentleman's garden … to furnish bouquets during August, September and October", which helps us understand why in England it was sold as 'Crimson Perpetual' rather than 'Rose du Roi'.

These Hybrid Perpetuals were in habit not unlike our large-flowered bushes of today, but they were built on more generous lines, with stout stems, large, rather coarse foliage, and rounded flowers, full of petals, in many shades of pink, carmine and crimson, with whites as well. Many reds and pinks were fragrant. There were no varieties in the yellow/orange spectrum. It is said that by 1900, four thousand varieties had been raised, and as the rise of this group coincides with growing public awareness of roses as garden plants for everyman, those who earn their living as rose nurserymen have good reason to be grateful. Hybrid Perpetuals were particularly favoured by exhibitors, and it was common practice for the same bloom to be on show in different places on successive days, such was the lasting quality of the prize flowers. The Rev. Foster Melliar declared the Hybrid Perpetual to be the Rose of England, and added: "It has been said of our climate that it has no weather, but only samples: this exactly suits the Hybrid Perpetuals, which like a cool damp one, and long continued 'weather' of any sort will prevent them from coming to perfection".

Famous members of the group included 'Baronne Prévost', with huge rich pink flowers crammed with petals going all ways; the light crimson 'Général

'GÉNÉRAL JACQUEMINOT'

shows wonderful regularity in the organisation of the petals, which seem to spin gracefully out of a central hub, giving symmetry and balance to the bloom.

The Hybrid Perpetuals made good garden plants because they were strong growers, healthy and hardy. Beside them the Tea Roses looked frail. Breeders now set out to combine the good qualities of both, so that the unique character of the Teas – high-pointed centres, neatly furled petals, colours of primrose and buff – might be displayed on bushes worthy of the name. The first successful crosses appeared from the 1860s onwards. Three pinks, 'La France' in 1867, 'Lady Mary Fitzwilliam' (1883) and 'Mme. Caroline Testout' (1890), proved good garden roses and also valuable for further breeding. The first red one was 'Cheshunt Hybrid' in 1872. The foliage of these newer roses was pleasing, having the pointed shape and shiny texture of the Teas, with some of the robust quality of the Hybrid Perpetuals, from which the best ones also inherited hardiness and health. There was still need for a decent yellow, in a shade bolder and more positive than the pale Teas could provide.

As recounted above, the only sources of bright yellow had been the five-petalled R. foe*tida* (also called 'Austrian Yellow'), and the full-petalled *R. hemisphaerica*, immigrants from western Asia centuries before. Attempts to breed with them had ended in frustration; seed would not set, pollen would not fertilise. In 1836 a new one was received, for planting in the Royal Horticultural Society's Gardens. It came from Sir Henry Willock, Britain's Chargé d'Affaires in Teheran some years earlier, who presumably brought it home with him. It resembled *R. foetida* but was full-petalled, and was given the name *R. foetida persiana* or 'Persian Yellow'. More than one breeder tried it, and some probably gave up the struggle, because 'Persian Yellow' was almost as mulish as the others. The prize for persistence went to Pernet-Ducher

ROSA FOETIDA PERSIANA OR 'PERSIAN YELLOW'

Jacqueminot' which is a famous ancestor of modern reds; 'Frau Karl Druschki', prized for its high centred white flowers, said to be Edward VII's favourite rose, and still offered by a dozen nurserymen today; 'Hugh Dickson', ruby red, and 'George Dickson', perhaps the deepest crimson on its day, which might be seldom, if Jack Harkness' experience was general: "Sometimes it gave a wonderful dark crimson flower, which on being seen in an exhibition box set people admiring it for another few years. I grew it for seven years, and never had that luck."

One of the most beautiful and enduring of them all was 'Mrs John Laing' of 1887, raised by Henry Bennett, a Wiltshire cattle breeder. He became interested in roses, studied new techniques in France, and proceeded to make the raising of new roses a scientific art, with proper recording of the parentage. Compared with the form of 'Baronne Prévost' of 1842, 'Mrs John Laing'

'MRS JOHN LAING'

'SOLEIL D'OR'

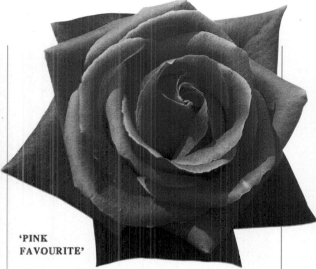

'PINK FAVOURITE'

chosen as "The World's Favourite Rose" on the first occasion that competition was held. Many Hybrid Teas have been raised using other types of rose, so that 'Pink Favourite' (1956) may thank a rambler for its outstanding health, and 'Silver Jubilee' (1978) a climber for its lustrous leaves and vigour, which it in turn is transmitting to present and future generations. The colour range has widened to include flame, salmon, orange, lilac, deep purple, tan and bicolours of all sorts in addition to the more traditional shades. 'Just Joey' (1973) is a rare shade of coppery-fawn-buff, and its huge flowers with their ragged petal outline give it a unique character. Vermilion hues came through 'Independence' (1950) which was outclassed by 'Super Star' (1960), and both are outshone by the purer colour tone of 'Alexander' (1972), one of today's top sellers.

'SILVER JUBILEE'

in his nursery at Lyon. He began in 1883, crossing a red Hybrid Perpetual with the 'Persian Yellow'. Only a few seeds rewarded all his efforts, and the plants they gave did little to inspire his confidence. He kept the strongest, and noticed in 1891 that one produced semi-double blooms of pink and yellow, a sign that he was some way towards his goal; only some way, because its flowering was limited to summer, as is inevitable with a first generation cross. What happened next is like a fairy tale. In 1893 a visitor called and expressed a wish to see the progress of Pernet-Ducher's work. As they walked towards the bush, a bright splash of colour caught their eye. Alongside the old plant a new one had appeared, only a few inches high, with petals of orange-yellow, apricot, bright red and salmon. No one had foreseen its coming, and the only explanation is that the old plant had produced a hip, seed had fallen to the ground, and in this way nature had rewarded the patience of the breeder. It taught breeders of the future another lesson, that allowing a hybrid to pollinate itself (called "selfing") could give valuable results; and further, that although genetic laws had caused the first hybrid to flower only in summer, remontant roses could come from the children of that hybrid. Pernet-Ducher exhibited his 'Soleil d'Or' in 1898, and was being spoken of as "The Wizard of Lyon" in recognition of his genius. The rose itself would not attract a second glance today, and that is a tribute to its fertility. The effect of its genes can be seen wherever one finds vivid yellow, flame and orange-salmon colours in the modern rose.

Hybrid Teas, with their large size and elegant form, have remained the most popular garden roses of the twentieth century, as the sales records of nurserymen bear witness. Thousands have been introduced, and many are described later. A handful deserve special mention here. The neat form and sweet fragrance of 'Ophelia', pale blush, have never been surpassed, which is remarkable for a rose of 1912. 'Crimson Glory', richly scented, came out in 1935; it is glorious at its best, and nearly all deep reds with fragrance descend from it, inheriting alas weak necks and mildew in the genetic package. The yellow/pink 'Peace' in 1945 set new standards, with handsome, shrublike growth, tough foliage and a vigorous constitution, and happily it has been prolific as a parent. It was deservedly

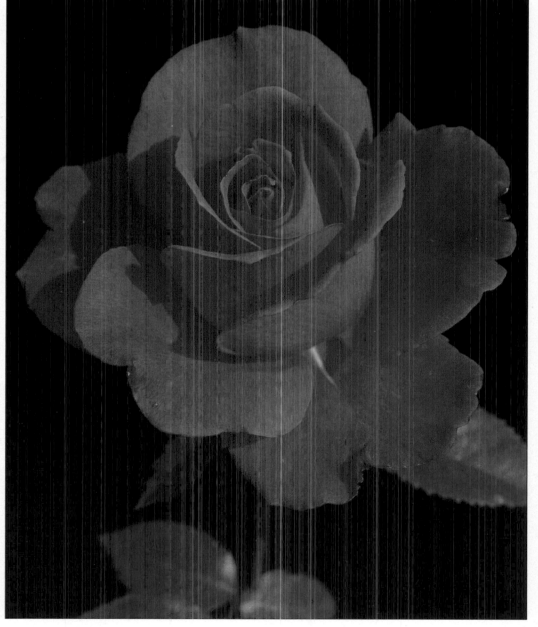

'ALEXANDER'

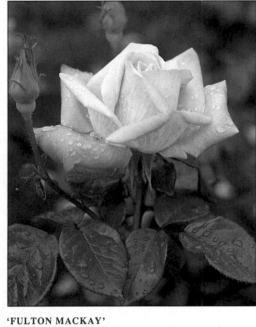

'WHISKY MAC'

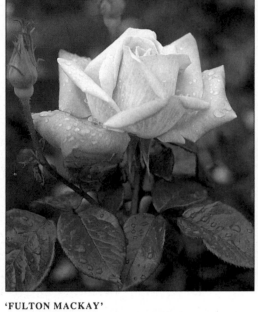

'FULTON MACKAY'

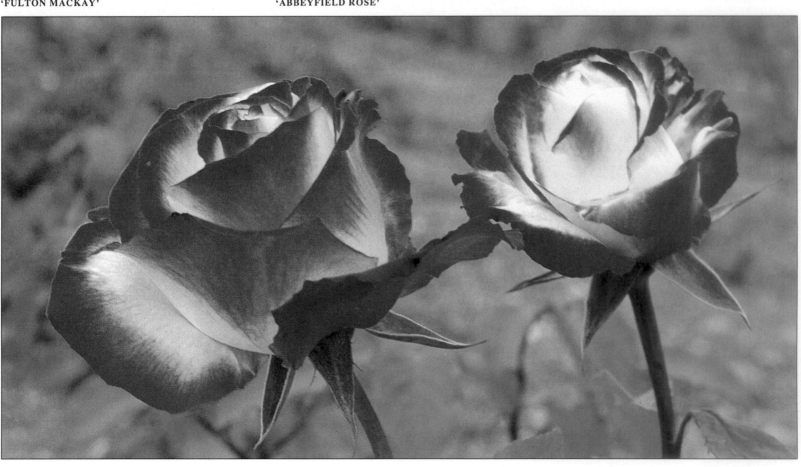

'ABBEYFIELD ROSE'

'DOUBLE DELIGHT'

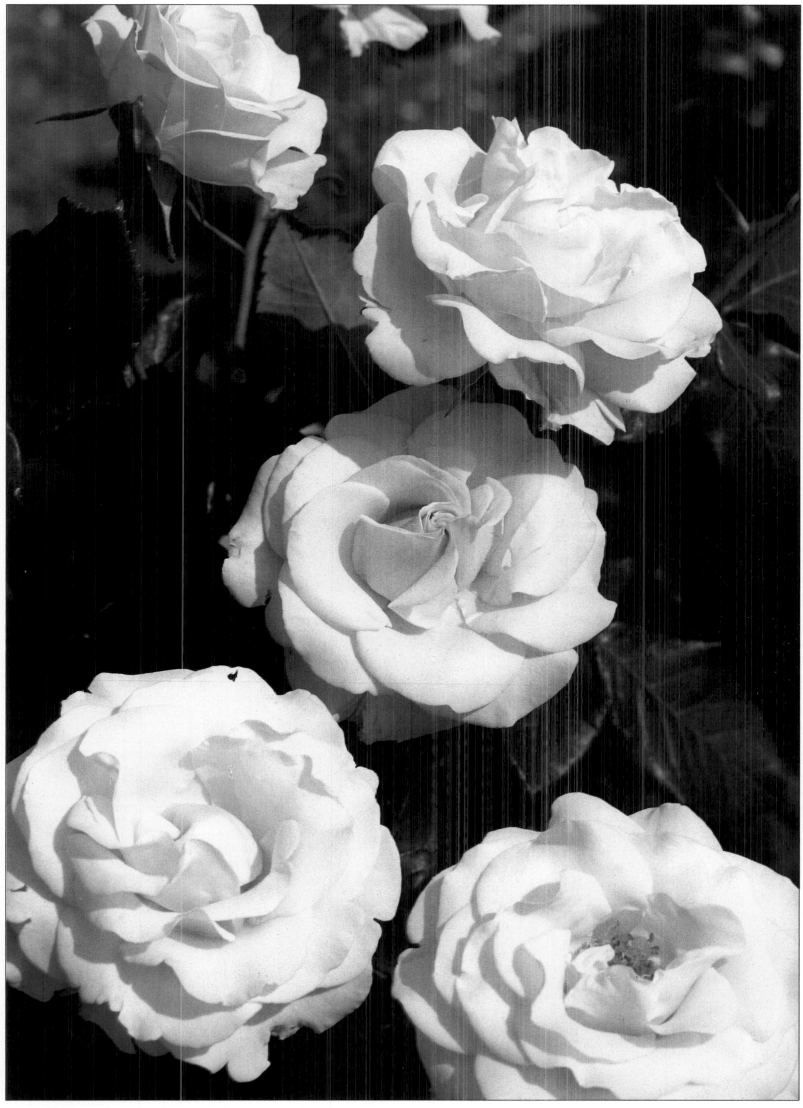

'FREEDOM'

'PEAUDOUCE'

'SAVOY HOTEL'

Others high in public favour include, as well as 'Just Joey' and 'Silver Jubilee', 'Alec's Red' (1970), pink 'Blessings' (1968), amber 'Whisky Mac' (1967), the pink and white 'Double Delight' (1977) and dusky scarlet 'Fragrant Cloud' (1963). It is always hard to forecast which of the more recent introductions will have staying power. Among the best prospects are 'Abbeyfield Rose' (deep pink, 1985), 'Freedom' (yellow, 1984), 'Fulton Mackay' (golden apricot, 1988), 'Peaudouce' (cream, 1985) and 'Savoy Hotel' (pink, 1989). There is plenty of room for improvement, in health, scent, vigour and especially in the reds.

That brings the story of the large-flowered bush roses up to date, but what of those which bloom in clusters? Lyon in France again saw the first developments. In 1865 a short growing blush-pink form of R. *multiflora*, admired for its showy panicles of tiny blooms even though their display was of short duration, had been received in England from China or Japan. Seeds of white forms were also sent direct to France. From one source or the other, maybe both, the Mayor of Lyon obtained stock and used it in a local park. Seeds were taken, and evidently pollen from a China or other remontant rose at some stage played its part, because in 1875 the firm of Guillot introduced 'Ma Pâquerette', meaning "My Daisy", which was white, with many little petals, about fifteen inches high, and more than making up for lack of stature by the generous continuity of its bloom. This is recognised as the world's first Polyantha Rose, from the Greek for "having many flowers". A pink version, 'Mignonette', or "Sweetheart", followed in 1881, and from that came 'Gloire des Polyantha' of 1887, deeper pink in colour, its name confirming the status of this new class. In the search for a wider colour range, breeders looked for other strains to use as parents. Crossing with Teas gave two delightful novelties, blush pink 'Cécile Brunner' in 1881 and honey-yellow 'Perle d'Or' in 1883. These were much more like scaled-down Teas than Polyanthas, bearing exquisitely pointed buds, but they inherited the genes for hardiness, and showed how versatile the results of this new breeding opportunity could be. Peter Lambert of Trier in Germany tried mixing Polyanthas with yellow and buff Noisettes, and before the century was out the fiery copper tints of his dainty 'Léonie Lamesch' were a source of wonderment; it was a truly startling colour for those days.

The next step was for red to be brought in. A splendid source was available in 'Crimson Rambler', launched in 1893 and already by 1896 acclaimed "The Rose of a Century" by nurserymen. It shared a common ancestor with the Polyanthas, and from their union came a red bush whose seeds produced 'Orleans Rose' (1909), somewhat puce in tone but progenitor of many famous sports. Two of these created a sensation in 1929-1930, when 'Gloria Mundi' and 'Paul Crampel' announced that henceforward roses could be orange-scarlet. The raisers could hardly take the credit (apart from their skill in observation) because this breakthrough was a gift of nature, due to a chemical change whereby pelargonidin, common in pelargoniums, first entered the kingdom of the rose. Soon the catalogues were offering white, cream, pink, salmon, copper red and crimson, as well as the new scarlets for which they soon ran out of adjectives — words like "dazzling", "brilliant", "spectacular" performed many years of service. These little roses, often called Poly Pompoms from their little rosette flowers, were widely used for bedding, and planted out in their thousands in parks and gardens to brighten the environment. Few survived the 1950s, due perhaps to changing public taste in favour of more shapely roses, but also due to mildew which often ruined the autumn bloom. Two of the healthiest are still grown, 'Yvonne Rabier', a creamy-white of 1910, and 'Ellen Poulsen', deep pink from 1911. Both have handsome, glossy foliage, for which they can thank the genes of R. *wichuraiana*.

The Poulsen brothers in Denmark had been noting the success of the Polyanthas, and saw an open market

'CÉCILE BRUNNER'

for such roses if they could be endowed with flowers of better form and larger size. They took the logical step of crossing a Polyantha and a Hybrid Tea, and in 1924 launched 'Else Poulsen' (pink) and 'Kirsten Poulsen' (red). Both were upright plants bearing big sprays of neatly spaced, sizeable flowers, with few petals, and very hardy, as they needed to be in the Danish climate. At first they were called Hybrid Polyanthas, but American growers used the term Floribundas, and eventually that description stuck. Some excellent reds and pinks appeared from Denmark and England in the 1930s, the best being 'Karen Poulsen', scarlet, 'Betty Prior', rich pink, 'Donald Prior', bright crimson, 'Dainty Maid', pink with golden stamens, and 'Dusky Maiden', one of the darkest reds, almost black in the bud stage. 'Frensham', which made its debut in 1946, was a bushy, vigorous plant with scarlet-crimson buttonhole buds of charming form. It was a great rose in its day, having the advantage, for the gardener, of not forming hips, so that it was quick to repeat its bloom without dead-heading. For the breeder that was a shame, for it offered little prospect of using 'Frensham' to endow further roses with its valuable features.

Svend Poulsen had a dream, to raise a Floribunda in pure yellow, something never satisfactorily achieved with the Polyanthas. He used a seedling of 'Persian Yellow', and in 1938 brought out 'Poulsen's Yellow'. It was a good rose but ill-timed. War and the aftermath of war disrupted what should have been its most successful years in commerce, and meanwhile breeders in the USA had raised roses of very different character which soon found public favour.

Kordes of Germany had pointed the way forward in 1933. He crossed a yellow Hybrid Tea with a Polyantha, and succeeded in increasing the number of petals while retaining the beauty of the spray. He called his rose 'Fortschritt', meaning "progress". It set such a standard of excellence that though fifty years have passed, at least one rosarian still considers it a yardstick against which to measure the merits and beauty of new Floribundas. Two 1949 introductions from Boerner,

'YVONNE RABIER'

USA, will never be forgotten; 'Fashion' for its pretty form and glowing salmon colour, a best seller until it had to be discarded because of rust; and the amazing 'Masquerade', whose yellow petals turned pink and red before your eyes. It may have shocked the sensibilities of more fastidious gardeners, but won public adoration for its novelty and brilliance. More magical effects were woven by Sam McGredy of New Zealand when he launched 'Picasso' in 1971, its petals marked as if the master had been busy with his brush, and followed it with prettily patterned roses, like 'Matangi' (1974) and 'Sue Lawley' (1980). In England, Edward LeGrice and Jack Harkness had an eye for unconventional colours, as found in 'Lilac Charm' (1961), the purple 'News' (1968) and 'Greensleeves' (1980). Of today's varieties, and there are hundreds of them, Britain's best selling Floribundas include the white 'Iceberg' (1958), yellow 'Korresia' (1974) and 'Mountbatten' (1982), amber 'Glenfiddich' (1976) and 'Amber Queen' (1984), apricot 'Southampton' (1972), blush 'Margaret Merril' (1978), pink 'Queen Elizabeth' (1954) and 'Sexy Rexy' (1985), and red 'Trumpeter' (1978).

Some would say 'Queen Elizabeth' is not a Floribunda, but a Grandiflora, or a Shrub, in view of its tremendous vigour, since it can grow as tall as fifteen feet, and is difficult to keep below five on fertile soil. Many extra vigorous growers introduced since Queen Victoria's days are called Shrub Roses, and they include a series of beautiful remontant hybrids from the Rev. Joseph Pemberton in Essex, successively an Anglican curate, National Rose Society President, and nurseryman. The flowers of his blush 'Penelope' (1923) and rose-apricot 'Felicia' (1928) are particularly fine, as is 'Buff Beauty', brought out by Ann Bentall in 1939. Not just the blooms, but the habit and the leaves set these apart as roses for the plantsman, for whom the

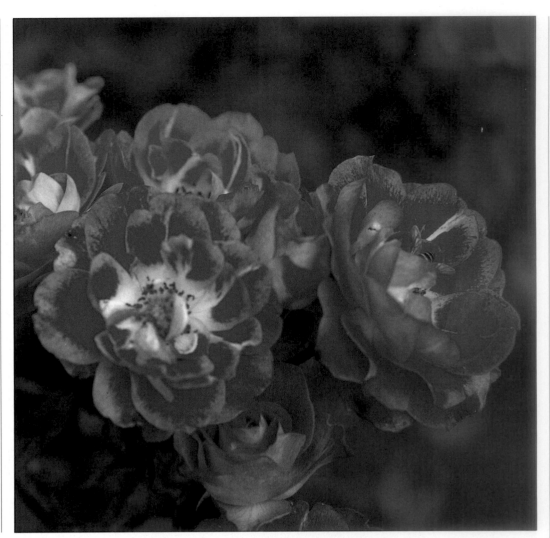

'PICASSO'

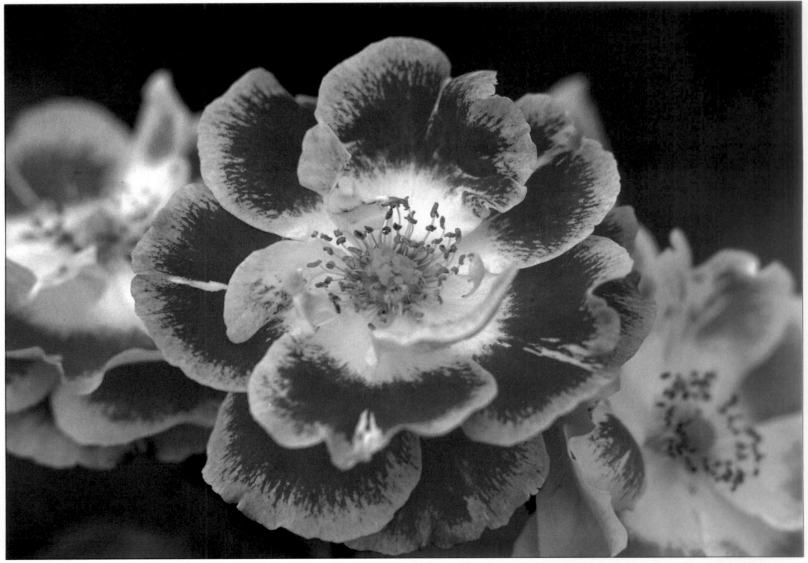

'SUE LAWLEY'

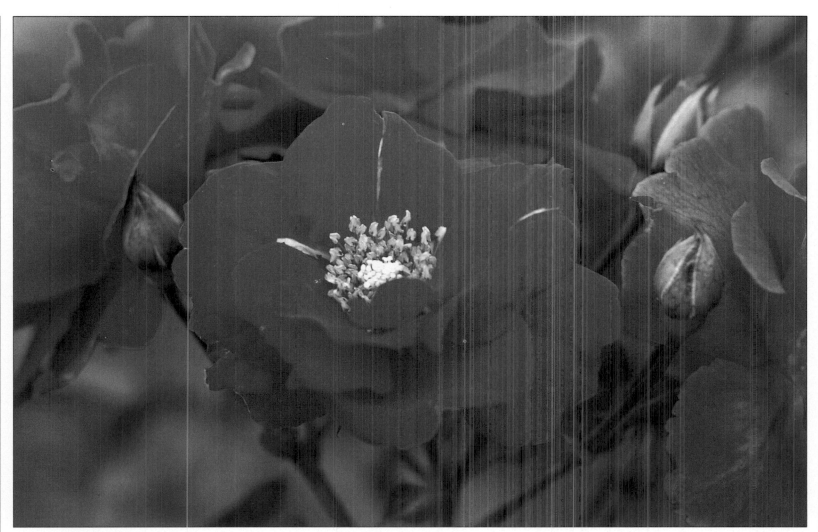

'NEWS'

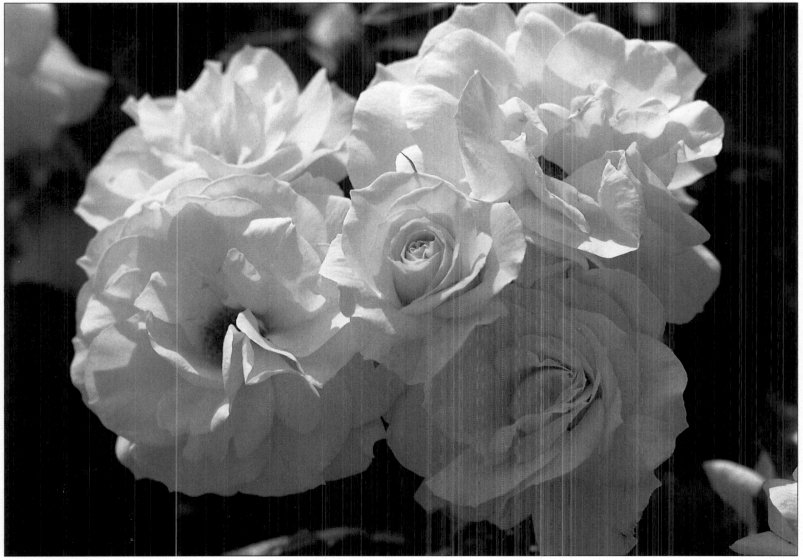

'KORRESIA'

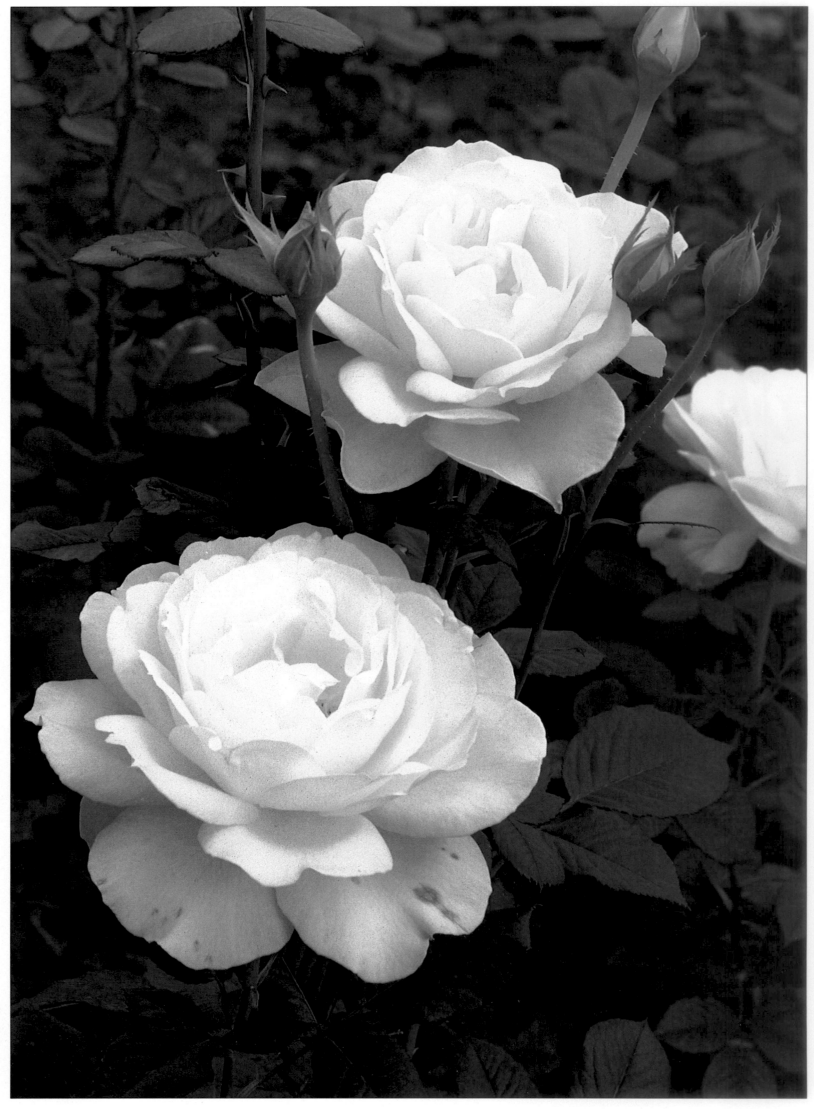

'MOUNTBATTEN'

'AMBER QUEEN'

'SOUTHAMPTON'

'MARGARET MERRIL'

'SEXY REXY' 'PENELOPE'

'TRUMPETER'

44

'BALLERINA'

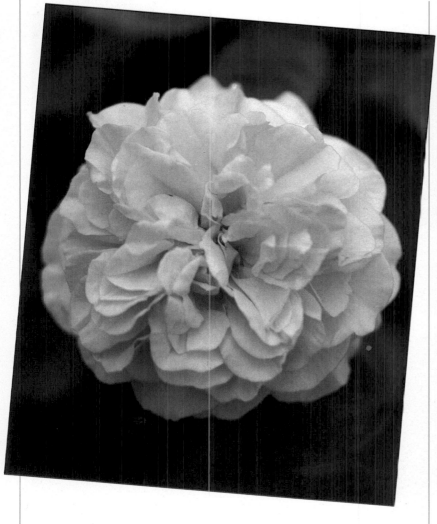

'BUFF BEAUTY' 'MARJORIE FAIR' IN STANDARD FORM.

whole ensemble needs to be acceptable. The Bentall family are also credited with 'The Fairy' (1932), which grows like a cushion and bears sprays of pink rosettes, and 'Ballerina' (1937), which forms a dense, rounded plant, smothered with flowers like apple-blossom. Using 'Ballerina', Jack Harkness raised the sweetly-fragrant, rosy-violet 'Yesterday' (1974), and also 'Marjorie Fair' (1978), which in Holland they call 'Red Yesterday', and in Germany 'Red Ballerina'!

Shrub roses are the equivalent of the rose world's pending tray, in which are filed all the hybrids raised since 1867 which do not clearly belong to other classes, everything in other words except Bush, Climbing, Miniature and Old Garden Roses. They provide a rich miscellany. Included are forms derived from the oriental Rugosa rose, among which the purple 'Roseraie de l'Hay' of 1902, with its sweet, pervasive perfume deserves a place in every garden. The class embraces Modern Shrubs that flower in summer only, like 'Frühlingsgold' of 1937, or pink 'Constance Spry' of 1961, and a rapidly increasing number of Modern Shrubs that are remontant, such as 'Golden Wings' (1956) and 'Graham Thomas' (1983). The last is reminiscent of an old Centifolia in shape with cupped flowers and many petals, except that it is yellow, and represents a remarkable achievement on the breeder's part in providing an Old Garden type of rose with the ability to repeat its flower. Other Modern Shrubs, like 'Fountain' (deep red, 1970) or 'Many Happy Returns' (blush, 1991) look like extra vigorous Floribundas. Of others one can only say that they look like themselves, due to their distinctive character; such are 'Nevada' (1927) and 'Jacqueline du Pré' (1989), two leafy

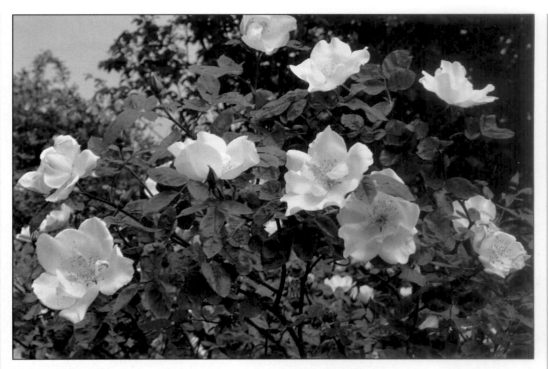

'FRUHLINGSGOLD'

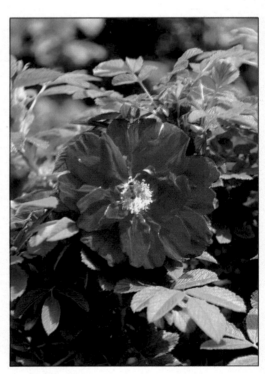

'ROSERAIE DE L'HAŸ'

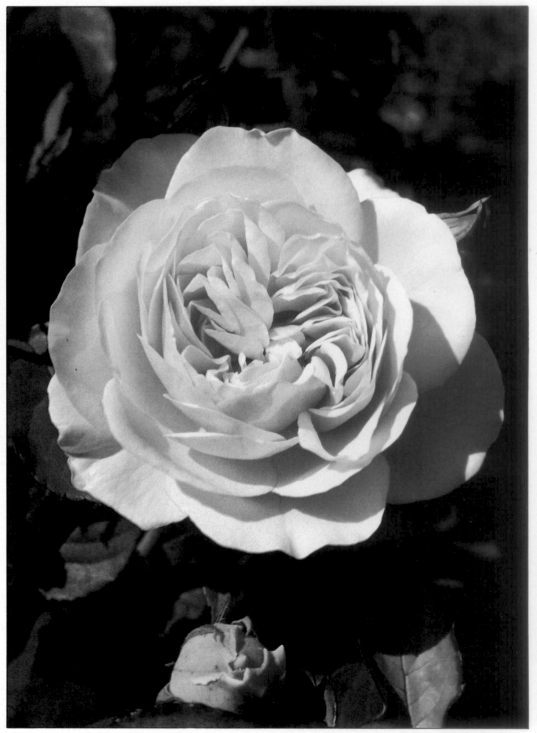

'GRAHAM THOMAS'

shrubs bearing large petalled creamy flowers which open wide to reveal the stamens; 'Raubritter' (1936), whose deep pink globe-shaped little flowers sway down the lax stems and bloom almost on the ground; and 'Nigel Hawthorne' (1989), whose unique coloration of pale salmon with red eyes at the petal base derives from breeding with the curious R. per*sica*.

Hybrids of the wild Sweet Briar, raised in the 1890s onwards are, exceptionally, considered as Old Garden Roses; they were developed by Lord Penzance, and it seems he achieved the rare feat of coaxing R. *foetida bicolor* into parenthood with his 'Lady Penzance' of 1894. This fawn-yellow rose has deliciously apple- scented foliage.

Breeders are aware that modern homes often have small gardens, and also of the need to save work. The raising of Dwarf roses and Ground Cover roses are two recent developments which enable rose lovers to maintain interest in their hobby even where space and time are limited. Dwarf forms such as the Polyanthas and the Miniatures had been available for years, but the flower form of the former was suited to the mass effect of colour at a distance, rather than to close inspection, and the Miniatures suited tiny sites, and looked fussy in the mass. The requirement was to produce flowers of improved form and size on lowly plants. 'Paddy McGredy' (1962) showed what could be done; the pinky red flowers were of such quality that they could pass for Hybrid Teas, and they were borne on leafy bushes, short and neat. 'Kerry Gold' (1967) and 'Kim' (1973) were yellow, with everything in place but on a still smaller scale. In the years since, many breeders have been active, and the wide choice available today

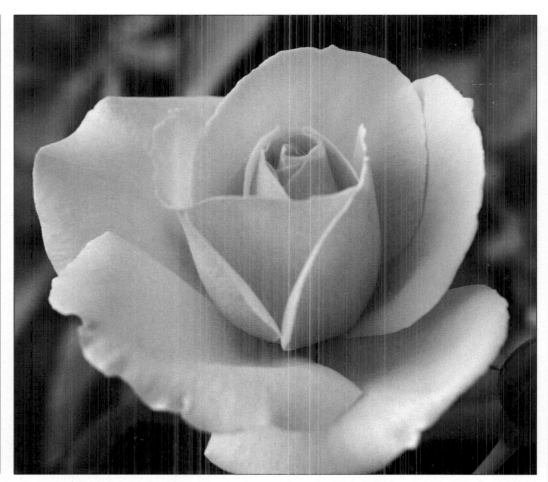

'MANY HAPPY RETURNS'

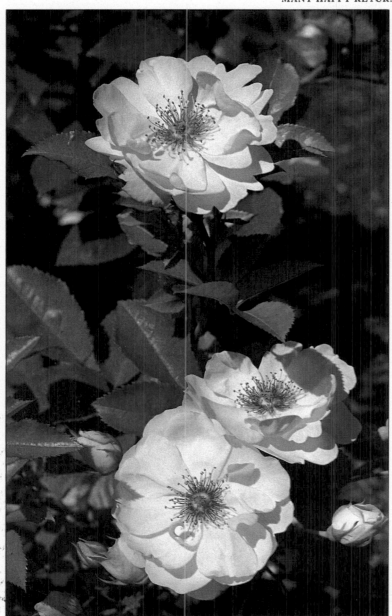

'JACQUELINE DU PRE'

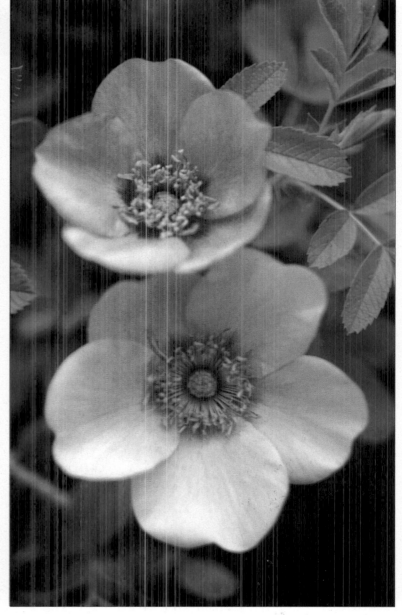

'NIGEL HAWTHORNE'

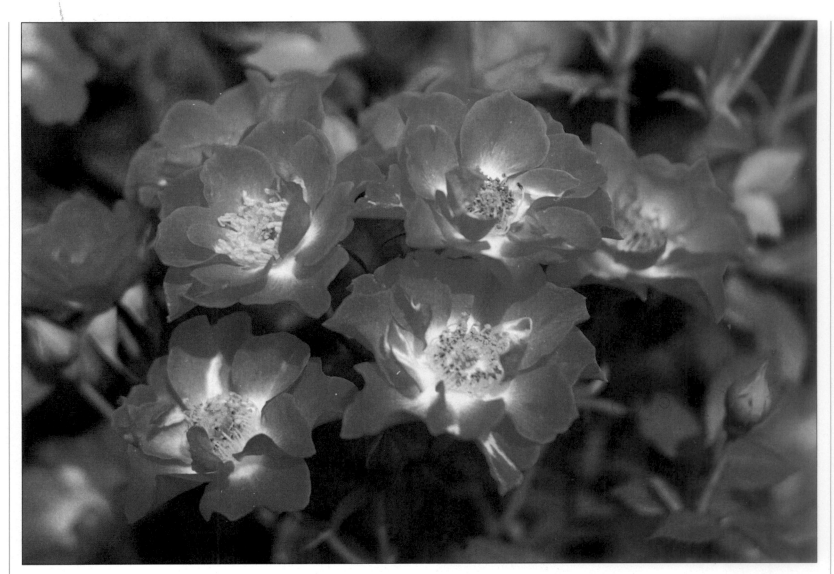

'ANNA FORD'

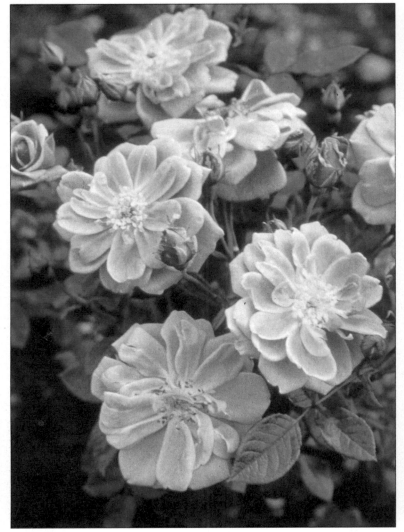

'SCOTTISH SPECIAL'

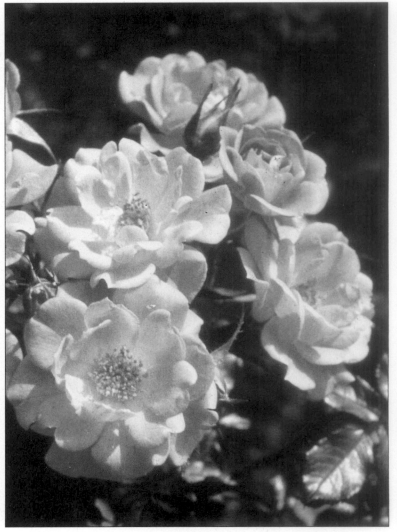

'SWEET MAGIC'

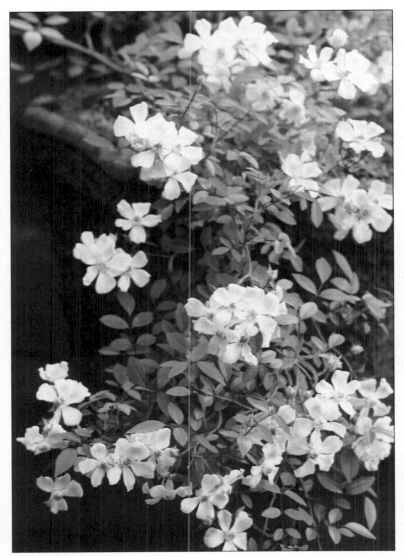

'NOZOMI'

'SUMA' IN WEEPING STANDARD FORM.

embraces varieties with relatively large flowers on short plants, such as the reds 'Marlena' (1964) and 'Piccolo' (1984) and pink 'Pretty Polly' (1987), some grown for health and freedom rather than for individual flower form, such as orange red 'Anna Ford' (1980), and peach pink 'Scottish Special' (1987), others where all plant parts have been reduced in scale, like the orange 'Sweet Magic' (1987) and deep apricot 'Cider Cup' (1988) and at least one where the old- fashioned flower shape of Old Garden roses has been introduced, rich pink 'Rosabell' (1986). In addition, lowly plants of spreading habit have been evolved, such as the white 'Snow Carpet' (1980) and 'Kent' (1988), and yellow 'Minilights' (1988).

As the dates reveal, much of this work is very recent, and to ascribe these petite growers the term "Patio Roses" has been suggested. Officially they are called "Dwarf Cluster-flowered".

Some Ground Cover roses are small enough to use with the above, including 'Nozomi', a blush white creeping rose of 1968 which was grown for a few years before its beauty and garden value were appreciated. This makes a very effective trailing Standard Rose, and can be trained as a low climber against a wall or fence. Its red seedling 'Suma', showing similar potential, but with the advantage of a longer period of bloom, was launched in 1989. More extensive Ground Cover roses include a very vigorous pale pink with fragrance called 'Grouse' (1984); the rose pink 'Surrey' (1985) and deeper 'Pink Bells', which also has white and red forms, (all 1983); the blush 'Fairyland' (1980) and cheerful red 'Eyeopener' (1987), whose graceful habit has been likened to a shallow pyramid flowing towards the ground. All lay claim to being remontant, some being more reliably so than others. As the introduction dates again suggest, constant improvements are being made.

Ground Cover roses are suited for that purpose because their slender stems trail naturally, bowing

'SURREY'

'PHYLLIS BIDE'

'DANSE DU FEU'

under the weight of leaves. Ramblers, too, will serve, if a generous area of ground needs covering, but if there is a glaring failure to report in the history of the rose, surely it is the inability of breeders to obtain a range of ramblers that will keep on flowering through the year. With climbers, whose stems are too stiff to trail, there has been considerable progress in the direction of remontancy, and it is, strangely enough, a rambler we have to thank for playing a major part in that, as we shall see.

Ramblers have been derived from the Species R. arvensis, *R. sempervirens*, *R. wichuraiana*, *R. luciae* and *R. multiflora*. All have a short season of bloom, spectacular for the last named, more sporadic for the others. What the first two contributed to our garden roses belongs to the earlier nineteenth century, and has already been described. As for *R. multiflora*, there were several Chinese garden forms which reached Europe before the wild one, and they were followed by the important 'Crimson Rambler' in the 1890s. The earliest arrival had been the 'Lotus Rose', or *R. multiflora carnea*, a likely parent of 'The Garland', a pretty blush rambler which came out in 1835. The other parent is thought to be the 'Musk Rose', but if the raiser hoped to bring noticeable fragrance into Multiflora Ramblers, he was disappointed. Attempts made to breed a race of yellow ramblers, by crossing Multifloras with Noisettes and Teas, were similarly frustrated, though several pretty, white-gold offspring were introduced, of which 'Goldfinch' (1907) is the most desirable, and 'Phyllis Bide' (1923) the most improbable; it bears tiny, high-centred, pinky-yellow flowers in open sprays and, most unusually for a Rambler, it is hardly ever out of flower from June to Autumn. 'Crimson Rambler' proved an interesting parent. It sired some violet ramblers, also the charming apple-blossom pink 'Blush Rambler' (1903), and no doubt contributed to 'Paul's

'MAY QUEEN'

'CITY OF YORK' OR 'DIREKTOR BENSCHOP'

'ALBÉRIC BARBIER'

'DOROTHY PERKINS' IN WEEPING STANDARD FORM.

Scarlet' (1916), whose vigour and rich colour made it king among red climbers between the wars. After 1954 it was supplanted by a seedling of its own, the orange-scarlet 'Danse du Feu', still widely grown.

To R. *luciae* and R. *wichuraiana* we owe some of the loveliest ramblers in the garden. Both come from eastern Asia, and look so similar that some say they are the same. Both have long shoots which creep along the ground, with shiny, semi-evergreen leaves and clusters of small white flowers. Breeders in the USA worked with R. *wichuraiana*, those in France R. *luciae*. From the USA, crossed with a Bourbon rose, 'May Queen' appeared in 1898; its gentle pink old-fashioned flowers seem to nestle against their leafy background, providing an annual summer delight. 'City of York', a white, could be its stable-mate, though its actual place of origin was Germany in 1945. In between these two, many fine varieties were introduced, the most notable being (from France) 'Albéric Barbier', creamy white, in 1900, 'Francois Juranville', pink, in 1906 and 'Albertine' (1921), with larger flowers of light rose salmon, sweetly scented, and one of the classic roses of all time. Best known of all perhaps is 'Dorothy Perkins' from the USA, whose tiny rosette flowers in uncountable profusion have been seen everywhere since its debut in 1901. It is suitable where trailing growth is wanted, and the best ramblers with this type of growth are 'Sander's White Rambler', vigorous and scented, introduced in 1912, and 'Crimson Shower' (1951), which is unusual because it only starts to bloom when the summer roses finish.

Wichuraianas showed no more willingness to accept yellow than had the Multifloras. Nearest to success was Dr Williams, an English amateur, with his 'Emily Gray'. This butter yellow rambler with beautiful dark leaves was introduced in 1918.

In eastern North America grows R. *setigera*, the

'CRIMSON SHOWER'

'DR W. VAN FLEET'

'Prairie Rose', noted for its vigorous growth and lavish display when in flower. In Maryland lived Dr van Fleet, a keen rosarian and hybridist. He crossed the 'Prairie Rose' with *R. wichuraiana* and their combined genes gave him a valuable child for further work. His greatest achievement from this line is 'American Pillar', a prolific rambler whose light-centred carmine flowers are so familiar, maybe because it grows easily from cuttings, and never seems to die. It came out in 1902. The doctor's second great achievement was the summer-flowering blush white rose that bears his name, 'Dr.W. van Fleet' of 1910, obtaining by crossing genes of Wichuraiana with those of Tea. The result was everything he could have hoped for, with the healthy spruce foliage of the first conjoined with the graceful form and fragrance of the second. The miracle of nature did not end there, for a few years later, so the story goes, some unsold plants were left to grow for an extra season in a nursery field. When visited next autumn, one was seen to be in bloom, well beyond its normal summer span. Further trial confirmed that a repeat-flowering Wichuraiana hybrid could for the first time be offered on the market, and in 1930 'New Dawn' made its bow. It was a pioneer in an entirely different context, being the very first plant protected under US patent legislation passed that year, holding Plant Patent No. 1.

The story of 'New Dawn' does not end there, for it has shown great generosity in passing on the goodness in its genes, giving health, fragrance, bright foliage and remontancy. A list of postwar climbers that have it as an ancestor reads like a roll of honour, among them the deeper pinks 'Aloha' (1949), 'Pink Perpétue' (1965), 'Bantry Bay' (1967), 'Morning Jewel' (1968) and

'NEW DAWN'

'Rosy Mantle' (1968), plus 'White Cockade' (1968), the fragrant apricot- pink 'Compassion' (1973), the blood red 'Dublin Bay' (1976), and the yellow 'Highfield' (1981). Current breeding work suggests that 'New Dawn' will extend its powerful influence on the development of the modern rose.

How do you tell a climber from a rambler? If we look around the garden, the distinction is not a clear one, for as shown above, the ancestry is often mixed. In the wild it is easier to separate them by saying species ramblers are distinguished by their lax growth, which will trail downwards without support, whereas climbers are stiff-stemmed, able to arch and clamber towards the sky. By this definition the likely ancestors of cultivated climbers number half a dozen, but three of those have so far given us little. The Banksian roses remain much as they were found, a resource to be exploited by breeders of the future. R. *bracteata*, the 'Macartney Rose' from China, gave 'Mermaid' (1918), one of the choicest and most remontant yellow climbers, but that is all, though the genes are being passed on in other types of rose. From *R. laevigata*, the 'Golden Cherry' rose of China, came 'Silver Moon' in 1910, very vigorous with ivory flowers opening wide in early summer, and the curious pink 'Anemone Rose' (c. 1896), which, like its deeper sport 'Ramona' (1913), is rather tender for the British climate. One of the other species climbers to consider, *R. moschata*, the 'Musk Rose', has many forms. The lowlier version which reached Europe early from West Asia, as told above, led to the Bourbon climbers via the Damasks, and also, via the Chinas, passed its genes to the Noisettes.

'BANTRY BAY'

'PINK PERPÉTUE'

'ALOHA'

53

'DUBLIN BAY'

'ROSY MANTLE'

'RAMONA'

'MORNING JEWEL'

'KIFTSGATE' AT LIMEKILNS, SUFFOLK.

'ZÉPHIRINE DROUHIN'

'Zéphirine Drouhin', the deep pink "Thornless Rose" of 1868, and the famous white 'Mme. Alfred Carrière' of 1879 are still widely planted as present-day reminders of those respective gifts. From *R. moschata's* East Asian relatives has come a group of vigorous white tree-scramblers, notably 'Kiftsgate' (via *R. filipes*) in 1954, 'Wedding Day' (1950), and 'Bobbie James' (1960), and the pale pink charmer 'Paul's Himalayan Musk', whose precise origins are as impenetrable as its interweaving canes.

The contribution to our climbing roses of the remaining species, the huge R. *gigantea* and sprawling *R. chinensis* spontanea, has been immense, though there is a paradox in this. *R. gigantea* is tender, and seedlings derived from it directly have attracted little general interest, being once-flowering and demanding many square feet of space, which becomes an embarrassing void should the plant be killed by frost. Under glass, and given space, it can show, as with the light pink 'La Follette' of ca. 1910, all the grace, beauty and wealth of bloom a rose lover can wish for. As for *R. chinensis spontanea*, no one is sure of its precise identity. Once more we say "thank you" to Chinese gardeners, in whose garden roses the genes of both were present. They made that presence felt in Europe when Noisettes and Teas were raised, and it was observed that Climbing sports of Teas might occasionally be found. The sign to watch for was an outsize stem shooting heavenwards with no terminal bud. 'Clg Devoniensis' was an early one, in 1858, bringing its blushing white flowers above eye level. Sports are not guaranteed to happen, and when they do it may be soon or late. 'Niphetos', a white rose with elegant slender buds much in demand for personal decoration, was introduced as a bush in 1843, and furnished a climbing sport years afterwards, ready for the market in 1889.

A similar process occurred with Polyanthas, as with 'Clg Cécile Brunner' in 1894, which proved remarkably remontant; many repeat-flowering bushes bloom in summer only in their Climbing form. Hybrid Tea and Floribunda sports are among the most popular climbing roses of today, such as 'Clg Iceberg' (1968), 'Clg Ena Harkness' (1954), whose large red blooms, inclined to bow, are all the better for viewing up on

'CLG ICEBERG' AT THE GARDENS OF THE ROSE, ST. ALBANS.

high, and 'Clg Etoile de Hollande' (1931), one of the loveliest dark reds ever, which might have been lost due to the frailty of its bush form, but preserves its fame through its vigorous climbing sport.

Sporting is not the only source of Large-flowered climbers. Two of the loveliest are 'Guinee', deep red, from France in 1938, and 'Mme. Grégoire Staechelin', deep pink, from Spain in 1927. Both are very vigorous and bloom in summer only, and the surprising fact is that, according to the records, each breeder used bush roses as the parents. Genes from the Chinese climbing ancestors had revealed their latent character. Examples of climbers raised from two bush parents in recent years include 'Dreaming Spires' yellow, in 1973, and 'Breath of Life' (1982), a light apricot remontant climber, whose parents are a crimson Floribunda and a vermilion Hybrid Tea!

A final group remains to be considered, for which credit is due to the USA and Germany. Mr Bowditch of Connecticut found an unusual rose upon his nursery, thought to be a chance hybrid between a Rugosa rose and R. *wichuraiana*. It impressed everyone by its hardiness, and had a vigorous trailing habit, ideal for

'BREATH OF LIFE'

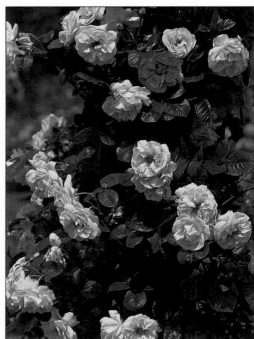

'DREAMING SPIRES'

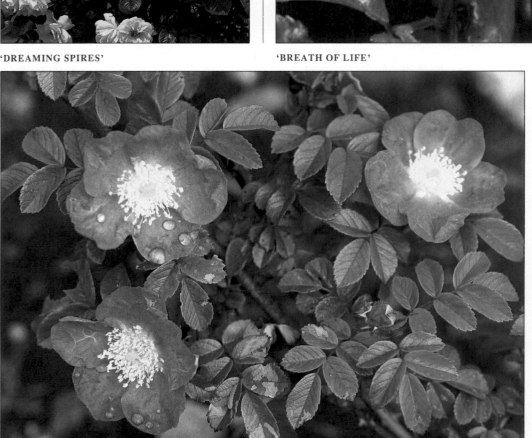

'MAX GRAF'

areas where easy garden maintenance was wanted, and all the better for that purpose because when its pink flowers were over it did not set seed. It was named 'Max Graf', and introduced in 1919. In 1940, after many attempts, Kordes of Germany obtained two seedlings from it. One proved extremely hardy and also, considering its history, amazingly productive as a parent. It was named R. *kordesii,* and from it have come a series of remontant hardy leafy climbers, among them 'Leverkusen', light yellow in 1954, 'Dortmund', red with white eye in 1955, and red 'Sympathie' in 1964, and many more pinks and reds.

Today's breeders can exploit all this accumulated inheritance, and more, for nothing has been said of the Scotch rose strain, as seen in 'Maigold' (1953) or of American work with the 'Prairie Rose' which lies behind 'Golden Showers' (1957). These are two of the finest yellow Climbers on the market, and though others come and go, they have not yet been supplanted.

Mention was made earlier of the desire to create roses for small spaces. Soon the first remontant Climbing Miniatures and and Climbing Patio Roses will be available. Two fine ones, the red 'Chewizz' (its selling name is still to be decided) and yellow 'Laura Ford', both raised in England by Chris Warner, are scheduled for introduction in the 1990s. They promise to add something novel to the garden, and to herald a new stage in the fascinating story of the evolution of the rose.

'MAIGOLD'

'DORTMUND'

'GOLDEN SHOWERS'

growing roses

It was the belief of Dean Hole, founder-President of the National Rose Society, that the key to success with roses is to love them. As with all love objects, that means trying to understand their needs. These can be summed up in seven words: Site, Soil, Selection, Preparation, Planting, Pruning and Aftercare.

SITE

In the Book of Genesis we read that "God said, 'Let there be Light'; and there was Light". If there were roses in Eden, we may be sure they enjoyed all the Light provided, for roses are at their happiest in the open. They can look miserable in shade, especially if it comes from sizeable trees or large shrubs, which not only cast shadows from above, but also compete for food and moisture down below, thus threatening the health and well-being of their lowlier neighbours, which will languish or become lanky in their efforts to gain their share of sun. The damaging influence of trees can often be seen in public parks, where growth in a bed will be retarded, the stems etiolated and the flowers poor in the vicinity of a tree, but as the distance increases the plants are perkier, responding gladly to the slightest improvement in their prospects. So choose the open sunny sites, or ones where there is partial shade for up to half the day, but not where competition from adjacent shrubs and trees can overwhelm the roses. Avoid draughty corners where winds sweep round between buildings; roses never look at their ease in such positions, because air moving over the leaf

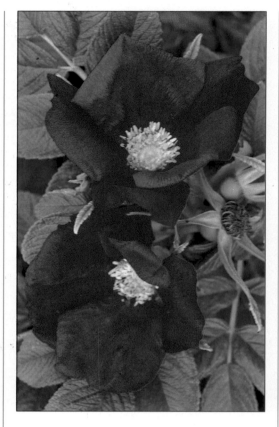

ROSA RUGOSA SCABROSA

surface can remove moisture faster than the plant's system can replace it and the consequence is likely to be scorched or mildewed foliage.

Against shadier walls and fences up to 6ft, it is best to grow taller growers which will have the ability to grow up to the light. Of the Large Flowered Hybrid Tea bushes, 'Peace', 'Alexander' and 'Peaudouce' are suitable, and of the Cluster-flowered Floribundas, 'Queen Elizabeth', 'Anne Harkness' and 'Mountbatten'. Many of the Shrub Roses will do well in such conditions. For house walls with a northern aspect, 'Morning Jewel', 'Albéric Barbier' and 'New Dawn' are good Climbers to try.

A few roses are tender, and a site which shelters them from cutting east winds and the effect of early morning frost in spring should be provided. The variety descriptions in Chapter Six indicate where this applies. Any position exposed to strong wind, such as a hillside or a garden by the sea, will be greatly improved if protection is given by a hedge, wall or fence. Without it, the plants can become dehydrated and the flowers easily damaged. Among roses that seem really happy near the coast are the Rugosas, especially *R. rugosa alba*, *R. rugosa rubra*, 'Scabrosa' and 'Roseraie de l'Hay', and all four make excellent protective hedges for other plants.

SOIL

When we see a rose growing, there is a vital part we do not see, because it is hidden in the ground. Yet the

'HERITAGE' AND WEEPING STANDARD 'FRANCOIS JURANVILLE' THRIVING IN AN OPEN SITE.

wellbeing of the plant depends just as much on its good health below soil level as above. Down below there exists a complete environment, including all the factors except sunlight of the world above.

Let us put ourselves in the place of the roots of a newly planted rose. Just below soil level we divide into several offshoots, which become thinner towards the tips, and many more offshoots branch out along our length with small fibrous roots attached. In springtime, as the soil warms up, we sprout young white rootlets, like little feelers reaching out for support in the dark environment around us. If the soil structure is helpful, we will find tiny channels open up, which allow us to take in moisture, containing plant foods to make us grow. We also encounter friends and enemies. Friends include the earthworm, which helps provide those spaces and channels we are going to explore, and which allow water and nutrients to come our way. Enemies include white chafer grubs and wireworms which will bite and eat us. An uncountable horde of microscopic life forms surround us, some helping to break down our food into forms we can absorb, others threatening to weaken us by sucking on our juices, or invading damaged tissue and becoming parasites within. If the structure of the soil continues to be good, we can take advantage of our friends and tolerate our enemies; but if the airways and water channels become blocked, depriving us of food, we lose many of the beneficial microbes and become more vulnerable to the harmful ones.

From all this, the message is clear. What a rose bush needs is soil that is fertile, "open" in its structure, and well drained at the bottom so that the food channels do not get silted up. Many types of soil can provide such an environment, be they clay, sand, chalk or gravel, and it is safe to say that if the garden grows a good variety of weeds, it should grow good roses. The easiest soils are loams, with a mix of clay and sand, because they have the ideal texture; the sand particles enable water and air to pass through, and the clay particles are the best for retaining nutrients. Without the sand, the clay particles stick together and become impermeable, as residents on "stiff" clay soils know only too well, so that water and air cannot pass and the nutrient is locked in. Without the clay, sand allows water to drain away too quickly, carrying with it much of the nutrient which thus is lost to the plants. At the optimum feeding time, sandy soil is reckoned to have half the available moisture of clay soil, and only one-third that of good loam.

It follows that heavy clay soils need improvement to make them more open, and sand, chalk and gravel need the opposite. Both wants can be provided, as will be seen when we consider the preparation of the ground.

Ground that is usually very bad for new roses is where old roses have been growing previously for five or more years. The rootlets of newly planted bushes are especially vulnerable to soil-borne diseases from micro-organisms. It has been suggested that eelworms, in association with a fungus called pythium, attack these rootlets and prevent them from feeding. The result is that the new plants in the old soil make little headway. Why are not all rose plants affected? Because, it is thought, once the roots have become mature, they can resist attack. This means that the extensive roots of old plants may co-exist with a large population of eelworm, commoner in light soil, and pythium, which grows a "tail" enabling it to travel along the moisture channels in wetter soils. A deterioration in soil structure caused by silting up of the air and water passages, known as "panning", may also encourage these organisms to multiply around the old plants, and may explain why many become past their best after seven to ten years; that such panning may occur is not surprising, since deep cultivation is not possible in a bed of roses. It is safer not to attempt to re-plant in the old soil until it has been rested from roses for two or three years, and been well cultivated with a different type of plant. Marigolds are said to be useful as

'KIFTSGATE' ON A WALL – NOT THE IDEAL PLACE FOR THIS RAMPANT GROWER!

cleaners of rose sick soil, on account of their suppressive effect some types of eelworm, though authorities disagree on their efficacy. White mustard is another suggestion, which can be turned in as a green manure. Even after an interval of rest, it is wise to give the new plants extra food to help them through the early stages. A much wiser solution is to prepare a rose bed in a different site, and put the old one down to other flowers or grass, and prepare a new bed in a different site. That is the easiest way to grow beautiful roses.

If there are old trees in the garden which have seen better days, they make marvellous supports for vigorous climbing roses, like those mentioned in the verse below. Because the ground under trees is usually poor and root bound, it is best to find a site a few feet away that is clear of tree roots, preferably where arching stems can readily be trained in the required direction. Once the plant has clambered up into the tree it will be able to look after itself, but it will need good soil at planting time, and sensitivity to its needs, especially of water, during the first two or three growing seasons.

<div style="background:gray;color:white;text-align:center">SELECTION</div>

Selection means deciding what roses to plant, and where to buy them. As to the first, take warning from

the verse about the man who put vigorous climbers round his dwelling:

"Rampant 'Kiftsgate' on my cottage,
'Seagull' too, and 'Bobbie James',
'Silver Moon' and *longicuspis*
Just to mention a few names.
Add 'Seven Sisters', 'Wedding Day'
And that is it, or just about;
I would dearly love to see them,
But I can't get out!"[1]

The growth of rampant climbers really can be astonishing, up to 50ft in some cases. The largest rose tree in the world is said to cover an area well exceeding 200 sq. yards, enabling 150 people to shelter beneath its branches. This is a 'Banksian Double White' planted in 1885 at Tombstone, Arizona. In England a Climbing Tea called 'La Follette', growing in a conservatory at Southill Park in Bedfordshire, was found to measure 48ft. by 30ft., nearly all at a height of 18ft. above soil level. It would have gone further but for the necessity of pruning to keep it within bounds. On a more modest scale, it is common for bush roses of 'Queen Elizabeth'

1 By Michael Gibson, RNRS President 1985/6.

'QUEEN ELIZABETH', A SPLENDID CHOICE FOR A TALL GROWER.

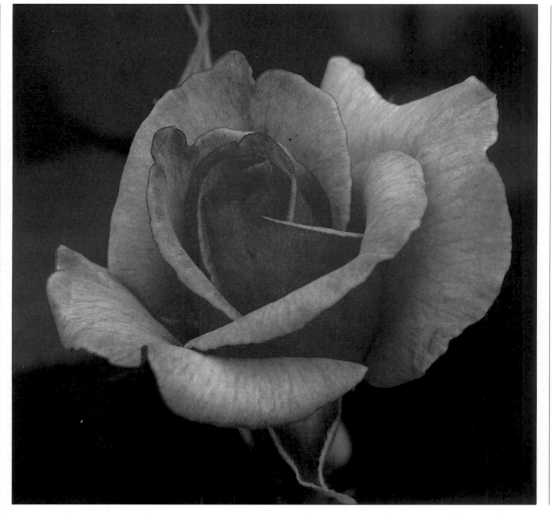

SPRAYS OF 'HARKNESS MARIGOLD' ARE GOOD TO CUT AND SHOW.

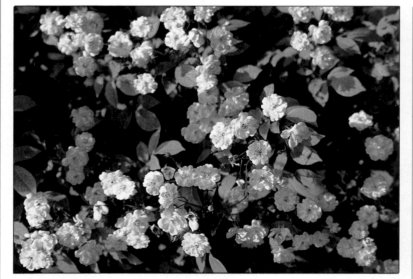

'PAUL'S HIMALAYAN MUSK RAMBLER' NEEDS AMPLE SPACE.

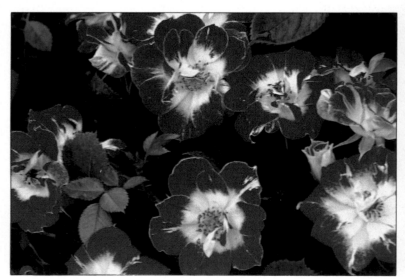

'LITTLE ARTIST', A MINIATURE ROSE FOR SMALL SPACES.

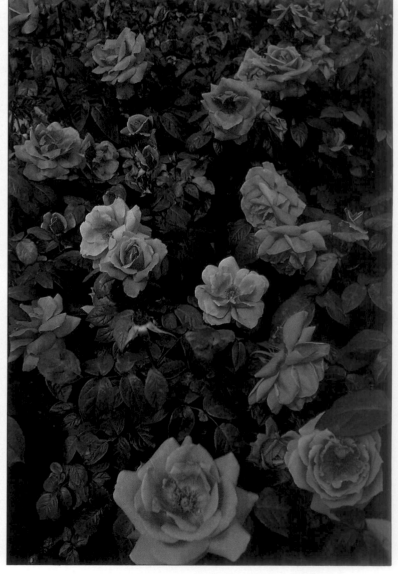

'PINK FAVOURITE', A SPLENDIDLY HEALTHY BEDDING ROSE.

to make huge specimen plants, stems measuring 16ft in length being not unknown.

These records are exceptional, but serve as reminders that varieties differ enormously, and can be traps for the unwary if care is not taken when deciding what to plant.

The choice of roses for the garden can be summarised as follows:

HYBRID TEA or LARGE-FLOWERED Bush Roses are the popular varieties you see everywhere, with big shapely blooms that are wonderful to cut and bring indoors. They are suitable to grow in beds and borders, and some make excellent hedges. Height 70cm to 1.6m according to the variety under normal conditions, but mostly 80cm to 1.2m.

FLORIBUNDA or CLUSTER-FLOWERED Bush Roses provide smaller blooms and an abundant supply of them, giving colour impact when grown in beds, borders and as hedges. Height 50cm to 2m according to the variety under normal conditions, but mostly 60cm to 1.2m.

PATIO or DWARF CLUSTER-FLOWERED Roses are like small-scale versions of the Floribundas, handy for small spaces in the garden, as edging plants where petite growth is wanted, and to grow in pots and tubs. Most grow from 45 to 60cm.

MINIATURE ROSES are the smallest growers of all, usually from 25- 45cm, though the height depends on how they have been grown; plants budded on an understock make more substantial plants than those raised from cuttings or micropropagation.[2] They serve the same general purposes as the Patio roses.

SHRUB ROSES, usually larger and leafier than Bushes, with amazing variation in growth and character, for they include the Species (Wild) roses, the Old Garden Roses and newer Shrub Roses including Ground Cover types. In the garden they fulfil many roles, being suitable to grow in mixed flower borders, to make substantial hedges and large beds or groups, and to plant as specimens, which means making a feature of a single shrub. The Ground Cover types are obviously ideal where low spreading growth is wanted, some of them being very extensive, such as 'Grouse', and others compact, like 'Suma', and they look well when

2 The alternative methods of production are considered elsewhere.

'ALBERTINE' IS VIGOROUS AND EXCELLENT FOR PERGOLAS.

planted at the top of a retaining wall and allowed to trail down over it.

CLIMBERS and RAMBLERS will cover any structure from a 2m pole to a 15m tree – and the importance of choosing the right one for the right place cannot be over stressed. The difference between a Climber and a Rambler is not clear cut, because so many rose ancestors are common to many climbing roses, but in general terms the Climbers tend to be stiff in growth, good on walls and fences where they can be stretched out, but not so good on low structures because of the rigid nature of their stems. Ramblers are more droopy, and lend themselves more readily to being trained on low supports and on arches and pergolas. Some varieties, 'Albertine' and 'Mermaid' among them, can be planted in a well-prepared position and left to grow and spread themselves; the best area for this would be a semi-wild area where they can develop naturally, with occasional pruning to saw off dead or moribund branches.

STANDARD ROSES are called Tree Roses or High Stem Roses in other lands, better indications of their purpose, which is to add height in the garden.

Nurserymen propagate the varieties grown as Standards near the top of upright stems, so that the shoots grow out into bushes, shrubs or, in the case of Weeping Standards, ramblers, all borne at an elevated level. With Weeping Standards, as the name suggests, the growth hangs down, since the shoots have nowhere else to trail. The height of stem can vary; Miniature roses are budded onto short stems, to keep them in proportion, and Weeping Standards on the tallest ones. Hybrid Teas and Floribundas are propagated on stems of different heights, the lower being called Half Standards, and the taller Full Standards.

A specialist rose grower's catalogue will contain scores, maybe hundreds of varieties. No matter how carefully they are described and illustrated, they reflect the nurseryman's tastes, and not the buyer's. Rose shows are spectacular, and give the advantage that you are looking at the real thing instead of the printed page, but the exquisite bowls of flowers do not show how the plant will shape up when growing in the garden. When considering what to plant, there is no better way than to see other people's roses growing. Studying parks

SPECIALIST GROWERS OFFER A WEALTH OF CHOICE AT SHOWS.

ROSEFIELDS AT HARKNESS NURSERIES, HITCHIN, IN 1989.

and gardens in the neighbourhood will show which varieties fare well – or badly. Rose nurseries often have growing fields or display areas open for viewing – remember to take stout boots in case the going is rough. There are famous gardens of roses up and down the country, most notable of all being The Gardens of The Rose at Chiswell Green, St. Albans, headquarters of the Royal National Rose Society, which also administers several Regional Rose Gardens. In Scotland, the City of Aberdeen provides an outstanding display in late summer, and must have the most extensive plantings anywhere in the British Isles. Cities where rose trials are held include Glasgow, Belfast and Dublin, all open to view and with associated plantings.

Observing the plants grow will give ideas on how to use them in the garden, and when the short list of favourites is drawn up, it is time to order them. For the best in roses, buy from a specialist. He will have an up-to-date selection, and a reputation to maintain. In Britain, over seventy members of the Rose Growers' Association produce a booklet called *Find That Rose!*, which is a guide to who grows what. It is a very helpful aid in tracking down a rose that has been noted.[3] In the USA, *The Combined Rose List* performs a similar function.[4]

Roses can be bought bare of soil, termed "bare-root", and are usually sold with wrapping of some kind round the roots to stop them drying out. Or they can be offered with soil round them in containers, in which case they may be bare-root roses that have been grown on, or they may have been produced in other ways, either from cuttings, or by means of micropropagation or tissue culture.

Bare-root roses can safely be transplanted during the dormant season, that is from late autumn to early spring. If ordered direct from a specialist nursery, they should come in the best of condition, freshly dug from the fields. If they are not ordered directly from the grower, then the interval between digging up on the nursery and re-planting in the garden can be over long, so always check plants on receipt for their condition, and report any that appear dry or otherwise give cause for concern. A good plant will have two or more firm stems, greenish or reddish in colour, unwrinkled and free from mould. Below them is the rootstock, which is actually more important than the top growth, because it provides the channel for the sap through the lifetime of the plant, and which therefore needs to be firm and stout. The root system should look well-balanced in relation to the plant, and supple to the touch.

3 Obtainable from many nurseries and from RGA, 303 Mile
 End Road, Colchester, Essex CO4 5EA. 1990 price £1.20.

4 Send $15 to Bev Dobson, 215 Harriman Road, Irvington,
 N.Y. 10533, U.S.A.

ST ANNE'S ROSE GARDEN, DUBLIN, IN MID-JULY.

CONTAINER-GROWN ROSES ON SALE FOR SUMMER PLANTING.

Roses in containers are useful for planting out in summer. Reputable nurseries pot them up in January and seeing they are watered, kept free of weeds and sprayed against disease up to the point of sale. Such plants show strong well balanced growth and leaves of good colour. If you notice poor looking leaves or loose soil, it probably means the plants have not been container grown in the proper sense of the word, and are unlikely to do well.

Roses grown from cuttings are mostly Miniatures, because it is not economic to produce other types that way. The method of production means they have small root systems, and so they are ideal for pots, tubs, flower baskets and the like. They can be grown in pots in an airy place, such as a light windowsill or conservatory,

were considered in "Soil" above, and it follows that on a heavy clay soil attention must be paid to whether or not it drains well, and on a light soil steps must be taken to see it does not drain too fast, taking all the nutrients away.

A simple way of testing the drainage is to dig a hole, fill it up with water, and observe how long the water takes to disappear. If it has all gone in a few hours, there is no need to break up the lower soil. If the water still stands, work must be done. In very stiff clay soils, it is a strenuous job, but the consolation is that this type of soil, when well-prepared, is capable of producing the very finest blooms on long-lived bushes. First the topsoil has to be removed, then the layer below it, to reveal the claggy subsoil, usually yellowish in colour

of digging has trapped air inside the soil. Rose roots cannot feed in pockets of air, therefore time must elapse between preparation and planting to let the ground consolidate again. On a light soil, two or three weeks may be enough, though four to six would be a safer interval. On heavy soil, it may be best to prepare the ground in autumn, then leave it over winter to give frost a chance to break up the heavier lumps of earth, which can then be hoed or raked to a fine tilth before planting in early spring. Avoid treading on heavy soil when it is wet, because the clay particles will stick together and undo the good work that has been done. If the soil does get trodden, chip it lightly afterwards to make it friable again.

A FEAST OF ROSES AWAITS VISITORS TO THE GARDENS OF THE ROSE, ST. ALBANS.

and even brought further indoors for a week or two at flowering time; but no rose is happy indoors unless there is plenty of light and ventilation, and a centrally heated room is not a good environment for them.

Much the same applies to micropropagated roses as to those grown on cuttings, i.e. they are fine as Miniatures for potting. Several bush varieties are now being grown extensively by this method, and after a period of "weaning" they can be removed from their pots and planted in the garden. The technology is comparatively new, and some are more successfully produced this way than others. A specialist grower will advise on suitable roses for particular sites, and such advice is normally given free. When a choice has been made, order early to secure the right varieties. The nursery crop is ready for despatch soon after mid-October, but the nature of the work means that some weeks elapse before all requests can be satisfied. In Britain, an order placed before the end of August is likely to arrive at the optimum time for planting, in late October or the beginning of November. Orders received in late October are bound to be deferred so that those with priority can receive their due attention. What to do when plants arrive will be considered under "Planting".

PREPARATION

Preparing the soil means getting it into the right condition for good plant growth. The plant's needs

and, when wet, of the consistency of plasticine. This deeper clay has to be forked over to provide the needed drainage channels, and with it can be mixed peat or wood-ash or forest bark so that its impermeability is reduced; calcium sulphate at the rate of 1.5kg per sq. metre will also help to break it down. The upper layers of soil are then replaced at their correct levels.

Most soils will drain perfectly well, and on those the soil below the upper layer should be examined. If it looks sour or panned, or chalky or stony, or has not been growing garden plants successfully, it needs forking over, and this is a splendid opportunity to add any organic humus-building material that is available: garden compost, leafmould, peat, and any form of rotted-down or dried manure are excellent to use. Hen manure is very strong so needs to be applied sparingly. If turfs have been removed to create the bed, they will do a power of good if placed upside-down and chopped into the lower layer, deep enough for the grass not to grow through. Grassland includes some of the most beneficial micro-organisms, ideal for conditioning the soil.

The easiest soil to prepare is that which is in good heart, and has been cultivated successfully with other plants. All that may be necessary is to fork over the topsoil, adding whatever organic material is handy.

Prepare the ground well before planting time. When it has been newly dug, it appears to occupy much more space than previously. That is because the action

PLANTING

The time for planting bare-root roses is from autumn to early spring, say in Britain from mid-October to the end of March, or mid-April if spring growth is not too far advanced. In Australia it translates to the months of May to August. For container-grown roses, the middle of May to the end of July is the most popular period in Britain, though they can be planted at any other time of year if so desired. There is an important exception to that statement, applying equally to both types: do not plant when there is snow or hard frost on the ground. In much of Canada the bare root planting season is thus of short duration: September or May.

If plants arrive at a time when they cannot be planted straight away, they will keep for up to three weeks if placed in their unopened package in a cool frost-free place such as an unheated shed or garage. If the package has been opened, keep the roots from drying out by dipping them in water and wrapping polythene around, or covering them with damp peat or soil. To keep them for longer periods, heel [5] them in, by digging a shallow trench in frost-free ground and covering the roots and lower part of the stems with fine soil. The plants will keep safe like that all through the dormant season.

5 "Heel-in" comes from an old English word with the sense of covering something over: it does not mean one has to stamp hard on the roots.

Bare-root roses should be planted firmly, and at the correct depth, so that the roots will be able to feed efficiently. If planted too deeply, the root system has to construct a fresh tier of feeding rootlets above its existing one, a needless diversion of energy in the earliest years of growth. If not planted deeply enough so that the rootstock sticks out above the surface, the rose is liable to catch the wind and work loose in the soil, and suckers are more likely to appear. A correctly planted rose has a shallow covering of soil over the rootstock, with stems upright (and clear of soil almost to the base) and the root system spread to take its natural direction in the soil.

For most bare-root roses, apart from Standard Roses, a hole eight inches deep and eighteen inches wide will normally be large enough; Patio roses and Miniatures require less space, well-grown shrub and climbing roses probably more. A glance at the plant's roots will, after the first attempts, be sufficient guide. The easiest way to plant is to dig a hole in the shape of the letter D. While doing this, place the plant with its roots in water, so that they will be refreshed.

Most bare-root roses have their root system running at an angle to the stems. Lean the plant against the straight edge of the hole, and spread out the roots to take their natural direction; any over long ones can be shortened with secateurs. Cover them with a generous layer of fine soil, from which the root hairs can readily draw nourishment when the time comes; peat and a sprinkling of bonemeal can be added to the fine soil, or used in its stead. When the hole is half filled, tread very firmly, then fill up with more soil until the ground is level. The rose should be firm in the ground, and a light tug will test if it is so. Before growth is due to start in the spring, check that the plant is still firm in the soil. This is important because as the soil settles down it can leave pockets of air below the roots, and if frost penetrates that far it can freeze them and so destroy their cell structure, with dire consequences. Any plant that appears slow to start into spring growth should be firmly trodden round, and given a bucketful of water. Provided the stems remain fresh looking, not withered, slow starters should soon catch up.

Bare-root Standard Roses probably need a slightly deeper hole, of perhaps ten inches, and circular in shape. They also benefit from having a stake to support them, and for a normal Full Standard rose, a stake about five feet tall and 1.5 inches thick is best. Dig the hole, set the Standard in it, and judge the most convenient

PEGGY NICOLL LINES UP THE WINNERS AT THE BERMUDA ROSE SOCIETY SHOW.

place for the stake to be driven in, where it will not cause damage to the roots. Plant to the soil mark left by the nursery, and do not try to make the Standard shorter by deep planting. Use fine soil, and tread firmly as described above. Drive in the stake, which should come level with a point just below the head. Tie the stem to the stake near the top, in the middle and near soil level; ties for Standard Roses which protect the stem from chafing are sold by many garden shops. As before, check for firmness in the spring, and give the same treatment if required.

Planting container-grown roses is very simple. Dig a hole larger than the size of the container, and line it with fine soil, or the same mix with peat and bonemeal as described above. If conditions are dry, wet the ground in and around the hole. Ease the plant carefully from its container, taking care to keep the soil block around the roots as intact as possible – it is best

to do this operation at ground level – and place it in the hole.[6] Give the plant a bucketful of water, and when the ground is dry again, tread it firmly in place. If the weather continues dry, repeat this as often as necessary, until the rose is well established in its new home.

Recommended planting distances in the UK are 40cm (15in) apart for miniatures, 45cm (18in) for dwarf and patio roses, 60cm (2ft) for most bush roses, 90cm (3ft) or more for standard and most shrub roses, and 2m (6ft) or more for climbing roses. Much depends on the variety concerned, and a rose specialist's catalogue will usually say, or the supplier can be asked in case of doubt.

PRUNING

There are two main reasons for pruning. The first is to rejuvenate the plant, which means helping it to produce young stems and discard old ones; and the second is to ventilate it, which means letting in more light and air around the branches, by removing misplaced and useless wood.

If these two aims are kept in mind, and the work done with the needs and interests of each particular plant in mind, pruning becomes a logical and absorbing task. Remember that each plant is an individual, and although general rules apply, one can only prune each plant according to what is there.

Hybrid teas, floribundas, patios and miniatures can be taken together. To rejuvenate them, look for smooth-barked reddish green stems growing up from near the base. These are the newest channels for the sap, and as such need preserving. We do have to shorten them, because left to their own devices they will grow out near the tips, producing thin stems and poor quality flowers. It is safe to prune off half to two-thirds of their length, or even more if fewer blooms of high quality are wanted to exhibit at the Flower Shows. The pruning cuts should be made just above an eye with a cut sloping in the same direction as the eye. If no eye can be seen do not be concerned, there are always some close to the base of stems, and any dead ends that result from faulty pruning can be tidied up later. It is worth getting a good pair of secateurs which make a clean over-lapping cut; 'Felco No.2' are what most nurserymen use.

'BALLERINA' REPEATS WELL IF OLD FLOWER HEADS ARE REMOVED.

6 Some container-grown roses are sold in biodegradeable pots, eliminating the need to separate the plant from the container.

THIS 'DOROTHY PERKINS' NEEDS THINNING OUT TO ALLOW LIGHT AND AIR TO CIRCULATE.

Since newly planted bushes only have the type of growth described, it follows that pruning them is easy. Cut them down to finger length, to about five inches, or less on smaller growing sorts. In this way new basal shoots will be encouraged, to lay the foundation for a shapely and vigorous bush.

On the older bushes, apart from the basal stems already mentioned, there are stems from previous years, with darker, calloused bark. Smooth-wooded greenish shoots branch off them, and these are pruned to leave a spur of wood. How far back? To where they are pencil thick is a rough and ready guide, as at that thickness the stem should bear future productive growth. If the rose is thin-wooded, as many patios and miniatures are, the spur will be perhaps only an inch or two in length, and thinner. Work up the stem, and when a point is reached beyond which there are no productive side shoots, cut off what remains. You have now limited the number of channels through which the sap can flow. When it has exploited them, it will have to create new ones lower down the stem. That is what rejuvenation means.

Next comes the job of clearing out unwanted pieces, so that light and air can circulate. Dead wood should be cut away, also decayed stubs from previous prunings, and feeble twiggy shoots. Unripe stems and suckers, if you can identify them, should be excised; if you are in doubt, they can be left and dealt with later. Finally, trim off any crossing shoots so that they do not rub against each other, and make a final check to see if anything has been missed or if a shoot needs shortening to maintain the overall symmetry.

For standard roses of these types the same general principles apply; as the sap has to work harder to bring food up to the leaves, don't prune excessively.

Newly planted climbing roses can be left alone, or slightly shortened, especially if the tips die back. After the first year, treatment will differ according to the variety. Modern repeat- flowering climbers can be pruned on the same general principles as bushes, except that where a long young shoot appears, either from the base or higher on the plant, it is more useful to train it so that the plant will cover up the structure it is growing on; if such a shoot is pruned hard it will do no harm to the plant, but the result will resemble a large shrub rather than a climber. The scented pink 'Compassion' illustrates the point, for with hard pruning it forms a desirable 1.5x1.5m (5x5ft) shrub, and trained as a climber it will attain 3x2.5m (10x8ft).

Climbers and ramblers that have one flowering only require different treatment. They produce long stems with no flowers on in the first year of growth, thereby provoking complaints to nurserymen that they are purveyors of "blind" roses. That is unfair, for all that is required is patience. Those long shoots should be *left alone* or, at most, tipped back if the stems are very thin. They should be trained in place, and next summer will bear flowering side shoots along their length. Pruning them would have deprived the garden

of those flowers. When the time to prune comes round again, treat those side shoots as you treated those on the bush varieties, pruning back to pencil thickness (or, for the likes of 'Dorothy Perkins', matchstick thickness, since their wood is so very thin). Sometimes a side shoot grows thick, strong and flowerless as if it were a first year growth, and such are to be welcomed, left unpruned, and trained for the joy they bring next summertime. The rest of the pruning obeys the ground rules already laid down, to allow the air and light to circulate. An important difference is that many ramblers make excessive numbers of shoots, and much of the old wood can be taken out each year to give elbow room to what remains. Where decisions must be made on which shoots to keep, choose youth and strength in preference to weakness and old age.

The lovely climber 'Mermaid' is probably better left alone, unless it grows awkwardly across the garden path, creating a hazard with its murderous prickles. Care is needed in tying it back in place, because the shoots are extraordinarily brittle. As for the Banksian roses, pruning should be limited to cutting out branches which after some years service have little more to give. Cutting the side shoots is likely to reduce the amount of flower, since they bloom on the sub-laterals – the side shoots off the side shoots off the main shoots!

Since training follows the pruning, this is the place to stress that climbers and ramblers will cover objects far more effectively if long shoots are trained *sideways* and not upwards. Sideways training means that more side shoots are produced, hence there are more blooms and a leafier plant. If such shoots are tied up vertically, the sap rushes up to produce new shoots near the top, and not so many lower down, with the result that there are fewer flowers, and bare brick or wood to look at instead of greenness. Where sideways training is not practicable, bending shoots spirally will achieve a satisfactory result.

Very vigorous climbers can be tackled every two or three years if they grow in sites where they can sprawl at will. In this category come 'Albertine' and

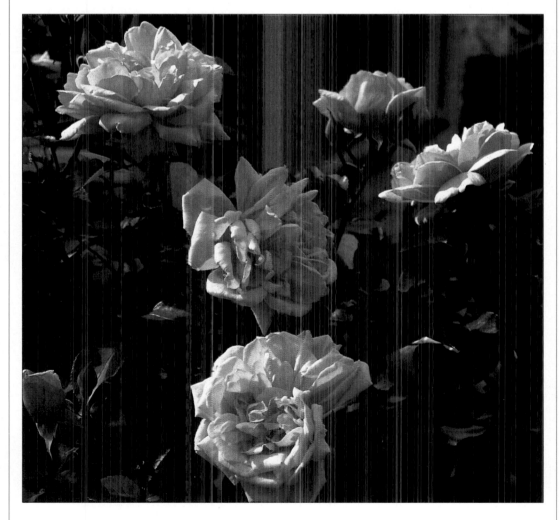

'ALBERTINE' IS A POPULAR ONCE-FLOWERING TYPE OF RAMBLER.

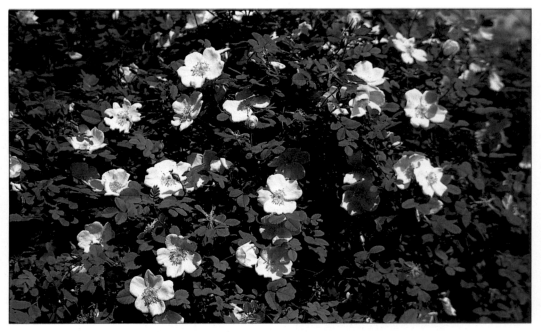

'NEVADA' IS BEST LEFT UNPRUNED EXCEPT FOR REMOVING USELESS WOOD.

'Blush Rambler'. As for the "fast-growing Climbers, suitable for rambling over old ruins" which my grandfather was advertising in 1896, the likes of them may never see a secateur yet flourish for many years. Graham Thomas tersely summed up one such, 'Rambling Rector', in three words: "Impenetrable, un-prunable, overpowering".

The pruning of Shrub roses depends very much on the variety. Some, including most Modern Shrubs, can be treated as big bushes, and most benefit from having their new wood reduced to some extent, and sideshoots shortened. Species roses and their near derivatives, such as 'Frühlingsgold', 'Marguerite Hilling' and 'Nevada', should be left alone, apart from the sawing out of dead branches in the course of time. If in doubt, ask a specialist rose grower; it's not much good though unless you know the name of the rose concerned!

The time to prune can be anytime from late October through to February for climbing roses. Many gardeners like to tidy up the roses in November, and a preliminary trimming or pruning can be accomplished then. The favourite period is from mid-February to late March, depending on the locality; earlier in the south, later in the north. After pruning on a fine day in early spring it's a great opportunity to spread a mulch around the roses, which brings us to our next and last of the seven essentials for success.

AFTERCARE

Mulching has rightly been called the natural method of soil formation, because it is essentially a ground covering litter of fallen leaves and other organic matter. Those with limitless purses can mulch their roses all year round, but for the majority with modest means, the best time is spring. It is then that the rootlets begin to feed, and can benefit from spring rains washing the nutrient down. If the same mulch were put on in November say, much of the goodness would have leached away without the plant being able to absorb it.

In earlier days, mulching material in Britain's stately gardens was nearly always stable manure, and that, or any other animal manure is admirable. In Saudi Arabia they use the products of goat and camel, in India cow manure, and Mrs. Runcie, who has transformed the garden of Lambeth Palace, speaks warmly of the offerings of rhinoceros at London Zoo. There is an important proviso – whatever manure is used, it needs to be well rotted. Used too fresh it will give the plants an overdose of nitrogen, causing distorted lush growth and vulnerability to disease.

The most popular mulch material in Britain at the present time is pulverised bark, which is clean, filters the rain, does not get scattered by the birds, suppresses

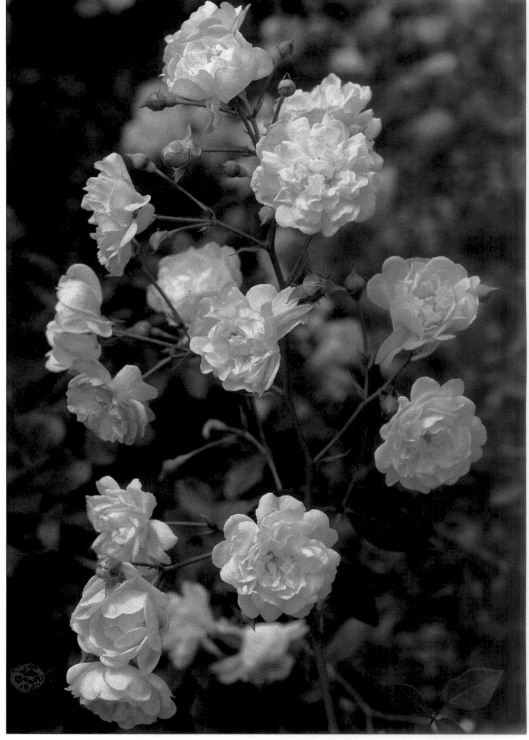

TO PRUNE 'FAIRYLAND' REMOVE UNWANTED WOOD AND CUT A THIRD OFF WHAT IS LEFT.

weeds, and is long lasting. Peat shares these advantages except that in dry conditions it can form a crusted surface through which water does not percolate. Bark can however rob the soil of nitrogen as it decomposes. A perfect mulch therefore will be composed of well rotted manure mixed with pulverised bark, and some additional peat whose fine particles are an asset to the structure of any soil. If well rotted manure is unavailable, a dried manure can be utilised instead.

The roots of roses feed on dissolved material, therefore for food to be available to them moisture must be present. In dry weather their activity declines, with obvious and sometimes serious consequences to the leaves and flowers. The best time to apply a mulch is after a good natural rain. The mulch then acts like a blanket, sealing the dampness in and reducing evaporation, so that the roots can continue their unseen feast.

Towards the middle of April, May and June a balanced rose food can be added to the mulch, and hoed in to prevent its loss by wind. There are many on the market, providing the three chief elements of nitrogen, phosphate and potash, known as NPK to chemists, plus the lesser elements required for healthy growth, including magnesium, iron, calcium, manganese, sulphur, zinc and boron and molybdenum. Of several of these only minute amounts are needed, and it is better to apply them in a balanced form than try to correct a suspected deficiency with a more specific remedy, like the man who, on learning iron was good for roses, dressed his rose beds with the sweepings from the blacksmith's forge, then wondered why they died. Nitrogen is a builder of handsome leaves and colourful large-sized flowers. Phosphate aids disease resistance generally and helps the roots to prosper. Potash also promotes good health, strengthens stems and plant tissue generally, and helps prepare the plant for overwintering. The three make an ideal team as their effects are complementary. The rate of application should be as suggested on the packet, and in case of doubt, two ounces (60gr) per square yard/metre should be safe. If possible, fertilisers should be put on at a time when they can promptly be taken down into the soil, as for example during rainy weather, or just before watering, or, in the case of spring applications, when the soil begins to thaw after frost.

The balance of nutrition between roots and leaves is critical, and leaflets soon show distress signals if a vital plant food is unavailable. Lack of nitrogen shows up in pale foliage, sometimes with reddish spots, and stunted growth. Shortage of phosphate leads to small leaves with purplish tints . If potash is missing, the leaves look reddish with brown margins as though they had been singed. Magnesium is a great builder of the chlorophyll that puts green colour in the leaves, and a deficiency causes paling in their centres. Indeed, the yellowing of leaves in autumn happens when the magnesium supply is switched off as the plant prepares for dormancy. Lack of iron can show up if leaves go yellow, and although sequestrene can be applied to correct supposed iron deficiency, the truth is that yellowing can also be due to other causes. Indeed the chemical reactions are so complex that too much or too little of one element may prevent absorption by the plant of another. That is why it is always safer to apply a balanced rose food, of which there are several kinds stocked in garden centres, rather than one mineral alone. However, if the pH value of the soil is known (and there are kits on sale to measure it) it would be reasonable, on a reading of 5.5 or less which indicates an acid soil, to add lime at the rate of eight ounces (250gr) per square yard/metre. A reading of pH7.5 or more shows a strongly alkaline, probably chalky soil, and this is harder to correct; applying ground sulphur at the preparation stage would help, at the same rate as the lime. It would have been better – and cheaper – to dig out larger holes at planting time, and fill them up with more fertile topsoil.

When plants are in active growth, an excellent way of feeding them is through the leaves. Foliar feeds are easy to buy, and provide a good balance of what the plant requires, including the foods that normally enter the plant tissues through the activity of the roots. This means that if the roots are under stress, as for example in dry weather, foliar feeding can make up for what the plant as a whole is lacking.

When spraying with foliar feed or anything else, be careful to observe these rules:

Use an efficient sprayer
Mix according to instructions
Give plants 100% coverage
Don't spray in hot sunshine
Clean the sprayer after use
Store sprays away from children

If spraying is being carried on with weedkiller or other substances that would injure plants, it is sensible to have two sprayers and to label each one clearly, to avoid harmful accidents. It is surprising how often weedkiller is sprayed on roses by mistake; even nurseries and rose trials have suffered losses in this way.

Spraying is more often associated with fungal disease and insect pests. The three fungus troubles to which roses are most prone are mildew, rust and blackspot.

FUNGI

Everybody recognises mildew, the familiar whitish grey mould seen on young shoots, flower stalks, seed pods and leaves. A bad attack can be very unsightly, but is not normally lethal. What causes it are spores of the fungus that are carried in the air, looking for a likely host; that host will be a plant that has suffered some check to its growth or suffers from some other disadvantage, making it a favoured target – and nature sees to it that the spores are adapted to be most effective in attack at a period when potential hosts are vulnerable.

Mildew targets include plants which are planted where air cannot circulate freely, for example if they have been planted too close together, near trees and shrubs, in shady places, in walled gardens, or left unpruned; also roses in sites where moisture is lacking, such as dry walls, under house eaves, in raised beds, at the top of steeply sloping ground, or in containers with insufficient soil. If roots become dry, through being planted in loose ground, or disturbed by digging, or in periods of drought, then the leaves become distressed and are easily infected. The leaves can also become

'DEAREST'

dehydrated in very draughty sites. Mildew attacks often occur at times when the temperature fluctuates, especially in late autumn when warm days are succeeded by cold nights. And finally, some roses inherit a tendency to mildew in their ancestral genes.

As prevention is always better – and easier – than cure, what can be done to forestall the problems? Careful choice of site, correct planting, pruning and aftercare will reduce the risk. The selection of varieties can be made so as to avoid known troublemakers, such as 'Papa Meilland', 'Super Star' and 'Dearest', and pick roses with good records like 'Alexander', 'Pink Favourite' and 'Memento'. If you think 'Papa Meilland', despite its faults, too beautiful to be without, plant it in the best site possible, and away from other roses so it cannot so easily infect them. There is no protection against nature's temperature changes, but they usually happen in autumn, by which time mildew is not likely to cause much damage since the plant will soon be entering its winter dormancy.

'MEMENTO'

If mildew is seen early or in mid-season, affected shoots can be cut off and burned, and there are several sprays which will clean up the plants efficiently, Nimrod-T, Benlate, Roseclear and Multirose among them. Late mildew, as just mentioned, may offend the eye but cannot greatly harm the roses. In wintertime, plants that have been persistent offenders in the past can be taken out, and, if the sites seem reasonably good, replaced with healthier varieties. Other affected plants should be pruned hard and the prunings burned, because some mildew spores can overwinter on the stems; these plants can be sprayed after pruning, as a preventive measure. The best preventive measures of all, especially for those who dislike using sprays, are to plant the right varieties in the right places, keep them mulched and watered, and be sensitive to their needs in likely periods of stress.

Reference has been made to the spread of mildew where plants are too close together. Growing large beds of roses is an unnatural practice, and facilitates the spread of fungus, since the spores will choose the nearest host. That is why nurseries and large rose gardens are forced to adopt a spraying programme. In gardens where roses are allowed to mix with other types of plant, the damage caused by fungus is easier to control, and there should be no need to resort to sprays except in an epidemic year.

Blackspot, as the name suggests, is recognised by the appearance on the leaves of purplish-black round spots, a quarter of an inch or more across, often with a fringed edge. Other dark marks can be confused with it, and leaflets can be posted to a nursery specialist for verification if there is any doubt. The spores can only germinate if the surface of the leaf stays wet for six hours at a stretch, so warm wet summers suit them best. In such a season every garden suffers, and trying to control the damage seems a hopeless cause. This is when a sense of proportion needs to be maintained; hopeless it may appear, but the truth is that the rose has co-existed with its parasites throughout the ages, and plants affected one year may be clean the next. As with all epidemics and plagues, there are peak years and these are the exceptional ones. Plants that are well cared for can survive diseases.

Look out for early signs of spotting, especially on the lower leaves of plants that have been vulnerable in the past, as these are the most likely sites for exploitation by overwintering spores. Plants downwind of known sources, such as a neglected plant in another garden for

'BLANC DOUBLE DE COUBERT' HAS TOUGH, HEALTHY FOLIAGE.

example, should also be checked carefully. If blackspot is confirmed, pick off and burn the worst affected leaves, and spray that plant and its neighbours. Nimrod-T and Roseclear are among the sprays usually found most effective. Repeated spraying may be needed, but what is more important is to encourage new growth by proper cultivation as described above. After August the plants will have built up their strength, and autumn attacks, although unsightly, are not particularly harmful so near the time of leaf fall. Opinions differ as to the wisdom of picking up and burning all the fallen leaves. Some say spores remain alive on them, others that dead tissue cannot support a living organism. What is sure is that spores can multiply at frightening speed, and prompt preventive action when the first signs are seen will save both time and trouble.

When selecting what to plant, choose varieties which appear from local observation or report to be less susceptible to blackspot. Upright leafy growers are better able to withstand attack since they can afford some loss of foliage, and so 'Queen Elizabeth', 'Alexander', 'Southampton', 'Sweetheart' and 'Rose Gaujard' can be used to take the place of discards. Of the shorter growers, 'Princess Michael of Kent' and

'Anna Ford' have shown themselves particularly resistant. What holds true for one area may not however be so everywhere, for it has been said that blackspot fungus is as genetically variable as the rose itself, and the twenty-six or so strains that scientists have identified are capable of further adaptation in the contest for survival. This is why research to find new sprays is necessary, and also why good husbandry, allied to common sense, is the best long-term remedy.

Rust is more serious than mildew or blackspot, because it can devastate a rose bed, and in the early stages is harder to detect. Be watchful for yellowing leaves near the base of the plant from mid-May onwards. Look on the undersides, and if small rusty-orange globules about the size of grains of sand are seen, take off the leaves, burn them, and spray with Systhane. It is essential to direct the spray on the undersides of the leaves. The rusty-orange bodies turn black when they mature.

In severe cases, prune the plant hard back, even in summer, to stop the trouble spreading, or dig it out and burn it. If the adjacent roses have tired-looking old shoots near ground level that are overgrown by newer growth, they should be removed so they cannot harbour

'SOUTHAMPTON' IS A POPULAR AND HEALTHY BEDDING ROSE.

fresh spores. As with blackspot, rust becomes a serious threat only in seasons when climatic factors favour it. It is commoner in the south and west of Britain than in the east and north, which suggests that warm wet conditions suit it best.

Honey fungus affects trees, and can put out underground shoots, looking like black bootlaces, to attack the roots of roses. The first sign that all is not well may be the appearance of yellowish toadstools nearby. It is best to remove and burn the plant, and as much of the fungus as can be found. If re-planting is desired, change the soil and use Armillatox as a precaution; it is less trouble to grass over the site where practicable. A likely source of honey fungus is an old tree stump, and any such suspect item is best dug out and burned.

INSECTS

The most common insect pest is the greenfly or aphis, which sucks the sap. It can be a serious nuisance because of its incredible reproductive rate, and is able to spread fast by flying or being carried great distances on currents of air. It wastes no time once growth starts:

> The zephyrs of spring are here;
> Green leaves unfurl in the sun,
> And crouched on their blocks the green-fly
> Wait for the starting gun.[7]

Because they multiply so fast, it is well worth while to check very young shoots, and squash any aphis found there. This early treatment means there will be several thousand fewer to cope with later on. If the garden has many roses, concentrate on those in sheltered places, where the first infestations are likely to occur. There are many sprays which will kill them, but most will also kill their predators, such as the larvae of the ladybird. Some sprays work by direct contact, others are called systemic, because the plant absorbs them in its sap and poisons the insects that way; the systemics are useful for plants growing out of reach, like climbers. Some of the first aphids of summer are sure to be sunbathing on their growing tips. A homemade spray that is said to spare the ladybird consists of half an ounce of permanganate of potash crystals dissolved in two gallons of water. If gardening time is limited, aerosol sprays are handy, as they can be kept ready for instant use when the enemy is sighted.

An aphis that is brown instead of green forms colonies below ground to suck the roots, and the earliest sign of trouble will be a general drooping of young growth. Pour on two or three bucketfuls of water and use a systemic spray. Such infestations are fortunately rare.

For caterpillars and grubs that chew the leaves and flowers, systemics will also work. These creatures rarely come in great numbers, and have usually done their worst damage by the time they are detected, so in small gardens picking them off by hand is a reasonable method of control. If a chewed leaf is seen, search the leaves or flower higher up the shoot, and often the quarry will be found.

In the flowers other inhabitants may be found, including small black insects known as thrips or thunderflies, and pollen beetles. Thrips are the little crocodile-shaped creatures that make a nuisance of themselves for a few days each summer, when they fly about in large numbers, often landing on the skin and making one want to scratch. They spoil some flowers but are not a serious problem. Pollen beetles are small with shiny round black backs, and are found in open flowers scurrying about to nibble on the pollen. They have become a common sight in recent years, and the explanation is that they like to feed on rape, which is much more widely cultivated during the 1980s. After the rape is harvested, the beetles require fresh hosts, and roses fill that role, especially yellow ones, for that is the colour they associate with food. Anyone wearing

'ICEBERG' IS ONE OF THE MOST FREE FLOWERING OF ALL ROSES.

yellow or cream clothing when the beetles are about will attract scores of hungry, hopeful and disappointed visitors. Do they do damage? They may if they are trapped inside a bloom, when they will chew through the petals to make their exit; normally they just fly in and out.

Among the most vexatious pests are sawflies. The rose slugworm sawfly and leaf-rolling sawfly somewhat resemble queen ants, with shining black bodies and wings. The grubs of the first one chew the undersides of leaves, creating a skeletonised effect where the leaf tissue is missing between the veins. The second deposits eggs in young leaves, which react by folding back to form tight tubes, making secure nurseries for the grubs when the eggs hatch out. Not all leaves hold grubs, but their function as food factories for the plant is ruined whether grubs appear or not, and as the ruination coincides with high summer, a bad attack can be devastating. It is noticeable that roses growing where there are trees and shrubs around suffer more attention from the sawflies than those in more open sites, which suggests these larger plants are harbouring them. Spraying the roses and nearby shrubs in winter with Bordeaux mixture or winter wash as used for fruit trees, but at half strength, may help. In summer, remove and burn affected leaves to destroy the grubs, or if they are too numerous, use a systemic insecticide to try and break the cycle. As always, keep a sense of proportion; bad attacks are the exception, and most years the sawflies are just a minor nuisance.

Leafhoppers, as the name suggests, hop when disturbed. They feed underneath the leaf which becomes pale and mottled on the surface. Leaf fall can be caused, especially on a climbing rose against a wall or fence. It is important to spray the underside of the leaves.

The cuckoo-spit insect or froghopper works hard for its living by extracting sap to create a frothy mound. This is intended for protection but is so conspicuous to the human eye that the little green nymph is easily located.

Red spider mites are a common pest in glasshouses, and they can spread around the garden in warm summers. Plants on old walls in warm sites, or near stonework, are most at risk. The mites are tiny round-bodied creatures, barely visible to the naked eye. The most obvious sign of their presence is the look of the foliage, dry and crispy, bronzy above, and with fine

'CLIMBING CÉCILE BRUNNER' – VIGOROUS AND REMONTANT.

7 Michael Gibson, *RNRS Rose Annual 1981*.

webbing below. The mites are hard to control, but one thing they do not like is cold water. If affected plants are hosed every two or three days, especially on the undersides of the leaves, this will help discourage them.

Occasionally a rather unsightly scaling is seen on rose stems. The scales protect soft-bodied sucking insects. A simple remedy is to brush on methylated spirits.

This catalogue of potential problems may sound alarming, but most of them will not cause lasting harm; it is right to be aware of them so that trouble can be forestalled. On the positive side, gardeners know that the magical chemistry of the life force is so potent that, with a little care and common sense, nature will reward them with a generosity far beyond what they deserve. Take steps to prevent troubles and keep spraying to the minimum.

WINTER CARE

During winter the roses take a rest. In many countries, including Britain, they need no protection.[8] If temperatures are likely to fall below twenty degrees Fahrenheit for any length of time, then some covering is advisable. Nature provides it in the form of snow, but not all frost-prone areas, such as the colder zones of USA, Canada and northern Europe can rely on sufficient snow. The practice there is to cover up the plants with whatever protective material is available, such as soil, peat moss, bark and straw. Tall plants and climbers may require elaborate frames to hold the material in place. Standards are sometimes bent over to lie upon the ground so that they can be covered, half the roots being cut to make this possible. During the 1980s, experiments at the Royal Botanic Gardens in Hamilton (Ontario) tested the use of microfoam and Poly-e-foam (expanded polyethylene). This material proved not only more effective for protection but also more labour-saving than the older methods, and it can normally be re-used for three seasons.

QUERIES

In early summer the new growths sometimes fail to develop a flower. This may be caused by a period of cold wind or frost in late spring, coinciding with the time when the plant would be developing its flower bud cells, as opposed to the normal growth cells. In an

8 Every rule has exceptions. In 1981 many plants were killed by frost-bearing wind, including 22 out of 23 Standard roses in one English garden, some of which were newly-planted, others over twenty years of age. There are no practical steps that can be taken against a freak occurrence of this kind, and in general it is true to say that roses in the garden stand up to hard winters as well as any other plant.

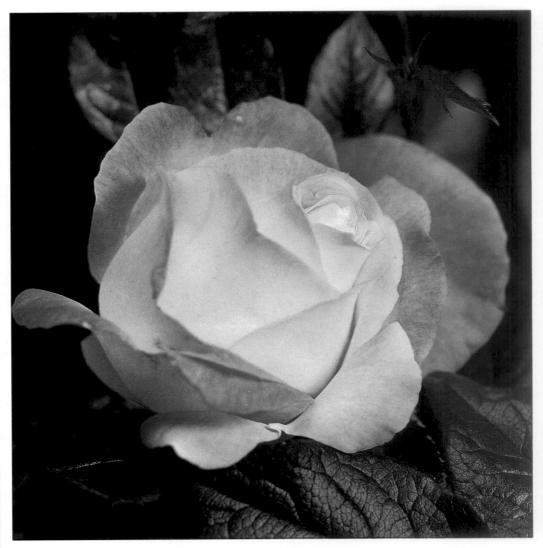

'PEACE' MAY HAVE 'BLIND' SHOOTS EARLY IN THE SEASON.

inclement season, the plant senses that conditions are not advanced enough for it to begin flower production. Some strong growers like 'Peace' and 'Queen Elizabeth' are noticeably affected in this way. New flowering shoots will soon appear. Sometimes lack of flower is due to lack of nourishment, when the plant does not have the considerable food resources it needs in order to convert flower buds into blooms.

Early flowers can show injury to their petals wherever they are not covered by the green sepals guarding them. Plump rosebuds like those of 'Zephirine Drouhin' where the tops are exposed can get nipped by frost or wind, or rain damaged or chewed by insects. The marks are mostly hidden as the flower unfolds and the inner petals expand.

If flower buds do not open, it may, paradoxically, be due to too much wet or too much drought. Drought periods make feeding difficult, and the plant may be forced to sacrifice its flowers, which dry out and wither; lots of water will help, but the problem needs to be anticipated for it to save the current crop of bloom. In wet conditions, after a spell of drizzly rain and cool weather when the flowers are naturally slow to develop, some varieties cannot open because the petals are stuck together. Roses with broad petals, including many exhibition varieties such as 'Red Devil', and also soft-petalled roses such as 'Camaieux', are most likely to be affected. An eye should be kept on varieties known to behave like this, and if "sticking" is detected in the very early stages, a gentle loosening of the outer petals may enable the rose to have a chance of opening in the normal way.

Sometimes a rose will sprout a green centre, especially in hot weather. This is regarded as a curious and cherished feature of some Old Garden roses, but it makes most varieties look malformed. It is all part of the plant's internal workings and no cause for concern.

Should roses be dead-headed when the flowers have faded? If they are varieties that will flower again, the answer is a definite yes, because otherwise hips will form, using up precious nutrients, and the plant will not feel the impulse to produce more bloom. Trim off the spent flowers with a short length of stem, cutting just above the nearest good foliage; do not cut back more than is necessary, because each leaf is a food factory helping the plant's well-being. There are some roses where dead-heading would be wrong, such as *Rosa moyesii*, 'Frau Dagmar Hartopp' and 'Scabrosa', which are grown for their decorative hips; and other roses where it is unnecessary except on grounds of tidiness, like 'Albertine' and 'Fritz Nobis' which only flower the once.

It may for sentimental or other reasons be desirable to dig up an old plant when moving house. If the move

LIKE MOST ROSES, *ROSA SERICEA PTERACANTHA* IS FROST HARDY.

takes place in the dormant season, this poses little problem, but if it coincides with the period of most active spring and summer growth, it may prove fatal. At other seasons there is a good chance of success if all young growth (leaves and flower buds) is trimmed off so as to prevent moisture loss, the plant and soil freely watered, the plant dug up (using sharp secateurs on some of the roots if they prove awkward to get out) and wrapped in polythene or a dustbin bag so the roots are not exposed to wind and sun, and carefully re- planted in a well prepared site, and watered in. The plant can be heeled in temporarily and kept watered while the new site is being prepared.

Containers can be used for growing roses, provided they are large enough to enable the roots to spread, and have reasonable drainage. A 15in deep tub would be suitable for bushes, and larger or smaller containers for other types according to their growth; for a climbing rose a half barrel approx. three feet across and two and a half feet deep is advisable, and the choice of varieties should be limited to repeat bloomers whose growth can be restrained, like 'Golden Showers', 'White Cockade', 'Morning Jewel', 'Breath of Life', 'Handel' and 'Compassion'. When a rose outgrows the container it can be transferred to a bigger one in the dormant season. Good compost should be used, such as John Innes No. 3. A balanced fertiliser can be applied in March, May and June, and foliar food from May to July. In winter, remove three to four inches of the topsoil and replace it with fresh compost. The plants must not be allowed to dry out nor to become waterlogged.

To increase stock of a variety, the quickest way is to buy more plants from a nursery. They will almost always be budded on a rootstock, for reasons of practicality, economy and health. Home gardeners can try the age-old method of producing them from cuttings. Cut pieces of ripe wood in August/September into four- inch lengths, trimming to just below an eye at the base, and just above one at the top. Insert them into pots filled with John Innes No. 2 compost. Rooting hormone can be used, and three could go into one seven-inch pot. Place the pot in a cold greenhouse or conservatory, or out of doors. Keep the soil moist but not waterlogged. Transplant those that have taken in their second spring, that is at the end of some eighteen months, or less in the case of miniature roses, which root more readily than other types of rose; for them a rooting bag could be used. Others likely to do well are ramblers, some shrub Roses and floribundas in the colours pink and red; the hardest of all are yellow, flame and orange hybrid teas.

Roses grown from cuttings have the advantage that any growth coming from the roots will be of the cultivated rose. Plants budded on a rootstock produce cultivated rose shoots from where the budding eye was inserted near ground level, and wild rose shoots, or suckers, from the rootstock and the roots. Most rootstocks used in Britain are selected because they produce few suckers, but some are bound to grow, especially if a plant gets disturbed or dry. The way to deal with a sucker is first to make sure that it is one. If it is a borderline case, which may or may not be springing from the rootstock, leave it alone until it has grown sufficiently for there to be no doubt. As they develop, suckers differ more and more from the normal rose growth, so comparison between the appearance of the leaves, thorns and stem should soon provide the answer. The number of leaflets is not a reliable guide, because many roses have seven leaflets. If a terminal flower bud is seen on a shoot from the base, that shoot will not be a sucker. The way to deal with suckers is to remove them at their point of origin, which is easy when they come close to the rootstock, but awkward when they are from outlying roots. If not cut off at source, they will grow again.

Speakers on roses are frequently asked the question: "What is the life of a rose?" It is reasonable to reply that with normal care a bush rose in Britain should give ten to fifteen years of pleasure. In warmer climates the life span can be much less. The sensible answer, surely, is to grow a rose as long as it continues to give pleasure. That can prove to be well in excess of fifteen years. In 1986 Mrs. Miskelly of Auckland had a miniature 'Rouletii' known to be at least 55 years old. Mr. & Mrs. Thorogood went to North Devon for their honeymoon in 1907 and bought a pink hybrid tea rose in a pot. In 1990 it grows happily in Letchworth, Herts. Both these items have survived moves to half a dozen different gardens; indeed, some old roses seem to enjoy being given new surroundings.

Roses on well-tended graves do not get moved about, but they too can be long lived. At Sandon, Herts. an early polyantha, the coppery red 'Leonie Lamesch', was planted in memory of a member of the Walker family. It is known to have been there for 60 years, and thought likely to have been planted circa 1910. Another rose thought to be older still thrives in a garden at East Hendred, Oxon. The same family have lived in a cottage there for seven generations, and living memory vouches for their 'Maiden's Blush', growing on its own roots, being there since the nineteenth century.

Claims of greater age do not always survive investigation, as happened when an alleged sixteenth century climber at the Alhambra in Granada was identified as 'Marechal Niel', which was introduced in 1864! Among cultivated roses, the record is thought to belong to China roses in the garden of a Chateau at Hex near Liege, planted around 1772-1784, some of which are said still to survive. There is no doubting the identity of the oldest rose of all. It is the famous rose of Hildesheim, which has been growing against the apse of the Cathedral crypt since well before 1629, when it was described as very old. A ninth century origin has even been suggested which accounts for its local description as "Der 1000 jahrige Rosenstock" or "The Thousand-year-old Rosebush". The rose itself is a form of *Rosa canina*. Wartime bombing on 22nd March 1945 burnt it nearly to destruction, but it grew back again in 1946. No doubt its stalwart root system has performed the same function many times in history, bearing witness to the amazing power of regeneration at work within the wild roses of the world.

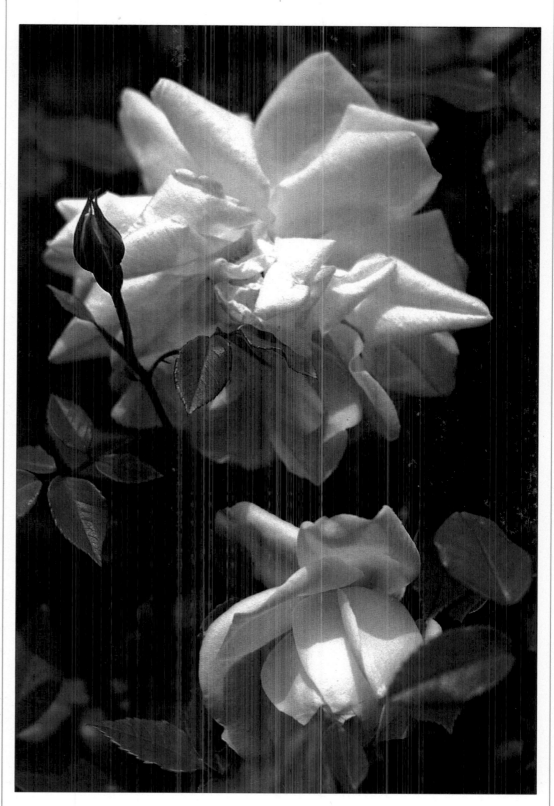

'TRINITY' – A CHINA ROSE OF UNKNOWN ORIGIN IN BERMUDA.

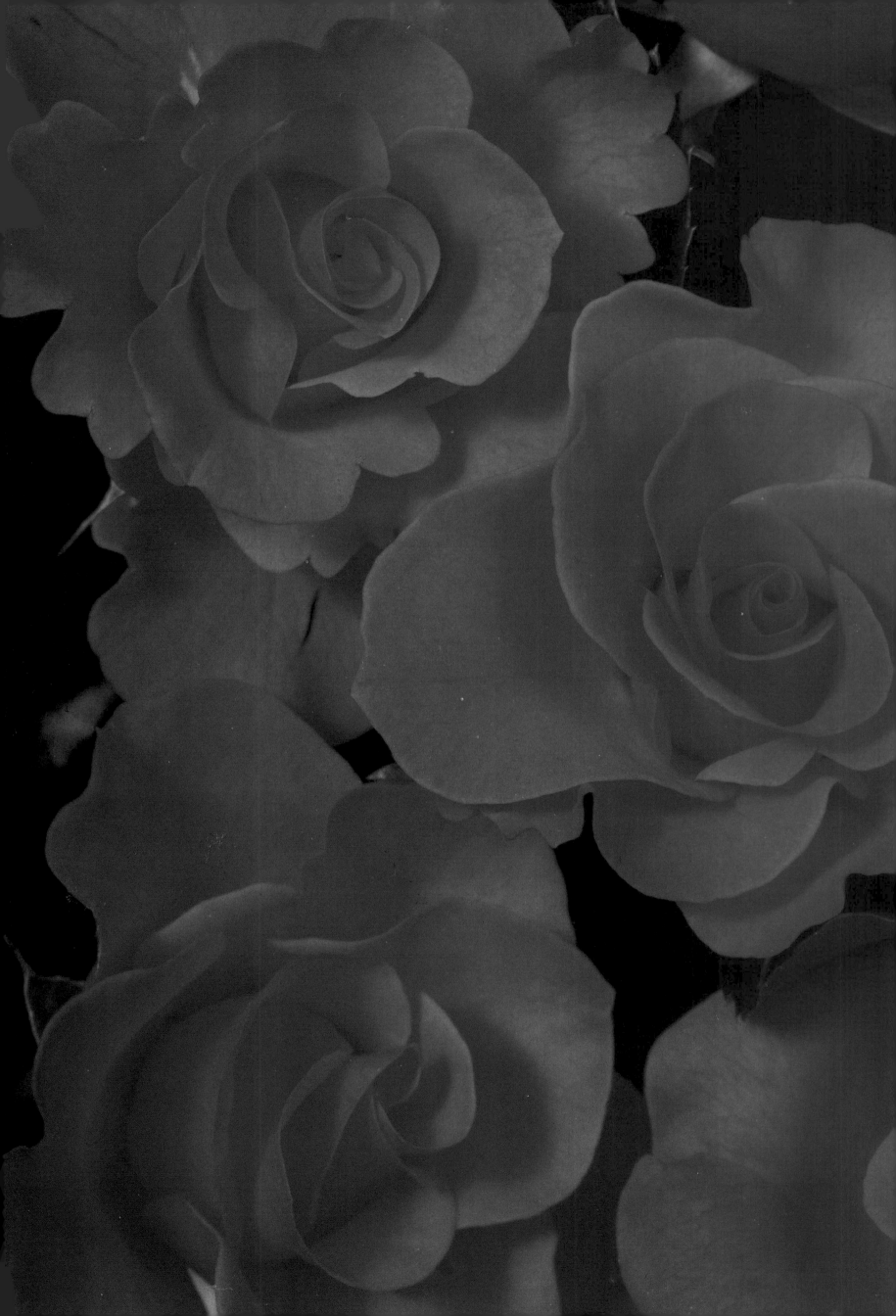

PART TWO

A-Z

rose selection

a–z rose selection

675 rose varieties are described, selected for their merit, fame, or importance in rose history. Included are alternative names, introduction date and raiser's name, and parentage where known. The uses for which the roses are best suited are given as follows:

Bed – meaning the plant is suitable to plant in a bed of one variety, or as a group within a mixed bed, or as an individual plant in a bed.

Border – good for planting in a border either as a group or as an individual plant, among roses or other types of plant. Shorter growers can be planted towards the front of a border as long as other plants do not overshadow them.

Container – suitable to plant in a container of reasonable size; theoretically any rose can be grown in a container if it is made big enough, but only smaller growers likely to be used are included under this heading.

Curiosity – for planting as something unusual, for garden interest and to surprise friends.

Cutting – most roses are suitable to cut for flower arrangements; this heading refers to those that are especially useful.

Exhibition – the sorts most likely to win prizes at shows.

Fence – varieties to grow on or up against a fence of average height, 2m (6-7ft); High fence means a bigger one and Low fence means a fence or support between 1-1.7m (3-5ft) tall.

Fragrance – most noses appreciate something from most roses; this heading refers to those whose scent is good enough to be appreciated by almost everyone.

Glasshouse – there are various reasons for growing roses under glass, such as to obtain early bloom, but this heading only refers to varieties that are particularly suitable, either because they give excellent flowers for cutting, or because the rose is tender and its beauty can best be appreciated when grown this way.

Ground Covering – having a creeping or low spreading habit of growth.

Health – used for roses which experience suggests have proved outstanding in this respect. For very recent varieties it is sometimes too soon to know for sure, and for them the absence of this factor should not be taken as significant.

Hedge – suitable for a hedge, having a dense or fairly dense free branching habit. The recommended distance apart when planting is shown in brackets, e.g. (60cm-2ft).

Hips – having hips of notable size, colour or decorative effect.

Naturalising – roses that can be left to romp in a semi-wild garden with little or no attention.

Pergola – roses rampant enough to be trained up and over a pergola-like structure, including for example a flat roof.

Pillar – restrained climbing roses or vigorous upright bushes well suited to growing on a stout upright structure up to 2.4m (8ft); Low Pillar means 1-1.7m (3-5ft).

Rosarium – a rose to grow for its historic or botanical interest.

Shrubbery – Suitable to plant in the company of other plants of substantial size, either as a group or singly.

Small space – useful for small areas where a short or low spreading plant is required; for miniature roses this includes their use in rockeries.

Specimen Plant – effective as a plant on its own, say in a lawn or other solo position.

Spreading – where the habit is spreading and the foliage dense, giving the effect of a taller ground cover rose.

Tree – among the best to train up into a sizeable tree.

Wall – good against a wall of average height, 2m (6-7ft). High wall means a bigger one, and Low Wall a structure 1-1.7m (3ft). This includes some of the shrub roses which will heap themselves up against a wall and give good coverage without needing to be trained in place.

Weatherproof – varieties which experience shows stand up to wind and rain.

Weeping – indicates the variety is one of the best to grow naturally in Weeping Standard form, requiring no supporting frame.

The heights given are for United Kingdom gardeners, and can be doubled or even trebled for many varieties in milder zones, and reduced in regions where harsh winters are the rule.

Major awards are indicated as follows:
AARS – All-America Rose Selection.
ADR – All-Germany Rose.
FRAG – Fragrance Award followed by place name.
GM – Gold Medal (or Golden Prize) followed by place name; awards of the Royal National Rose Society since 1965 are shown as RNRS, and before that date as NRS; the Gold Medal of the American Rose Society is shown as ARS.
GR – Golden Rose followed by place name.
GSSP – Gold Star of the South Pacific.
JMMGM – James Mason Memorial Gold Medal of the RNRS.
PIT – President's International Trophy of the RNRS.
PRIZE – important Prize or Diploma followed by place name.
ROTY – Rose of the Year (a United Kingdom award).

ABBEYFIELD ROSE (Cocbrose)
Cocker, Scotland, 1985

Hybrid tea large flowered bush, flowering summer to autumn. An excellent bedding rose for the garden, not just for its prolific bloom production, but also for the way it clothes itself with handsome healthy foliage, making it pleasing to the eye even when not in flower. The colour is rose red to rose pink, a warm and

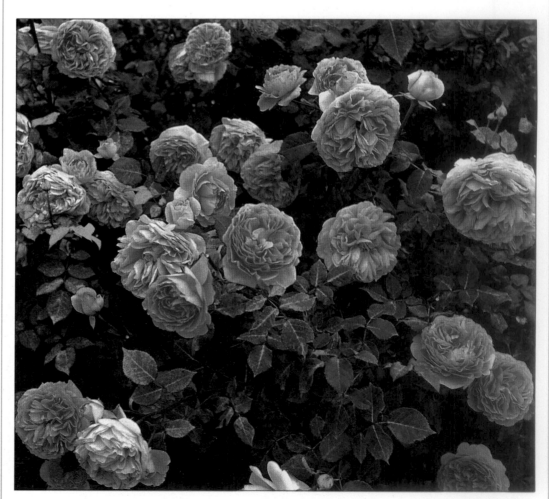

PREVIOUS PAGES: DISCO DANCER 'ABRAHAM DARBY'

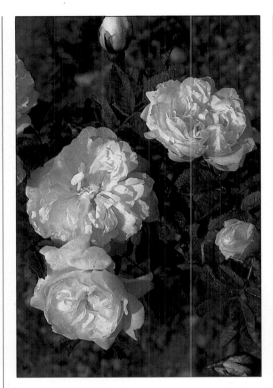

'AGNES'

ALBERIC BARBIER
Barbier, France, 1900
Rambler, summer flowering. Spectacular in summertime, when petite yellow buds open into 8cm (3in) wide creamy white flowers, well filled with small petals. They look clean and fresh whatever the weather, and stand out beautifully against the dense background of shiny near-evergreen leaves. 'Alberic Barbier' tolerates awkward sites, such as unpromising walls and fences, is vigorous enough to romp over pergolas and tree stumps, excellent for concealing unsightly garden features, and will naturalise itself into a great spreading mound for birds to nest in for those who have space to practise gardening on the grand scale. 5x4m (15x12ft). *R. wichuraiana* x 'Shirley Hibberd'. Plant this for fence, health, naturalising, pergola, spreading, tree, high N E & W wall; weatherproof.

ALBERTINE
Barbier, France, 1921
Rambler, summer flowering. This light salmony pink rose is seen everywhere in June-July, when its shaggy rounded blossoms are borne in scores along thorny plum-coloured branches. Many people have nostalgic memories of childhood days, when grandmother's 'Albertine' was fully out during the fortnight of the holidays, casting its sweet aroma round the neighbourhood. Needs plenty of space, and thick gloves at pruning time. In dry sites some mildew may be expected, so avoid S and E walls. 5x4m (15x12ft). *R. wichuraiana* x 'Mrs A.R. Waddell'. Plant this for fence, fragrance, pergola, tree, high SW or W wall.

ALEC'S RED
Cocker, Scotland, 1970
Hybrid tea large flowered bush, flowering summer to

cheerful shade. The blooms are high-centred, neatly formed, and of medium size. Bushy habit, 65x60cm (24x24in). 'National Trust' x 'Silver Jubilee'. "Abbeyfield" is the name of a charity which runs homes for the elderly; the rose was originally sold in aid of that good cause. Plant this for bed, border, health, hedge (50cm-20in); weatherproof.

ABRAHAM DARBY (Auscot)
Austin, England, 1985
Shrub, flowering in summer with some later flower. This old-fashioned looking rose with cupped, full petalled blooms has a colour rare in shrub roses, being apricot pink with some yellow. Fruity scent. Makes a spreading, arching shrub, 1.5x1.5m (5x5ft), or can be grown against a wall or fence up to 2.5m (8ft). Named in honour of Abraham Darby, who built England's first iron bridge in 1777-79. Plant this for big border, fence, fragrance, shrubbery, wall.

AGNES
Saunders, Canada, 1922
Rugosa shrub, summer flowering. A most interesting and unusual rose, being a cross between *R. rugosa*, renowned for health and length of flowering period, and the vivid-hued but frail 'Persian Yellow'. The breeder got some answers right, for 'Agnes' is vigorous and healthy, with tough Rugosa leaves. Although the full petalled flowers are pretty, the colour is an uninteresting pallid yellow, and there is no significant second flush of bloom. 'Agnes' seems to resent pruning which is just as well, since the stems carry a formidable armament of prickles. Uneven, rather lanky growth, 1.5x1.2m (5x4ft). Plant this for border, fence, fragrance, health, rosarium, shrubbery.

AGRIPPINA (Cramoisi Supérieur)
Coquereau, France, 1832
China bush/shrub, flowering summer to autumn. Grow this in temperate zones, and you will see full petalled crimson scarlet flowers on a sprawling spindly bush. In regions free of frost it can make a substantial shrub and carry bloom for nearly all the year. In Bermuda such plants are a notable feature in churchyards and naturalised gardens. Many small petals, curving inwards after the fashion of a peony, make up the flowers of 'Agrippina'. They are borne in open sprays on slender stems, causing them to bow as if to conceal their undoubted beauty. The leaflets are pointed and shiny, and rather sparse. 75cmx1.2m (30x48in). Plant this for bed, border, health, low fence, low pillar, naturalising, rosarium.

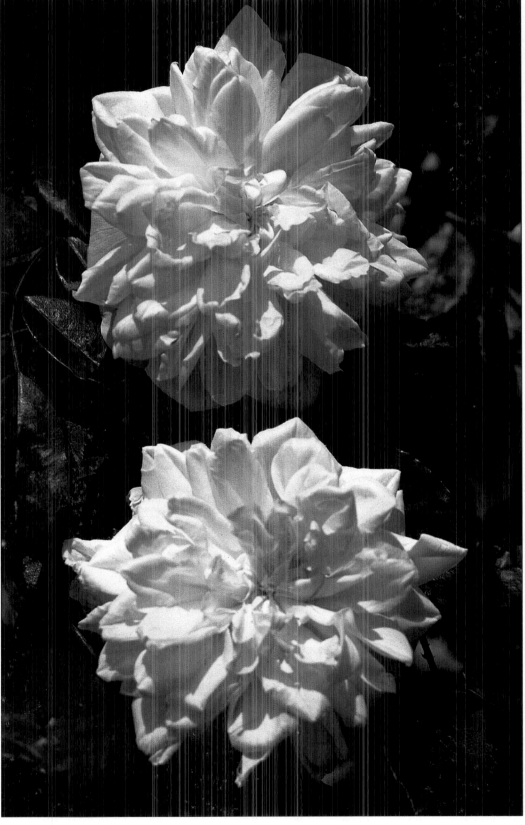

'ALBÉRIC BARBIER'

'ALISTER STELLA GRAY'

autumn. Rich cherry red to deep crimson, capable of giving wonderfully formed large blooms with lots of petals and superb fragrance. Growth is sturdy, bushy and free-branching. 90x60cm (36x24in). 'Fragrant Cloud' x 'Dame de Coeur'. ADR, FRAG Baden-Baden, Belfast, Hamburg & RNRS, GM Hamburg & RNRS, PIT. Bears the name of its raiser; he was undecided what to call this fine rose, and nurserymen who admired it while on trial began to call it "Alec's red one", and 'Alec's Red' it stayed. Plant this for bed, border, cutting, exhibition, fragrance, hedge (50cm-20in).

ALEXANDER (Alexandra)
Harkness, England, 1972
Hybrid tea large flowered bush, flowering summer to autumn. If you see tall upstanding roses with flowers of vermilion red so bright that they seem to glow, they are almost certain to be 'Alexander'. Its natural vigour and excellent health record makes this a marvellous rose to try for those who find difficulty in growing roses. The flowers come on long stems, making them ideal for cutting, though it is important to take them in bud before the petals open; then they will last well and maintain their pure dazzling colour. It is also excellent as a hedge. Foliage is dark, bright and abundant. 1.5mx75cm (60x30in). 'Super Star' x ('Ann Elizabeth' x 'Allgold'). ADR, GM Belfast & Hamburg, JMMGM. Named in honour of Field Marshal Earl Alexander of Tunis, under whom the breeder Jack Harkness saw service in World War II. Plant this for bed, border, cutting, fence, health, hedge (60cm-24in), pillar.

ALISTER STELLA GRAY (Golden Rambler)
Gray, England, 1894
Noisette climber, flowering summer to autumn. This is a delightful rose for a sheltered site, bearing sprays of plump buds which open into two-toned yellowish flowers, 6cm(2.5in) across, pale gold towards the margins and yolk-yellow in the centres, with musky fragrance. The petals form tight whorls in the young flower and open to give a rather shaggy effect. The autumn blooms may be better than those of summer,

which are more likely to be nipped by frost, but much depends on the weather in a particular year. It may take time to settle down, but is capable of covering a high wall with its long upright stems. 5x3m (15x10ft). Thought to be a Noisette crossed with a yellow Tea rose. Plant this for fragrance, rosarium, high S or SW wall.

ALLGOLD
LeGrice, England, 1956
Floribunda cluster flowered bush, flowering summer to autumn. For some years this was the healthiest rich yellow rose in commerce, bearing a bright array of neat 6cm (2.5in) blooms on compact bushy plants. They are remarkable for the way the colour is held, without noticeable fading until petal fall. The leaves are glossy and deep green, but their small size gives the plants a sparse effect by comparison with more recent introductions. Prune really hard into the young wood to encourage basal growth. 60x50cm (24x20in). Edward LeGrice used 'Goldilocks' x 'Ellinor LeGrice' in the breeding, and is said to have raised 8000 seedlings from these two which shows how highly – and rightly – he valued their potential. GM NRS. Plant this for bed, border, health, hedge (45cm-18in); weatherproof.

ALOHA
Boerner, USA, 1949
Climber, flowering summer to autumn. Grow this on a wall, and you will be rewarded by a succession of fragrant full-petalled flowers, 8cm (3.5in) across, displaying warm rose-pink shades with a hint of salmon in the centre. It can also make a rather open shrub, but is better with some support. Leaves are leathery, dark and healthy. 2.5x2.5m (8x8ft), or less if pruned to grow as a shrub. 'Mercedes Gallart' x 'New Dawn'. Plant this for cutting, fence, fragrance, health, pillar, shrubbery, wall; weatherproof.

ALPINE SUNSET
Cant, England, 1974
Hybrid tea large flowered bush, flowering summer to autumn. The flowers are well scented and very large, 20cm (8in) across, in the gentle peachy shades associated with a winter sunset. They are produced so freely that you wonder where the plant gets its energy, and the answer seems to be that so much is used up by the flowers that there is insufficient left over for the stems, which tend to be short and stumpy, and not always ripe enough to withstand hard winters. It makes a lovely bedding rose of even habit, but sites exposed to cold east wind should be avoided. 60x60cm (24x24in). 'Dr A.J. Verhage' x 'Grandpa Dickson'. FRAG The Hague. Plant this for bed, border, cutting, exhibition, fragrance, hedge (50cm-20in).

ALTISSIMO
Delbard-Chabert, France, 1966
Climber, flowering summer to autumn. This rose

'ALPINE SUNSET'

'AMBER QUEEN'

shows the difficulty of classification. It produces large flowers 11cm (4.5in) across; sometimes they are borne one to a stem, and sometimes several together in wide clusters. So is it a Large Flowered climber or a Cluster Flowered one? There is no controversy about its beauty, which is apparent as the dark red seven-petalled flowers unfold, revealing golden hearts. They keep coming with remarkable constancy for weeks on end. Up to 3mx2.5m (10x8ft). 'Tenor' x unknown. Plant this for fence, pillar, wall.

AMBER QUEEN (Harroony, Prinz Eugen von Savoyen)
Harkness, England, 1984
Floribunda cluster flowered bush, flowering summer to autumn. This desirable garden rose bears 40-petalled flowers of pretty form and good size (7cm-3in) on low spreading plants. They are a refreshing shade of amber, and contrast beautifully with the plentiful reddish green foliage. The fragrance is pleasing too. 50x50cm (18x18in). 'Southampton' x 'Typhoon'. Eleven of its twenty awards are major ones: AARS, FRAG The Hague, GM Genoa, GSSP New Zealand, PRIZE Belfast, France, Genoa, Lyon, Orleans (2), ROTY. Plant this for bed, border, fragrance, hedge (45cm-18in); weatherproof.

AMERICA
Warriner, USA, 1976
Climber, flowering summer to autumn. The blooms are salmony pink, about 10cm (4in) across, prettily formed with overlapping petals, and often borne in clusters of four or five. It flowers well on new wood

at the expense of growth, and can be grown as a large shrub. 2.2x2.2m (7x7ft). 'Fragrant Cloud' x 'Tradition'. AARS. Plant this for fence, pillar, shrubbery, wall.

AMERICAN PILLAR
Van Fleet, USA, 1902
Climber, summer flowering. It's hard to mistake this variety, for its arching stems wreathed in five-petalled carmine roses each with its distinctive white eye are familiar in the month of July. The flowers, borne in big clusters, make a bold display, and despite seasonal mildew the plants are hardy, long-lived, and can be left to rampage if space permits. New basal shoots can be mistaken for suckers, so if in doubt leave them alone until their identity is certain. 4mx3m (12x10ft). (*R. wichuraiana x R. setigera*) X a red Hybrid Perpetual. Plant this for fence, naturalising, pergola.

ANGELA RIPPON (Ocarina, Ocaru)
De Ruiter, Holland 1978
Miniature or patio or dwarf cluster flowered bush, flowering summer to autumn. Makes a colourful plant, rather too substantial to call a miniature. The cheerful rose pink flowers have a touch of salmon about them. They open from pretty urn-shaped buds and last well, being made up of many small petals. Bushy, leafy habit, 45x30cm (18x12in). 'Rosy Jewel' x 'Zorina'. Named for the celebrated British newscaster and journalist. Plant this for bed, border, container, cutting, exhibition, glasshouse, health, hedge, small space; weatherproof.

ANGEL FACE
Swim & Weeks, USA, 1968
Floribunda cluster flowered bush, flowering summer to autumn. Bears sizeable (9cm-3.5in) flowers with waved petals in rich shades of dark mauve and lavender. It is offered in USA, Australia and India but not elsewhere, perhaps because warmer climates help bring out the pretty colour tones. Foliage dark, rather leathery. Bushy, 65x60cm (24x24in). ('Circus' x 'Lavender Pinocchio') x 'Sterling Silver'. AARS. Plant this for bed, border, curiosity, fragrance.

ANISLEY DICKSON (Dickimono, Dicky, Münchner Kindl)
Dickson, N. Ireland, 1983
Floribunda cluster flowered bush, flowering summer to autumn. Produces some of the loveliest sprays imaginable, full of prettily formed flowers in a warm shade of rosy reddish salmon. They are carried against a background of handsome dark green leaves. Bushy, 90x75cm (36x30in). 'Coventry Cathedral' x 'Memento'. GM St Albans. Named as a tribute to his wife by the raiser Pat Dickson. Plant this for bed, border, hedge (60cm-24in); weatherproof.

ANNA FORD (Harpiccolo)
Harkness, England, 1980
Patio or dwarf cluster flowered bush, flowering summer to autumn. One of the most reliably healthy roses among dwarf growers. It makes a low spreading plant, and if planted in a group the effect is of a green leafy carpet, ornamented continually with flowers from June to late autumn. We could do with this sort

'ANNA FORD'

give a quartered effect at the final stage. The flowers are large for a Tea rose, 9cm (3.5in) across, and they change colour from creamy blush to a definite yellow when fully open. This is a fascinating rose but needs a warm climate to reveal its charms. Up to 1.2mx90cm (4x3ft). Plant this for border, cutting, fragrance, glasshouse, rosarium.

ANNA PAVLOVA
Beales, England, 1981
Hybrid tea large flowered bush, flowering summer to autumn. At its best this is a beauty, with broad petals of the subtlest light pink shade making up a huge flower of rounded form, and very sweetly scented. Enjoys warm weather, may ball up in the rain. Large dark foliage. Rather upright, 1.2x90cm (4x3ft). Named after the famous Russian ballerina (1885-1931). Plant this for border, exhibition, fragrance, glasshouse.

'ANNA ZINKEISEN'

of rose in every colour, but have to be content with 'Anna Ford's rather bright red small petalled blooms, 4cm (1.5in) across, with yellow centres. Neat habit, 45x40cm (18x15in). 'Southampton' x 'Darling Flame'. GM Genoa, Glasgow & St Albans, PIT, PRIZE Baden. Named for the British writer and television presenter. Plant this for bed, border, container, health, hedge (40cm- 15in), small space; weatherproof.

ANNA LIVIA (Kormetter, Trier 2000)
Kordes, Germany, 1985
Floribunda cluster flowered bush, flowering summer to autumn. A fine clear pink bedding rose, with showy trusses of neatly formed blooms, especially pretty in the young flowers. Well foliaged, bushy

habit. 75x60cm (30x24in). GM Orleans, GR The Hague. The reason for the name is that 'Anna Livia' is how James Joyce referred to the River Liffey in Dublin, and the rose honoured that city's Millennium in 1988. Plant this for bed, border, exhibition, health, hedge (60cm- 2ft); weatherproof.

ANNA OLIVIER
Ducher, France, 1872
Tea bush, flowering summer to autumn. There is some query whether or not this is correctly named, for the roses grown and admired in USA and Bermuda are hard to reconcile with the descriptions in old books and catalogues. The variety being offered has blooms of beautiful form, with many petals holding a tight centre in the young flower, then unfolding to

ANNA ZINKEISEN (Harqühling)
Harkness, England, 1983
Shrub, flowering summer to autumn. The petals are pale gold in the bud stage, becoming ivory in the open blooms, which have the look of an old garden rose; indeed this is a good example of an "old-style" rose with the repeat- blooming quality of a modern one. The scent is like sweet hay, and derives from Scotch roses in the parentage. The plant grows broad and strong, with plentiful foliage. 1.2x1.2m (4x4ft). Seedling x 'Frank Naylor'. PRIZE, Copenhagen. Named in memory of a much admired Suffolk artist. Plant this for border, low fence, fragrance, hedge (1m-40in), shrubbery, specimen, spreading, low wall; weatherproof.

ANNE COCKER
Cocker, Scotland, 1970
Floribunda cluster flowered bush, flowering summer to autumn. Lively small to medium sized flowers of rich dark scarlet are carried in wide sprays, each individual bloom being neat in all respects – form, petallage and placement. They last extremely well when cut. Growth is upright, foliage plentiful and on the dark side. May get a touch of late season mildew. 80x55cm (32x20in). 'Highlight' x 'Colour Wonder'.

'ANNA PAVLOVA'

'ANNE COCKER'

Named for the wife of the raiser, Alec Cocker. Plant this for bed, border, cutting, exhibition, hedge (55cm-20in); weatherproof.

ANNE HARKNESS (Harkaramel)
Harkness, England, 1980
Floribunda cluster flowered bush, flowering late summer to autumn. Remarkable for spectacular flower sprays, among the loveliest you will see, in which each perfect flower is evenly spaced to create a natural floral bouquet. They are borne on long stems, perfect for cutting. The energy needed to produce so many flowers all at once means they do not appear before late July, and continue on full flush through August at a time when few garden roses are at their best; so it is a useful rose for out of season bloom. It stands up to rain particularly well. Growth upright, vigorous, 1.2mx60cm (4x2ft). To keep it from being over tall, prune hard into the previous summer's wood. 'Bobby Dazzler' x seedling. PRIZE BARB (UK). Named for the author's elder daughter, now Mrs Anne Chambers. Plant this for bed, border, cutting, exhibition, health, hedge (50cm- 20in), low fence, low wall; weatherproof.

ANNEKA (Harronver)
Harkness, England, 1990
Hybrid tea large flowered bush, flowering summer to autumn. Yellow, with a touch of pink as the flowers develop. They are freely borne on vigorous plants, full of leaf and health. 90x60cm (3x2ft). 'Goldbonnet' x 'Silver Jubilee'. Named for Anneka Rice of BBC TV at the suggestion of the Royal National Rose Society, following its success in the St Albans trials. Plant this for bed, border, health, hedge (60cm); weatherproof.

APRICOT NECTAR
Boerner, USA, 1965
Floribunda cluster flowered bush, flowering summer to autumn. In warm weather this will produce some of the loveliest flowers of summer, rounded in form, well filled with petals, in a delicate shade of apricot; a flower arranger's delight. Cold wet conditions do not suit it. Bushy, branching, 60x60cm (24x24in). Seedling x 'Spartan'. AARS. Plant this for bed, border, cutting, exhibition, fragrance, glasshouse.

ARDS BEAUTY (Dicjoy)
Dickson, N. Ireland, 1986
Floribunda cluster flowered bush, flowering summer to autumn. Canary yellow flowers of medium size are

borne on short stiff stems on very leafy plants. Always seems to be carrying bloom. In hot weather some green-centred flowers may appear. Bushy, 60x60cm (24x24in). ('Eurorose' x 'Whisky Mac') x 'Bright Smile'. GM & PIT, St Albans. Named by the raiser for the region of County Down where his nursery lies (at Newtownards). For bed, border, fragrance health, hedge; weatherproof.

ARMADA (Haruseful)
Harkness, England, 1988
Shrub, flowering summer to autumn. Deep pink, bearing many cupped blooms in open sprays on

'ANNEKA'

'ARDS BEAUTY'

'ANNE HARKNESS'

vigorous tough plants, well furnished with deep green glossy leaves. Growth somewhat uneven, 1.5x1.2m (54x48in). Interesting parentage in 'New Dawn' x 'Silver Jubilee'. PRIZE Copenhagen. Named to commemorate the 400th anniversary of the Spanish Armada; monies raised from initial sales were used to help restore Buckland Abbey, the Devon home of Sir Francis Drake. Plant this for bed, border, fragrance, low fence, hedge (1m- 3ft), naturalising, low pillar, shrubbery, low wall; weatherproof.

ARTHUR BELL
McGredy, N. Ireland, 1965
Floribunda cluster flowered bush, flowering summer to autumn. Yellow, bright in the young flower, paling to primrose. The neatly formed, long-petalled blooms make ideal buttonholes, and open to a good size (8cm-3in). Good fragrance. This is a clean, refreshing looking rose, with bright foliage and neat upright habit, 90x60cm. (36x24in). 'Cläre Grammerstorf' x 'Piccadilly'. FRAG Belfast. Named for a member of the family with a well known name in whisky. Plant this for bed, border, cutting, exhibition, fragrance, health, hedge (50cm-20in); weatherproof.

'ARMADA'

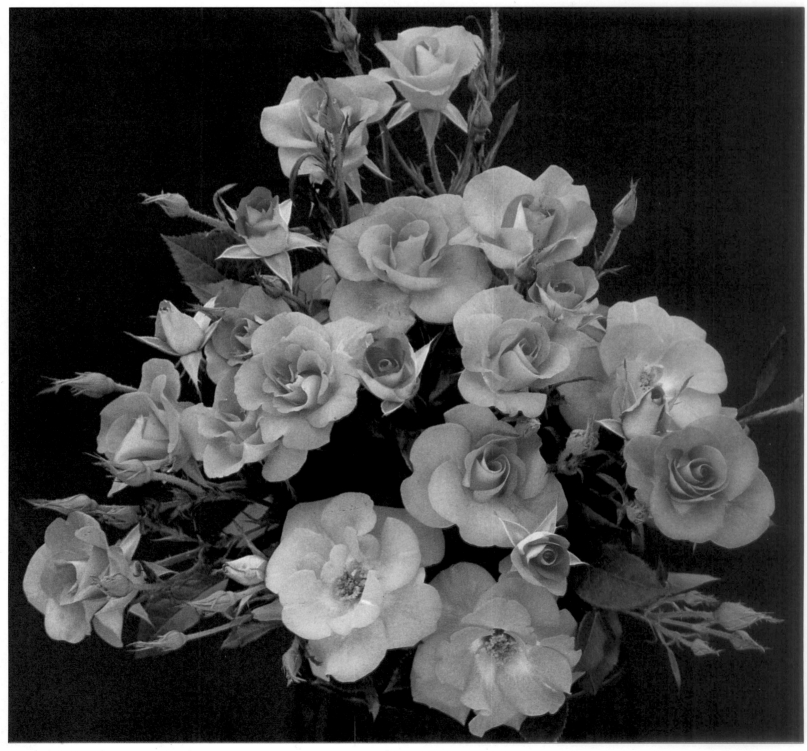

'AVOCET'

AVOCET (Harpluto)

Harkness, England, 1984

Floribunda cluster flowered bush, flowering summer to autumn. The basic colour is coppery orange, taking pink shades as the blooms age. They are borne many together in sizeable heads, with prettily waved petals, and are produced very freely over many weeks. Plentiful dark green glossy leaves make an attractive background and all round this is a splendid bedding rose. Growth free, bushy, 75x75cm (30x30in). 'Dame of Sark' x seedling. PRIZE The Hague. Named for the Royal Society for the Protection of Birds. Plant this for bed, border, health, hedge (60cm-24in); weatherproof.

BABY FAURAX

Lille, France, 1924

Polyantha bush, flowering summer to autumn. Some say this is the nearest to a blue rose, and it is variously described as violet or amethyst. The flowers are small, packed together in dense clusters, which look large because the plant itself is tiny, often less than 30x30cm (12x12in). It has foliage of *R. multiflora* type but there is no record of the parentage. Plant this for front of border, container, curiosity, health, rosarium, small space; weatherproof.

BABY MASQUERADE

Tantau, Germany, 1956

Miniature bush, flowering summer to autumn. This must be one of the best buys in the rose world, for it begins to flower early and continues late, without any appreciable breaks. The flowers are small, full petalled, and embody shades of yellow and pinky red, deepening as they age. Tiny leaves cover the plants which if unpruned can get tall, up to 75cm (30in) and with pruning attain 45x40cm (18x15in). 'Peon' x 'Baby Masquerade'. Plant this for bed, front of border, container, exhibition, health, hedge (30cm-12in), small space; weatherproof.

BACCARA (Meger, Jaqueline)

Meilland, France, 1954

Hybrid tea large flowered bush, flowering summer to autumn. The long stems and hard petal texture have made this famous as a cut flower rose, grown by the million for commercial sale. The colour is deep red, very bright yet not strident, and the many short petals provide a cupped to flat effect in the open bloom, enhancing its value for flower arrangement. Needs warmth if grown out of doors. Upright, 1mx60cm

'BALLERINA'

(36x24in). 'Happiness' x 'Independence'. Plant this for cutting, greenhouse, health.

BALLERINA

Bentall, England, 1937

Polyantha shrub, flowering summer to autumn. An unforgettable sight in full bloom, when tiny light pink single flowers cram themselves together like so many hydrangea heads. This is a real plantsman's rose, with a graceful rounded habit and abundant foliage; dense enough for birds to nest in. Very bushy, 1x1.2 (40x48in). Parentage unknown but it reminds one of a shorter 'Blush Rambler'. Plant this for large bed, border, large container, cutting, exhibition, low fence, health, hedge (75cm-30in), naturalising, shrubbery, specimen plant, spreading; weatherproof.

Banksian Roses – see under *Rosa banksiae*

BANTRY BAY

McGredy, N. Ireland, 1967

Climber, flowering summer to autumn. Bears a good succession of deep pink, rather loosely formed flowers, at different levels on the plant. An excellent and colourful garden performer of restrained growth, with dark glossy foliage. 3.5x2.5m (12x8ft). 'New Dawn' x 'Korona'. Plant this for fence, health, pillar, wall; weatherproof.

'BABY MASQUERADE'

'BANTRY BAY'

BARKAROLE (Tanelorak)
Tantau, Germany, 1988
Hybrid tea large flowered bush, flowering summer to autumn. Produces large long-petalled flowers on long stems, making it a good rose to cut. The colour is very deep red, without too much crimson pigment, so it holds a good colour tone. Glossy dark green foliage. 1mx75cm (40x30in). Plant this for border, cutting, fragrance.

BARONESS ROTHSCHILD
Pernet père, France, 1868
Hybrid perpetual bush, flowering in summer and giving some flowers later. The big flowers are light pink and filled with petals so broad that they fold around one another to reveal confused centres. Growth is sturdy, upright and well foliaged. 1.2x90cm (4x3ft). Sport of 'Souv. de la Reine d'Angleterre'. Plant this for bed, border, fragrance, health, shrubbery.

BARONNE PREVOST
Desprez, France, 1842
Hybrid perpetual bush, flowering in summer and giving some flowers later. The full, flat rose pink blooms can attain great size, and seem to have far more petals than they can reasonably hold. Shrubby grower, and vigorous despite its age. 1.2mx90cm (4x3ft). Plant this for bed, border, fragrance, health, rosarium, shrubbery.

BASILDON BOND (Harjosine)
Harkness, England, 1980
Hybrid tea large flowered bush, flowering summer to autumn. The urn-shaped buds make a lovely splash of colour as they open to reveal warm apricot tones with hints of yellow and flushes of red. The blooms are cupped, and drop their petals cleanly. The leaves are handsome, glossy and dark reddish-green. Upright, 90x45cm (36x18in). ('Sabine' x 'Circus') x ('Yellow Cushion' x 'Glory of Ceylon'). GM & PRIZE Belfast. Named for John Dickinson Ltd., makers of Basildon

'BASILDON BOND'

Bond stationery. Plant this for bed, border, health, hedge (45cm-18in).

BEAUTIFUL BRITAIN (Dicfire)
Dickson, N. Ireland 1983
Floribunda cluster flowered bush, flowering summer to autumn. This rose bears flowers the colour of not quite ripe tomatoes. They have neat pointed form in bud, just right for buttonholes. This was to have been called "Moneymaker" after the well known variety of tomato, but when it was chosen Rose of the Year that name seemed inappropriate, and it was re-christened and launched with the blessing of the Keep Britain Tidy Group. Bushy, rather open growth, 75x60cm (30x24in). 'Red Planet' x 'Eurorose'. ROTY. Plant this for bed, border, health.

BEAUTY QUEEN (Canmiss)
Cant, England, 1984
Floribunda cluster flowered bush, flowering summer to autumn. Clear rose pink flowers of perfect rounded form show up to good effect against the dark purplish green leaves. The scent is pleasant and enduring. 75x60cm (30x24in). Bred from 'English Miss' which the raiser reckons ought logically to produce a beauty queen; his optimism was well founded. Plant this for bed, border, cutting, fragrance, health, hedge (50cm-20in); weatherproof.

BELLE AMOUR
Origin unknown
Shrub, summer flowering. There seems to be something of the Alba rose with its grey-green foliage about this mystery rose, of which ancient plants were found at a convent in France in the 1940s and by Graham Thomas in a Norfolk garden in 1959. Because the cupped semi-double flowers are myrrh-scented

'BARONESS ROTHSCHILD'

and have a salmon pink tone not usually seen in old roses, the trailing rose 'Ayrshire Splendens' (known by 1838) may be a parent. Sturdy, upright, 1.8x1.2m (6x4ft). Plant this for fence, fragrance, health, hedge (1m-40in), hips, rosarium, shrubbery, specimen; weatherproof.

BELLE DE LONDRES – see **COMPASSION**

BENSON & HEDGES GOLD (Macgem)
McGredy, N. Zealand, 1979
Hybrid tea large flowered bush, flowering summer to autumn. This neat bushy grower bears well-formed scented golden yellow blooms, with hints of red. Good repeat flower. 75x60cm (30x24in). 'Yellow Pages' x ('Arthur Bell x 'Cynthia Brooke'). Named for the tobacco firm. Plant this for bed, border, fragrance, health, hedge (50cm- 20in); weatherproof.

BERYL BACH (Hartesia)
Harkness, England, 1985
Hybrid tea large flowered bush, flowering summer to autumn. A prolific producer of high-pointed elegant blooms, large and full of petals, in the classic hybrid tea tradition. The colour varies from creamy pink to primrose yellow, with suffusions of pale crimson. In habit the plant is leafy, shrublike and vigorous. 1mx75cm (42x30in). 'Korresia' x 'Silver Jubilee'. Named in memory of Welsh-born Mrs Beryl Willemstyn at her husband's wish, "bach" being a term of endearment in Wales. Plant this for bed, border, cutting, fragrance, health, hedge (60cm-24in); weatherproof.

BETTY PRIOR
Prior, England, 1935
Floribunda cluster flowered bush, flowering summer to autumn. Bears large clusters of five-petalled

'BELLE AMOUR'

'BERYL BACH'

'BIG CHIEF'

salmony pink flowers, lighter on the inside of the petal, and with whitish centres. Because it is quick to repeat its bloom, trouble-free and hardy, this unassuming rose has had a longer life in commerce than almost all its near contemporaries, being widely grown in cooler climates. Upright, 90x60cm (36x24in). 'Kirsten Poulsen' x seedling. GM (NRS). Plant this for bed, border, health, hedge (50cm-20in); weatherproof.

BIDDULPH GRANGE (Frydarkey)
Fryer, England, 1988
Polyantha shrub, flowering summer to autumn. This bears sizeable clusters of small velvety bright red flowers, darkening as they age, with white at the petal base; they show an eye-catching contrast against the yellow stamens. Flower production is good, and the growth habit is excellent – dense, leafy and compact. 1mx75cm (40x30in). GM Rome. Sold in aid of the National Trust property of that name, where an old rose garden is being re-constructed. Plant this for bed, border, large container, health, hedge (75cm-30in), shrubbery, spreading; weatherproof.

BIG CHIEF (Portland Trailblazer)
Dickson, N. Ireland, 1974
Hybrid tea large flowered bush, flowering summer to autumn. Go to a Rose Show in July, and wonder at the skill of exhibitors with flawless deep red blooms of this variety, of such a size as to outstretch the bounds of what seems possible. As a garden rose it gives too few flowers to justify its presence, being declared "only for the dotty exhibitor" and unkindly stigmatised as "Big Chief of a very small tribe" in New Zealand garden trials. But if you *are* a dotty exhibitor, it's for you. Lanky, may die back. 1mx60cm (36x24in). 'E.H.Morse' x 'Red Planet'. Plant this for exhibition.

BIG PURPLE (Nuit d'Orient, Stebigpu)
Stephens, New Zealand, 1987
Hybrid tea large flowered bush, flowering summer to autumn. A remarkable colour, being beetroot purple, which is not everyone's favourite shade. It has a beautiful flower, large, well formed and scented, on a sturdy, branching dark-leaved bush. 90x60cm (36x24in). Plant this for bed, border, curiosity, fragrance.

BILL SLIM (Harquito)
Harkness, England, 1988
Floribunda cluster flowered bush, flowering summer to autumn. Lively red, like a ripe tomato. This is a rose of quality, bearing sizeable 25-petalled flowers of good form, which hold their colour, stand bad weather, repeat well and present themselves to view against abundant glossy foliage. 85x60cm (32x24in). Seedling x 'Silver Jubilee'. Named by the raiser after Field Marshal Slim under whom he served in World War II. Plant this for bed, border, hedge (50cm-20in); weatherproof.

BLANC DOUBLE DE COUBERT
Cochet-Cochet, France, 1892
Rugosa shrub, flowering summer to autumn. The flowers are large (9cm-3.5in across) and as white as can be imagined, with a fair number of petals and fragrance which is detectable even at night. They open out flat at different levels on the plant, which is more open in growth than the wild Rugosa, with small, neat foliage. 1.5x1.2m (5x4ft). *R. rugosa* x 'Sombreuil'. Plant this for border, low fence, fragrance, health, hedge (90cm-36in), naturalising, shrubbery, spreading; weatherproof.

BLANCHE MOREAU
Moreau-Robert, France, 1880
Moss shrub, flowering in summer. Sizeable pure white flowers, full of petals, are much enhanced by their backing of dark brown bristly moss. The growth is rather lax, 1.5x1.2 (5x4ft). Fine prickles cover the stems. 'Comtesse de Murinais' x 'Quatre Saisons Blanc Mousseux' may be the parentage. Plant this for border, low fence, fragrance, shrubbery, rosarium.

BLESSINGS
Gregory, England, 1968
Hybrid tea large flowered bush, flowering summer to autumn. The rosy salmon pink blooms are carried firmly upright on long stems, and are consistently well formed, opening to cupped flowers 10cm (4in) across. An excellent garden rose, free with its blooms and good in all weathers. 1mx75cm (38x30in). 'Queen Elizabeth' x seedling. GM Baden-Baden. Plant this for bed, border, cutting, fragrance, health; weatherproof.

BLUE MOON (Mainzer Fastnacht, Sissi)
Tantau, Germany, 1964
Hybrid tea large flowered bush, flowering summer to autumn. Lilac pink, a beauty in fine weather which

'BLUE MOON'

'BLESSINGS'

brings out the 'blue' tones; if the skies are dull and grey, so will be the flowers, but their fine high centred form and fragrance can still evoke admiration. Leaves large but somewhat sparse. Growth upright, reasonably sturdy but may die back. 1mx60cm (36x24in). Seedling x 'Sterling Silver'. GM Rome. Plant this for border, curiosity, cutting, fragrance, glasshouse.

BLUE PETER (Bluenette, Ruiblun)
De Ruiter, Holland, 1983

Miniature, flowering summer to autumn. The young flowers are a startling shade of lavender purple; they are 5cm (2in) across with about 20 small petals, carried upright on short neat plants, 35x30cm (14x12in). 'Little Flirt' x seedling. Plant this for container, curiosity, small space.

BLUSH NOISETTE
Noisette, France, 1817

Noisette climber, flowering in summer with some later flower. The origin of this historic remontant rose is described in Chapter One. The pretty cupped blush flowers are borne in large sprays. The size of plant depends on location; in warm climates the smooth stems will cover up to 4x2.5m (12x8ft), double what they can achieve in cooler areas. Assumed to be a seedling of 'Champney's Pink Cluster'. Plant this for S or SW fence, fragrance, pillar, rosarium, S or SW wall.

BLUSH RAMBLER
B.R.Cant, England, 1903

Rambler, flowering in summer. Hundreds of semi-

'BLUSH NOISETTE'

double apple-blossom flowers garland the sturdy arching stems in July. This spectacle is an annual treat and well worth the space. It caught the author's eye in a cottage garden at Old Warden, Beds., in the 1960s, and when stock had been grown on it was kindly identified by Miss M.G. Cant of the raiser's family. 2.8x3.6m (9x12ft). 'Crimson Rambler' x 'The Garland'. Plant this for fence, health, naturalising, pergola, pillar, smaller tree, wall; weatherproof.

BOBBIE JAMES
Sunningdale, England, 1960
Rambler, flowering in summer. Graham Thomas describes this as a "foundling" which he named in memory of a keen Yorkshire rosarian, the Hon. Robert James of St Nicholas, Richmond. It is very rampant, capable of reaching 9x6m (30x20ft), and carries large heads of small creamy white flowers on long arching stems, casting their scent for yards around. Plant this for fragrance, health, naturalising, tree.

BOBBY CHARLTON
Fryer, England, 1974
Hybrid tea large flowered bush, flowering summer to autumn. Very large full-petalled flowers make this a front-rank exhibition rose. The deep pink colour with silvery reverse is refreshing and attractive – "classy clean and crisp" say the New Zealanders – but the effort of producing those fine blooms means there are fewer of them than is desirable in a garden rose, and rain can spoil them. Rather tall, 1mx60cm (40x24in). 'Royal Highness' x 'Prima Ballerina'. GM Baden-Baden & Portland. Named for Bobby Charlton CBE, capped 106 times for England's soccer team. Plant this for border, exhibition, fragrance.

BONFIRE NIGHT (Bonfire)
McGredy, N. Ireland, 1971
Floribunda cluster flowered bush, flowering summer to autumn. A vivid blend of yellow with orange-scarlet overlays. Makes a good bed, being free flowering with well spaced clusters which display the colour well, and even in growth. Dark foliage creates

'BONICA'

an effective background to the blooms. 75x60cm (30x24in). 'Tiki' x 'Variety Club'. Plant this for bed, border, health, hedge (60cm-2ft); weatherproof.

BONICA '82 (Meidomonac)
Louisette Meilland, France, 1981
Shrub, flowering summer to autumn. Clear rose pink flowers, daintily formed with many petals, are borne in open clusters with remarkable freedom and consistency. Makes a neat, rather spreading well foliaged plant of modest size – every garden should have it. 90cmx1.1m (34x42in). Seedling x 'Picasso'. AARS, ADR, PRIZE Paris. Plant this for bed, border, large container, low fence, health, hedge (75cm-30in), shrubbery, spreading, low wall; weatherproof.

BOULE DE NEIGE
Lacharme, France, 1867
Bourbon shrub, flowering in summer, occasionally later. Buds streaked with crimson open rather surprisingly to white flowers, cupped, scented and with many petals. The leaves are dark and the plant somewhat open and awkward looking, as though needing a support, which indeed will add to its effectiveness in the garden. 1.5x1.2m (5x4ft). 'Blanche Lafitte' x 'Sappho'. Plant this for border, low fence, fragrance, low pillar, shrubbery, low wall.

BOURBON QUEEN (Souvenir de la Princesse de Lamballe)
Mauget, France, 1834
Bourbon shrub, flowering in summer, occasionally later. This historic rose has survived due to its vigour and cheerful character. Scented double bright pink flowers with crinkled inner petals and mottled colour on the outer ones are borne freely in summertime. Plentiful mid-green foliage sets them off. 2x1.2m (6x4ft) or more on support. Plant this for large border, fence, fragrance, health, large hedge (1m-40in), naturalising, pillar, rosarium, shrubbery, wall.

BOYS' BRIGADE (Cocdinkum)
Cocker, Scotland, 1983
Dwarf cluster flowered or patio bush, flowering summer to autumn. Compact, and somewhere between carmine and crimson in colour, with light centres to each little flower in the cluster. The ratio of flower to plant is very high, creating a most colourful effect. Low, even leafy growth, 45x45cm (18x18in). ('Darling Flame' x 'Saint Alban') x ('Little Flirt' x 'Marlena'). Named for the centenary of the celebrated youth organisation. Plant this for bed, border, container, low hedge (40cm-16in), small space; weatherproof.

BREATH OF LIFE (Harquanne)
Harkness, England, 1982
Climber, flowering summer to autumn. A most unusual colour, like that of the skin of an apricot in the

'BONFIRE NIGHT'

'BREATH OF LIFE'

'BRIGHT SMILE'

young flowers, which take on pinker tones as they age, especially when cut for arrangement. The flowers are large, full of petals like a hybrid tea, and interesting at every stage. Growth is stiff, upright and branching, and may be trimmed if the effect of a tall shrub is required, so height depends on treatment. Normally it grows to 2.8x2.2 (9x7ft). Bred from 'Red Dandy' x 'Alexander' – the raiser was pleasantly surprised to obtain a climber from two bush parents. Named for The Royal College of Midwives, who chose the name, the Breath of Life signifying both the Creator Spirit in Genesis, and our own first vital act when we come into the world. Plant this for cutting, fence, fragrance, health, pillar, wall.

BRIGHT SMILE (Dicdance)
Dickson, N. Ireland, 1980
Floribunda cluster flowered bush, flowering summer to autumn. Well named, for this is a cheerful rose to have in the garden. Slender buds open wide and flat, showing off the bright yellow petals to maximum effect. Always seems to have flowers on when you pass by. Growth is neat, bushy, short with plenty of shiny foliage, so the plant is first rate for bedding, and looks bright and busy even before the first flowers open. 45x45cm (18x18in). 'Eurorose' x seedling. PRIZE Belfast. Plant this for bed, border, cutting, health, low hedge (40cm-16in), small space; weatherproof.

BROWN VELVET (Colorbreak, Maccultra)
McGredy, New Zealand, 1983
Floribunda cluster flowered bush, flowering summer to autumn. As the names suggest, this rose is of interest for its colour, which is a sort of orange brown, and pretty at its best in cooler weather; also reported to be "fantastic by moonlight". The full-petalled blooms open wide to show ruffled quartered petals. Dark glossy leaves, upright growth 90x60cm (3x2ft). 'Mary Sumner' x 'Kapai'. GSSP, New Zealand. Plant this for bed, border, curiosity, hedge (50cm-20in).

BUCCANEER
Swim, USA, 1952
Hybrid tea large flowered bush, flowering summer to autumn. In USA this is called a Grandiflora, meaning it makes a big plant of upright habit with many well formed flowers after the manner of 'Queen Elizabeth'.

Certainly 'Buccaneer' fits that concept, having long petalled buds which open into cupped, rather shaggy blooms of bright pure yellow, carried boldly on long firm stems, and pleasantly fragrant too. This is little grown, being neither fish nor fowl in most garden schemes, which is a pity, for it is an undoubted beauty, and repeats well. The best way to grow it is up a strong supporting post, with light pruning. Good foliage, dark and leathery. 1.2x60cm (48x24in) or more, depending on treatment. 'Geheimrat Duisberg' x ('Max Krause' x 'Captain Thomas'). GM Geneva. Plant this for large bed, border, cutting, fragrance, health, tall hedge (60cm-24in), pillar, wall.

BUFF BEAUTY
Ann Bentall, England, 1939
Hybrid musk shrub, flowering in summer, some flower in autumn. Pale apricot with a touch of yellow, a rare colour, which shows up tellingly against the handsome dark leathery foliage. The blooms are large, very full of petals, and show a wonderfully intricate construction as they unfold. The plant habit is rounded (due partly to the weight of the flower trusses), and leafy all over. Autumn flower comes sparingly. 1.2x1.2m (4x4ft). The raiser's name has only recently become generally known, and her son believed she used 'William Allen Richardson' in the parentage. Plant this for large bed, border, low fence, fragrance, health, big hedge (90cm-36in), naturalising, rosarium, shrubbery, spreading, low wall; weatherproof.

BURMA STAR
Cocker, Scotland, 1974
Floribunda cluster flowered bush, flowering summer to autumn. Yellow with buff-orange flush, bearing large cupped fragrant flowers in big clusters on tall upright plants. 1.2mx60cm (48x24in). 'Arthur Bell' x 'Manx Queen'. Named for the Burma Star Association. Plant this for tall bed, border, cutting, fragrance, health, low pillar; weatherproof.

BUSH BABY (Peanob)
Pearce, England, 1986
Miniature, flowering summer to autumn. This bears clusters of petite pale salmon pink roses with pretty reflexed petal tips. The plant is very small and compact, well furnished with tiny matt leaflets. 25x25cm (10x10in). Plant this for front of small border, container, petite hedge (23cm-9in), small space; weatherproof.

BUTTONS (Dicmickey)
Dickson, N. Ireland, 1987
Patio or dwarf cluster flowered bush, flowering summer to autumn. Slim urn shaped buds open to show pretty shades of salmon red, in rather open sprays on springy stems. Everything is neatly reduced

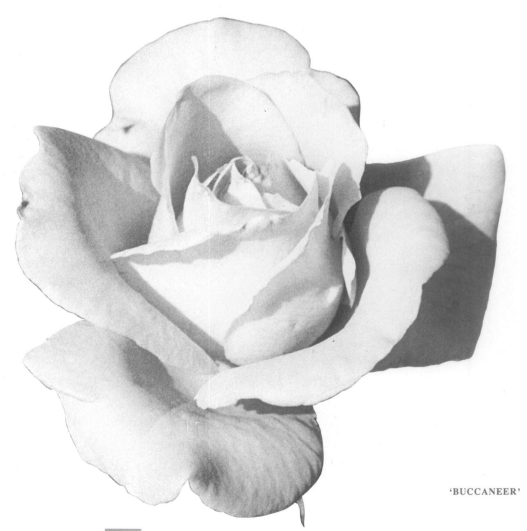

'BUCCANEER'

'BUTTONS'

in scale, like a petite replica of a hybrid tea. Useful to cut for small table arrangements and posies. The habit is upright and the leaflets dark and lance shaped. 45x35cm (15x12in). ('Liverpool Echo' x 'Woman's Own') x 'Memento'. Plant this for front of border, container, cutting, health, small space; weatherproof.

BY APPOINTMENT (Harvolute)
Harkness, England, 1990
Floribunda cluster flowered bush, flowering summer to autumn. Very elegant as the long furled creamy petals begin to part, revealing hints of apricot within, reminiscent of the gentle pleasing shades seen in old Tea roses. Very dark leaves contrast cleanly with the blooms, which are borne in big clusters on stiff stems. Upright, 75x50cm (30x20in). 'Anne Harkness' x 'Letchworth Garden City'. Named to mark the 150th anniversary of The Royal Warrant Holders' Association. Plant this for bed, border, cutting, glasshouse, narrow hedge (45cm-18in); weatherproof.

CAMAIEUX
Vibert, France, 1830
Gallica shrub, flowering in summer. Gives a bizarre

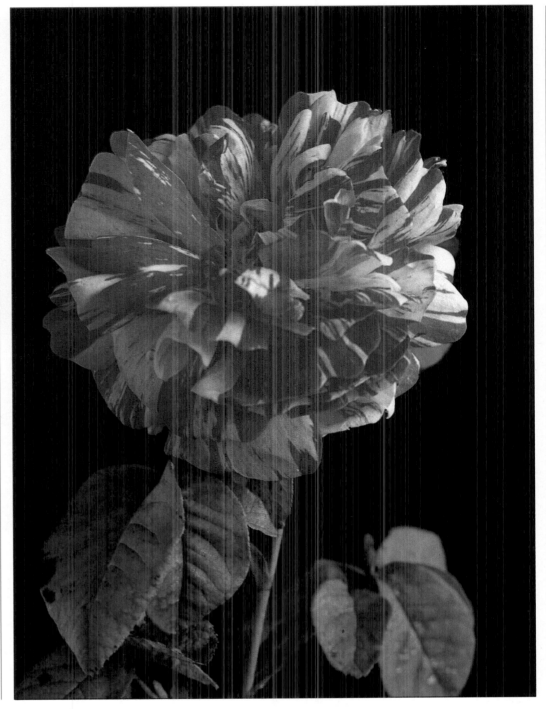

'CAMAIEUX'

display of colours, with pink, splashes of crimson-purple, blush white and lilac grey tones all present. The petals are somewhat loosely arranged, but when they reflex to display their colours they give the effect of a well-filled flower. "Rewards good cultivation" as the old catalogues used to say, this being coded language to warn gardeners that an item needs plenty of feeding and good soil to do well. Shrubby habit, 90x90cm (3x3ft). Plant this for border, curiosity, fragrance, hedge (75cm- 30in).

CANARY BIRD
from China, early 20th century
Species hybrid, flowering in early summer. The harbinger of the rose season in English gardens, and a glorious one as the yellow flowers along the branches sway them down in arches of beauty. The five-petalled flowers are small yet large in proportion to the tiny leaflets and dark red stems behind them. Needs plenty of space as it can easily reach 3x4m (9x12ft), and it is a shame to prune it except to remove dead branches. Its origin is mysterious, as it is very similar to *R. xantaina spontanea*, a wild rose introduced from China after 1907, but superior for garden cultivation. Jack Harkness has suggested it may be a chance seedling from a Botanic Garden that has been passed around. Plant this for curiosity, fence, fragrance, health, vast hedge (2.2m-7ft),

'CANARY BIRD'

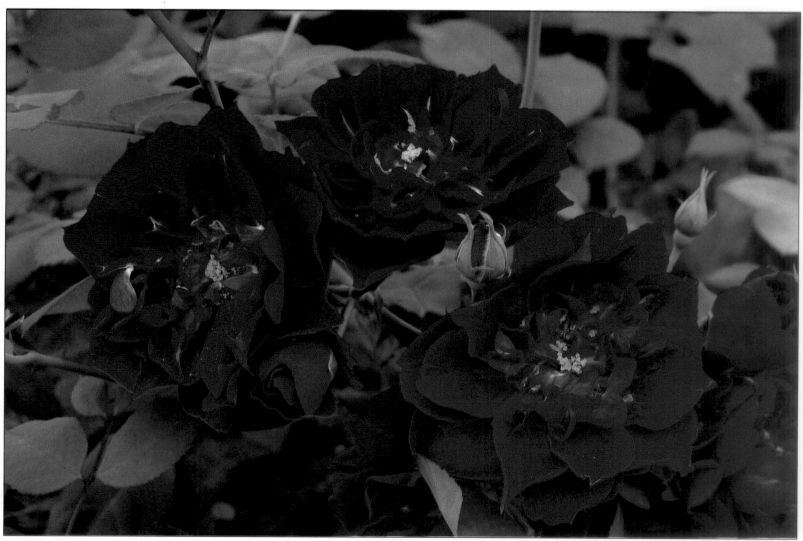

'CARDINAL HUME'

naturalising, rosarium, shrubbery, specimen plant, spreading, wall; weatherproof.

CARDINAL DE RICHELIEU
Laffay, France, 1840
Gallica shrub, flowering in summer. Clusters of plump buds open into flowers of rich maroon purple with an air of opulence and joie de vivre about them when sun lights up the redder tones. The old flowers go dark and dusty looking. Growth rather lax, stems and leaves smoother than other Gallica roses. 90x1.2cm (3x4ft). Named after Cardinal Richelieu (1585-1642) – the "de" should not be there. Plant this for border, low fence, fragrance, rosarium, shrubbery, spreading.

CARDINAL HUME (Harregale)
Harkness, England, 1984
Shrub, flowering summer to autumn. The young flowers are freely borne in quite large clusters, and open maroon purple, dark and bright, deepening as they age. They have many small petals, and are held close to the plant, appearing to nestle against the leafy background. The plant seems always to be in flower throughout the season. Dark matt foliage, spreading growth, 90cmx1m (35x42in). Scotch, lilac and purple roses were used by the raiser, the parentage being Seedling x 'Frank Naylor'. Named to honour Cardinal Basil Hume, Archbishop of Westminster. Plant this for large bed, border, low fence, fragrance, hedge (90cm-3ft), shrubbery, spreading; weatherproof.

CAREFREE BEAUTY (Audace, Bucbi)
Buck, USA, 1979
Shrub, flowering summer to autumn. Bears sprays of semi-double rose pink flowers of pleasing cupped form on chest-high plants; there can be up to twenty good-sized blooms in the cluster. Foliage semi-glossy, growth sturdy and hardy, a quality the raiser was aiming to provide so as to withstand the winters of the American Midwest. 1.2x1.2m (4x4ft). Seedling x

'Prairie Princess'. Plant this for large bed, border, low fence, fragrance, health, hedge (90cm-3ft), shrubbery, spreading, low wall; weatherproof.

CAROLINE DAVISON (Harhester)
Harkness, England, 1980
Dwarf cluster flowered bush, flowering summer to autumn. Bears clusters of small semi double flowers of an unusual colour, begonia-rose, with white at the

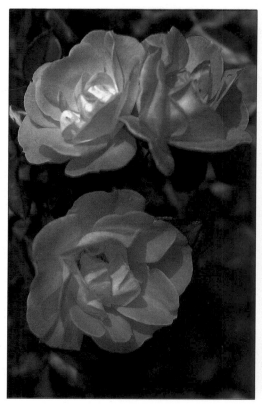

'CAROLINE DAVISON'

petal base. The leaves are dark and reddish, and the habit upright and compact. Remove spent flowers to keep it in bloom. 50x45cm (20x18in). 'Tip Top' x 'Kim'. Named to honour the memory of a brave seven-year old and initially sold in aid of the Leukaemia Research Fund. Plant this for small bed, front of border, container, short hedge (45cm-18in), small space.

CASINO (Gerbe d'Or, Macca)
McGredy, N. Ireland, 1963
Climber, flowering summer to autumn. Large, high-centred yellow flowers are borne on stiff upright stems. They sometimes open out with charming quartered form like an old Noisette rose. The leaves are large and a rich deep green, not over-abundant so the effect can be rather bare. 3x2.2m (10x7ft). 'Coral Dawn' x 'Buccaneer'. GM NRS. Plant this for cutting, fence, fragrance, pillar, wall.

CATHERINE MERMET
Guillot fils, France, 1869
Tea bush, flowering summer to autumn. The large double blooms of this old rose were highly valued by cut flower growers a century ago, for their lasting qualities, scent and pretty form. The colour is flesh pink with mauvish tinges at the petal margins. Grows vigorously in milder climates ("the finest of all Teas" someone wrote of it in 1882), but not happy out of doors in cool damp conditions. 1.2x1.2m (4x4ft). Plant this for fragrance, rosarium, sheltered wall; and also for border and shrubbery in sunnier frost free zones.

CECILE BRUNNER (Maltese Rose, Mignon, Sweetheart Rose)
Veuve Ducher, France, 1881
China or polyantha bush, flowering summer to autumn. The petite pale pink urn-shaped buds have decorated wedding cakes, lapels and posies without number in

the past hundred years. They last well, having many small petals, and are produced with remarkable continuity in wide clusters on springy stems. Foliage narrow, dark, pointed, rather sparse. The climbing form of this rose is better value. 75x60cm (30x24in). Bred from a white Polyantha and the Tea rose 'Mme. de Tartas', whose genes have contributed its distinctive slender flower form. Plant this for border, container, cutting, health, small space; weatherproof.

CLG CECILE BRUNNER
Hosp, USA, 1894
China or polyantha climber, flowering summer to autumn. This climbing sport of the above is remarkable for its vigour and continuity of bloom. 4x4m (12x12ft). Plant this for cutting, high fence, health, naturalising, pergola, tree, high wall; weatherproof.

CELESTE (Celestial)
Origin unknown, may be Dutch
Alba shrub, summer flowering. Well named, for there is an ethereal quality about this plant; the flowers are light pink, a gentle and delicate shade, with gold stamens admitted to view as the petals part. They are sweetly scented, and sea-green leaves complement them beautifully. Vigorous and free branching, 1.5x1.2m (5x4ft). Plant this for border, low fence, fragrance, health, big hedge (1m-40in), naturalising, rosarium, shrubbery, wall.

CHAMPAGNE COCKTAIL (Horflash)
Horner, England, 1985
Floribunda cluster flowered bush, flowering summer to autumn. Sizeable flowers in wide clusters open their petals to reveal a wonderful mélange of colours – pale yellow, splashed and flecked carmine and pink. The bloom continuity is excellent. The plants are vigorous, upright, and darkly foliaged. 1mx70 (40x24in). 'Old Master' x 'Southampton'. PRIZE,

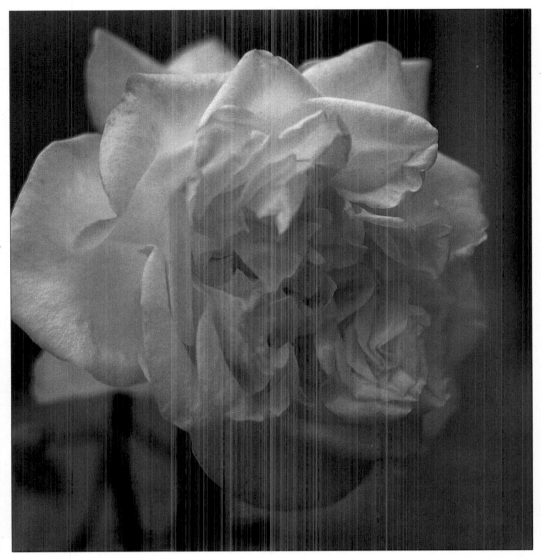

'CATHERINE MERMET'

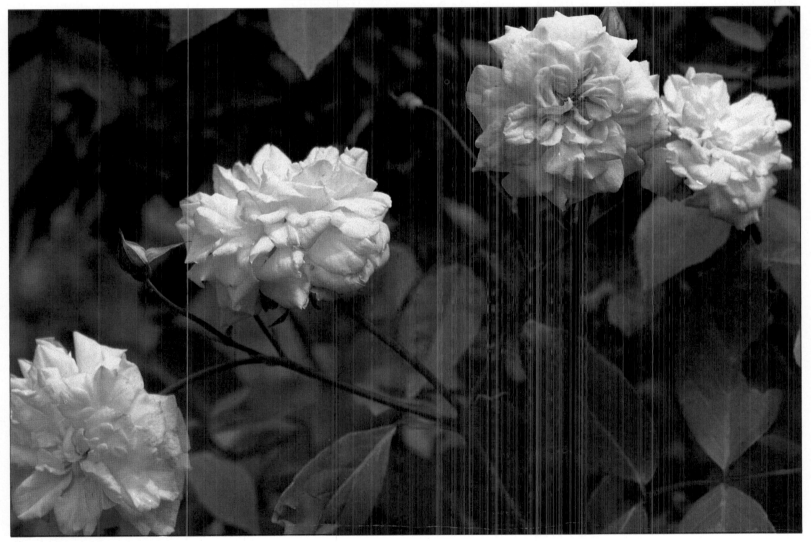

'CLIMBING CÉCILE BRUNNER'

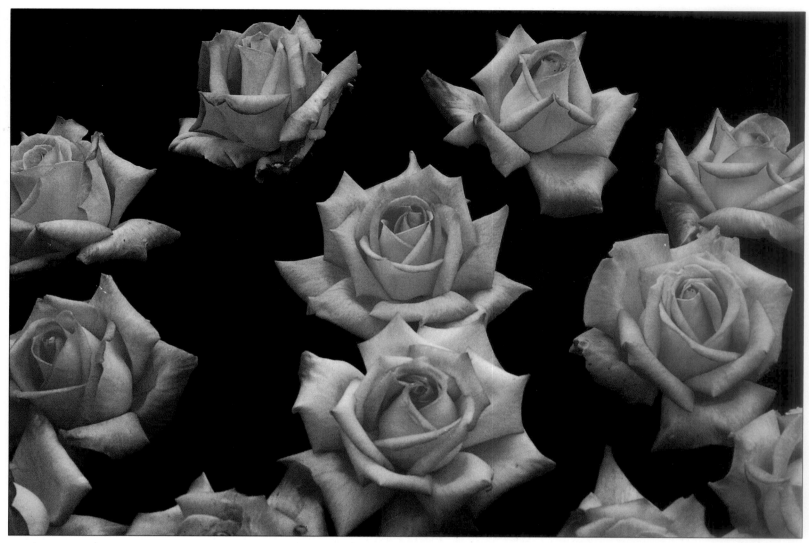

'CHAMPION'

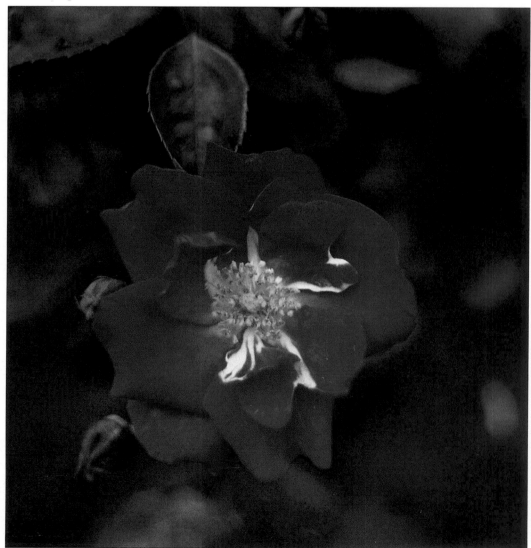

'CHAPLIN'S PINK CLIMBER'

RNRS. Plant this for tallish bed, border, curiosity, exhibition, fragrance, upright hedge (60cm-24in).

CHAMPION
Fryer, England, 1976
Hybrid tea large flowered bush, flowering summer to autumn. Bears very large full-petalled blooms of primrose yellow with rose pink shading. Their soft petal texture renders them vulnerable to rain, and the main importance of the rose is for exhibitors, who provide protective cones as a matter of routine. Bushy, 60x60cm (24x24in). 'Grandpa Dickson' x 'Whisky Mac'. Plant this for exhibition, fragrance.

CHAMPNEY'S PINK CLUSTER
Champney, USA, 1811
Noisette climber, flowering in summer. The origin of this historic rose is described in Chapter One. It flowers in neatly spaced clusters, with deep pink buds opening into loose semi-double blush flowers. Shiny rich green leaves show them off to good effect. There's an impression of refinement and grace about this rose, but it needs sheltered conditions to give of its best. 1.2x2.2 (4-7ft) with support. Plant this for low fence, fragrance, glasshouse, rosarium, low sheltered wall.

CHAPEAU DE NAPOLEON – see CRESTED MOSS

CHAPLIN'S PINK CLIMBER
Chaplin, England, 1928
Climber, flowering in summer. Makes a cheerful spectacle in June-July, when clusters of bright pink roses smother the plant. The leaves are handsome, dark green and glossy. A remontant version of this would be an asset indeed. Vigorous, 4x3m (12x10ft). 'Paul's Scarlet Climber' x 'American Pillar'. GM NRS. Plant this for fence, health, naturalising, pergola, wall; weatherproof.

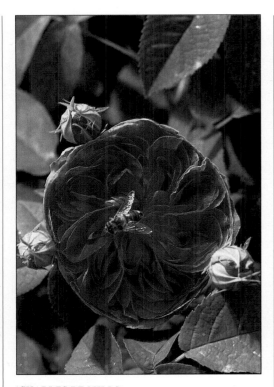

'CHARLES DE MILLS'

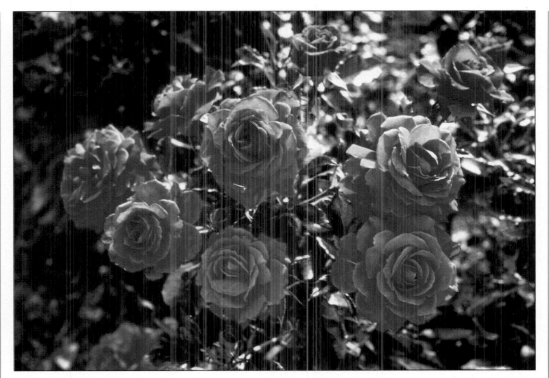

'CHRISTINGLE'

CHARLES DE MILLS (Bizarre Triomphant)
Origin not known
Gallica shrub, flowering in summer. Fink buds open to show beetroot-coloured petals that look as though someone has neatly sliced the tops off. The flowers expand, huge, heavy, overcrowded, taking various reddish purple tones until they fall. This is best grown on a support. 1.2x1.2m (4x4ft). Plant this for border, low fence, fragrance, low pillar, rosarium, low wall.

CHERRY BRANDY 85 (Tanyrandy)
Tantau, Germany, 1985
Hybrid tea large flowered bush, flowering summer to autumn. The colour is a mélange of orange and salmon shades, very noticeable because of the number of blooms produced, often more than one to a stem. Glossy bright leaves add to the general impression of a cheerful, busy garden rose. Growth is rather diffuse and uneven. 75x60cm (30x24in). GM & PRIZE Belfast. Plant this for bed, border, health.

CHESHIRE LIFE
Fryer, England, 1972
Hybrid tea large flowered bush, flowering summer to autumn. Vermilion, something like a shorter 'Alexander'. Bears well formed medium sized blooms that withstand wet weather well. Leafy, bushy, 80x60cm (32x24in). 'Prima Ballerina' x 'Princess Michiko'. Plant this for bed, border, health, hedge (50cm-20in); weatherproof.

CHINATOWN
Poulsen, Denmark, 1963
Shrub, flowering summer to autumn. This is a wonderful garden plant, bearing sizeable high centred yellow blooms at different levels. They are fragrant, freely borne in clusters or sometimes singly, and displayed on vigorous leafy bushes. The problem is that its uneven growth makes this rose difficult to place. An informal group in a mixed border would be ideal, where the presence of extra tall shoots can be accepted. 1.2x90cm (4x3ft) or more on support. 'Columbine' x 'Cläre Grammerstorf'. GM NRS. Plant this for large bed (but see above), border, low fence, fragrance, health, hedge (75cm-30in), pillar, shrubbery, low wall; weatherproof.

CHRISTINGLE (Harvalex)
Harkness, England, 1987
Floribunda cluster flowered bush, flowering summer to autumn. Produces some remarkable heads of bloom, with full petalled hybrid tea shaped flowers carried in great sprays – which the stems are sufficiently sturdy to support. The colour is rich orange red, with dusky red veining on the outer petals. Leafy, free- branching habit, 75x60cm (30x24in). 'Bobby Dazzler' x 'Alexander'. Named for The Children's Society whose funds were aided by the initial sales, and which helps organise Christingle services, following an old Moravian custom. Plant this for bed, border, hedge (50cm-20in); weatherproof.

CHRYSLER IMPERIAL
Lammerts, USA, 1952
Hybrid tea large flowered bush, flowering summer to autumn. Capable of producing the loveliest deep red fragrant roses one could wish for, with perfect placement of the long large petals. Sadly the plants deteriorate, becoming prone to die-back. Well foliaged, upright and bushy. 80x60cm (32x24in). 'Charlotte Armstrong' x 'Mirandy'. AARS, FRAG

'CHRYSLER IMPERIAL'

'CITY OF BRADFORD'

USA, GM Portland, PRIZE ARS. Plant this perhaps for border, certainly for fragrance – and sentiment.

CIDER CUP (Dicladida)
Dickson, N. Ireland, 1988
Patio or dwarf cluster flowered bush, flowering summer to autumn. The apricot pink flowers are petite, like a hybrid tea in miniature, borne in large heads on springy stems, long enough to make them snippable as a constant resource for small flower arrangements; they are quick to repeat their flower too. Small dark leaves, bushy growth, 50x40cm (18x15in). 'Memento' seedling. Plant this for small bed, border, container, cutting, health, petite hedge (40cm-15in), small space; weatherproof.

CITY OF BELFAST (Macci)
McGredy, N. Ireland,1968
Floribunda cluster flowered bush, flowering summer to autumn. Rich scarlet, bright without being strident, one of the best in its colour. The flower clusters are neatly spaced on compact leafy plants. Would be more widely grown if Sam McGredy had not followed up this good rose with a great one, 'Trumpeter'. 60x60cm (2x2ft). 'Evelyn Fison x ('Circus' x 'Korona'). GM Belfast, RNRS & The Hague, GSSP New Zealand. Plant this for bed, border, health, hedge (50cm-20in); weatherproof.

CITY OF BIRMINGHAM (Esprit, Holstein 87, Korholst, Petit Marquis)
Kordes, Germany, 1987
Floribunda cluster flowered bush, flowering summer to autumn. Deep crimson scarlet blooms with waved petals are carried in large trusses on a compact well-spread bush. The foliage is plentiful, dark and glossy. 75x60cm (30x24in). Named to celebrate the centenary of Birmingham's status as a city. Plant this for bed, border, hedge (60cm-24in); weatherproof.

CITY OF BRADFORD (Harrotang)
Harkness, England, 1986
Floribunda cluster flowered bush, flowering summer to autumn. Produces colourful sprays of wavy-petalled flowers, showing orange highlights on a vermilion base. The plant quality is superb, with vigorous bushy growth and abundant dark glossy foliage. 90x60cm (36x24in). ('Manx Queen' x 'Whisky Mac') x seedling. The variety was selected by representatives from the city who admired its character and beauty.

Plant this for bed, border, fragrance, health, hedge (50cm- 20in); weatherproof.

CITY OF LEEDS
McGredy, N. Ireland 1966
Floribunda cluster flowered bush, flowering summer to autumn. This salmon pink rose has proved one of the most effective for bedding in recent years. The

secret lies in its neat well-spread habit, and good succession of well spaced cupped flowers. 75x60cm (30x24in). 'Evelyn Fison' x ('Spartan' x 'Red Favourite'). GM RNRS. Plant this for bed, border, exhibition, hedge (50cm-20in); weatherproof.

CITY OF LONDON (Harukfore)
Harkness, England, 1988
Floribunda cluster flowered bush or shrub, flowering summer to autumn. Neatly furled petals open from pretty urn-shaped buds into wide loose flowers, which hold their form well and are excellent to cut. They are blessed with the most delightful fragrance, sweet and enduring. The leaves are rich green, shiny and abundant. Growth is uneven, and rather than cut longer shoots down it is better to plant the rose in an informal setting and enjoy the extra blooms. With support it will become a semi- climber. 1mx80cm (39x34in) or more. 'New Dawn' x 'Radox Bouquet'. PRIZE Belfast, GM Le Roeulx. Named to celebrate the City of London's octocentenary. Plant this for border, cutting, low fence, fragrance, health, informal hedge (75cm-30in), low pillar, low wall; weatherproof.

CITY OF YORK (Direktor Benschop)
Tantau, Germany, 1945
Climber, flowering in summer. Bears graceful clusters of middling-sized creamy white flowers in the earlier part of summer, contriving to look clean and fresh whatever the weather. The foliage is an asset, bright and plentiful. 3x3m (10x10ft). 'Prof. Gnau' x 'Dorothy Perkins'. GM ARS. Plant this for fence, fragrance, health, naturalising, pergola, pillar, smaller tree, wall; weatherproof.

CLARISSA (Harprocrustes)
Harkness, England, 1983
Floribunda cluster flowered bush, flowering summer

'CITY OF LONDON'

'CLARISSA'

to autumn. This is a strange little rose, as the petite flowers look as though they belong to a dwarf or miniature rose, but are carried at a much higher level; it has been described as "a miniature on stilts". The 5cm (2in) flowers are packed with tiny petals in an even shade of apricot, and there may be three dozen in the truss, so a group of this makes a superb resource for cutting for small arrangements. Narrow upright growth, small leathery leaves. 80x45cm (32x18in). 'Southampton' x 'Darling Flame'. GSSP New Zealand, PRIZE Geneva. Named in honour of Clarissa Mason when her husband James Mason opened the British Rose Festival in 1981. Plant this for border, cutting, health, narrow hedge (40cm-16in), small space; weatherproof.

COLIBRI 79 (Colibri 79, Meidanover)
Meilland, France, 1979
Miniature, flowering summer to autumn. The flowers are golden apricot with reddish pink veining, neat and pretty. Both blooms and foliage are reduced in scale in the best tradition of true miniatures. Upright, 40x30cm (15x10in). Plant this for small bed, front of border, container, small space.

COLOUR WONDER (Königin der Rosen)
Kordes, Germany, 1964
Hybrid tea large flowered bush, flowering summer to autumn. Produces full shapely roses in a blend of orange, salmon and yellow. For flowers of this size and quality the plant is surprisingly free blooming. Vigorous, bushy and leafy, 75x60cm (30x24in). 'Perfecta' x 'Super Star'. ADR, GM Belfast. Plant this for bed, border, hedge (50cm-20in).

COMMANDANT BEAUREPAIRE (Panachée d'Angers)
Moreau-Robert, France, 1874
Bourbon shrub, flowering mostly in summer. The large double flowers open cupped, revealing an extraordinary melange of blush, splashed with mauve, crimson, purple and scarlet. Good fragrance. The leaves are waved, light green. Vigorous, spreading growth, 1.2x1.2m (4x4ft). Plant this for border, curiosity, low fence, fragrance, shrubbery.

COMMON BLUSH CHINA – see OLD BLUSH

COMMON MOSS (Communis, Old Pink Moss, R. x centifolia Muscosa)
Found in France ca. 1700
Moss shrub, flowering in summer. This is considered to be the original moss rose, whose origins are obscure. It was certainly given to Philip Miller for the Chelsea Physic Garden in 1727 when he visited Holland, and was reported to have been at Carcassonne in south-west France thirty years before. The curious furry mosslike growth covers the calyx, sepals and stems of what would otherwise be a normal Cabbage or

'COMPASSION'

Provence rose, so this is an example of one of those sports or freaks of nature that happen occasionally. It is thought that the mossing is really a modification of the prickles, and some moss roses have harder "more prickly" mossing, while in others it feels like soft down. The flowers are pink, packed with petals and sweetly scented. They are so heavy that they bend the stems down, and a light support is useful. Branching growth, 1.5x1.2m (5x4ft). Plant this for border, curiosity, low fence, fragrance, low pillar, rosarium, shrubbery.

COMPASSION (Belle de Londres)
Harkness, England, 1973
Climber, flowering summer to autumn. The flowers are large and full petalled with rounded form, and their basic colour is light rosy salmon, admitting tints of apricot which vary according to the time of year. Good scent and continuity of flower. The stems are plum red and the foliage dark and plentiful, providing a solid background to the blooms. The plant can be pruned to grow as a shrub, but normally will attain 3x2.5m (10x8ft). 'White Cockade' x 'Prima Ballerina'. ADR, FRAG RNRS & The Hague, GM & PRIZE Baden-Baden & Geneva, GM Orleans (which it achieved two years running, having been entered twice in the Trials – only the first one counted!). Named on behalf of the UK welfare organisation REHAB, which benefited from the proceeds of the initial sales. Plant this for large bed (as shrub), border (ditto), fence, fragrance, pillar, wall; weatherproof.

COMPLICATA
Europe, Origin unknown
Shrub rose, flowering in summer. The flower of this rose is pink, paler in the centre, which opens to view as its five petals reflex. The blooms are large for a single rose, 11cm (4in) across. They are carried on vigorous arching rampant stems, capable of invading neighbouring plants, so it needs room. 2.2x2.5 (7x8ft). For some reason this is usually called a Gallica rose, but it bears little obvious relationship to any Gallica; descent from R. x macrantha (whose origin is also obscure) seems more likely. As for the name, which seems puzzling for such an unsophisticated looking rose, it surely refers to the way many of the petals have a fold in the middle, because that is what the

'COMPLICATA'

'COMTE DE CHAMBORD'

botanical term complicata implies. Plant this for big border, health, enormous hedge (2m-6ft), naturalising, rosarium, shrubbery, specimen plant; weatherproof.

COMTE DE CHAMBORD
Robert & Moreau, France, 1860
Portland shrub, flowering in summer, some in autumn. The large full-petalled flowers have the delightful quartered formation associated with older roses. They are pink with pretty lilac tints, and have good fragrance. The plants grow rather erect, with plentiful, light green leaves and no sign of diminished vigour after so many years in commerce. This is perhaps the best survivor of the Portland roses which showed how vigour, large flower size and remontancy could be combined for our enjoyment. 1.2x1m (4x3ft). Plant this for large bed, border, fragrance, health, hedge (75cm-30in), rosarium, shrubbery.

CONGRATULATIONS (Korlift, Sylvia)
Kordes, Germany, 1979
Hybrid tea large flowered bush, flowering summer to autumn. Some call this a floribunda, for the flowers also come in groups, and are not particularly large. They are rose pink, urn-shaped in the young flower and perfectly formed as they open. Their lasting quality and long stems make them wonderful for cutting. Tall, upright habit, large dark leaves. 1.5x1m (5x3ft). 'Carina' x seedling. ADR. Plant this for border, cutting, tall hedge (75cm-30in); weatherproof.

'CONGRATULATIONS'

CONQUEROR'S GOLD (Donauwalzer, Hartwiz)
Harkness, England, 1986
Floribunda cluster flowered bush, flowering summer to autumn. At first glance this is yellow, with rounded flowers opening from pointed buds; gradually from the rims inwards they are suffused with orange pink which deepens to red. The clusters can hold many blooms so the colour effect is bold and pleasing. Bushy habit, bright foliage. 80x60cm (32x24in). 'Amy Brown' x 'Judy Garland'. PRIZE Belfast. Named on behalf of London's Public Record Office to commemorate the 900th anniversary of Domesday Book – the flower colour recalls the rubrication (red colour) used on the ancient yellow parchment. Plant this for bed, border, health, hedge (50cm-20in).

CONRAD FERDINAND MEYER
Müller, Germany, 1899
Rugosa shrub, flowering in summer, occasionally in autumn. Grown for its generous early summer display of big silvery pink roses held aloft on vigorous arching canes. They are large, full of petals, and scented, if any nose can get to them above the myriad prickles on the stems. The foliage is dark, rather rough looking, and liable to rust, so it should be watched for early signs of trouble and not be planted close to other roses. 2.5x1.2m (8x4ft). Rugosa hybrid x 'Gloire de Dijon'. Plant this for fragrance, shrubbery

'CONQUEROR'S GOLD'

(but not among roses in rust-prone areas), specimen plant; weatherproof.

CONSERVATION (Cocdimple)

Cocker, Scotland, 1988

Patio or dwarf cluster flowered bush, flowering summer to autumn. A neat rose, both in habit and the way its presents the flowers to view – on short stemmed sprays, well spaced and with eighteen crisp petals, dimpled in the centre. The colour is orange to apricot pink. Leaves small, glossy and plentiful. 45x45cm (18x18in) Seedling x 'Darling Flame'. GM Dublin. Named for the fiftieth anniversary of the World Wildlife Fund; the local rabbits celebrated by having it for breakfast, lunch and supper on the Harkness nursery, and it says much for its vigour that the plants grew back splendidly after being eaten almost to ground level. Plant this for small bed, front of border, container, health, low hedge (40cm-15in), small space; weatherproof.

CONSTANCE SPRY

Austin, England, 1961

Shrub rose, flowering in summer. The large rose pink flowers are full of petals. They are of globular form before opening into cupped wide flowers, 12cm (5in) across. The size and weight of these blooms is often more than the stems can carry, but the nodding character this lends them is quite endearing, especially if the plants have strong support. Leaves large, plentiful. 2x1.5m (6x5ft) – wider if trained as a wall climber. 'Belle Isis' x 'Dainty Maid'. Named for the celebrated exponent of floral art. Plant this for big border, sturdy fence, myrrh fragrance, health, big hedge (1.2m-4ft), shrubbery, wall.

'CONSERVATION'

'CONSTANCE SPRY'

'CORNELIA'

CORDON BLEU (Harubasil)
Harkness, England, 1992
Hybrid tea large flowered bush, flowering summer to autumn. The blooms have an unusual shape, as some petals hold a conical centre while the outer ones reflex. The colour is apricot with reddish shading, and there is a fruity fragrance. They stand out well against the dark glossy leaves on neat upright plants. 90x60cm (3x2ft). 'Basildon Bond' x 'Silver Jubilee'. Named for the Cordon Bleu School of Cookery. Plant this for bed, border, fragrance, health, hedge (50cm-20in); weatherproof.

CORNELIA
Pemberton, England, 1925
Hybrid musk shrub, flowering summer to autumn.

'COUNTRY LADY'

This produces dainty sprays of small pink flowers with many petals and a hint of apricot about them. The sprays can be very large and on long arching stems, valuable for showpiece flower arrangements. The plants are dense, rounded in outline and full of leaves, satisfying to the eye even when not in flower. 1.5x1.5m (5x5ft). Plant this for large bed, border, cutting, exhibition, low fence, fragrance, health, hedge (1m-39in), naturalising, shrubbery, spreading, low wall; weatherproof.

COSETTE (Harquillypond)
Harkness, England, 1983
Patio or dwarf cluster flowered bush, flowering summer to autumn. Scores of narrow petals make the light china pink flowers beautiful works of nature, as

they reveal layer upon layer of petite tips. The blooms look large in proportion to the plant. The leaves are small and dark, growth very low, spreading, uneven. 30x40cm (12x15in). Seedling x 'Esther's Baby'. Plant this for front of border, container, curiosity, small space; weatherproof.

COUNTRY LADY (Hartsam)
Harkness, England, 1988
Hybrid tea large flowered bush, flowering summer to autumn. The flowers are an unusual "tinned salmon" colour, with a distinctive inflorescence too, as longish stems radiate from a point on the main branch to give a very wide spray, the blooms being what is termed decorative, which means they are a useful size for flower arranging. Plentiful reddish green foliage. 90x75cm (36x30in). 'Alexander' x 'Bright Smile'. Named for the Country Gentlemen's Association. Plant this for bed, border, cutting, health, hedge (60cm-2ft); weatherproof.

CRAMOISI SUPERIEURE – see **AGRIPPINA**

CRATHES CASTLE (Cocathes)
Cocker, Scotland, 1980
Floribunda cluster flowered bush, flowering summer to autumn. Fresh-looking pink roses with a touch of salmon are produced on bushy, leafy, well spread plants. The double end flowers open from pointed buds to charming wide blooms with a look of informality – and quality – about them. 70x60cm (28x24in). 'Dreamland' x 'Topsi'. Named for the National Trust for Scotland's property which is famous for the ancient yew hedges in its six-acre garden. Plant this for bed, border, hedge (50cm-20in); weatherproof.

CRESTED MOSS (Chapeau de Napoléon, Crested Provence, *R. x centifolia cristata*)
Vibert, France, 1827
Provence or centifolia shrub, flowering in summer. This is thought to be a sport of the Provence or centifolia rose, found growing at Fribourg around 1820. It differs by having curious tufts of greenery on the sepals covering the buds, so large that they almost conceal the buds. The fragrant flowers are packed with rose pink petals, heavy enough to cause the

'COSETTE'

stems to bow. The leaves are rather dull. Despite the name there is no actual "mossing". 1.5x1.2m (5x4ft). Plant this for border, curiosity, low fence, fragrance, health, low pillar, rosarium, shrubbery, low wall.

CRIMSON GLORY
Kordes, Germany, 1935
Hybrid tea large flowered bush, flowering summer to autumn. The dark crimson, richly fragrant blooms used to be seen everywhere, but the variety has lost its former vigour and is included because it is a historic rose, a leap forward in its own time and important in rose breeding. 60x60cm (24x24ft). Bred from a seedling of 'Cathrine Kordes' x 'W.E. Chaplin'. GM NRS, FRAG USA. Plant this for fragrance, rosarium.

CLIMBING CRIMSON GLORY
Miller, USA, 1946
Hybrid tea large flowered climber, flowering summer to autumn. This is the climbing sport of the above rose, which is vigorous and widely grown; avoid dry sites as it may mildew. 4.5x2.5m (15x8ft). Plant this for SW or W fence, fragrance, pergola, SW or W wall.

CRIMSON SHOWER
Norman, England, 1951
Rambler, flowering in late summer, early autumn. Important for its extraordinary blooming period, continuing long after all the other ramblers have retired for the season. The blooms come in thick clusters of dark crimson rosettes, very pleasing against a dense background of bright small polished leaflets. 2.5x2.2 (8x7ft). Seedling of 'Excelsa'. Plant this for fence, health, naturalising, pillar, rosarium, weeping; weatherproof.

DAME WENDY (Canson)
Cant, England, 1990
Floribunda cluster flowered bush, flowering summer to autumn. The flowers are a pretty even shade of pink, well formed and full of petals. They are borne

'DANSE DU FEU'

WEEPING STANDARD 'CRIMSON SHOWER'

on spreading plants with glossy greyish green foliage, 60x60cm (2x2ft). 'English Miss' x 'Memento'. Named for Dame Wendy Hiller. Plant this for bed, border, health, hedge; weatherproof.

DANSE DU FEU (Spectacular)
Mallerin, France, 1954
Climber, flowering summer to autumn. This was a rose marvel when first introduced because of its novel orange scarlet colour. The medium sized cupped flowers are borne in clusters and are attractive when young, but they discolour with age. 2.5x2.5m (8x8ft). Plant this for fence, pillar, wall.

DARLING FLAME (Meilucca, Minuetto)
Meilland, France, 1971
Miniature, flowering summer to autumn. Bears well filled vermilion flowers, with a hint of yellow, sizeable for a miniature, on upright bushy plants. Has been much used in breeding. 40x30cm (15x12in). ('Rimosa' x 'Rosina') x 'Zambra'. Plant this for small bed, front of border, container, exhibition, petite hedge (25cm-10in), small space; weatherproof.

DEAREST
Dickson, N. Ireland, 1960
Floribunda cluster flowered bush, flowering summer to autumn. The pretty rosy-salmon flowers of rounded form have their petals arrayed in the style of a camellia. This rose was the number one pink bedder for many years. Leaf dark green, habit neat and well spread. 60x50cm (24x24in). Seedling x 'Spartan'. GM NRS. Plant this for bed, border, cutting, hedge (50cm-20in); weatherproof.

DEEP SECRET (Mildred Scheel)
Tantau, Germany, 1977
Hybrid tea large flowered bush, flowering summer to

'DESPREZ À FLEURS JAUNES'

'DIAMOND JUBILEE'

autumn. At their best the intensely dark crimson flowers are beautiful, being large, fairly full and with fragrance. At other times they can appear ragged and dull. Grows vigorously, with dark glossy foliage, 90x75 (36x30in). ADR. Plant this for bed, border, fragrance, hedge (60cm-2ft).

DESPREZ A FLEURS JAUNES (Jaune Desprez)
Desprez, France, 1830
Noisette climber, flowering summer to autumn. A rare and beautiful early climber, bearing rather small double flowers of creamy apricot pink, flushed peach-yellow, with an appropriately fruity scent. There is excellent continuity of bloom on established plants, but this is not a rose for every garden, as it needs a sheltered site and is capable of attaining 5m (15ft) height and spread. Said to be 'Blush Noisette' x 'Parks' Yellow'. Plant this for fragrance, rosarium, sheltered high wall.

'DISCO DANCER'

DIAMOND JUBILEE
Boerner, USA, 1947

Hybrid tea large flowered bush, flowering summer to autumn. Ugly buds open to reveal honey coloured blooms of elegance and beauty, full of petals and fragrance. They need fine weather because rain causes them to ball and rot. Vigorous, with dark tough healthy leaves. 90x60cm (3x2ft). 'Maréchal Niel' x 'Feu Pernet-Ducher'. AARS. Plant this in warmer climates for bed, border, fragrance, health, hedge (50cm-20in), rosarium.

DIREKTOR BENSCHOP – see CITY OF YORK

DISCO DANCER (Dicinfra)
Dickson, N. Ireland, 1984

Floribunda cluster flowered bush, flowering summer to autumn. Produces many flowering trusses filled with neatly formed semi-double flowers that are rich orange almost scarlet, appearing almost luminous when lit up by the sun. Growth dense, bushy, well furnished with glossy foliage. 75x60cm (30x24in). 'Coventry Cathedral' x 'Memento'. GM The Hague. Plant this for bed, border, health, hedge (50cm-20in); weatherproof.

DORIS TYSTERMAN
Wisbech Plant Co. England, 1975

Hybrid tea large flowered bush, flowering summer to autumn. The long-petalled flowers are orange red with some suggestion of yellow behind them, adding a light touch to their vivid colour. They are carried on long stiff stems. The leaves are handsome and the plants vigorous. 1.2mx75cm (42x30in). 'Peer Gynt' x seedling. Named for the wife of W.E. (Bill) Tysterman, director of the Wisbech company. Plant this for large bed, border, cutting, upright hedge (60cm-2ft); weatherproof.

DOROTHY PERKINS
Jackson & Perkins, USA. 1901

Rambler, flowering in summer. The numerous dainty clusters of pretty pink rosettes are among the most familiar roses in the world, seen everywhere in summer

'DORIS TYSTERMAN'

'DORTMUND'

in gardens large and small, for the variety roots readily from cuttings and seems to live for ever. The bright polished leaflets are often dimmed by mildew in dry conditions. 3.5x3m (12x10ft). *R. wichuraiana* x 'Mme. G. Luizet'. Named for the small daughter of George C. Perkins of the J&P company. Plant this for fence, naturalising, pergola, pillar, weeping.

DOROTHY WHEATCROFT
Tantau, Germany, 1960

Shrub, flowering summer to autumn. This can be considered over-tall, because the plant is gaunt and the huge clusters of orange scarlet flowers often bow down the stem that bears them. They come into their own at shows, when long stems are just what exhibitors require. 1.3mx90cm (54x36in). GM NRS. Named for the wife of Harry, the celebrated rosarian from Nottingham. Plant this for back of border, cutting, exhibition, pillar; weatherproof.

DORTMUND
Kordes, Germany, 1955

Climber, flowering summer to autumn. A five-petalled red rose with a white eye may not sound remarkable, but the blooms are sizeable (10cm-4in across), freely borne up and down the plant in showy clusters, and continue to give a bold display for many weeks. Add to these qualities excellent foliage and good health, and reasons for the garden-worthiness of this rose are obvious. 3x1.8m (10x6ft), or less if kept pruned to make a substantial shrub. Seedling x *R. kordesii*. ADR, GM Portland. Plant this for border (as large shrub), fence, health, big hedge (1.2m-4ft), naturalising, pillar, shrubbery, wall; weatherproof.

'DR A. J. VERHAGE'

autumn. The orange to salmon pink blooms are huge, of interest to exhibitors because they hold their high form. Upright, 90x60cm (36x24in). 'Fragrant Cloud' x 'Corso'. Named in memory of the Scottish rosarian Archie Dick (1915-84) former Vice-President of the Royal National Rose Society. Plant this for border, exhibition, fragrance.

DR McALPINE (Peafirst)
Pearce, England, 1983
This rose has an identity crisis. It is a hybrid tea large flowered bush according to the Royal National Rose Society, and a floribunda or patio according to the registration authorities in USA. Reference books and catalogues are also undecided. This correctly implies that it bears fairly large flowers in clusters, and shows the unwisdom of trying to pigeonhole nature's gifts. The flowers are pure rose pink, well formed on lowly spreading bushes, 45x60cm (18x24in). Named in memory of Dr McAlpine and sold in aid of Multiple Sclerosis research when first introduced. Plant this for small bed, front of border, fragrance, health, low hedge (45cm-18in); weatherproof.

DREAMING SPIRES
Mattock, England, 1973
Climber, flowering summer to autumn. Large scented yellow flowers in a clear bold colour are borne on upright branching plants. This is an interesting example of a climber bred from two bush roses, and it gives good continuity of bloom. It grows to 2.8x2.2m (9x7ft). 'Buccaneer' x 'Arthur Bell'. PRIZE Belfast. The "dreaming spires" adorn Oxford's city skyline. Plant this for fence, fragrance, health, pillar, wall; weatherproof.

DRUMMER BOY (Harvacity)
Harkness, England, 1987
Dwarf cluster flowered or patio bush, flowering

DOUBLE DELIGHT
Swim & Ellis, USA, 1977
Hybrid tea large flowered bush, flowering summer to autumn. The big shapely flowers look as if their blush petals have been dipped in strawberry-juice. The blooms vary greatly in colour, size and quality, the best of them being among the loveliest in the world, as was shown when this rose was voted "The World's Favourite Rose". Growth uneven, approx. 95x60cm (36x24in). 'Granada' x 'Garden Party'. AARS, FRAG Baden-Baden & USA, GM Baden-Baden & Rome. Plant this for border, curiosity, fragrance, health.

DR A.J. VERHAGE (Golden Wave)
Verbeek, Holland, 1963
Hybrid tea large flowered bush, flowering summer to autumn. The petals of this deep yellow rose are long and large with an attractive wave in them. It has been a popular cut flower variety and a useful parent for breeders. Deep green foliage, compact bushy habit, 70x60cm (30x24in). 'Tawny Gold' x ('Baccará' x seedling). Plant this for bed, border, cutting, fragrance, glasshouse.

DR DARLEY (Harposter)
Harkness, England, 1982
Hybrid tea large flowered bush, flowering summer to autumn. This is fuchsia pink, quite an unusual colour in roses, very strong and positive. The flowers have long petals and maintain their elegant urn shape to a late stage. Upright and compact, 75x50cm (30x20in). 'Red Planet' x ('Carina' x 'Pascali'). GM Munich. Name in memory of Dr William Ward Darley; initial sales benefited The British Polio Fellowship. Plant this for bed, border, health; weatherproof.

DR DICK (Cocbaden)
Cocker, Scotland, 1986
Hybrid tea large flowered bush, flowering summer to

'DR DARLEY'

'DRUMMER BOY'

summer to autumn. Masses of small bright crimson flowers with dimpled petals create a brilliant show of colour near the ground. One of the best to keep the colour tone from the opening of the bud to petal fall. Very free, well foliaged, neat low habit, 45x50cm (18x20in). Seedling x 'Red Sprite'. PRIZE Baden. Plant this for low bed, front of border, container, health, small space; weatherproof.

DUBLIN BAY (Macdub)
McGredy, New Zealand, 1976
Cluster flowered climber, flowering summer to autumn. A beautiful plant in which ample lustrous foliage supports a constant supply of rich crimson scarlet flowers, neat and rounded in their form. Growth is shrublike rather than climbing, and it may be grown as a shrub. 2.2x2.2m (7x7ft) or less if pruned as shrub. 'Bantry Bay' x 'Altissimo'. Plant this for large border (as shrub), fence, health, big hedge (1.5m-5ft), pillar, shrubbery (as shrub), wall; weatherproof.

DUC DE GUICHE
Prevost, France, pre 1829?
Gallica shrub, flowering in summer. Has flowers of beautiful formation, packed tight with rich crimson to purple petals, which are infolded and quartered. The petals reflex as the blooms expand, sometimes exposing green eyes at the centre. Grows with handsome foliage to about 1.2x1.2m (4x4ft). Plant this for border, fragrance, health, rosarium, shrubbery.

DUCHESSE DE BRABANT (Comtesse de Labarthe, Comtesse Ouwaroff, Shell)
Bernède, France, 1857
Tea bush, flowering summer to autumn. One of the loveliest of the old Tea roses, with long slim buds opening into loosely cupped silky-looking flowers. The name 'Shell' is used for it in Bermuda, where the colour varies from pale blush to deepish salmony pink according to season. Bud, flower, leaf, habit – everything looks right about this rose; it needs a warm

'DUC DE GUICHE'

103

'DUCHESSE DE BRABANT'
climate to display its beauty. 90x90cm (3x3ft). Plant this in sheltered frost free location for bed, border, cutting, fragrance, low wall; or in greenhouse.

DUPONTII (*R. moschata nivea*, Snowbush Rose)
Before 1817
Species hybrid, flowering in summer. A very distinctive plant for three weeks or so in midsummer, when creamy white flowers appear in clusters all over the bush, opening wide to show their centres. The leaves are greyish green, an admirable backcloth to the pale blooms. Grows tall and upright, so best planted where you can look down on it. 2.2x1.5m (7x5ft). Its origin is a mystery, *R. moschata*, *R. gallica* and *R. x alba* could all be involved. Named in honour of André Dupont who founded the rose collection at the Luxembourg Gardens in Paris. Plant this for large border, health, rosarium, shrubbery, specimen; weatherproof.

DUTCH GOLD
Wisbech Plant Co. England, 1978
Hybrid tea large flowered bush, flowering summer to autumn. These blooms are indeed large, about 15cm (6in) across, and full of long petals. They are carried high on firm stems to display their clear yellow colour and fine form. Good dark green foliage, vigorous upright growth. 1.1mx75cm (42x30in). 'Peer Gynt' x 'Whisky Mac'. GM The Hague – hence the name. Plant this for upright bed, border, cutting, exhibition, fragrance, health, hedge (60cm-2ft); weatherproof.

EASLEA'S GOLDEN RAMBLER
Easlea, England, 1932
Climber, flowering in summer. Cheerful yellow flowers, rather ragged in outline but of good size (10cm-4in across) appear very freely in summer, usually in clusters, and sometimes with little red flecks on the petals. The leaves are dark and leathery, the plant vigorous, with arching stems. 5x3m (15x10ft). GM NRS. Plant this for fence, fragrance, health, naturalising, pergola, wall.

EASTER MORNING
Moore, USA, 1960
Miniature, flowering summer to autumn. Petite urn-shaped buds open into neatly formed full-petalled flowers of ivory white. They look well against deep

green shiny leaflets. 40x25cm (16x10in). 'Golden Glow' x 'Zee'. Plant this for front of border, container, small space.

EDITH HOLDEN (Chewlegacy, Edwardian Lady)
Warner, England, 1988
Floribunda cluster flowered bush, flowering summer to autumn. A remarkable colour, russet brown shades suffused with gold. The small to medium sized semi-

'EASLEA'S GOLDEN RAMBLER'
double flowers open cupped, and are carried high on the plant on firm stems. Dark leaves, upright growth, 80x60 (32x24in). Commemorates the best-selling author. Plant this for border, curiosity, cutting; weatherproof.

ELEGANCE
Brownell, USA, 1937
Climber, flowering in summer. One of the treats of

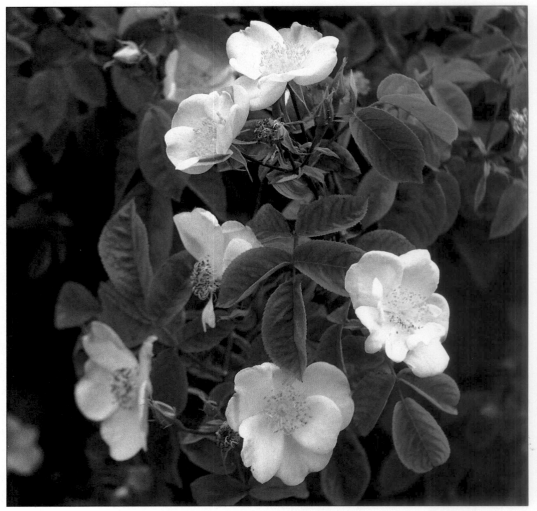

'DUPONTII'

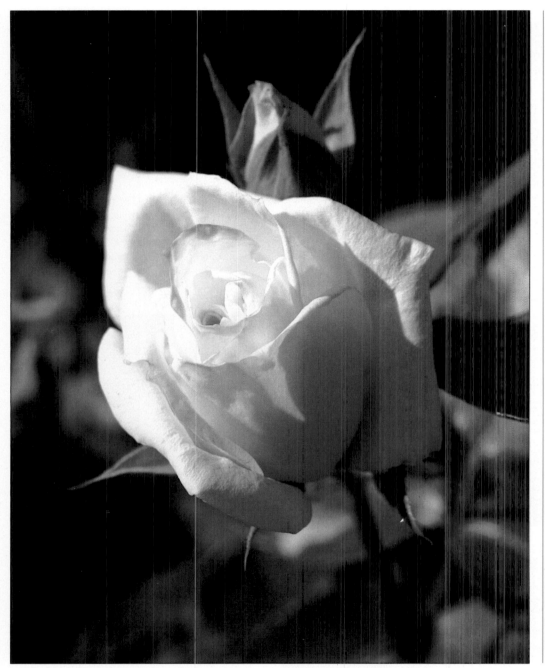

'ELEGANCE' APPEARS ALMOST WHITE IN BUD; THE FLOWER OPENS YELLOW.

classic proportions of the perfect hybrid tea. They are freely produced on bushy dark leaved plants, 80x60cm (32x24in). 'Red Dandy' x 'Piccadilly'. Named for the raiser's daughter, now Mrs Elizabeth Poole. Plant this for bed, border, fragrance, hedge (50cm-20in); weatherproof.

CLG ELIZABETH HARKNESS
Harkness, England, 1975

Hybrid Tea large flowered climber, flowering summer, some in autumn. A vigorous sport of the bush form, with strong stiff growth to 3x2.5m (10x8ft). Plant this for high fence, fragrance, high wall; weatherproof.

ELIZABETH OF GLAMIS (Irish Beauty)
McGredy, N. Ireland, 1964

Floribunda cluster flowered bush, flowering summer to autumn. The colour is breathtakingly lovely, salmon with orange, for which no words can do justice. The blooms are perfectly formed, opening cupped to flat to reveal the neat arrangement of their many petals, and so spaced in the spray that each sets off its neighbour. To realise this potential, the rose requires good cultivation, and a site where cold spring wind will not touch it. Otherwise die back or disease may be a problem. Upright, 75x60cm (30x24in). 'Spartan' x 'Highlight'. GM NRS. Plant this for border, fragrance, rosarium.

ELMSHORN
Kordes, Germany, 1950

Shrub, flowering summer to autumn. Makes a stalwart thick plant, with small rosy red pompon type flowers carried in big clusters on strong stems; there can be as many as forty in the cluster. A utilitarian looking plant, grown for hardiness rather than glamour. Small light green wrinkled foliage. 1.8x1.2m (6x4ft). 'Hamburg' x 'Verdun'. Plant this for border, health, big hedge (90cm-3ft), shrubbery; weatherproof.

EMILY GRAY
Williams, England, 1918

Climber, flowering in summer. The buttery yellow flowers of this are distinctive, being neat in bud, opening cupped with pretty rounded form, and carried on vigorous reddish stems against a background of shiny large green leaves. Wind or cold may cause

'ELIZABETH HARKNESS'

early summer is to see this against an old brick wall, when the large urn shaped primrose flowers begin to open, revealing golden yellow in their depths. The plant has lots of vigour, splendid foliage, and is laden with bloom for its three weeks of glory; if only someone could breed remontancy into it! 3x2.5m (10x8ft). 'Glenn Dale' x seedling. Plant this for fence, health, wall; weatherproof.

ELIZABETH HARKNESS
Harkness, England, 1969

Hybrid tea large flowered bush, flowering summer to autumn. Ivory flowers with a touch of pink and gold open wide to show, in their size and elegance, the

'ELIZABETH OF GLAMIS'

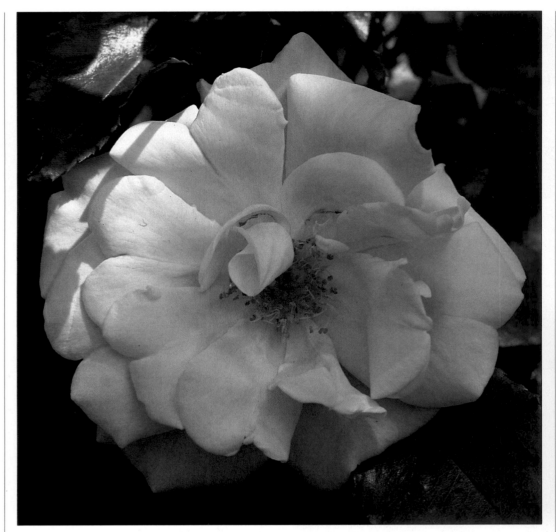

'EMMY GRAY'

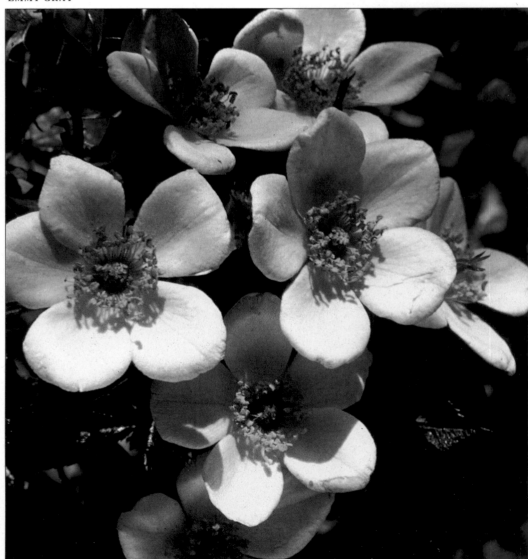

'EMILY LOUISE'

some die back, and the plant should not be overpruned. Arching stems, vigorous and strong, to 5x3m (15x10ft). 'Jersey Beauty' x 'Comtesse du Cayla'. GM NRS. The amateur who raised it, Dr A.H. Williams, named it for his sister. Plant this for fence, pergola, SW or W wall (it may mildew in a dry site).

EMILY LOUISE (Harwilla)
Harkness, England, 1990
Patio or dwarf cluster flowered bush, flowering summer to autumn. An extraordinary little plant; it bears small five petalled flowers reminiscent of a potentilla, bright yellow on opening, taking brownish-pink tones as they age. The petal tips have pretty points to them. Always seems to be in bloom. The leaves are remarkable too, dark purple-green. Low spreading grower, 45x60cm (18x24in). 'Judy Garland' x 'Anna Ford'. Named in memory of a four-year old who lost her life in exceptionally sad circumstances in the "Herald of Free Enterprise" ferry disaster in

'EMILY GRAY'

1987. Plant this for bed, border, container, curiosity, health, low hedge (40cm-16in), rosarium, small space; weatherproof.

EMMY GRAY
Bermuda, 19th century?
China bush/climber, flowering summer to autumn. Bears a consistent supply of five petalled flowers about 5cm (2in) across. The consistency ends there, for what is astonishing about this rose is the variation in flower colour. Side by side in the same spray may be seen light pink, dark pink, and rich scarlet-crimson flowers. The shiny narrow leaflets are typical of China roses, and this may be a sport of *R. chinensis semperflorens* ('Slater's Crimson China'), with the genes playing strange tricks. Growth in the mild Bermudian climate can be up to 2.5x2m (8x6ft); needs protection in cooler regions. Named for a teacher at the Bermuda High School for Girls who ensured its survival by giving cuttings to her alumnae. Plants this in mild climate for border, curiosity, fence, pillar, rosarium, wall; and elsewhere for glasshouse or sheltered wall.

EMPEREUR DE MAROC
Guinoisseau, France, 1868
Hybrid perpetual bush, flowering summer, sometimes in autumn. Interesting for the rich colour, crimson with mauve touches on purple; imperial tones indeed. The flowers are quartered and very double, though not large for the class (7m-3in across). The plants are shrubby and compact, well foliaged, 1.3x1m (4x3ft). Seedling of 'Géant des Batailles'. Plant this for border, fragrance, shrubbery.

EMPRESS JOSEPHINE
1820s or earlier
Gallica hybrid shrub, flowering in summer. There is some doubt whether this is *R. francofurtana*, so called because it was noted growing in Frankfurt in 1583. It looks like an improved form, with fuller flowers.

'EMPRESS JOSEPHINE'

'ERNEST H. MORSE'

They are rich pink with lilacy purple flushes and waved petals. The hips are shaped like a spinning top, the Latin name for which is "turbo", giving rise to another old name, *R. turbinata*. The growth is leafy, bushy and wide to 90x90cm (3x3ft). May be *R. majalis x R. gallica*. Plant this for border, fragrance, health, hedge (80cm-38in), hips, rosarium, shrubbery; weatherproof.

ENA BAXTER (Cocbonne)
Cocker, Scotland, 1989
Hybrid tea large flowered bush, flowering summer to autumn. Carries high-centred and shapely reddish salmon flowers either singly or several together. This is bred from 'Silver Jubilee' and shows the influence of that rose in its lovely foliage. The habit is neat, bushy and compact, 75x60cm (30x24in). Named for the Vice-Chairman of the food manufacturing company Baxters of Speyside Ltd. Plant this for bed, border, health, hedge (60cm-2ft); weatherproof.

ENA HARKNESS
Norman, England, 1946
Hybrid tea large flowered bush, flowering summer to autumn. Made a great impact after World War II because of its non-blueing scarlet crimson tones, perfect shape and fragrance. A stiffer stemmed and better foliaged replica would go down well today. 75x60cm (30x24in). 'Crimson Glory' x 'Southport'. GM Portland & NRS, FRAG NRS. Raised by an amateur who was a friend of the introducer, and named for his wife, who was herself a rosarian and flower arranger of international renown. Plant this for border, fragrance, health; weatherproof.

CLG ENA HARKNESS
Murrell/Gurteen & Ritson, England, 1954
Hybrid tea large flowered climber, flowering summer to autumn. A successful sport of the above; the variety's tendency to nod becomes something of an asset in the climbing form. 2.5- 4.5x2.5m (8-15x8ft).

Plant this for high fence, fragrance, health, pergola, high wall; weatherproof.

ENGLISH GARDEN (Ausbuff)
Austin, England, 1987
Shrub/bush, flowering summer to autumn. This produces sizeable yellow rosettes, full of petals which

open folded and quartered in the style of an old fashioned rose. They open out flat to display their beauty on neat upright plants. 90x90cm (3x3ft). Plant this for bed, border, fragrance, hedge (75cm-30in); weatherproof.

ENGLISH MISS
Cant, England, 1978
Floribunda cluster flowered bush, flowering summer to autumn. Produces full, wide opening, camellia shaped blush pink flowers. They have spicy fragrance and show up well against dark leathery foliage. Bushy, 75x60cm (30x24in). 'Dearest' x 'Sweet Repose'. Named by the raiser for his daughter, Sallyanne Pawsey. Plant this for bed, border, fragrance, hedge (50cm-18in); weatherproof.

ERNEST H. MORSE
Kordes, Germany, 1964
Hybrid tea large flowered bush, flowering summer to autumn. Large fragrant flowers of deep turkey red appear freely on upright bushes. A good garden rose, with leathery leaves and even habit of growth. 75c60cm (30x24in). FRAG The Hague, GM NRS.

'ENGLISH GARDEN'

Named for one of the rose growing brothers at Brundall, Norwich, who were friends of the raiser and introduced this rose. Plant this for bed, border, fragrance, health, hedge (50cm-18in); weatherproof.

ESCAPADE
Harkness, England, 1967
Floribunda cluster flowered bush, flowering summer to autumn. Opens rosy violet around a white centre, reminding the observer of butterflies perching on the bush. The clusters can be very large, but so well spaced that they never appear crowded. Despite its few petals it lasts well when cut, as long as the buds are taken young. Growth is shrublike, splendidly leafy; it is a plantsman's rose and the colour looks well against stone or dark background, or in association with old garden roses. 80x60cm (30x24in), bigger if lightly pruned. 'Pink Parfait' x 'Baby Faurax'. ADR, GM Baden-Baden, Belfast, Erfurt, PRIZE Copenhagen. Plant this for bed, border, cutting, exhibition, fragrance, health, hedge (55cm-22in), low wall; weatherproof.

ESSEX (Pink Cover, Poulnoz)
Poulsen, Denmark, 1988
Ground cover shrub, flowering summer to autumn. Bears clusters of small rather star-like flowers, bright reddish pink when young, paler as they open and with white centres. The plant has a low creeping habit, with super glossy foliage showing the blooms off to advantage. 60cmx1.2m (2x4ft). GM Dublin. Plant this for bed, front of border, container, ground cover, health, smallish space, against low wall; weatherproof.

ESTHER'S BABY
Harkness, England, 1979
Patio or dwarf cluster flowered bush, flowering summer to autumn. Opens flat, with the petals lying counter to one another, which gives an unusual starry effect to the bright pink flowers. The leaflets are small, dark and crisp. 40x45cm (16x18in). ('Vera Dalton' x seedling) x 'Little Buckaroo'. Named for

Emily Alice Wilcox, daughter of Esther Rantzen, promoter of good causes; initial sales aided the Spastics' Society. Plant this for small bed, front of border, container, petite hedge (38cm-15in), small space; weatherproof.

ETOILE DE HOLLANDE
Verschuren, Holland, 1919
Hybrid tea large flowered bush, flowering summer to autumn. At their best the blooms are vivid dark velvety crimson, opening into rather loose cupped flowers from long slim buds. The fragrance is sweet and strong. A sad decline in the plant's constitution makes this no longer worth growing but luckily we have the climbing form to use instead. 'General MacArthur' x 'Hadley'. Plant this for fragrance, rosarium, sentiment.

CLG ETOILE DE HOLLANDE
Leenders, Holland, 1931
Hybrid tea large flowered climber, summer to autumn flowering. Splendidly vigorous sport of the bush form, which needs plenty of space, as it is capable of growing up to 6mx5m (18x15ft). Plant this for high fence, fragrance, high wall; weatherproof.

EUPHRATES (Harunique)
Harkness, England, 1986
Persica hybrid shrub, flowering in summer. A strange item, bearing clusters of small five-petalled flowers, of an uncommon salmon rose tone with scarlet eye-patches at each petal base. The plants are low and spreading, and the leaflets vary in shape, a characteristic of the rare persica hybrids. *R. persica* x 'Fairy Changeling'. 60x75cm (24x30in). Plant this for border, curiosity, health, hedge (55cm-22in), rosarium, small space; weatherproof.

EVELYN FISON (Irish Wonder)
McGredy, N. Ireland, 1962
Floribunda cluster flowered bush, flowering summer to autumn. Vivid dark scarlet, a glowing but not

strident shade which keeps its pure tone until the petals drop. The neatly formed medium sized flowers are well displayed in large clusters. The foliage is dark green, glossy and plentiful, but turns yellow and falls surprisingly early in the autumn. 70x60cm (30x24). 'Moulin Rouge' x 'Korona'. GM NRS. Plant this for bed, border, exhibition, hedge (50cm-20in); weatherproof.

EXCELSA (Red Dorothy Perkins)
Walsh, USA, 1909
Rambler, flowering in summer. This produces many clusters on pendulous stems, each with numerous small rosettes. They are rosy crimson, not a very lively shade but their quantity creates colour impact. There is a background of small pointed leaflets, shiny except when seasonal mildew strikes. 3.5x3m (12x10ft). GM ARS. Plant this for fence, naturalising, pergola, pillar, weeping; weatherproof.

EYEOPENER (Erica, Interop, Tapis Rouge)
Ilsink, Holland, 1987
Ground cover shrub, flowering summer to autumn. This rose has a delightful habit, like a shallow pyramid flowing towards the ground. Hydrangea-like clusters of bright red yellow-centred flowers are borne very freely at all levels. The rapport between flower and leaf is especially pleasing. The leaves are bright and plentiful, and the habit spreading, 70cmx1m (28x40in). (Seedling x 'Eyepaint') x (seedling x 'Dortmund'). PRIZE, Belfast & Orleans. Plant this for bed, front of border, container, ground cover, health, smallish space; weatherproof.

EYE PAINT (Maceye, Tapis Persan)
McGredy, New Zealand, 1975
Cluster flowered floribunda shrub, flowering summer to autumn. Full of flower and foliage, with seven-petalled scarlet buds in big clusters opening to show pale centres around the yellow stamens. Colourful and shrubby, bushing out low, 1mx75cm (40x30in). Seedling x 'Picasso'. GM Baden-Baden & Belfast.

'EUPHRATES'

'EYE PAINT'
Plant this for tallish bed, border, hedge (70cm-28in), shrubbery, specimen plant, spreading; weatherproof.

FAIRY CHANGELING (Harnumerous)
Harkness, England, 1981
Patio or dwarf cluster flowered bush, flowering summer to autumn. Strange colour variations appear in the many-flowered clusters, which contain blush, deep pink and magenta rosettes all mixed together. The leafy cushiony plants are covered with dark burnished leaflets to enhance the flower display. 45x50cm (18x20in). 'The Fairy' x 'Yesterday'. Plant this for low bed, front of border, container, health, small hedge (40cm-16in), small space; weatherproof.

FAIRYLAND (Harlayalong)
Harkness, England, 1980
Ground cover shrub, flowering summer to autumn. This pushes out shoots in all directions to form a spreading leafy plant, which it decorates with prolific dainty sprays of blush rosettes. They have sweet fragrance and continuity of bloom is excellent. 60cmx1.2m (2x4ft). 'The Fairy' x 'Yesterday'. Plant this for bed, border, container, fragrance, ground cover, health, low wide hedge (90cm-3ft), front of shrubbery, small space, specimen plant, weeping; weatherproof.

FANTIN-LATOUR
France? – origin unknown
Provence or centifolia shrub, flowering in summer. Makes a rather open, spreading and substantial plant, with a marvellous crop of pink roses, large, full petalled and warm in tone, maintaining a lovely circular outline as they expand. For Michael Gibson,

'FAIRY CHANGELING'

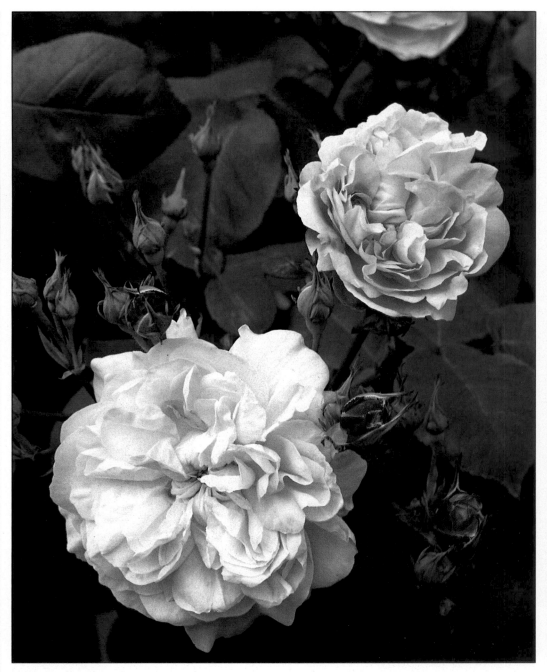

'FANTIN-LATOUR'

a discerning and much-travelled rosarian, "this is one of the most beautiful roses of all". Up to 2.2x2.2m (7x7ft). Fantin-Latour (1836-1904) painted still-lifes, and often including roses. This ancient rose come to bear his name through Graham Thomas, who says he "found it is a garden where its name was unknown, labelled 'Best Garden Rose', and as such it is worthily named after the great French artist".[1] Plant this for big border, fence, fragrance, naturalising, rosarium, shrubbery, specimen, wall.

FASHION
Boerner, USA, 1949
Floribunda cluster flowered bush, flowering summer to autumn. The peach salmon colour – words cannot describe it – beguiled everyone in the 1950s, and for some years propagators could not keep pace with the demand. In part this was due to winter die- back necessitating replacement plants. Then it fell a tragic victim to rust fungus, and swiftly fell from favour. There has been no rose since in that beautiful shade. 50x60cm (20x24in). 'Pinocchio' x 'Crimson Glory'. AARS, GM NRS, Paris, Portland. Plant this for rosarium or sentiment, and give it special care.

FELICIA
Pemberton, England, 1928
Hybrid musk shrub, flowering summer and autumn. Cupped double flowers in light pink with a hint of

1 In *The Old Shrub Roses*, (Dent 1979)

apricot are borne in graceful fashion on vigorous bushy plants. This is a plantsman's rose of pleasing proportions. The foliage is handsome too, plentiful and with a greyish green tint. 1.5x2.2m (5x7ft). 'Trier' x 'Ophelia'. Plant this for large bed, border, low fence, fragrance, health, big hedge (1.5m-5ft), naturalising, shrubbery, specimen plant, spreading, low wall; weatherproof.

FELICITE PARMENTIER
Origin unclear – grown since 1834
Alba shrub, summer flowering. Flower densely petalled, showing pale yellow tints in the bud, becoming flesh pink in the expanded blooms. They open very flat, as though their tops had been sliced off, and are quartered in the centre. Sturdy but not as tall as other alba roses. 1.3x1.2m (54x48in). Plant this for large bed, border, low fence, fragrance, health, rosarium, shrubbery, specimen, low wall; weatherproof.

FELICITE PERPETUE
Jacques, France, 1827
Climber, flowering in summer. The white rosettes show a most beautiful construction whereby layer upon layer of tiny petals show their tips. They are carried in open sprays on arching stems. Despite its age, this rose seems as vigorous as ever, the long arching stems being capable of reaching 5x4m, 15x12ft. It is thought to be a seedling of *R. sempervirens*, the 'Evergreen Rose', and in mild

winters the leaves stay late on the plants. The name of this rose has an odd history. It was called 'Félicité Perpétue' from its introduction to the turn of the century, when "et" was inserted in the middle. This usage spread like a computer virus, and the last rosarian to keep the old name as far as I can trace was my grandfather John in his catalogue of 1926. Sixty years passed before Graham Thomas and others suggested the name be corrected back again. It is said that it refers to the twin baby daughters of the man who raised it, A.A. Jacques, gardener at Neuilly to the Duc d'Orléans, soon to become king of the French as Louis-Philippe. An addition to the family was expected, and if it were a girl the rose was to bear her name. In the event twin girls arrived, so the double name was given, recalling the Christian martyrs who perished in 203 AD and are commemorated in the introduction to the Catholic mass. Plant this for fence, health, naturalising, pergola, rosarium, tree, wall; weatherproof.

FELICITY KENDAL (Lanken)
Sealand, England, 1985
Hybrid tea large flowered bush, flowering summer to autumn. The vermilion flowers make themselves noticed, being carried boldly on strong stems above bushy branching plants. They are large and well formed, and their colouring is of the kind rather than strident sort. They are not so happy in the rain. 1.1mx75cm (42x30in). 'Fragrant Cloud' x 'Mildred Reynolds'. Named for the famous actress who first appeared on stage at nine months old, being carried on as the Changeling boy in *A Midsummer Night's Dream*. Plant this for bed, border, exhibition, health, hedge (60cm-2ft).

FELLENBERG (Fellemberg)
Origin uncertain, 1830s?
China shrub, flowering summer to autumn. This is after the style of 'Agrippina', bearing cupped, rather small (5cm-2in) full petalled flowers in crimson, deeper in the bud than the open flower. It continues in flower over many weeks, indeed for months in milder climates. It can be trimmed and grown as a bush, or allowed to extend to 2.5x1.2m (8x4ft), with some support. Plant this for border, sheltered fence, health, naturalising in warmer climate, pillar, rosarium, S, SW or W wall; weatherproof.

FERDY (Keitoli)
Suzuki, Japan, 1984
Shrub, flowering summer and autumn. Surely this holds the record for the number of blooms per square yard – the stems are wreathed with dense clusters all the way down to the ground, and they must be almost uncountable, each one little more than an inch (3cm) across. They are fuchsia pink, reddening as they fade, with two dozen tiny petals. It seems ungracious to say so, but this valiant flower production gives so unnatural an effect that it is hard to place the variety in the garden; massed by itself in a landscaped setting it looks fine. Growth is very dense, with arching stems and fine-cut dainty leaves. 80cmx1.2m (32x48in). Climbing seedling x a 'Petite Folie' seedling. Plant this for bed, border, curiosity, health, hedge (75cm-30in); weatherproof. See note above regarding garden use.

FERGIE (Ganfer)
Gandy, England, 1987
Floribunda cluster flowered bush, flowering summer to autumn. Bears neatly formed flowers, like small scale hybrid teas. The buds lead one to expect a pink rose, but they open to show orange buff with hints of ginger, very pretty and unusual. The foliage is light green and the growth compact, 45x45cm (18x18in). Raiser Douglas Gandy tells the world he named it for his old Ferguson tractor. Nice one, Douglas! Plant this for bed, border, low hedge (45cm-18in), small space; weatherproof.

'FELLENBERG'

FIONA (Meibeluxen)
Meilland, France, 1979
Shrub, flowering summer to autumn. This is useful for group planting where colour impact is required. Sprays of blood red flowers nestle among the dense glossy leaves, providing a good show through the season. The habit is bushy and spreading, 80cm x 1.2m (32x48in). 'Sea Foam' x 'Picasso'. Plant this for bed, border, health, hedge (1m-40in), spreading; weatherproof.

FLORENCE NIGHTINGALE (Ganflor)
Gandy, England, 1989
Floribunda cluster flowered bush, flowering summer to autumn. The flowers have a fresh and clean look, due to the pleasing buff colour, admitting some buff pink shades. They are well formed and last when cut. Flower arrangers will find such a restful colour useful. Shiny olive green leaves, bushy growth, 75x60cm (30x24in). Plant this for bed, border, cutting, fragrance, hedge (50cm- 20in); weatherproof.

FORTUNE'S DOUBLE YELLOW (Beauty of Glazenwood, Gold of Ophir, San Rafael Rose)
from China to Europe, 1845
Tea climber, early summer flowering. The discovery of this rose by Robert Fortune is described in Chapter One. The yellow flowers have a strong suffusion of copper, and open to a rather ragged cupped shape on short side shoots. Not everyone can enjoy its beauty, for it is tender. Rather lax open growth to 2.5x1.5 (8x5ft), up to twice that in warmer climates. Needs no pruning apart from trimming off dead flower heads. Plant this for container in sheltered site, fragrance, glasshouse, rosarium, sheltered wall.

FOUNTAIN (Fontaine, Red Prince)
Tantau, Germany, 1970
Shrub, flowering summer to autumn. This makes a great big handsome plant, bearing clusters of large full petalled flowers in deep bright crimson. The leaves are dark and glossy, growth rather wide. 2x1.2m (6x4ft). GM & PIT RNRS. Plant this for large bed, border, health, big hedge (90cm-3ft), pillar, shrubbery, specimen plant; weatherproof.

'FIONA'

'FRAGRANT DELIGHT' IN REGENT'S PARK, LONDON.

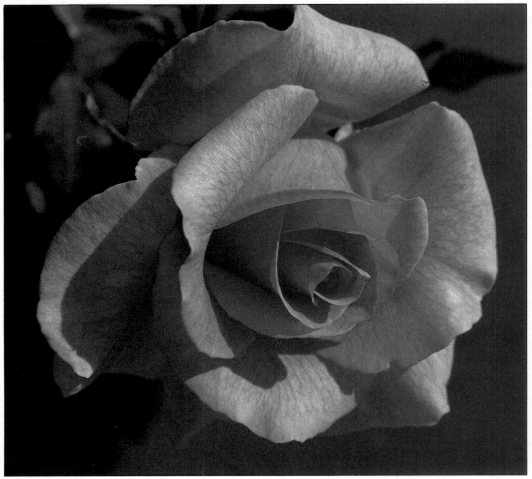

'FRAGRANT DREAM'

FOUR SEASONS ROSE – see **QUATRE SAISONS**

FRAGRANT CLOUD (Duftwolke, Nuage Parfume)
Tantau, Germany, 1963
Hybrid tea large flowered bush, flowering summer to autumn. This fragrant dusky scarlet rose has been a favourite since the year it first came out. The flowers are produced early, repeat quickly, and their large petals make it capable of giving exhibition blooms. Rain can cause balling and loss of colour. Bushy and very leafy, 75x60cm (30x24in). Seedling x 'Prima Ballerina'. FRAG USA, GM NRS, Portland. Plant this for bed, border, cutting, exhibition, fragrance, hedge (50cm-20in).

FRAGRANT DELIGHT
Wisbech Plant Co. England, 1978
Floribunda cluster flowered bush, flowering summer to autumn. This variety has pretty light orange salmon shades, and is a good one to plant instead of 'Elizabeth of Glamis' if that has proved difficult. It is vigorous, free branching, and carries a lot of bloom in generous sprays. 90x75cm (36x30in). 'Chanelle' x 'Whisky Mac'. FRAG & JMMGM RNRS. Plant this for bed, border, cutting, fragrance, hedge (60cm- 2ft); weatherproof.

FRAGRANT DREAM (Dicodour)
Dickson, N. Ireland, 1989
Hybrid tea large flowered bush, flowering summer to autumn. This is in the classic tradition of hybrid teas, with broad petals building a flower of high centred form. The colour is basically light apricot, with undertones of salmon. Leafy, bushy, 80x60cm

(32x24in). Plant this for bed, border, fragrance, health, hedge (50cm- 20in); weatherproof.

FRANCOIS JURANVILLE
Barbier, France, 1906
Rambler, flowering in summer. A delightful old variety, very vigorous, bearing big clusters of small double rosette-style flowers. They have many small quilled petals and open wider than most roses bred from *R. wichuraiana*, about 8cm (3in) across, to display a pretty and welcoming colour, warm rosy salmon pink. Very leafy, though it can become bare around the base. Up to 6x4.6m (20x15ft). *R. wichuraiana* x 'Mme. Laurette Messimy'. Plant this for high fence, fragrance, naturalising, pergola; weatherproof.

FRAU KARL DRUSCHKI (Reine des Neiges, Snow Queen, White American Beauty)
Lambert, Germany, 1901
Hybrid perpetual bush/shrub, flowering summer to autumn. For many rose lovers early in the century, including it is said King Edward VII, this was the favourite white rose. Its good qualities are vigour, which pleased nurserymen and gardeners alike, bloom production, which is excellent, and the quality of the flowers themselves, full petalled, high centred in the young flower, and holding well when cut for the show bench or to use at home. For show they would need protection, as they ball up in rain. Today it is probably the most widely grown of the hybrid perpetuals, which were the forerunners of the hybrid teas; indeed the flower often passes for a hybrid tea. The growth looks very different, having arching stems up to five feet (1.5m) long and bearing the dull foliage typical of many older roses. The long shoots, if pegged down, will carry a lot of flower on short side stems. The variety will grow to 1.2x1.2m (4x4ft), wider if the long shoots are retained. 'Merveille de Lyon' x 'Mme. Caroline Testout'. The breeder called this after the wife of the President of the society whose name translates as "True German friends of the Rose"; 'Snow Queen' had earlier been its nickname, and was revived in Britain and France when German names became unpopular during the first World War. Plant this for border, low fence, rosarium.

FRED GIBSON
Sanday, England, 1966
Hybrid tea large flowered bush, flowering summer to autumn. Grown by and for exhibitors, who find in the high centred, long petalled flowers the right qualities for success. They are light apricot in colour with a suffusion of golden tints. Makes a tall and vigorous plant, 1mx75cm (40x30in). 'Gavotte' x 'Buccaneer'. Named for a former President of the Royal National Rose Society who was a very keen exhibitor, and won the Amateur Championship in 1960. Plant this for exhibition.

FRED LOADS
Holmes, England, 1967
Floribunda cluster flowered shrub, flowering summer to autumn. A very noticeable rose, by reason of its height and bright colour. The flowers are vermilion, with few petals, quite large (7cm-3in) and are produced in great trusses. It is the effect of all those open petals at the top of long canes that creates the colour impact, both in the garden and particularly at shows. The leaves are large and the habit upright, sometimes bowing under the weight of all the flowers. Up to 2x1.2m (6x4ft). 'Orange Sensation' x 'Dorothy Wheatcroft'. GM RNRS. Fred Loads was a well known English gardening expert. Plant this for back of border, cutting, exhibition, fragrance, health, pillar; weatherproof.

FREEDOM (Dicjem)
Dickson, N. Ireland, 1984
Hybrid tea large flowered bush, flowering summer to

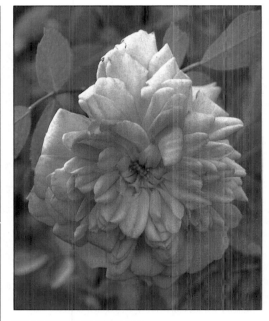

'FRANCOIS JURANVILLE'

autumn. Nurserymen love the way this rose makes new shoots freely from the base, providing a high ratio of first quality plants to sell. It looks to be the outstanding yellow bedding rose for some years ahead, admired for its bright colour, neat even habit, handsome glossy foliage and because it is free flowering. The flowers are not very large, rounded in form, with crisp petals. 75x60cm (30x24in). ('Eurorose' x 'Typhoon') x 'Bright Smile'. GM

RNRS. Named for the Ulster Defence Regiment. Plant this for bed, border, fragrance, health, hedge (50cm- 20in); weatherproof.

FRENSHAM
Norman, England, 1946
Floribunda cluster flowered bush, flowering summer to autumn. A famous scarlet-crimson rose in Britain in the years after World War II, until mildew upset it in the 1950s. The buds are beautifully formed, with neatly scrolled petals at the centre, and open with a wave to the petals. The flowers are small, about 6cm (2.4in) across, and make a bold and cheerful show because this is an exceptionally prolific blooming rose, and there are a good many of them in each cluster. Repeat bloom comes quickly without any call for dead-heading, because seed pods do not form. Very leafy indeed, and capable of making a dense thickety shrub. Experience shows that it is better to reduce its size by pruning hard, because otherwise the plant puts out more foliage than it can sustain, which encourages mildew spores. 90cm-1.5m (3-5ft). 'Crimson Glory' x seedling. GM NRS. Named by the raiser from the village in Surrey near his home. Plant this for bed, border, hedge (80cm-32in), front of shrubbery; weatherproof.

FRITZ NOBIS
Kordes, Germany, 1940
Shrub, flowering in summer. One of the most noble looking plants ever raised, seeming to have every leaf, petal and flower in exactly the right place. The flowers are rosy salmon pink, paler on the inside,

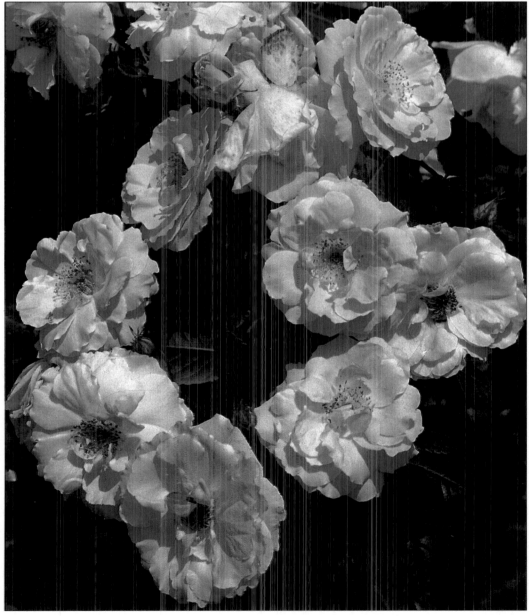

'FRITZ NOBIS'

delicately cupped and very freely produced – but for a brief period only. The plant grows strongly, making a dense shrub covered with rugged looking leaves. Up to 2.2x1.5m (7x5ft). 'Joanna Hill' x 'Magnifica'. Plant this for back of border, health, huge hedge (1.3m-54in), naturalising, shrubbery, specimen plant; weatherproof.

FRU DAGMAR HASTRUP (Frau Dagmar Hartopp)
Hastrup, Denmark, 1914
Rugosa shrub, flowering in summer, some in autumn. Widely used in public planting schemes because of its hardiness and ability to grow with little or no maintenance and to withstand the attentions of pets and children. Bears wide single rose pink flowers very freely in summer. They are succeeded by tomato-like hips. The leaves are large, leathery, rough to the touch, and cover the plant for most of the year. 90cmx1.2m (3x4ft). "Fru" is Danish and since the rose is of Danish origin it seems logical, as Peter Beales suggests, to keep that earlier form of the name. Plant this for bed, border, fragrance, health, hedge (75cm- 30in), hips, shrubbery, small specimen plant, spreading; weatherproof.

FRUHLINGSGOLD
Kordes, Germany, 1937
Shrub, flowering in spring or early summer. Easily recognised in established gardens by its open, tree-like growth, decorated with large (up to 15cm-6in) pale primrose yellow single flowers. It is one of the earliest roses to flower, due no doubt to the genes of its pollen parent, a wild Scotch rose. The shoots from the base are among the loveliest of any rose when they are young, completely covered with a downy fuzz of red-gold prickles. Should not be pruned except to clear out spent or misplaced wood, therefore space needs to be allowed for it to grow up to 2.5x2.5m (8x8ft). 'Joanna Hill' x *R. spinosissima hispida*. Plant this for fragrance, health, naturalising, shrubbery, specimen plant; weatherproof.

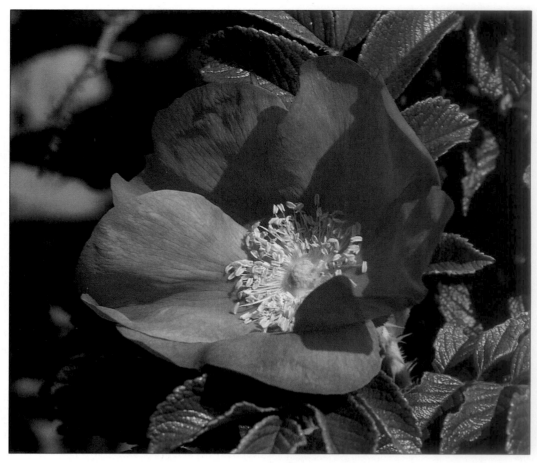

'FRU DAGMAR HASTRUP' OR 'FRAU DAGMAR HARTOPP'

FRUHLINGSMORGEN

Kordes, Germany, 1941
Shrub, flowering in late spring or early summer. This is not unlike the last variety in habit, but makes a smaller and less imposing plant. The flowers are large, single, and of striking beauty, rimmed with cherry pink, primrose in the centre and with reddish stamens. A few late ones may appear in autumn. 2x1.5m (6x5ft). ('E.G. Hill' x 'Cathrine Kordes') x *R. spinosissima altaica*. Plant this for border, fragrance, health, shrubbery, specimen plant; weatherproof.

FULTON MACKAY (Cocdana)
Cocker, Scotland, 1988
Hybrid tea large flowered bush, flowering summer to autumn. This is a beauty. It bears large long petalled blooms of bright golden apricot, with lovely high centres. The leaves are glossy and plentiful, growth vigorous and bushy to 75x60cm (30x24in). 'Silver Jubilee' x 'Jana'. Named in memory of the distinguished Scottish actor. Plant this for bed, border, fragrance, health, hedge (50cm- 20in); weatherproof.

FYVIE CASTLE (Amberlight, Cocbamber)
Cocker, Scotland, 1985
Hybrid tea large flowered bush, flowering summer to autumn. This neat compact grower produces a good succession of large well formed blooms, in a gentle and harmonious blend of light apricot, amber and pink. The plants are well furnished with shiny foliage. 60x60cm (2x2ft). (Seedling x 'Dr Verhage') x 'Silver Jubilee'. GSSP New Zealand, PRIZE Baden-Baden. Named for the National Trust property in Aberdeenshire. Plant this for bed, border, fragrance, health, hedge (50cm- 20in); weatherproof.

GALWAY BAY
McGredy, N. Ireland, 1966
Climber, flowering summer to autumn. The flowers, borne in clusters, are salmony reddish-pink, shading deeper towards the petal rims, fairly full and reflexing to display their beauty. New flowering shoots grow from near the base, ensuring good continuity of bloom; indeed there is less sideways growth than usual for a climber, and one can think of this as a tall shrub needing support. Leafy, with good coverage near the base, 3x1.5m (10x5ft). 'Heidelberg' x 'Queen Elizabeth'. Plant this for fence, fragrance, pillar, wall; weatherproof.

GARNETTE
Tantau, Germany, 1947
Floribunda cluster flowered bush, flowering summer

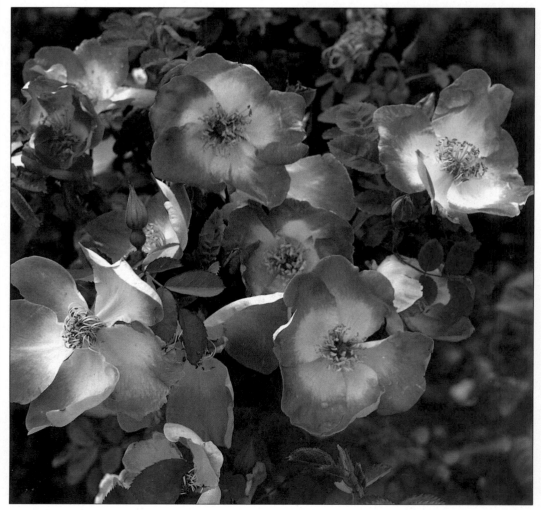

'FRUHLINGSMORGEN'

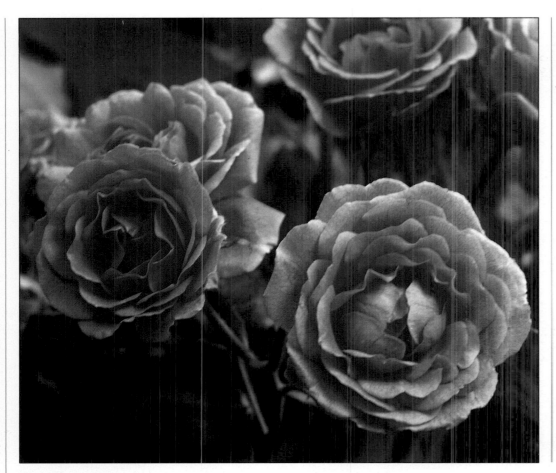

'CAROL GARNETTE'

to autumn. This is red, rather a dull deep shade, bearing clusters of small to medium sized flowers opening flat in rosettes. Their petals are hard, and hold position for many days when cut, for which purpose this rose has been widely used. In fact it was the prototype for what are termed "Garnette" roses, of which the pink 'Carol Amling', often abbreviated to plain 'Carol' is one of the best, and others are 'Garnette Apricot', 'White Garnette' and (from a different breeding line) 'Pink Chiffon'. Many a bride, admiring the dainty 'Carol' in her bouquet, has searched the nurseries in vain to obtain one for her garden. The explanation is that these roses are sold wholesale to the cut flower trade by commercial glasshouse growers, and not grown by the majority of nurserymen, who believe their customers may be disappointed with their performance out of doors. A few specialists do have them for those who want to try. 'Garnette' itself grows upright, 75x45cm (30x18in). Plant this type of rose for cutting, in greenhouse.

GENERAL JACQUEMINOT (General Jack)
Roussel, France, 1853
Hybrid perpetual shrub, flowering summer to autumn. This rose is an important ancestor of large flowered red roses, and handsome in its own right, with full fragrant blooms on long strong stems, and a scarlet tone to the crimson in the flower. It must owe its fine colour to a derivative of the China roses, maybe the Bourbon 'Gloire des Rosomanes' or hybrid perpetual 'Géant des Batailles'. 1.2x1m (4x3ft). Roussel was an amateur in Montpellier, who, Jack Harkness relates, "raised seedling roses as a hobby, but found no good ones up to the day he died. His gardener found 'General Jack' in the last lot, after his employer's death".[2] Plant this for border, fragrance, rosarium.

GENERAL MacARTHUR
E.G. Hill, USA, 1905
Hybrid tea large flowered bush, flowering summer to autumn. A famous garden rose in its day, and, like the above, an important parent. Its great merits are vigorous growth, freedom of bloom, hardiness and a heady damask fragrance. The flowers are rose red,

not all that full, but making the most of their broad petals to open cup-shaped and hold their form before dropping cleanly. The foliage cover looks inadequate by modern standards, but in other respects this variety earns full marks. Plant this for border, fragrance, health; weatherproof.

CLG GENERAL MacARTHUR
H. Dickson, N. Ireland, 1923
Hybrid tea large flowered climber, flowering summer, some in autumn. A vigorous climbing sport of the variety described above, 4x2.8m (12x9ft). Plant this for high fence, fragrance, health, pergola, high wall; weatherproof.

GENTLE MAID (Harvilac)
Harkness, England, 1988
Patio or dwarf cluster flowered bush, flowering summer to autumn. This low spreading dark leaved plant bears clusters of rosette type flowers, full of small quilled petals that lie back layer upon layer. The colour is pink with a lilac tone, thanks to the influence of several lilac roses including *R. californica* in the parentage. 40x40cm (16x16in). Plant this for small bed, front of border, container, health, petite hedge (40cm-16in), small space; weatherproof.

GENTLE TOUCH (Diclulu)
Dickson, N. Ireland, 1986
Patio or dwarf cluster flowered bush, flowering summer to autumn. One of the first of Pat Dickson's patio roses, having all parts of the plant uniformly

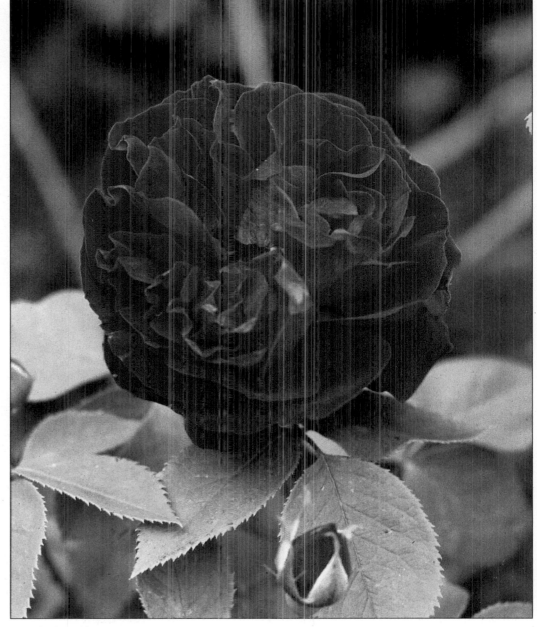

'GÉNÉRAL JACQUEMINOT'

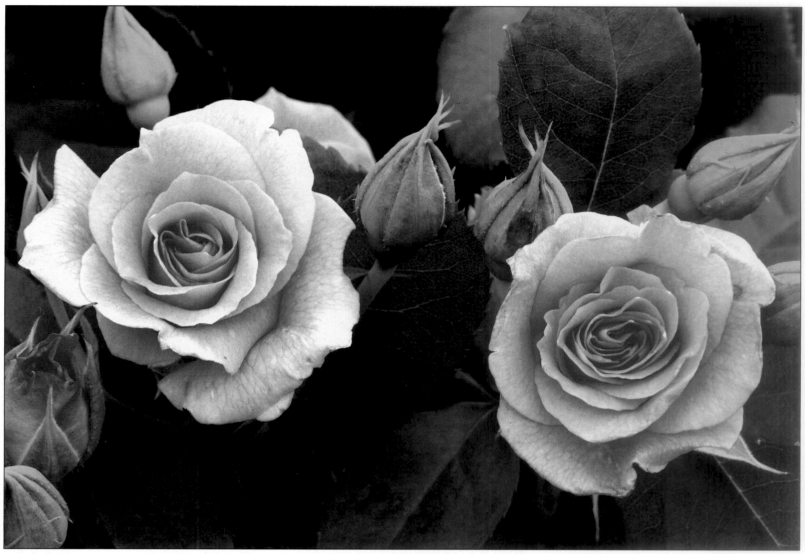

'GERALDINE'

reduced in scale. Tiny urn-shaped buds open into shallow-cupped flowers of palest salmony pink. There are many of them, so a group of this is a handy source of flowers for small arrangements. The plants grow upright, clothed in small dark leaves. 50x30cm (20x12in). 'Liverpool Echo' x ('Woman's Own' x 'Memento'). ROTY. Plant this for small bed, front of

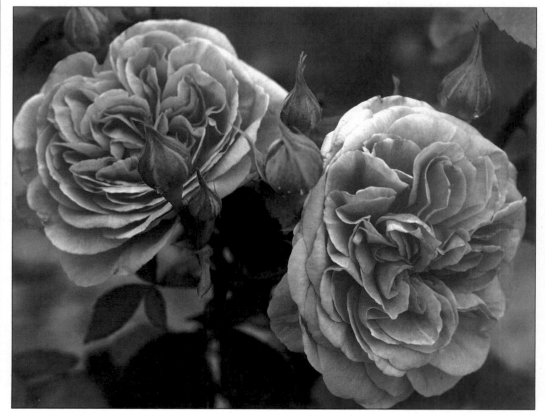

'GERTRUDE JEKYLL'

border, container, cutting, short hedge (40cm-16in), small space; weatherproof.

GERALDINE (Peahaze)
Pearce, England, 1983
Floribunda cluster flowered bush, flowering summer to autumn. The flower colour is composed of pretty

blends of orange. It makes a bushy well-spread plant, carrying many blooms in the cluster. They last well so are useful to pick and bring indoors. 70x60cm (28x24in). Named by the raiser for his wife. Plant this for bed, border, hedge (50cm-20in); weatherproof.

GERTRUDE JEKYLL (Ausbord)
Austin, England, 1986
Shrub, flowering summer to autumn. Bears sizeable flowers, well filled with petals opening in the random fashion associated with old style roses. They earn high marks for beauty, and more for their lovely scent. The plant could do with more foliage to clothe the lanky stems. 1.5mx90cm (5x3ft). Seedling x 'Comte de Chambord', an interesting modern use of an old Portland variety. The rose commemorates Gertude Jekyll, who through her writings and by practical example did much to influence garden design, especially in the grouping of flowers for colour effect. Plant this for border (with shorter plants in front), low fence, fragrance, low pillar.

GINGERNUT (Coccrazy)
Cocker, Scotland, 1989
Patio or dwarf cluster flowered bush, flowering summer to autumn. A remarkable colour, bronze orange with reddish reverse, pinky orange towards the inner petal tips. The petals reflex to lie in neat array, with all their pretty shades open to view, a lovely work of natural artistry. Leaves petite, dark and glossy. 40x45cm (16x18in). ('Sabine' x 'Circus') x 'Darling Flame'. Plant this for small bed, front of border, container, low hedge (40cm-16in), small space; weatherproof.

GLAD TIDINGS (Tantide)
Tantau, Germany, 1988
Floribunda cluster flowered bush, flowering summer to autumn. Dark red, an intense and velvety crimson

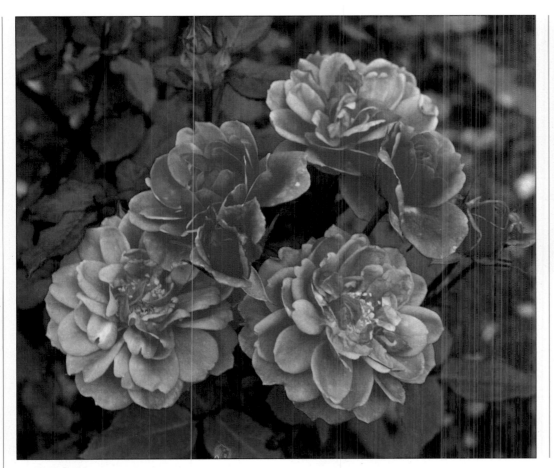

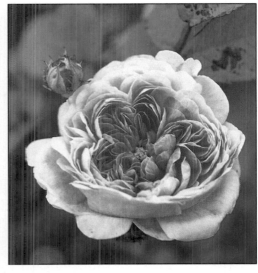

'GLOIRE DE FRANCE'

GLOIRE DE FRANCE
Unknown origin, pre-1819

Gallica shrub, flowering in summer. This member of the gallica group has flowers of gentle pink with lilac overtones, and appears less apt than the others to mildew after blooming. The flowers are works of art, and it would take a skilful draughtsman to depict them, jammed as they are with petals trying to go in all directions. Rather lax and spreading, up to 1x1.2m (3x4ft). Plant this for border, fragrance, health, rosarium, front of shrubbery, spreading.

'GINGERNUT'

shade, bearing even clusters on neat upright plants. The foliage is dark glossy green. 75x60cm (30x24in). ROTY. Plant this for bed, border, hedge (50cm-20in).

GLENFIDDICH
Cocker, Scotland, 1976

Floribunda cluster flowered bush, flowering summer to autumn. A pure and beautiful amber yellow colour. The flowers have about two dozen large petals, giving them good hybrid tea form in their early stages. They hold their shape and rich colour much better in cooler northern Britain than in the south, where they are paler and the open flowers look ragged. Observations in Aberdeen and Hitchin suggest that amber roses are especially sensitive to differences in the quality or the amount of light. Upright growth, with dark green foliage, to 85x60cm (33x24in). Seedling x ('Sabine' x 'Circus'). Named after the celebrated malt whisky which was associated very successfully with its introduction. Plant this for bed, border, fragrance, health, hedge (50cm-20in), and see note above about locality.

GLOIRE DE DIJON
Jacotot, France, 1853

Noisette climber, flowering summer and autumn. This classic old rose is still offered by many nurseries. The flower colour is a subtle blend of buff-orange with hints of salmon, paling towards the margins of the petals. The flowers are full of petals, quartered, and fairly large (10cm-4in across). Starts flowering early, and usually has flower somewhere on the plant until forced into winter dormancy. Can attain 4.5x4m (15x12ft), but is not the most handsome of plants, as the foliage looks skimpy. Said to have been raised from a Tea rose x 'Souvenir de la Malmaison', leading to much spillage of ink over whether it should be called a Tea Climber or a Noisette. Plant this for high fence, fragrance, rosarium, high wall. One often sees it recommended for a north wall, perhaps because it was seen to do well in that situation, but it is madness to sacrifice this old treasure on such an uncongenial altar; give it the best, SW for preference where the setting sun can add its glory to those pretty colours.

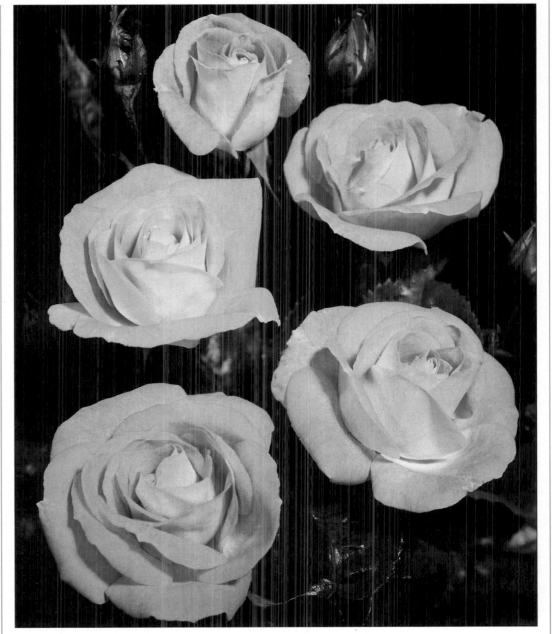

'GLENFIDDICH'

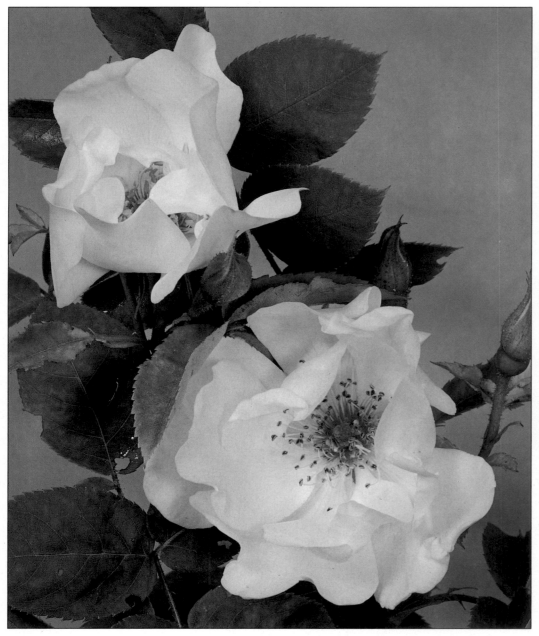

'GOLDEN WINGS'

GLOIRE DES MOUSSEUX
Laffay, France, 1852
Moss shrub, flowering in summer. This is thought to have the largest flower of any of the moss roses, 14cm (6in) across. The cupped blooms are bright pink, paling to blush. The petals are so crowded that they fold into one another as if to find room within the flower. The mossing and the leaves are bright green, and the plants vigorous to 1.2mx90cm (4x3ft). Plant this for border, fragrance, rosarium, shrubbery.

GOLDEN ANGEL
Moore, USA, 1975
Miniature, flowering summer to autumn. This is one of the shorter miniatures, with double flowers large in relation to the plant. They are deep yellow. Bushy growth to 30x35cm (12x14in). It is astonishing that Ralph Moore obtained pigmies such as this through his use of 'Golden Glow', a rampant climber, as the seed parent, and illustrates how grateful breeders ought to be that genes are capable of such surprises. The pollen parent was 'Little Darling' x seedling. Plant this for container, small space.

GOLDEN CHERSONESE (Hilgold)
Allen, England, 1969
Species hybrid shrub, early summer flowering. This is an interesting hybrid between *R. ecae*, which is a beautiful deep yellow wild rose but not easy to establish, and the less intense yellow and more vigorous 'Canary Bird'. The result is an upright plant with red stems, ferny light green foliage, and a striking display of rich buttercup-like blooms along the branches. It grows more readily than *R. ecae* though die back sometimes occurs. Avoid sites exposed to the effects of spring frost and east wind. 1.8x1.5m (6x5ft). The name is an ancient one referring to the Malay Peninsula. Plant this for back of border, fence, fragrance, rosarium, shrubbery, wall.

GOLDEN JUBILEE (Cocagold)
Cocker, Scotland, 1981
Hybrid tea large flowered bush, flowering summer to autumn. Big yellow flowers, with a touch of pink, are carried on stiff stems, with surprising freedom considering the size and quality of the blooms. The plants have crisp foliage and sturdy growth, and they make useful anniversary presents. 90x60cm (3x2ft). 'Peer Gynt' x 'Gay Gordons'. Plant this for bed, border, health, hedge (50cm-20in); weatherproof.

GOLDEN SHOWERS
Lammerts, USA, 1957
Climber, flowering summer to autumn. This is one of the world's most popular and pleasurable roses, whose performance is hard to fault in any way. The flowers are elegant in bud, cheerful with their bright yellow fragrant flowers, drop their petals cleanly, and are quick to repeat. The leaves have a pleasing gloss to them, and adequately clothe the plant, though more foliage would be welcome. As for the wood, it throws out plenty of fresh shoots, rarely dies back, and blithely responds to whatever treatment, from brutal pruning to near neglect, that its owner prescribes. It is convenient to cut, having long flower stems with comparatively few prickles, and seems little troubled by disease. After thirty years in commerce it ought to be deteriorating, but there is no other climber in the colour that gives such good value. 3x2m (10x6ft) or more or less according to treatment. 'Charlotte Armstrong' x 'Captain Thomas'. AARS, GM Portland. Plant this for border (with or without support), fence, fragrance, health, tall hedge (1m-40in) with pruning, pergola, pillar, wall; weatherproof.

GOLDEN WINGS
Shepherd, USA, 1956
Shrub, flowering summer to autumn. The parentage of this is given as 'Soeur Therese' x (*R. spinosissima altaica* x 'Ormiston Roy'), the species involved being a very hardy Scotch rose. The resulting shrub is valuable because it is so free flowering, illustrating the point that though a first generation cross with a species will give once-flowering offspring only, the genes for repeat-flowering can be unmasked a generation later. The rose has large pale yellow flowers, up to 12cm (5in) across, and usually of five petals. They have a frail look, perhaps by contrast with the tough and thorny plants, but in fact stand bad weather well. 1.1x1.3m (42x54in). GM ARS. Plant this for border, low fence, fragrance, health, hedge (1.1m-42in), rosarium, shrubbery, low wall; weatherproof.

GOLDEN YEARS (Harween)
Harkness, England, 1990
Floribunda cluster flowered bush, flowering summer to autumn. The colour of this rose is golden yellow with a suggestion of bronze. The blooms are cupped and average over 40 petals, very full for a floribunda and large in relation to the plant, so that as they open they make a most colourful display. They have a generous accompaniment of shiny dark green leaves. Bushy habit and vigorous growth to 75x60cm (30x24in). 'Sunblest' x 'Amber Queen'. GR & PRIZE Hradec Kralove. Named for the centenary celebrations of Hitchin Girls Grammar School. Plant this for bed, border, fragrance, hedge (50cm-20in); weatherproof. It is a most acceptable rose to give for anniversary occasions.

GOLDFINCH
Paul, England, 1907
Climber, flowering in summer. In a good summer, established plants are bowed down with clusters of small pointed pale gold buds, which on opening become ivory-white rosettes, 4cm (1.5in) across, with the golden stamens showing in their hearts. Not every season suits it, but the rewarding ones are worth the wait. It is an easy plant to grow, but be careful not to prune away good basal stems by mistaking them for suckers; if in doubt, leave them alone and wait until you can be sure. 2.2x2m (9x6ft). Parentage uncertain. Plant this for fence, fragrance, health, naturalising, pergola, pillar, weeping; weatherproof.

GOLDSTAR (Candide, Goldina)
Cant, England, 1983
Hybrid tea large flowered bush, flowering summer to autumn. A consistently good garden performer, with medium sized urn-shaped flowers of bright yellow which last well when cut. They are carried on upright firm stems, rather high on the plant, against dark green shiny leaves. 95x60cm (3x2ft). 'Yellow Pages' x 'Dr A.J. Verhage'. GM The Hague. Plant this for bed, border, cutting, health, hedge (50cm-20in); weatherproof.

GRACE ABOUNDING
Harkness, England, 1968
Floribunda cluster flowered bush, flowering summer to autumn. Forms great clusters of open flowers, in a variety of pale shades – off white, cream or wheat or even pink. A beautiful sight, all those open blossoms, both in the garden and on the show bench, where it excels. Leafy, with a pleasing shrublike habit of

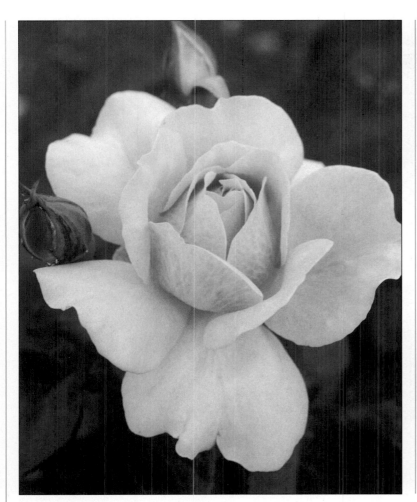

'GOLDEN YEARS'

'GOLDSTAR'

growth. 90x75cm (36x30in). 'Pink Parfait' x 'Penelope'. The name, which describes its qualities so aptly, is taken from one of the works of John Bunyan. Plant this for bed, border, exhibition, musk fragrance, health, hedge (60cm-2ft).

GRAHAM THOMAS (Ausmas)
Austin, England, 1983
Shrub, flowering summer to autumn. The novelty of this yellow rose lies in its resemblance in form and petal arrangement to the large flowered hybrid perpetual and other shrubs of the nineteenth century. In those days all they had were reds, pinks, and pale shades. What a sensation it would have been! 'Graham Thomas' is a good clear yellow, deeper in the centre of the full cupped flowers. The flowers are heavy which causes its long stems to bow, especially after rough weather; in other respects it is a fine rose, with shiny bright foliage. 1.2x1.5m (4x5ft). Named to honour the leading authority on the older roses. Plant this for border, low fence, fragrance, health, low pillar, rosarium, shrubbery.

GRANDPA DICKS0N (Irish Gold)
Dickson, N. Ireland, 1966
Hybrid tea large flowered bush, flowering summer to autumn. Remarkable for the flawless perfection of the light yellow blooms; they have the ideal hybrid tea combination – size with elegance. It follows that they are much favoured by exhibitors, and the freedom with which they flower makes this an excellent garden rose as well. In hot weather there are pink flushes on the petal edges. Growth is upright, not tall, and the only obvious improvement would be in the foliage, which could be more plentiful. 75x60cm (30x24in). ('Perfecta' x 'Gov. Braga de Cruz') x 'Piccadilly'. GM Belfast, Portland, RNRS, The Hague, GR The Hague, PIT RNRS. That haul certainly justifies the name 'Irish Gold' under which it is sold in USA. The Dickson in its title was Alex (1893-1975), fourth generation of the family firm, admired for his breeding skill and for his modest character; a tangible measure of his success is the gold chain worn by mayors of Newtownards to this day, which was created by

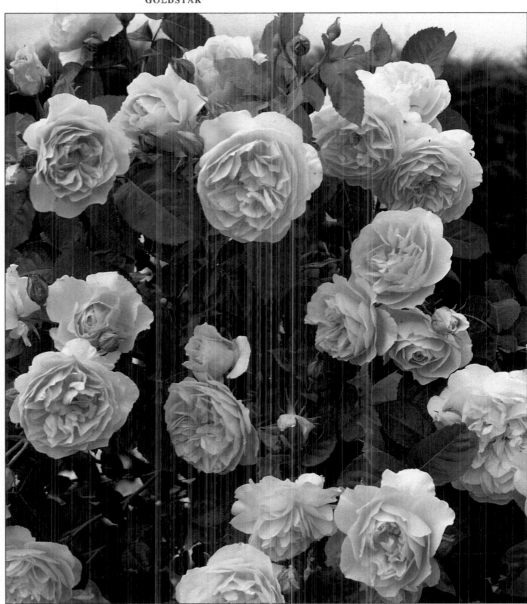

'GRAHAM THOMAS' GROWN IN STANDARD FORM.

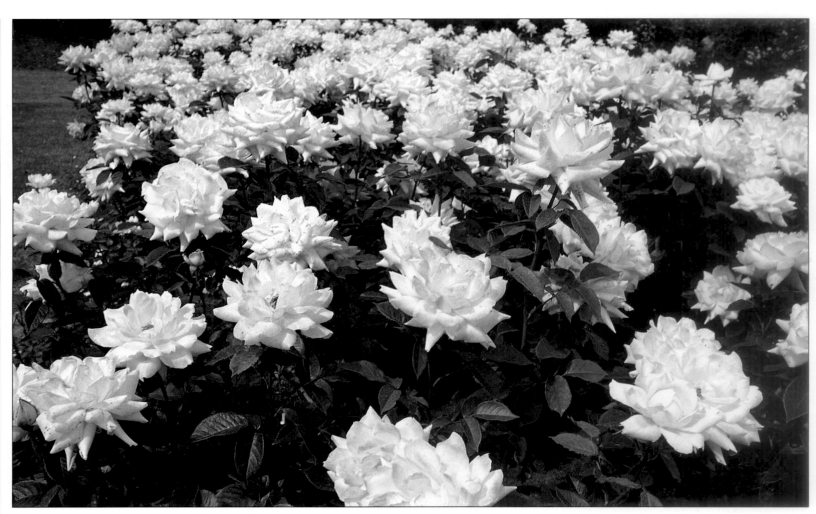

'GRANDPA DICKSON' IN REGENT'S PARK, LONDON.

melting down some of Alex Dickson's many medals. Plant this for bed, border, exhibition, health, hedge (50cm- 20in); weatherproof.

GREEN DIAMOND
Moore, USA, 1975
Miniature, flowering summer to autumn. This is an oddity, only worth growing for the strange colour. It is not always certain of its greenness; the buds are whitish and the dying flowers pale straw. In between a host of petal tips peep shyly at the sunshine, greening as they open out. In cool weather they may not come out at all, so the best answer is to grow this under glass. Compact and leafy, 30x30cm (12x12in). Seedling x 'Sheri Anne'. Plant this for container, curiosity, glasshouse.

GREENSLEEVES (Harlenten)
Harkness, England, 1980
Floribunda cluster flowered bush, flowering summer to autumn. This was an unexpected by-product of trying to breed for fragrance, which the variety lacks entirely. Instead it has in the open flowers as green a colour as any rose. The buds have pink cones, and open flat to show chartreuse green on the inside of the petals. The flowers come in long-stemmed sprays, and for cutting should be taken before the buds are fully open; the blooms stay fresh and green for up to a fortnight if they are treated in this way. Otherwise the flowers mottle and discolour. The plant grows leggy, with dark foliage, and a watch should be kept for blackspot. 90x45cm (36x18in). ('Rudolph Timm' x 'Arthur Bell') x seedling. PRIZE Baden-Baden. The name is the title of a well-known English folk song. Plant this for curiosity, cutting.

GREEN SNAKE (Lenwich)
Lens, Belgium, 1985
Ground cover species hybrid, flowering in summer. Bears white flowers, small and single, in clusters on very prostrate plants, that grow as if imitating a snake's sinuous progress. Has small spoon shaped leaves. 45cmx1.3m (18x54in). Bred from two wild roses, *R. arvensis x R. wichuraiana*. Plant this for front of border, curiosity, ground cover, health, rosarium; weatherproof. Because it flowers in summer only, it will probably not be in demand commercially, but could play a fascinating role in future breeding.

GROUSE (Immensee, Korimro, Lac Rose)
Kordes, Germany, 1984
Ground cover, flowering summer and autumn. Makes a creeping mound, with thousands of tiny bright leaves and hundreds of small flat flowers of blush white, showing prominent yellow stamens. Casts a delicious fragrance in the air around. Gets full marks for health and beauty, but the later bloom is sporadic, and the plant so adventurous that it needs careful placing or it will swamp its neighbours. Best left to romp unpruned. 60cmx3m (2x10ft). 'The Fairy' x *R. wichuraiana*. GM RNRS. Plant this for front of big border, fragrance, ground cover, health, naturalising, front of shrubbery; weatherproof.

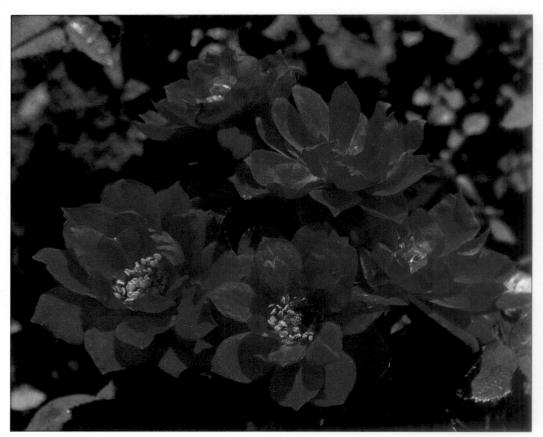

'GUIDING SPIRIT'

GUIDING SPIRIT (Harwolave)
Harkness, England, 1989
Patio or dwarf cluster flowered bush, flowering
summer to autumn. An unusual rose, very prolific
with its deep rose red flowers. They open rather flat,
displaying neatly arranged petals of an elegant fluted
shape, and because the flower stems are very short
they seem to be perching on the compact dark-leaved
bushes. 50x40cm (20x15in). ('Blue Moon' x seedling)
x 'Little Prince'. Named for the World Association of
Girl Guides and Girl Scouts in the centenary year of
the birth of Olave, Lady Baden-Powell, and sold
initially to aid their work. Plant this for bed, front of
border, container, health, low hedge (38cm-13in),
small space; weatherproof.

GUINEE
Mallerin, France, 1938
Climber, flowering mainly in summer. Perhaps the
best rose of all to plant for intensely blackish crimson
flowers. They are large, full and cup-shaped, borne
mostly in summer, and beautiful when the sun gives
velvety reflections off the petals. After the summer
show there may be a few laggards, which do not
match the standard of the first lot. The growth is stiff
and vigorous. Up to 5x2.5m (15x8ft). 'Souv. de
Claudius Denoyel' x 'Ami Quinard'. English speakers
expecting a yellow rose for their money should know
that it was named after a French colony in the Dark
Continent of Africa. Plant this for high fence,
fragrance, health, high wall; weatherproof.

HAKUUN
Poulsen, Denmark, 1962
Dwarf cluster flowered or floribunda bush, flowering
summer to autumn. This lowly bush is a great
performer in the garden, bearing trusses of small buff
to creamy white flowers so prolific that they seem to
cover the plant. With so much energy expended on
the flowers, it is not surprising that the bushes are
small, but they are tough, hardy and adequately
foliaged. 45x45cm (18x18in). Seedling x ('Pinocchio'
selfed). 'Hakuun' means "white cloud" in Japanese,
and it was so named by the Danish raiser after being
awarded a medal in the trials there. Plant this for bed,
front of border, health, low hedge (40cm- 16in), small
space; weatherproof.

HAMBURGER PHOENIX
Kordes, Germany, 1955
Climber, flowering summer to autumn. Grown for
the overall colour impact rather than the individual
beauty of the blooms, which are semi-double, carried
in large clusters, and rich crimson. If the dead heads
are picked off, it gives excellent flower value in the
garden. Leafy, dense, 2.8x2m (9x6ft). *R. kordesii* x
seedling. Plant this for fence, health, pillar, wall;
weatherproof.

HAMPSHIRE (Korhamp)
Kordes, Germany. 1989
Ground Cover bush, flowering summer to autumn.
Their bright colour and yellow stamens catch the eye
as the scarlet single flowers unfold. Forms a dense
shrublet, about 30cmx60cm (12x24in), with many
small shiny leaflets. Named for the county council's
centenary. Plant this for bed, front of border, compact
ground cover, health, small space, wind.

HANDEL
McGredy, N. Ireland, 1965
Climber, flowering summer to autumn. This is
distinctive and easy to recognise when it holds aloft
its blush flowers, rimmed with red, in wide clusters
on upright stems. The buds are slender, very pretty for
buttonholes, and open into loosely double 8cm (3.5in)
blooms of circular outline and neat form. The pinky
red rims make them most attractive, but may be
absent in hot weather. This rose always seems to be in
bloom, and can be pruned to form a hefty bush but

'HAKUUN'

'HAMBURGER PHOENIX'

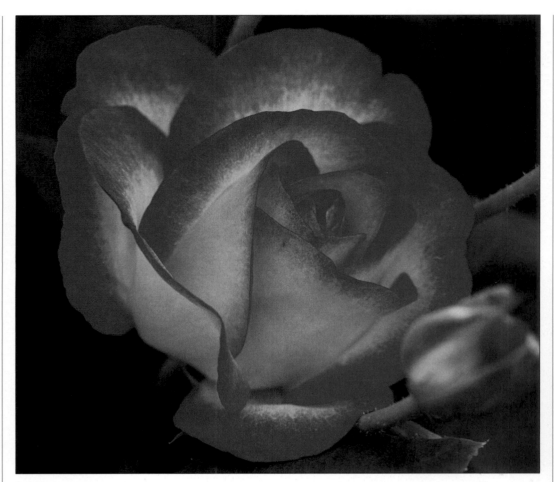

'HANNAH GORDON'

looks better with support. Up to 3x2.2m (10x7ft). 'Columbine' x 'Heidelberg'. GM Portland. Plant this for cutting, exhibition, fence, pillar, wall; weatherproof.

HANNAH GORDON (Korweiso)
Kordes, Germany, 1983
Floribunda cluster flowered bush, flowering summer to autumn. In flower colour and form, this is rather like 'Handel' described above, except that it is a bush rose, the blooms are larger with more petals, and the coloration is more subtle, cherry pink rather than pinky red. The growth is bushy, with fairly large deep green leaves. 75x60cm (30x24in). Seedling x 'Bordure'. Named for the celebrated actress who is well known for her interest in gardening. Plant this for bed, border, cutting; weatherproof.

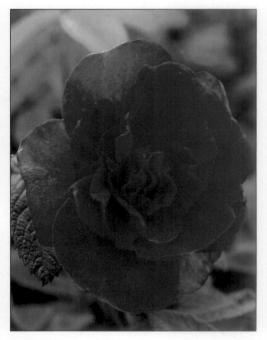

'HANSA'
HANSA
Schaum & Van Tol, Holland 1905
Rugosa shrub, flowering summer to autumn. This useful hardy plant, like its other rugosa cousins, gives colour for months on end, and good leaf cover. The large flowers are violet red highlighted with mauve, and so heavy with petals as to cause the necks to bow. Their fragrance has been likened to cloves. Upright, 1.3x1m (54x40in). Plant this for big border, fragrance, health, large hedge (90cm-36in), hips, shrubbery, specimen plant; weatherproof.

HARKNESS MARIGOLD (Hartoflax)
Harkness, England, 1986
Floribunda cluster flowered bush, flowering summer to autumn. The colour is unusual, best described as rich peachy pink salmon. The flower sprays are very large and well spaced, each neatly formed flower having some thirty petals, and because of the energy needed to produce them it begins to bloom later than most roses. Strong grower but not over tall, 1mx60cm (40x24in). 'Judy Garland' x 'Anne Harkness'. Named by Mrs Marigold Somerset through a fund-raising exercise undertaken by the Worshipful Company of Farriers, on behalf of Riding for the Disabled. Plant this for tall bed, border, exhibition, health, upright hedge (50cm-20in); weatherproof.

HAROLD MACMILLAN (Harwestsun)
Harkness, England, 1989
Floribunda Cluster Flowered bush, flowering summer to autumn. Orange red, a very noticeable and luminous shade. It carries several flowers in the spray, and their broad petals display the colour to advantage; it is remarkable how well they hold the beautiful tone with little fading and no sign of "blueing". The bushes

'HARKNESS MARIGOLD'

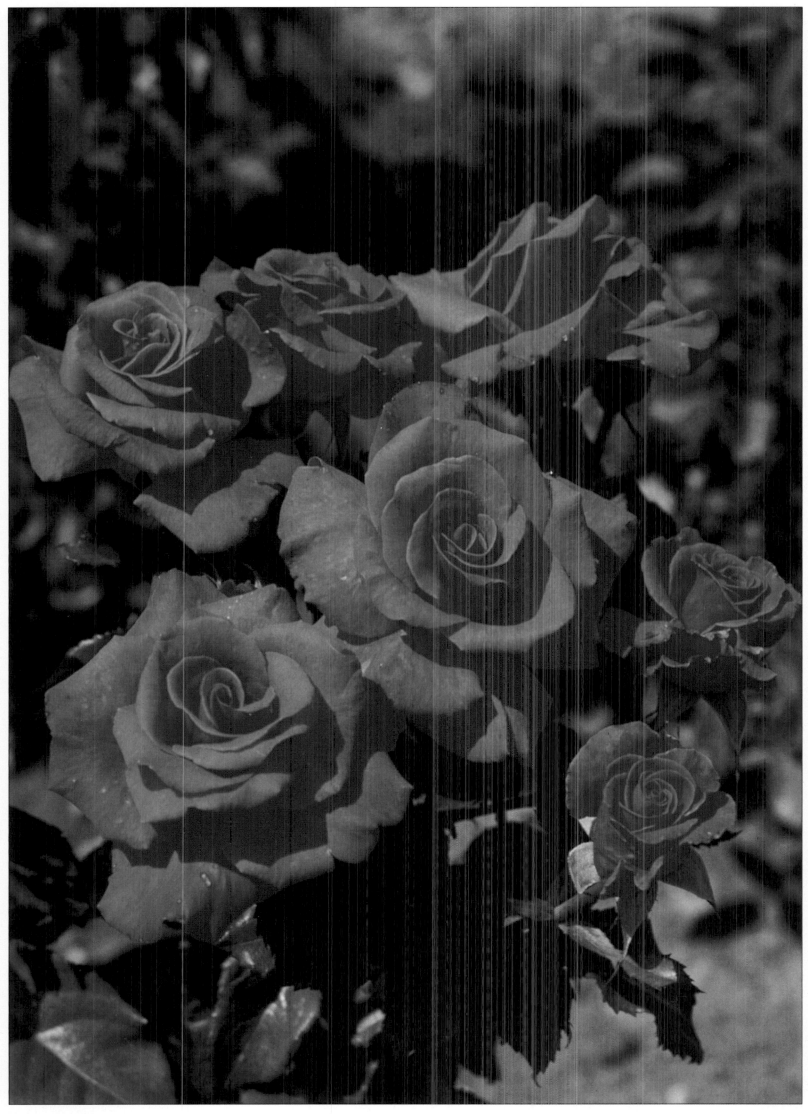

'HAROLD MACMILLAN'

'HARISON'S YELLOW'

are clothed with dark glossy foliage and grow with a high shouldered habit to 80x65cm (32x26in). 'Avocet' x 'Remember Me'. Named for the former premier. Plant this for bed, border, health, hedge (60cm-24in); weatherproof.

HARISON'S YELLOW (Harisonii)
Harison, USA, ca.1830
Species hybrid shrub, early summer flowering. This is a mystery rose which appeared in New York and became so popular and widespread that it was the subject of a famous song – "The Yellow Rose of Texas". What made it so special was the colour of the flowers, a really deep and bright yellow, and the fact that it had larger and fuller petalled blooms than the single *R.foetida*, the only other deep yellow known to have been in the USA. There is speculation that that species might have crossed with a paler yellow Scotch rose, and so given rise to the mystery plant. 'Harison's Yellow' makes a rather unkempt shrub with fussy foliage, but is welcomed for its cheerful early season bloom. 1.5x1.2m (5x4ft). Plant this for sizeable border, rosarium, shrubbery.

HARRY EDLAND
Harkness, England, 1977
Floribunda cluster flowered bush, flowering summer to autumn. This lilac pink rose is one of the easiest to grow in the not very popular colour. The flowers are well formed, large, full, and scented, usually three or more to a stem, though in New Zealand it may behave differently, for there it is reckoned a hybrid tea. Bushy, rather open habit, with large dark leaves. 90x60cm (3x2ft). Four lilac roses are in the parentage. FRAG RNRS. Named in memory of a former Secretary of the National Rose Society. Plant this for bed, border, fragrance, hedge (50cm-20in); weatherproof.

HARRY WHEATCROFT (Caribia, Harry)
Wheatcroft, England, 1972
Hybrid tea large flowered bush, flowering summer to autumn. A sport of the bicolour red and yellow 'Piccadilly', but striped in the most extraordinary way to give bizarre and colourful results. Behaves in other respects like 'Piccadilly'. 75x60cm (30x24in). Aptly chosen to bear the name of one of Britain's most successful postwar nurserymen, known for his extrovert behaviour which cloaked a shrewd head and kind heart. Plant this for bed, border, curiosity, hedge (50cm-20in); weatherproof.

HARVEST FAYRE (Dicnorth)
Dickson, N. Ireland, 1990
Floribunda cluster flowered bush, flowering summer

'HARRY WHEATCROFT'

to autumn. The colour, a pretty shade of orange apricot, stands out most noticeably when you see this from a distance, and this is particularly true in autumn when it continues late in flower. The blooms are neatly formed, of medium size, and carried in well spaced sprays on firm stems. Growth is bushy, with plenty of light green shiny foliage. 75x60cm (30x24in). ROTY. Plant this for bed, border, health, hedge (50cm-20in); weatherproof.

HARVEST HOME (Harwesi)
Rock, England, 1983
Rugosa shrub, flowering summer to autumn. This makes a pleasing rounded shrub of modest size, full

'HARVEST FAYRE'

of typically wrinkled rugosa leaves, and bearing a succession of mauve-pink loosely cupped flowers all through the flowering season. Some of them result in hips, of the shape and size and colour of small tomatoes. It is an easy rose to grow and will suit those who want shrub roses for a small garden. 1x1m (40x40in). Seedling of 'Scabrosa'; it got its name because it originated from seed contained in a strangely shaped 'Scabrosa' hip found by Mrs Rock in her back garden. Plant this for large bed, border, fragrance, health, hedge (90cm-3ft), hips, shrubbery, small-scale specimen plant, spreading; weatherproof.

HEBE'S LIP (Rubrotincta, Reine Blanche)
Paul, England, 1912
Damask shrub, flowering in summer. The buds are tinted red, and open into wide creamy semi-double flowers, with hints of reddish pink upon their tips. The effect is very restful and pleasing against dark foliage. Growth untidy and rather twiggy, 1.2x1.2m (48x48in). It is thought likely that the parents are a Damask and a Sweet Briar. Plant this for border, low fence, fragrance, rosarium, shrubbery; weatherproof.

HELEN KNIGHT
Knight, England, 1970
Species hybrid shrub, early summer flowering. For years one of the early season delights at the Royal

'HEBE'S LIP'

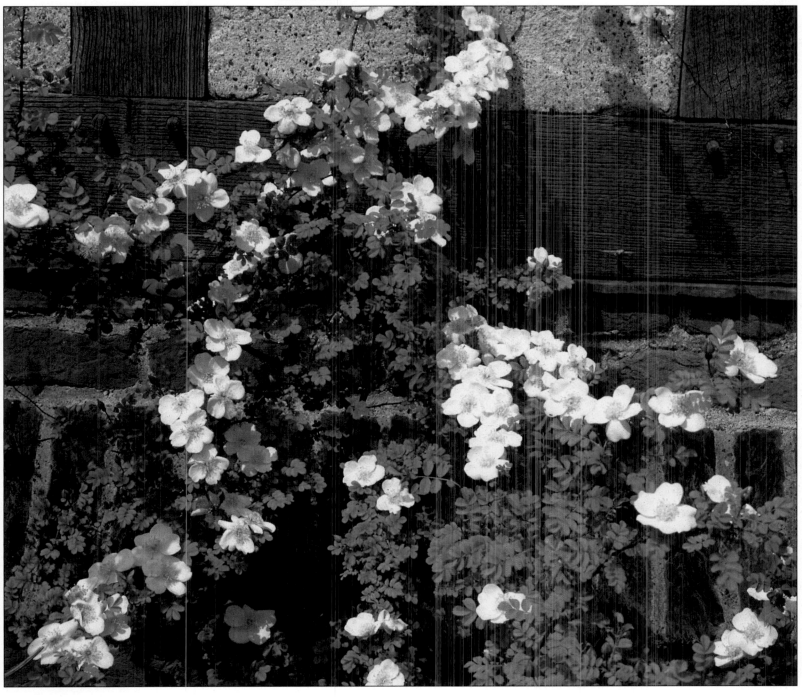

'HELEN KNIGHT'

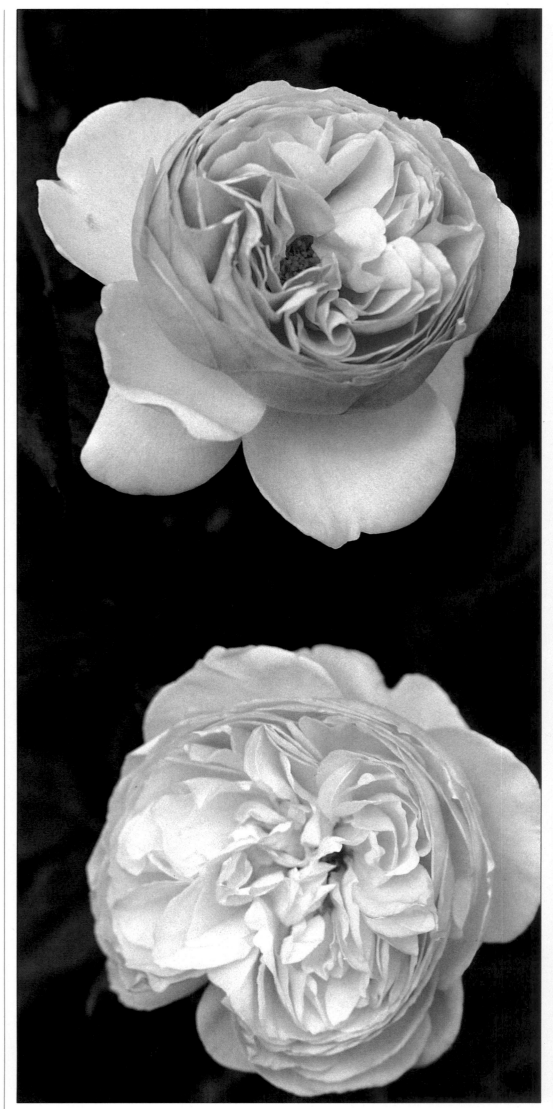

'HERITAGE'

Horticultural Society's Wisley gardens has been the sight of this rose bearing its clear yellow saucer shaped flowers in great sweeps along the branches. It can be allowed to run up against a wall, or grown as a free standing plant to 2.2x1.3m (7x5ft). Raised from *R. ecae* (whose fernlike foliage it shares) maybe crossed with a Scotch rose. Plant this for back of border, fence, rosarium, shrubbery. Wall; avoid sites exposed to frost and east wind.

HERITAGE (Ausblush)
Austin, England, 1984
Shrub, flowering summer to autumn. Bears cupped flowers of over forty petals, prettily infolded in the shell-pink blooms, which have greater depth of colour in their centres. Makes a sturdy bushy plant, with dark semi-glossy foliage. 1.2x1.2m (4x4ft). Seedling x 'Iceberg' seedling. Plant this for border, low fence, fragrance, hedge (1m-40in), shrubbery, low wall.

HIGHFIELD (Harcomp)
Harkness, England, 1980
Climber, flowering summer to autumn. This is a yellow sport of 'Compassion', and similar in most respects save colour. The flowers are not so full, and on rare occasions a flower or stem has shown reversion to the parent form. 2.5x2.2m (8x7ft). PRIZE Geneva. Named to mark the sixtieth anniversary of Highfield Nurseries in Gloucestershire. Plant this for fence, fragrance, pillar, wall; weatherproof.

HIGHLAND LADDIE (Cocflag)
Cocker, Scotland, 1989
Floribunda cluster flowered bush, flowering summer to autumn. Signals its presence with wide showy heads of scarlet blooms made up of prettily crinkled petals. It is a tough rose for standing up to weather conditions, and a colourful choice for public parks. Growth is fairly upright, 80x60cm (32x24in). 'National Trust' x 'Dainty Dinah'. Plant this for bed, border, hedge (50cm-20in); weatherproof.

HIROSHIMA'S CHILDREN (Harmark)
Harkness, England, 1985
Floribunda cluster flowered bush, flowering summer to Autumn. Basically a light yellow rose, with much cream and pink, especially towards the petal margins. The flowers are like hybrid teas reduced in scale to 9cm (3.5in) across, with that delicate parting of the outer petals that makes a rose so tempting to cut. The growth is rather open and branching, with the flower clusters held on stiff stems. 75x70cm (30x24in). Seedling of 'Bobby Dazzler'. Named at the request of Dr Tomin Harada, who was away serving with the Japanese army's medical corps when the atomic bomb fell on his home city of Hiroshima; he dedicated his life to caring for the survivors, and presented this rose to the city as a symbol of peace and harmony on the fortieth anniversary of the attack. Plant this for border, cutting.

HOLLIE ROFFEY (Harramin)
Harkness, England, 1986
Miniature, flowering summer to autumn. Bears pretty rosettes of a clear even pink, little more than 2cm (1in) across yet filled with some sixty tiny petals. Their lasting quality makes this a useful plant to cut for small arrangements. The plants grow very compact, with small dark leaflets. 30x30cm (12x12in). Seedling x 'Darling Flame'. Named in memory of a young child who died in tragic circumstances.

HONEYBUNCH (Cocglen)
Cocker, Scotland, 1989
Patio or dwarf cluster flowered bush, flowering summer to autumn. The range of petite bush roses is visibly improving, and this one has a wheaten yellow background with touches of light salmon, and fully double well formed blooms. They are neatly spaced in the short clusters, and good to cut for small

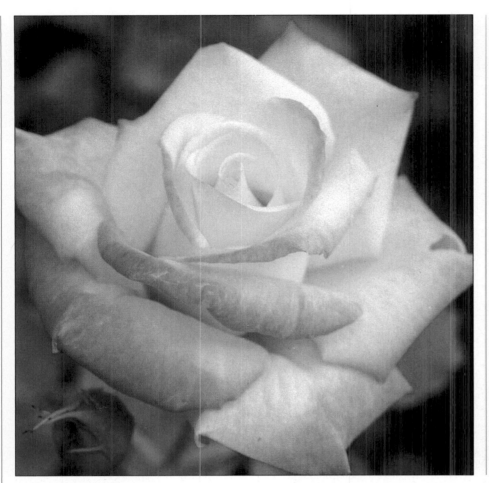

'HIROSHIMA'S CHILDREN'

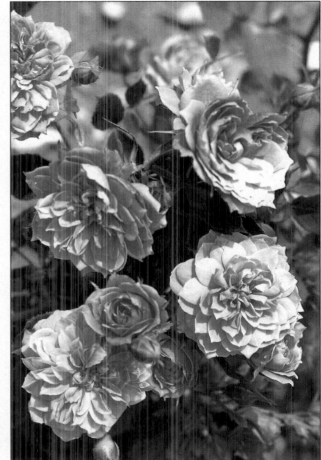

'HOLLIE ROFFEY'

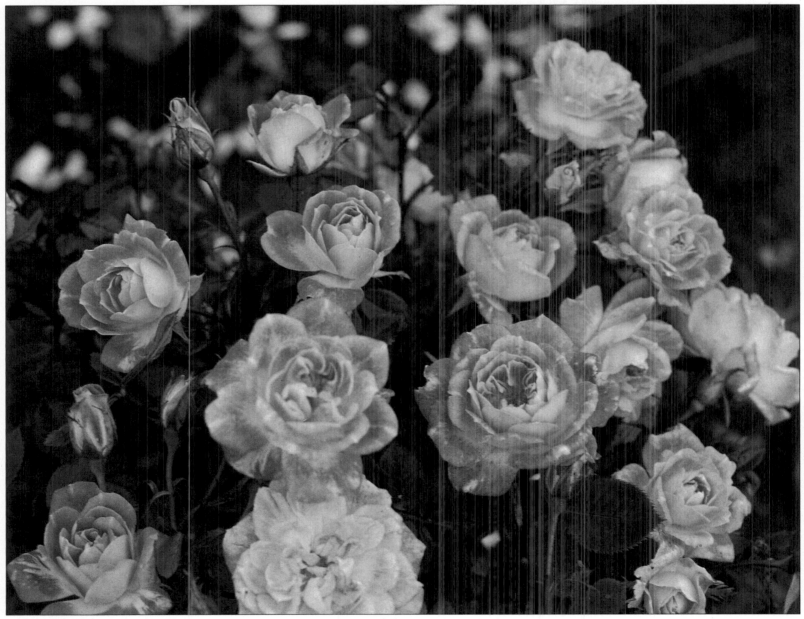

'HONEYBUNCH'

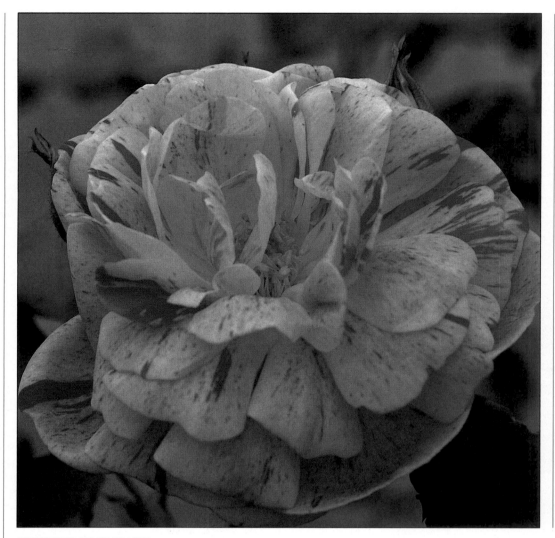

'HONORINE DE BRABANT'

arrangements. 45x45cm (18x18in). Seedling x 'Bright Smile'. Plant this for small bed, front of border, container, cutting, fragrance, low hedge (40cm-16in), small space; weatherproof.

HONEYMOON (Honigmond)
Kordes, Germany, 1959
Floribunda cluster flowered bush, flowering summer to autumn. This clear yellow full petalled rose was something of a landmark at the time of its introduction, admired for its vigour, health and hardiness as well as for the beauty of the large flowers, carried high on the plant in generous clusters. It is still grown by many nurseries, but other varieties can claim to have bushier bedding habits and greater freedom of bloom. Its best use would be in a mixed border with lower plants in front. 90x60cm (3x2ft). 'Cläre Grammerstorf' x 'Spek's Yellow'. Plant this for border, fragrance, health; weatherproof.

HONORINE DE BRABANT
Origin unknown
Bourbon shrub/climber, flowering summer, some in autumn. This has remarkable colouring, striped and mottled crimson and purple on a lilac pink background. The medium sized flowers are cupped, fairly full of petals and sometimes quartered. They also have good scent, but the plant that carries them is rather sprawling, and difficult to grow satisfactorily without support. Plentiful light green foliage, bushy wide growth to 2x2m (6x6ft). Plant this for open fence, fragrance, pillar (or rather tripod to allow free circulation of air), shrubbery with support.

ICEBERG (Schneewittchen, Fee des Neiges)
Kordes, Germany 1958
Floribunda cluster flowered bush, flowering summer

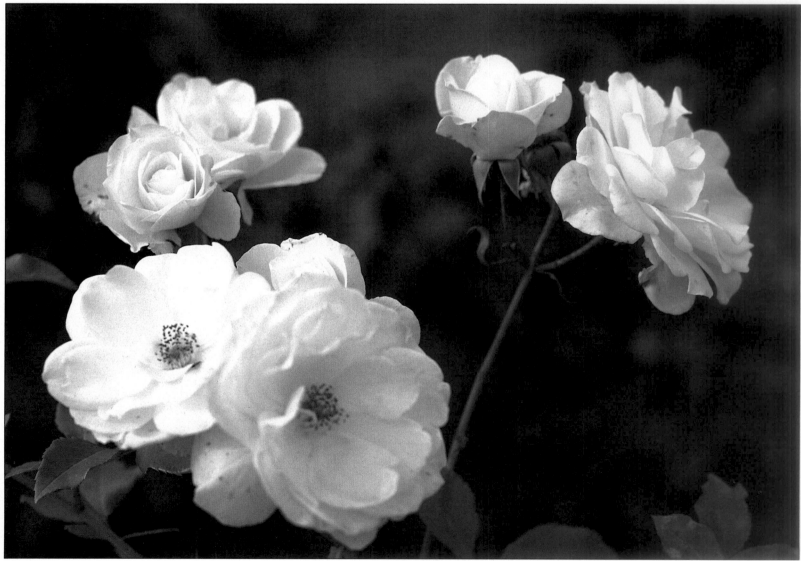

'ICEBERG'

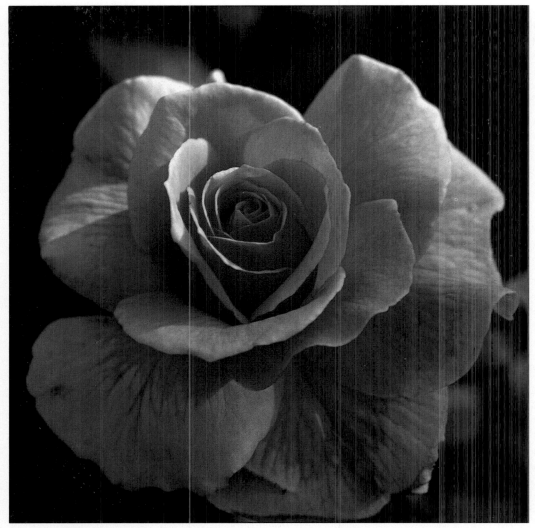

'ICED GINGER'

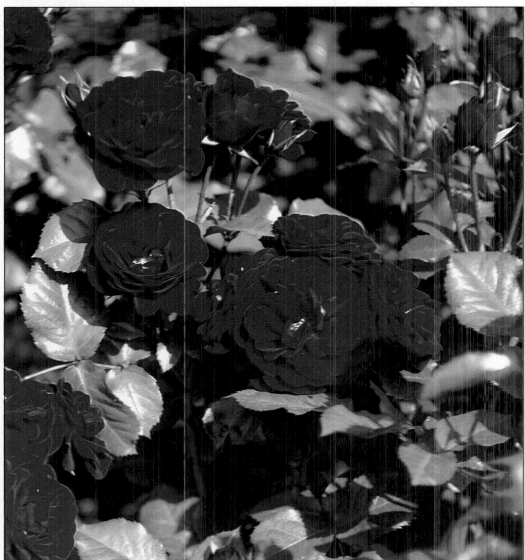

'INTRIGUE'

to autumn. A great rose, which for years has been the world's favourite cluster flowering white. It scores for the freedom with which it produces its flowers, their pretty rounded shape, their placement in the cluster, and the way they drop their petals cleanly. The whole plant has a graceful rounded outline and looks handsome in a group or by itself. The foliage is plentiful, shiny and attractive. 90x75cm to 1.5mx90cm (36x30in to 5x3ft) according to pruning; with light pruning it makes a fine specimen bush. 'Robin Hood' x 'Virgo'. ADR, GM Baden-Baden & NRS, PRIZE Orleans. Plant this for bed, border, exhibition, hedge (70cm-27in), shrubbery, specimen plant; weatherproof.

CLG ICEBERG
B.R.Cant, England, 1968
Floribunda cluster flowered climber, flowering in summer, some later. The climbing sport of 'Iceberg' has the same good flower qualities as the bush. The amount of flower late in the season seems to vary; the first flowering is a glorious sight. 3x3m (10x10ft). Plant this for fence, pergola, wall; weatherproof.

ICED GINGER
Dickson, N. Ireland, 1971
Floribunda cluster flowered bush, flowering summer to autumn. Has one of the largest flowers among the floribundas, 11cm (4.5in) across, and they are well formed, full of petals, and a strange mélange of colours – buff to copper with ivory and pink. This confection yields some of the prettiest roses imaginable, and they are good for cutting. The habit of the plant is not good, being lanky and open; shorter items should be planted in front. 1mx75cm (40x24in). Seedling of 'Anne Watkins'. Plant this for border (see note above), cutting.

INGRID BERGMAN ((Poulman)
Poulsen, Denmark, 1986
Hybrid tea large flowered bush, flowering summer to autumn. The flowers are an excellent shade of dark red, really deep and without the influence of magenta to "blue" them. In form they vary from the beautiful to the indifferent, depending on the time of year; at their best they are excellent for cutting, being of middling size and with long firm stems, and the flowers are produced freely. The growth is free and branching but the flower stems protrude noticeably above the general level of the dark leathery leaves. 80x60cm (32x24in). 'Precious Platinum' x seedling. GM Belfast & Madrid, GR The Hague. Named after the famous actress. Plant this for bed, border, health; weatherproof.

INTERNATIONAL HERALD TRIBUNE
(Harquantum, Violetta, Viorita)
Harkness, England, 1985
Dwarf cluster-flowered floribunda bush, flowering summer to autumn. The colour of this rose is violet bordering on lilac purple, of a rich and bright intensity rarely seen in roses. The continuity of bloom is excellent. Habit short and neat, with dark crisp leaves. 40x40cm (15x15in). Seedling x [(Orange Sensation x Allgold) x *R. californica*]. GM Monza, Tokyo, GR Geneva, PRIZE Baden-Baden, Geneva. Named for the IHT's tenth anniversary. Plant this for bed, border, container, curiosity, fragrance, health, hedge. (40cm -16in), small space; weatherproof.

INTRIGUE (Korlech, Lavaglow, Lavaglut)
Kordes, Germany, 1979
Floribunda cluster flowered bush, flowering summer and autumn. The flowers are intensely dark velvety red, like jewels when sun lights up the petals. They are carried in quite big sprays, held close to the plants, and the double flowers open up like camellias. With its neat well spread habit and dark foliage, this has all

'INVINCIBLE'

the desired qualities of a fine bedding rose, except that it may need watching in bad blackspot areas. 75x65cm (30x24in). 'Grüss an Bayern' x seedling. Plant this for bed, border, exhibition, hedge (60cm-20in); weatherproof.

INVINCIBLE (Fennica, Runatru)
De Ruiter, Holland, 1983
Floribunda cluster flowered bush, flowering summer to autumn. The flowers are bright crimson, and carried firmly upright in well spaced heads, creating a very colourful effect, for they are quite large and full of petals. They last on the plant for many days without losing their neat form. The leaves have a nice sheen to them, and the whole ensemble looks clean and tidy. 75x60cm (30x24in). 'Rubella' x 'National Trust'. Plant this for bed, border, health, hedge (50cm-20in); weatherproof.

IPSILANTE
Origin not known, ca.1821
Gallica shrub, flowering in summer. A delightful flower, light pink with lilac tones, opening flat with quartered petal form. The blooms can be very large, and the plant normally grows to about 1.2mx95cm (4x3ft), with rich dark green foliage. Presumably named for Alexander Ypsilanti, who as every Greek schoolchild knows, led a revolt against the Turks in 1821. Plant this for border, fragrance, shrubbery.

ISPAHAN (Pompon des Princes, Rose d'Isfahan)
Before 1832
Damask shrub, flowering in summer and with some later bloom. The origin of this is a mystery, but the name recalls the importance of Persia in the development of garden roses, both for the way varieties were cherished and preserved, and as a meeting ground for garden-minded travellers from east and west. 'Ispahan' makes a sturdy upright plant with

'IPSILANTE'

greyish leaves, and its clear pink blooms appear freely in clusters over a much longer period than is usual with old roses. They open to show a pretty arrangement of petals in the flowers as they reflex; it has been observed that they look fuller of petals than they are, so neatly are they ordered. Up to 1.5x1.2m (5x4ft). Plant this for border, fragrance, health, rosarium, shrubbery.

JACQUELINE DU PRE (Harwanna)
Harkness, England, 1989
Shrub, flowering summer to autumn. Clusters of slim buds open into wide semi-double flowers of ivory-blush, with scalloped edges to their petals, and red-gold stamens prominent in the centre. They are borne freely on vigorous bushy plants, well furnished with dark shiny leaves that make a wonderful background to the pale flowers. This is a rose of character, and the influence of Scotch roses in the parentage is shown in the flower form, sweet musk fragrance, hardiness and strong growth. 1.5x1.3m (60x54in). 'Radox Bouquet' x 'Maigold'. GM Le Roeulx. Jacqueline du Pré chose this rose to bear her name several months before her death; initial sales helped the work of The Multiple Sclerosis Society. Plant this for border, fence, fragrance, health, big hedge (1.2m-4ft), shrubbery, wall, wind.

JACQUES CARTIER (or Marquise Boccella)
Moreau-Robert, France 1868 (or Desprez, France, 1842)
The rose sold under the name 'Jacques Cartier' is classified as a Portland shrub, and its cupped pink flowers are lovely at their best, with more petals than you imagine any rose could hold. There is usually some autumn bloom. Growth is rather upright, very leafy and dense, to 1.2x90cm (4x3ft). The American Rose Society think the identity is wrong and that the rose is actually 'Marquise Boccella', classified as a hybrid perpetual. This illustrates the difficulty (some may say futility) of trying to pigeon hole these old roses into separate classes when there is little outwardly to distinguish them and the parentage is unknown. In USA it has caused an added problem, because their shows give prizes based on the date of introduction, and 1867 is a key date. This means the same variety, under the different names, could be entered in two classes and win awards in both, 'Jacques Cartier' eligible for the Victorian Award, and 'Marquise Boccella' doing some social climbing to earn the accolade of Dowager Queen. Whatever it is, plant and enjoy it for border, fragrance, health, shrubbery.

'JACQUES CARTIER' – OR IS IT 'MARQUISE BOCCELLA'?

'JAMES MASON'

'JOHN WATERER'

JAMES MASON
Beales, England, 1982
Shrub, flowering in summer. Makes a magnificent leafy plant, decorated in summer with large bright crimson semi-double flowers, opening wide to display gold stamens. 1.5x1.2m (5x4ft). 'Scharlachglut' x 'Tuscany Superb'. Named for the famous actor, who loved roses. Plant this for border, fragrance, health, big hedge (1m-42in), shrubbery; weatherproof.

JANE ASHER (Peapet)
Pearce, England, 1988
Patio or dwarf cluster flowered bush, flowering summer to autumn. A neat short plant, bearing well formed bright scarlet flowers which open out to show a pretty array of petal tips. 30x30cm (12-12in). Named for the well-known actress. Plant this for small bed, front of border, container, health, small space; weatherproof.

JOHN WATERER
McGredy, N. Ireland, 1970
Hybrid tea large flowered bush, flowering summer to autumn. The large, long petalled dark crimson flowers of this rose have provided pleasure in many gardens and first prizes at many shows. Growth is strong and sturdy with deep green foliage, 90x60cm (3x2ft). 'King of Hearts' x 'Hanne'. FRAG The Hague. Plant this for bed, border, exhibition, health, hedge (50cm-20in); weatherproof.

JOSEPHINE BRUCE
Bees, England, 1952
Hybrid tea large flowered bush, flowering summer to

'JOSEPHINE BRUCE'

'JOSEPH'S COAT'

autumn. This rose has so many drawbacks – crabby growth, mildew, poor mid-season flowers – that there must be compelling reasons for its being grown by over thirty specialist nurseries after almost forty years in commerce. The answer lies in the colour - intensely blackish crimson, with that velvet sheen on the petals the sun captures so unforgettably; once you've witnessed that on a perfect flower, it for ever has a soft spot in your heart. Bushy, rather splayed growth, 75x60cm (30x24in). 'Crimson Glory' x 'Madge Whipp'. Plant this for border, fragrance.

JOSEPH'S COAT
Armstrong & Swim, 1964
Cluster flowered shrub/climber, flowering summer to autumn. This is a versatile rose in two ways. The colour variation is remarkable, from golden yellow with red flushes in the bud stage to yellow, orange, pink and red before the last petals fall. The changes are gentle rather than dramatic, so the effect is cheerful and pleasing to the eye, as are the sizeable and rather loosely formed flowers. The growth also is variable; hard pruning will produce an upright bush of a height between knee and hip, lighter pruning will bring it chest high, and if trained on a support its dimensions can match the span of outstretched arms. Usually 1.2mx75cm (48x30in), more if on support. 'Buccaneer' x 'Circus'. GM Bagatelle. The biblical reference in the name is particularly apt. Plant this for large bed, border, low fence, hedge (65cm-26in), pillar, low wall; weatherproof. Virus has been observed in some strains, otherwise it is very healthy.

JULIA'S ROSE
Wisbech Plant Co. England, 1976
Hybrid tea large flowered bush, flowering summer to autumn. A beautiful colour, which has been likened to "coppery parchment" and "tan with pink", with shapely flowers whose refined form has been called "porcelain-like". They last well and this makes it a wonderful flower arranger's rose, but an awkward one for gardeners, who have to give it the best site, soil and general care for good results. Growth is rather branching and open, 75x60cm (30x24in). 'Blue Moon' x 'Dr. A.J. Verhage'. GM & PRIZE Baden-Baden. Named for one of Britain's leading exponents of floral art, who is probably the only non-royal

individual to have three roses named for her: 'Julia Clements' in 1957, 'Lady Seton' in 1966, and this one. Plant this for border, curiosity, cutting, glasshouse.

JUST JOEY
Cant, England, 1973
Hybrid tea large flowered bush, flowering summer to autumn. This is a variety that seems to improve with age. The flowers are large and full of petals in rare shades of copper, fawn and buff. The petals appear loose, but are so large that in warm weather you get

blooms of astonishing size, often with a ragged outer edge which gives them an endearing character. The leaves are dark green and handsome, though not as plentiful as one would wish. 75x60cm (30x24in). 'Fragrant Cloud' x 'Dr. A.J. Verhage'. FRAG The Hague, JMMGM RNRS. This rose got its name as the result of a misheard conversation. The raiser thought of naming it for his wife, Joey Pawsey, but that seemed something of a tongue twister; you could call it just "Joey" suggested his father – and 'Just Joey' it became. Plant this for bed, border, cutting, fragrance, health.

'JULIA'S ROSE'

'KATHARINA ZEIMET'

KATHARINA ZEIMET (White Baby Rambler)
Lambert, Germany, 1901
Polyantha bush, flowering summer to autumn. Bears double white flowers in sprays of up to fifty blooms, making a wonderful display . The compact plants are furnished with many small dark leaflets which form a most effective background. 50x50cm (20x20in). 'Etoile de Mai' x 'Marie Pavie'. Plant this for small bed, front of border, container, health, hedge (45cm-18in), small space; weatherproof.

KATHLEEN HARROP
Dickson, N. Ireland, 1919
Bourbon shrub/climber, flowering summer to autumn. This is a blush pink sport of the better known deep pink 'Zephirine Drouhin' (q.v.), which it resembles in all respects save colour. Plant this for border, preferably with support, fence, fragrance, hedge (1.2m-4ft) if kept pruned, pillar, shrubbery, preferably with support; weatherproof.

'KAZANLIK'

KAZANLIK (*Rosa damascena trigintipetala*)
Date unknown
Damask shrub, summer flowering. This is the celebrated rose used extensively to make attar of roses. In the garden it will make a vigorous bush with rather loose petalled flowers of mid to deep pink; having, as the Latin name indicates, about thirty petals. Up to 2.2x1.8m (7x6ft). There seem to be several forms, as growth and colour show some variations, which is not surprising in a plant so ancient and so widely grown. Kazanlik in central Bulgaria is in the heart of the area where the rose is cultivated for attar.

KEEPSAKE (Esmeralda, Kormalda)
Kordes, Germany, 1981
Hybrid tea large flowered bush, flowering summer to autumn. Bears full petalled flowers of excellent rounded form and good size (12cm-5in. across). They are deepish pink, admitting hints of light carmine and blush. The habit is upright, rather uneven, and the foliage dark and robust. 75x60cm (30x24in). Seedling x 'Red Planet'. GM Portland. Plant this for bed, border, exhibition, health; weatherproof.

KENT (Poulcov)
Poulsen, Denmark, 1988
Ground cover or dwarf cluster flowered shrublet, flowering summer to autumn. Produces large trusses

'KATHLEEN HARROP'

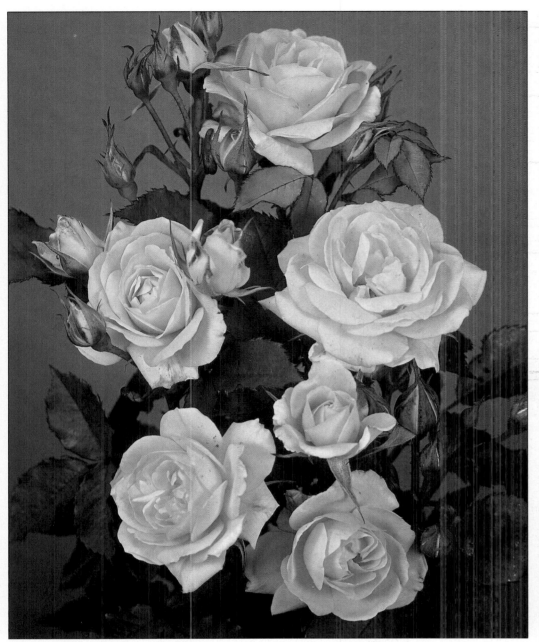

'KIM'

KING'S RANSOM
Morey, USA, 1961

Hybrid tea large flowered bush, flowering summer to autumn. For years this has proved a dependable rose to give a good succession of clear bold yellow flowers. They are well formed, with long petals, and are not spoilt by rain. This makes a fairly upright plant, well furnished with glossy dark leaves. 75x60cm (3x2ft). 'Golden Masterpiece' x 'Lydia'. AARS. Plant this for bed, border, health.

KONIGIN VON DANEMARK
Booth, Denmark, 1826

Alba shrub, summer flowering. This bears delightfully fragrant quartered flowers of a deeper colour than other Albas. They are full of petals, crimson pink when young, light pink as they unfold, and as they are slow to open out both tones are evident in the halfway stage. The foliage is rich grey-green, and the plant habit rather lax and open, as though an Alba had met a Damask in the parentage. 1.5x1.2m (5x4ft). Plant this for border, low fence, fragrance, health, rosarium, shrubbery, low wall; weatherproof.

of semi double white flowers on shoots that hug the ground. Very compact and dense, 30x75cm (12x30in). Plant this for small bed, front of border, container, ground cover, small space, weatherproof.

KIFTSGATE (*Rosa filipes* 'Kiftsgate')
E.Murrell, England, 1954

Climber, flowering in summer. This is the most extensively rampant rose normally planted in gardens. The flowers are single, creamy white, and borne in great clusters of up to a hundred blooms on long arching stems. This is a rose to choose for growing up and into trees – it is capable of reaching 50ft. Pruning is not practicable, except for taking out dead wood that can easily be reached. The foliage is rich green and glossy. 10x7m (30x20ft) or more. This appears to be a seedling of *R. filipes*, and takes its name from Kiftsgate Court in Gloucestershire where it had been established for many years. Plant this for fragrance, health, naturalising, tree; weatherproof.

KIM
Harkness, England, 1973

Dwarf floribunda or dwarf cluster flowered bush, flowering summer to autumn. Makes a short compact bush, studded with flowers that are proportionately large with over thirty petals. They are yellow, with a flush of pink in hot weather, and look very colourful against the dark crisp leaves. 40x40cm (16x16in). ('Orange Sensation' x 'Allgold') x 'Elizabeth of Glamis'. Named in memory of Master Kim Mulford. Plant this for small bed, front of border, container, health, small space; weatherproof.

'KING'S RANSOM'

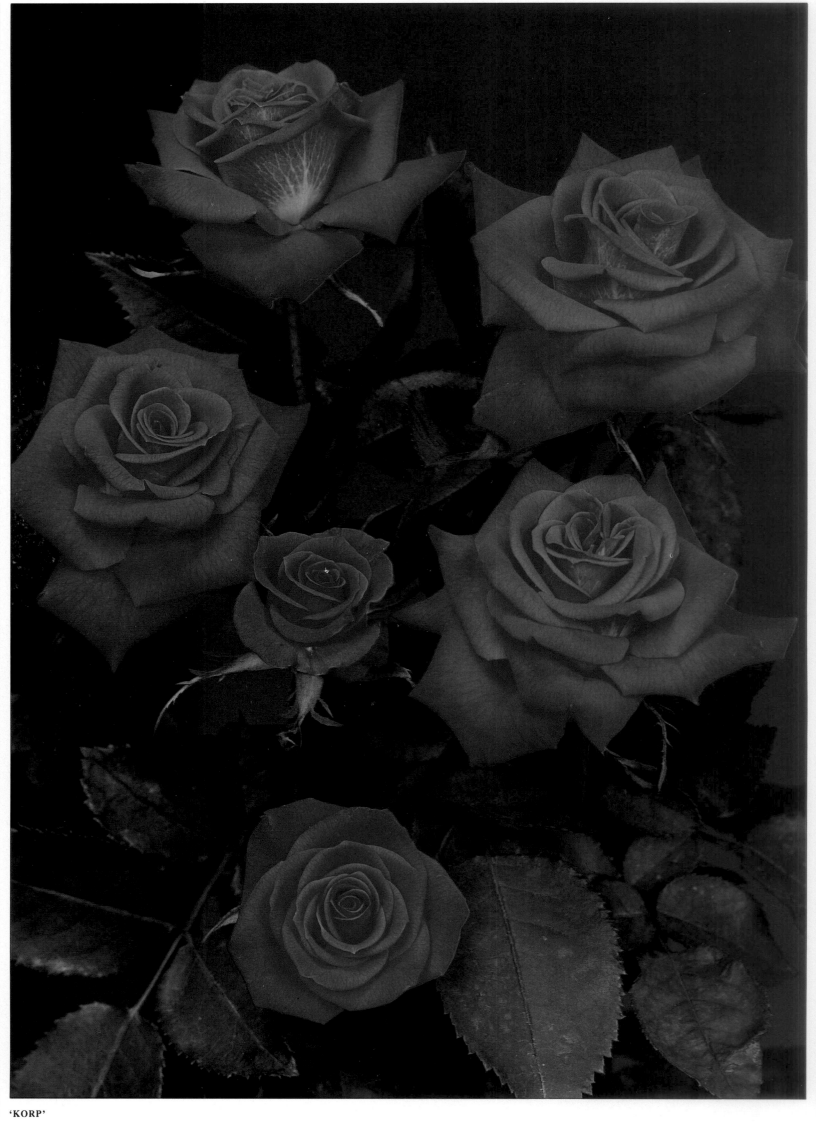

'KORP'

KORP (Prominent)
Kordes, Germany, 1970

Floribunda cluster flowered bush (some say hybrid tea), flowering summer to autumn. 'Prominent' is the better name for this rose, because it so well describes its character. Flowers of the brightest and boldest red are held up to view; there are not many of them in a cluster, and they are carried on firm stems, attracting the eye for their good form as well as the startling colour. They last well when cut. Strong upright growth, tough looking deep green foliage. 90x70cm (36x27in). 'Colour Wonder' x 'Zorina'. AARS, ADR & GM Portland. 'Korp' is the breeder's denomination, or officially registered name of the rose; 'Prominent' is the commercial or selling name, used in some countries but not in Britain, where for legal reasons the raiser called it 'Korp'. Plant this for bed, border, cutting, health, hedge (60cm- 24in); weatherproof.

KORRESIA (Friesia, Sunsprite)
Kordes, Germany, 1974

Floribunda cluster flowered bush, flowering summer to autumn. This is one of the most delightful yellows. The young flowers hold their centres while the outer petals unfold with wavy edges, creating a most attractive rose to cut. The colour is bright and does not fade, there is good fragrance, and the old flowers drop their petals cleanly. Neat, bushy growth to 75x60cm (30x24in). 'Friedrich Wörlein' x 'Spanish Sun'. ADR, GM Baden-Baden. Plant this for bed, border, cutting, fragrance, glasshouse, health, hedge (50cm-20in); weatherproof.

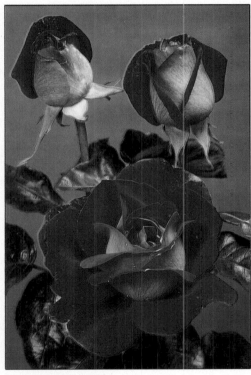

'KRONENBOURG'

KRONENBOURG (Flaming Peace)
McGredy, N. Ireland, 1965

Hybrid tea large flowered bush, flowering summer to autumn. This is a sport from 'Peace' with a similar habit of growth and flower form, but the colour is very different, being deep crimson purple on the inside of the petals and light yellow on the outside. It is not a particularly attractive combination, and the rose is included here as a matter of interest because it was one of the first to be protected under the United Kingdom legislation on Plant Breeders' Rights. 1.2mx90cm (4x3ft). Plant this for bed, border, health, hedge (75cm-30in).

LADY HILLINGDON
Lowe & Shawyer, England, 1910

Tea bush, flowering summer to autumn. The long slender buds of this light apricot rose are a beautiful

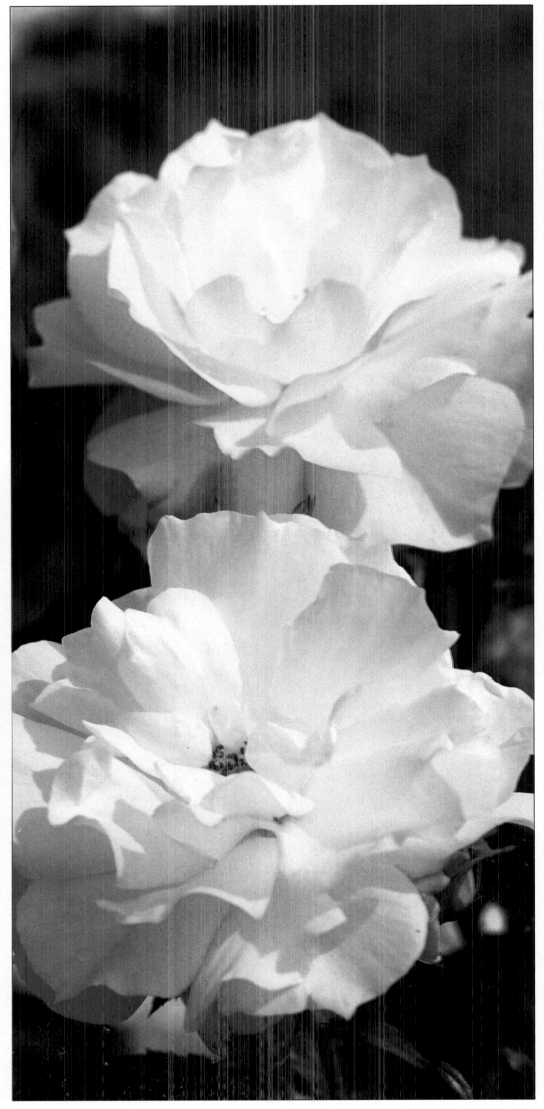

'KORRESIA'

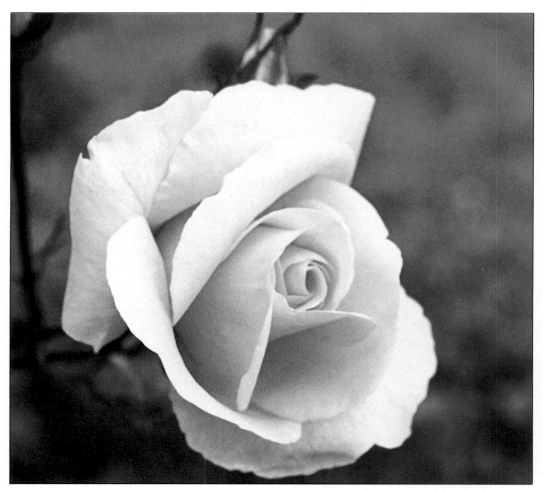

'CLIMBING LADY HILLINGDON'

sight, and they open to loose semi-double blooms with refreshing fragrance. Before the advent of apricot hybrid teas, this was very popular, and it is hardier than most of its fellow teas, though still requiring shelter from east winds and frost in springtime. Set beside today's hybrid teas, 'Lady Hillingdon' looks a poor frail creature, with thin purple stems and nodding blooms. 75x60cm (30x24in). Said to be 'Papa Gontier' x 'Mme. Hoste', though this is questionable. Plant this for fragrance, rosarium.

CLG LADY HILLINGDON
Elisha Hicks, England, 1917
Tea climber, flowering summer to autumn. This climbing sport is still worth growing as a souvenir of the beauty of the old teas, and is vigorous enough to become well established in a sheltered site. There is usually some bloom to be seen on it throughout the flowering season. Can achieve 4.5x2.5m (15x8ft). Plant this for fragrance, high S, SW or W fence, pillar, high S, SW or W wall.

LADY PENZANCE
Penzance, England, 1894
Sweet briar shrub, flowering in summer. The best feature of this rose is its foliage, which has apple fragrance, sweet and refreshing, especially after a shower of rain when it casts its scent around the garden. As for the flowers, they are small, light coppery pink with yellow, pretty but fleeting. Growth is fairly dense, with arching prickly stems quite well covered by the small shiny leaflets. 2x2m (6x6ft). *R. rubiginosa* x either *R. foetida* or *R. foetida bicolor*. Named for the wife of the raiser, who introduced several Sweet Briar hybrids in the 1890s, of which this seems the most fragrant and garden worthy. Plant this for big border, curiosity, fragrance, big prickly hedge (1.2m-4ft), naturalising, rosarium, shrubbery; weatherproof.

LADY SYLVIA
Stevens, England, 1926
Hybrid tea large flowered bush, flowering summer to autumn. Rose pink, a deeper coloured sport of 'Mme.

Butterfly' (q.v.) which it resembles in all other respects. 90x60cm (3x2ft). Plant this for border, cutting, fragrance, glasshouse, health; weatherproof.

LA FRANCE
Guillot fils, France, 1867
Hybrid tea large flowered bush, flowering summer to autumn. Silvery pink, with flowers which look ordinary today, but were the sensation of 1867 when fifty judges met at Lyon to choose a rose worthy to bear their nation's name. This was the one they selected, noting (and doubtless being reminded by the raiser) that it combined the elegant form and carriage of a tea rose with the substance and vigour of a hybrid perpetual. It was a splendid Gallic launch for what was to be recognised as the first of a new class, the hybrid teas. The sequel was less fortunate for Jean-Baptiste Guillot. He took the rose to the Paris Universal Exhibition for its public debut, staged it in perfect shape at the appointed time, and waited for the judges' plaudits; he waited all that day, and the next day, seeing his poor roses wilting in the heat. When the judges came, two days late, they gave his roses nothing. 60x45cm (24x18in). Possibly 'Mme. Victor Verdier' x 'Mme. Bravy', or a seedling of 'Mme. Falcot'. It has to be said that recent doubts have been expressed by two eminent rosarians, Deane Ross in Australia and Ralph Moore in California, on whether the plants usually sold as 'La France' are the true variety. Moore's nursery sells what he has known for eighty years as the correct one, which his grandmother had in her garden; that takes his family's testimony back well into M. Guillot's lifetime. Plant this for rosarium.

LAMARQUE
Maréchal, France, 1830
Noisette climber, flowering summer to autumn. This early cross between 'Blush Noisette' and the yellow Tea rose gave an indication of the vigour and beauty which could come from the marriage of genes from east and west. The colour is lemony in bud, opening to ivory white. The nodding flowers have many quilled petals and open quartered with low centres and a rather shaggy outline. They have a refreshing light tea fragrance. This variety is a beauty but needs a sheltered site in Britain; it is best grown in warmer countries where it can extend for many yards and bear hundreds of blooms in a season. 3x3m (10x10ft) in UK climate. Named for Général Lamarque. Plant this for warm SW fence, fragrance, big glasshouse, rosarium, sheltered high S or SW wall.

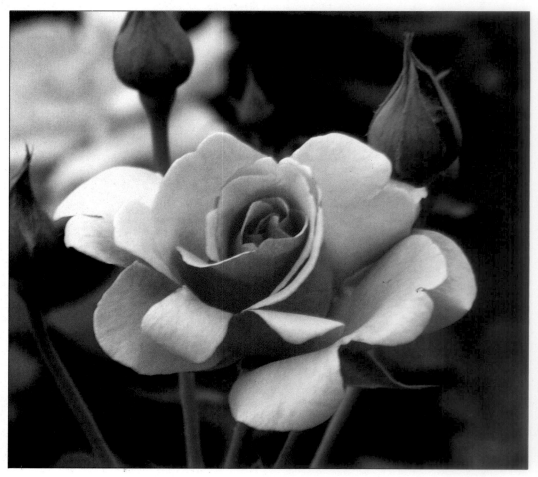

'LADY SYLVIA'

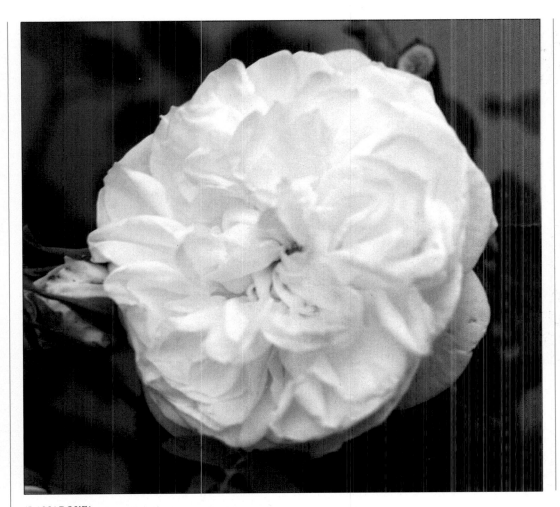

'LAMARQUE'

LA REINE VICTORIA – see **REINE VICTORIA**

LA SEVILLANA (Meigekanu)
Meilland, France, 1978
Shrub, flowering summer to autumn. Produces many bright red flowers in showy clusters on dense growing, rather wide shrubby plants. 1.2x1.2m (4x4ft). ADR, PRIZE Orleans. Plant this for large bed, border, health, hedge (90cm-3ft), spreading; weatherproof.

LAUGHTER LINES (Dickerry)
Dickson, N. Ireland, 1987
Floribunda cluster flowered bush, flowering summer to autumn. A bold and beautiful combination of cherry red, gold and white against a rosy-pink background, rather after the style of the 'Picasso' painted roses, and with the benefit of wonderfully crisp dark foliage. 75x60cm (3x2ft). ('Pye Colour' x 'Sunday Times') x 'Eye Paint'. GM RNRS. Plant this for bed, border, curiosity, health, hedge (50cm-20in); weatherproof.

LAURA ASHLEY (Chewharla)
Warner, England, 1991
Cluster flowered shrub, remontant. So many five-petalled blooms are carried in each cluster that the rest of the plant is almost hidden at peak flowering time. The colour is deep rosy violet, with white at the petal base and showy yellow stamens. The low spreading plants are well furnished with shiny foliage. 90x50cm (36x20in). Named in memory of the celebrated clothes and fabric designer. Plant this for bed, border, container, fragrance, ground cover, health, front of shrubbery, spreading; weatherproof.

'LAUGHTER LINES'

'LA VILLE DE BRUXELLES'

LAURA FORD (Chewarvel)
Warner, England, 1990
Miniature climber, flowering summer to autumn. For small gardens, or wherever a climbing plant of limited extent is needed, this new type of rose will be of great value. The flowers are yellow, small, neatly formed, and carried in clusters at different levels on the plant. They are backed by excellent bright looking leaves. 2.2mx1.2m (7x4ft). Plant this for fence, health, pillar, wall; weatherproof.

LA VILLE DE BRUXELLES
Vibert, France, 1849
Damask shrub, flowering in summer. This makes a rather open well-spread plant, with strong stems bowed under the weight of blooms, which are carried in clusters. Each is densely packed with rose pink petals, folding against one another and opening quartered, sometimes with a green button 'eye'. The leaves are large and handsome. 1.5x1.2m (5x4ft). Plant this for large border, low fence, fragrance, shrubbery.

LEDA (Painted Damask)
Early 19th century, England?
Damask shrub, flowering in summer. The pale blush flowers open with just a hint of red on the outer petal tips, hence the reason for the popular name of this old rose. The flowers are quite full, and reflex prettily. They are backed by dark rounded leaves which set them off well and help to make this one of the most aesthetically pleasing of the old garden roses. Compact

enough for smaller gardens. 1x1m (3x3ft). Plant this for border, fragrance, health, hedge (75cm-30in), shrubbery; weatherproof.

LEN TURNER (Daydream, Dicjeep)
Dickson, N. Ireland, 1984
Floribunda cluster flowered bush, flowering summer to autumn. Bears prettily marked flowers, with reddish pink edging to the blush petals. The petals are rather stiff and hold their form, and often they are waved, giving the expanded flower the appearance of a pompon dahlia. The flowers are particularly beautiful when grown under glass. Neat, leafy and compact, 50x50cm (20x20in). 'Mullard Jubilee' x 'Eye Paint'. Named to honour the former Secretary of the Royal National Rose Society. Plant this for bed, front of border, container, glasshouse, health, low hedge (50cm-18in); weatherproof.

LETCHWORTH GARDEN CITY (Harkover)
Harkness, England, 1979
Floribunda cluster flowered bush, flowering summer to autumn. Urn-shaped slender buds open into wide flowers, giving a spectacular overall effect as there are many blooms in the cluster. They are rose pink with hints of peach and orange. 75x60cm (30x24in). ('Sabine' x 'Pineapple Poll') x ('Circus' x 'Mischief'). GM Monza. Named for the 75th anniversary of the world's first Garden City, which has greatly influenced modern urban architecture and planning. Plant this for bed, border, health, hedge (50cm-18in), weatherproof.

LEVERKUSEN
Kordes, Germany, 1955
Climber, flowering in summer, and giving some autumn bloom. Bears clusters of light yellow flowers with rather narrow petals, like large rosettes. They contrast well with the polished bright green leaves, and are carried on vigorous flexible stems, making it easy to train on a support or grow as a sizeable arching shrub where there is plenty of space. 3x2.2m (10x7ft). *R. kordesii* x 'Golden Glow'. Plant this for fence, health, substantial hedge (2m-6ft), naturalising, pergola, pillar, wall; weatherproof.

LILLI MARLENE (Kolima)
Kordes, Germany, 1959
Floribunda cluster flowered bush, flowering summer to autumn. A very popular dark red for parks planting, maintaining a good succession of bloom. The flowers are rounded in form and reasonably well filled with petals. Even bushy growth, 75x60 (30x24in). ('Our Princess' x 'Rudolph Timm') x 'Ama'. ADR, GR The Hague. Plant this for bed, border, exhibition, hedge (50cm-20in), weatherproof.

LINCOLN CATHEDRAL (Glanlin)
Langdale, England, 1987
Hybrid tea large flowered bush, flowering summer to autumn. The flowers are borne with surprising freedom considering their large size. They are a pretty blend of orange and pink, and are produced on shrubby plants whose generous foliage reflects the parentage, 'Silver Jubilee' x 'Troika'. 90x75cm (36x30in). GM RNRS. Plant this for bed, border, health, hedge (60cm-24in).

LITTLE ARTIST (Macmanly, Top Gear)
McGredy, New Zealand, 1982
Miniature, flowering summer to autumn. The low spreading plants support very pretty open flowers, which are red with whitish marking at the base and on the petal reverse, giving a "hand-painted" effect. Small shiny leaves. 40x40cm (15x15in). 'Eyepaint' x 'Ko's Yellow'. Plant this for small bed, front of border, container, curiosity, small space.

LITTLE PRINCE (Coccord)
Cocker, Scotland, 1983
Patio or dwarf cluster flowered bush, flowering

'LEN TURNER'

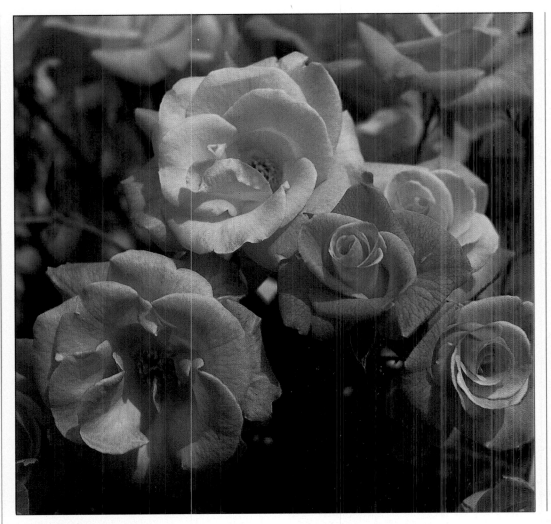

'LETCHWORTH GARDEN CITY'

summer to autumn. Bright orange red flowers of small to medium size are carried on firm stems. Everything about this rose is neat – the petal formation, upright habit and petite pointed foliage. 45x30cm (18x15in). 'Darling Flame' x ('National Trust' x 'Wee Man'). Plant this for small bed, front of border, container, health, small space; weatherproof.

LITTLE WHITE PET (White Pet)
Henderson, USA, 1879
Dwarf cluster flowered bush, flowering summer to autumn. White, very double with narrow petals, making beautifully constructed rosette style flowers. This is like a bush form of the climber 'Félicité Perpétue' of which it is most probably a seedling with the other parent unknown. The little flowers are carried freely in neatly spaced clusters, looking the essence of Victoriana. It is much favoured for period gardens in both bush and standard form. 45x45cm (18x18in). Plant this for bed, border, container, curiosity, health, hedge (40cm-15in), small space; weatherproof.

LITTLE WOMAN (Diclittle)
Dickson, N. Ireland, 1987
Patio or dwarf cluster flowered bush, flowering summer to autumn. The petite urn-shaped flowers are like replicas of hybrid teas, and are carried in well-spaced sprays on slim firm stems. The colour has prettily varied tints of rose pink and rosy salmon, shown off against petite dark pointed leaflets. Produces many blooms through the season, which are ideal for small arrangements. 50x40cm (20x16in). Plant this for small bed, front of border, container, cutting, health, upright narrow hedge (35cm-15in), small space; weatherproof.

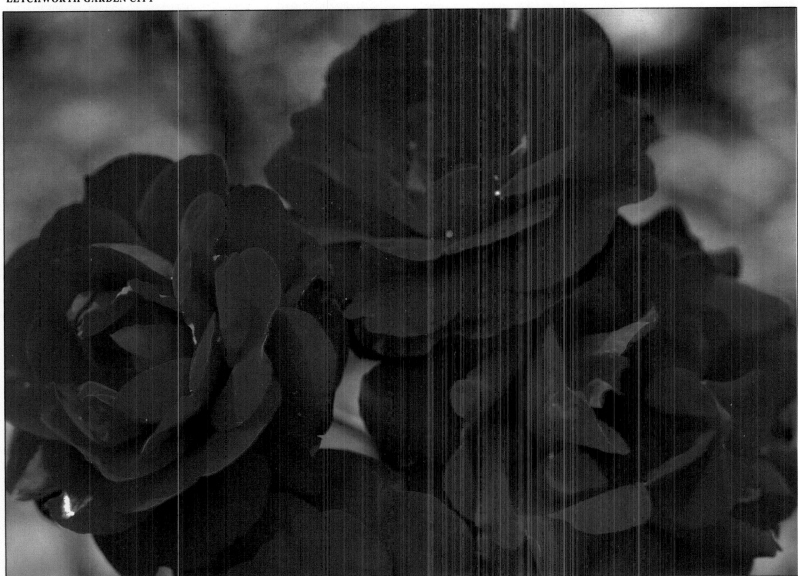

'LILLI MARLENE'

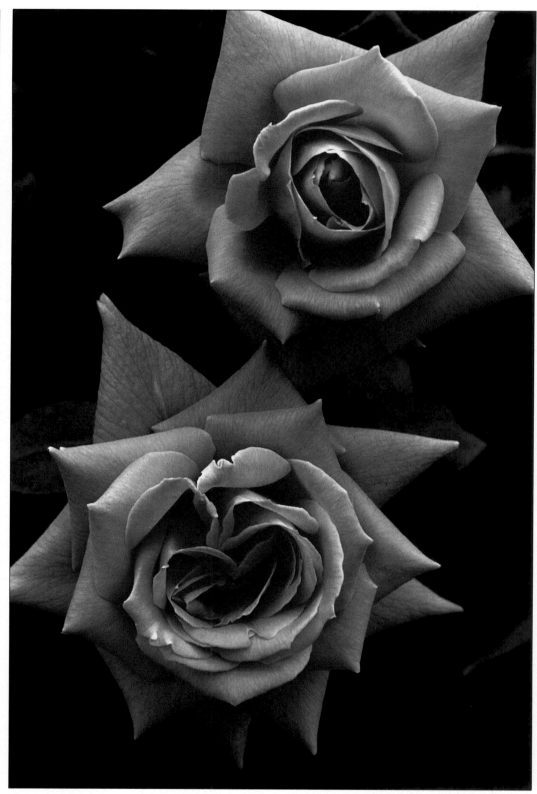

'LOVERS' MEETING'

'L'ORÉAL TROPHY'

LIVERPOOL ECHO
McGredy, New Zealand, 1971
Floribunda cluster flowered bush, flowering summer to autumn. Salmon pink, a pretty refreshing shade. The flowers are quite large and fairly full of petals, so well placed in the cluster that this rose is a great standby for exhibitors. They make heavy heads but have strong stems to sustain them. Rather bushy, rounded habit, and plenty of foliage. 90x60cm (3x2ft). ('Little Darling' x 'Goldilocks') x 'München'. GM Portland. Plant this for bed, border, cutting, exhibition, hedge (50cm- 20in); weatherproof.

L'OREAL TROPHY (Alexis, Harlexis)
Harkness, England, 1982
Hybrid tea large flowered bush, flowering summer to autumn. This is a sport of 'Alexander' with the same strong upright growth and value for cutting – provided that the flowers are cut young. The colour is light orange-salmon, very bright and pure. 1.2mx75cm (48x30in). GM Paris & Belfast, GR Courtrai, PRIZE Amsterdam. Named for the company well known for hair-styling preparations. Plant this for large bed, border, cutting, health, tall hedge (60cm-2ft); weatherproof.

LOUISE ODIER (Mme. de Stella)
Margottin, France, 1851
Bourbon climber/shrub, flowering summer to autumn. The flowers of this rose are a very warm shade of pink, cupped, full of petals and fairly large (13cm-5in) across. The plants grow rather upright with light greyish green leaves, but can bow under the weight of bloom if not supported. 2x1.2m (6x4ft). Plant this for low fence, fragrance, pillar, shrubbery, low wall.

LOVELY LADY (Dicjubell, Dickson's Jubilee)
Dickson, N. Ireland, 1986
Hybrid tea large flowered bush, flowering summer to autumn. The rosy pink flowers are large and beautifully formed, with the high centres and rounded outline that characterise all the best qualities of the hybrid teas. The plants flower freely and have good foliage. 75x60cm (30x24in). 'Silver Jubilee' x ('Eurorose' x 'Anabel'). GM & PRIZE, Belfast. Plant this for bed, border, cutting, exhibition, health, hedge (50cm-20in); weatherproof.

LOVERS' MEETING
Gandy, England, 1980
Hybrid tea large flowered or floribunda cluster flowered bush; the classifiers are not in agreement on this one, but it has more affinity with the hybrid teas. It flowers from summer to autumn. Elegant, rather slim buds open into large loosely double flowers with pointed centres, which keep their form due to their broad petals. They are a warm reddish orange, and so freely produced in such wide sprays that the stems incline under their combined weight. 75x75cm (30x30in). Seedling x 'Egyptian Treasure'. The breeder took the name from Shakespeare's *Twelfth Night*. Plant this for bed, border, cutting; weatherproof.

LOVING MEMORY (Burgund '81, Korgund, Red Cedar)
Kordes, Germany, 1981
Hybrid tea large flowered bush, flowering summer to autumn. Bears some of the finest of red roses in good weather, on long stiff stems. They are high pointed, fully double and hold their form magnificently as the petals open. The colour can look dull in cool conditions. 1.1mx75cm (42x30in). Seedling x 'Red Planet'. GM Dublin. Plant this for tall bed, border, cutting, exhibition, health.

MME. ALFRED CARRIERE
Schwartz, France, 1879
Noisette climber, flowering summer to autumn. A famous old rose, hardier than others of its class and capable of making extensive growth. The flowers are

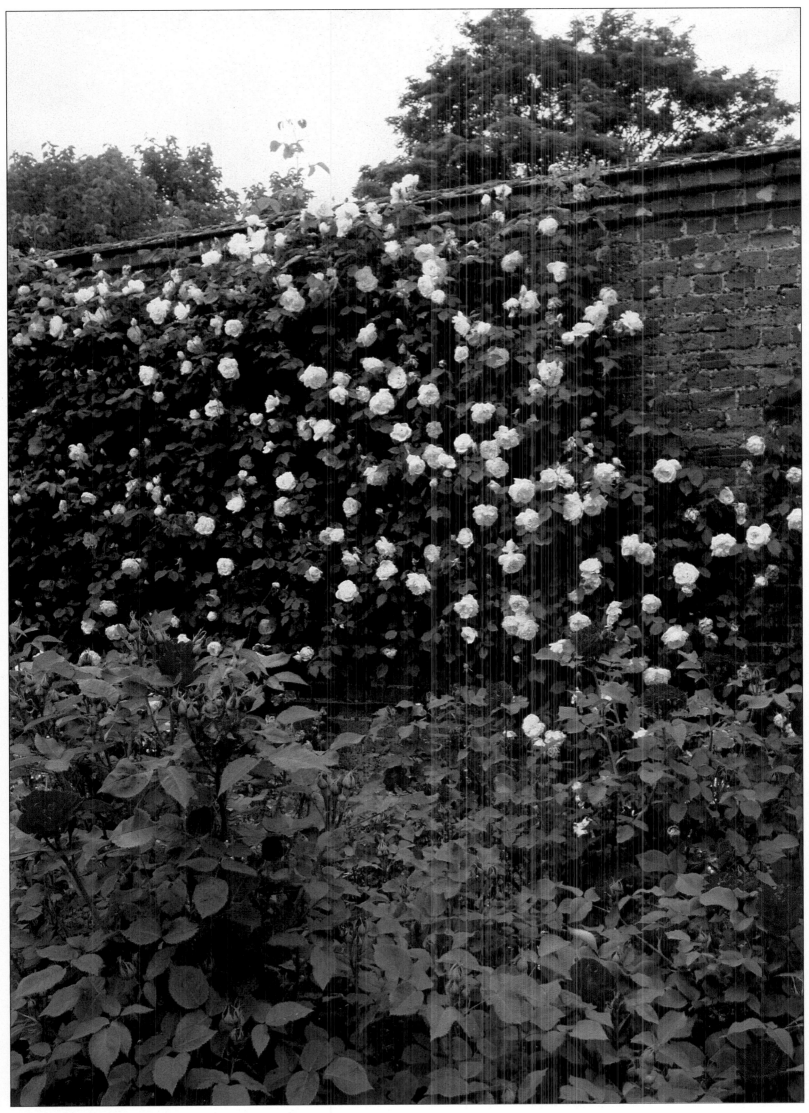

'MADAME ALFRED CARRIÈRE' ON AN OLD WALL AT MOTTISFONT.

'LOVING MEMORY'

'MADAME ALFRED CARRIÈRE'

creamy white, opening from plump buds to cupped, rather loose flowers with many petals. They are very freely produced in summer and spasmodically later. The stems are smooth and thin wooded, with a frail look which belies their capabilities. The young growth may be affected by seasonal mildew. 5.5x3m (18x10ft). Plant this for high fence, fragrance, naturalising, pergola, high wall.

MME. BUTTERFLY
Hill, USA, 1918
Hybrid tea large flowered bush, flowering summer to autumn. Light creamy rose pink, a slightly deeper sport of 'Ophelia' (q.v.) which it resembles in other respects. 90x60cm (3x2ft). Plant this for border, cutting, fragrance, glasshouse, health; weatherproof.

MME. CAROLINE TESTOUT
Pernet-Ducher, France, 1890
Hybrid tea large flowered bush, flowering summer to autumn. This is important because its vigour, freedom of bloom and hardiness helped to establish the rose as a pre-eminent garden plant during the years following its introduction. The colour is pink with hints of carmine, the flowers large and rounded. 90x60cm

'MADAME CAROLINE TESTOUT'

'MADAME GRÉGOIRE STAECHELIN'

(3x2ft). 'Mme. de Tartas' x 'Lady Mary Fitzwilliam'. This was selected by a well known French couturiere to bear her name, and may well be the first rose to be commercially sponsored. Plant this for border, rosarium.

CLG MME. CAROLINE TESTOUT
Chauvry, France, 1901
Hybrid tea large flowered climber, summer flowering. The vigorous climbing sport of the above. It is a stiff grower and needs a strong support. Up to 6x3m (20x10ft). Plant this for high fence, high wall.

MME. DELAROCHE-LAMBERT
Robert, France, 1851
Moss shrub, flowering in summer. The flowers are well mossed, with petals of rich crimson purple backed by long leafy sepals. The blooms are very full, and hold their colour remarkably well. 1.2x1m (48x40in). Plant this for border, fragrance, shrubbery.

MME. EDOUARD HERRIOT (Daily Mail Rose)
Pernet-Ducher, France 1913
Hybrid tea large flowered bush, flowering summer to autumn. This was the remarkable salmon-orange rose with which the raiser won a cup and £1000 – a huge sum in 1912 – in a competition sponsored by the *Daily Mail* newspaper for the best new rose. The colour, a rich mixture of terracotta, salmon and orange-yellow, was so novel that it was an easy winner. The

'MADAME DELAROCHE-LAMBERT'

plant had a long run in commerce, being well foliaged and vigorous, and making the most of its long petals with their ability to open out and show a good expanse of colour. 'Mme. Caroline Testout' x a hybrid tea. GM NRS. Plant this for border, fragrance, rosarium.

CLG MME. EDOUARD HERRIOT
Ketten Bros. Luxembourg, 1921
Hybrid tea large flowered climber, summer flowering. This vigorous climbing sport is still being grown, as there are very few near to its colour. 4mx2.5m (12x8ft). Plant this for high fence, fragrance, pergola, high wall.

MME. GREGOIRE STAECHELIN (Spanish Beauty)
Dot, Spain, 1927
Climber, summer flowering. This is a wonderful sight in early summer, when dozens of large pink blooms cover the plant. There is no mistaking the flowers because they have a ruffled look about them, not quite like any other rose. The colour is rosy carmine with lighter pink shades. The colourful display is soon finished, and the plant spends the rest of summer making great arching growths in readiness for next year. Strong and vigorous, to 7x4m (22x12ft). 'Frau Karl Druschki' x 'Château de Clos Vougeot'. Plant this for fragrance, high fence, naturalising, pergola, tree, high wall; weatherproof.

MADAME HARDY
Hardy, France, 1832
Damask shrub, summer flowering. Bears large white flowers, crammed with petals and beautifully structured, with folding and quartering and sometimes a central green eye. The growth is rather upright, with plentiful rather rough looking foliage to set off the handsome blooms. 1.5x1.2m (5x4ft). Named for the wife of M. Eugène Hardy, director of the famous Luxembourg Gardens in Paris. Plant this for sizeable border, low fence, fragrance, shrubbery.

MME. ISAAC PEREIRE
Garçon, France, 1881
Bourbon shrub/climber, flowering summer to autumn. Rich purple pink suffuses the majestic flowers, which have so many broad petals that it seems a wonder that they can all open and bloom in such profusion; the

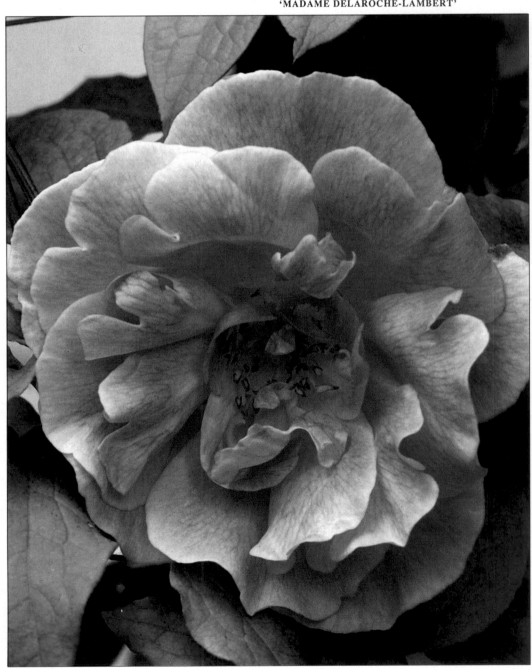

'MADAME GRÉGOIRE STAECHELIN'

summer display is particularly generous, and the cupped and quartered flowers are delightful, though their strong colour is not to everyone's liking. Well foliaged, 2.2x2m (7x6ft). This is best grown on some kind of support as it will flop under the weight of bloom. Named after a banker's wife. Plant this for large border, low fence, fragrance, pillar, shrubbery, wall.

MME. LEGRAS DE ST. GERMAIN
France, in the 1840s?
Alba shrub, flowering in summer. The beautiful white flowers are rounded in form and very full of small petals. The outer ones lie flat and the inner ones reflex slowly, so that they create an outline that reminds one of a powderpuff. Makes a big plant, 1.8x1.8m (6x6ft) with smooth arching shoots and grey-green leaves. Plant this for big border, fragrance, health, large hedge (1.3m (54in), shrubbery.

MME. LOUIS LAPERRIERE
Laperriere, France, 1951
Hybrid tea large flowered bush, flowering summer to autumn. One of the loveliest dark red garden roses at its best, though the quality of the flower is variable. The blooms are rounded, of medium size and hold their crimson colour well. Growth rather low and spreading, 60x60cm (2x2ft). 'Crimson Glory' x seedling. GM Paris. Plant this for bed, border, fragrance; weatherproof.

MME. PIERRE OGER
Oger, France, 1878
Bourbon shrub/climber, flowering summer to autumn. This bears daintily formed cupped blooms in shell pink tints, which may deepen to rosy lilac in warm sunny weather. It is not the sturdiest grower, needing good soil, but worth the effort for its undoubted beauty. A sport of 'Reine Victoria' (q.v.) which it

'MADAME ISAAC PEREIRE'

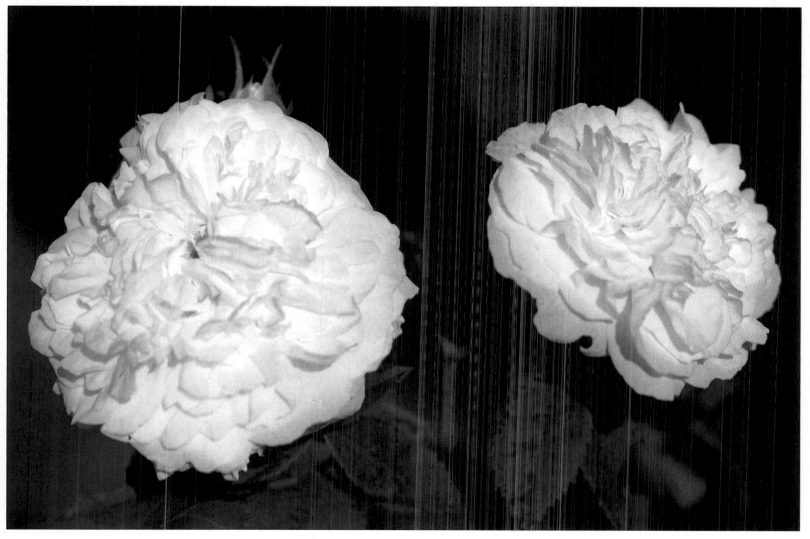

'MADAME LEGRAS DE ST GERMAIN'

'MADAME DE SANCY DE PARABÈRE'

resembles apart from the flower colour. 2x1.2m (6x4ft). Plant this for border (on support), low fence, fragrance, pillar, shrubbery (on support).

MME. DE SANCY DE PARABERE

Bonnet, France, 1874 or earlier?

Boursault climber, summer flowering. One of a small group of roses of uncertain origin, named after the Parisian botanist Henri Boursault who formed a large rose collection in the early nineteenth century. They have smooth arching or drooping stems, and leaves with affinity to China roses. This variety bears rose pink flowers with a touch of mauve in them, full of petals which reflex to produce a rounded outline, with shorter petals creating a pleasingly muddled centre. On a warm sheltered wall this can attain 5x3m (15x10ft). Plant this for SW or S fence, pergola in sheltered garden, rosarium, SW or S wall.

MAESTRO (Mackinju)

McGredy, New Zealand, 1980

Hybrid tea large flowered bush, flowering summer to autumn. Important because it brings the "hand-painted" roses descended from 'Picasso' into the hybrid tea section. The flowers are crimson with white and cream markings, very striking, borne freely on dark-leaved bushes, 75x60cm (30x24in). Plant this for bed, border, curiosity, hedge (50cm-20in); weatherproof.

MAGENTA

Kordes, Germany, 1954

Shrub, flowering summer to autumn. Bears very large clusters of magenta pink blooms, so full of petals that the stems bow under their weight. Makes

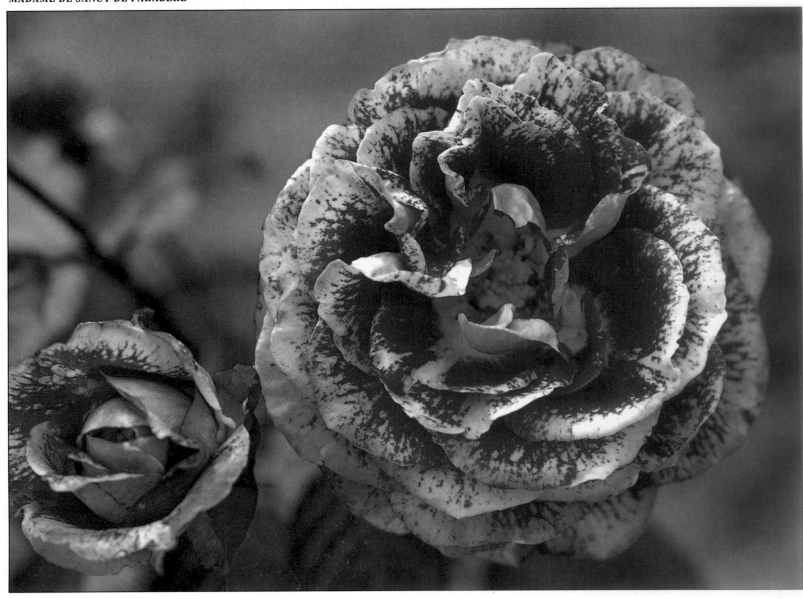

'MAESTRO'

'MAGENTA'

a showy plant, as the flowers expand to flaunt their rich colour against dark leathery leaves. 1.5x1.2m (5x4ft). Seedling x 'Lavender Pinocchio'. Plant this for border, fragrance, shrubbery.

MAGIC CARROUSEL
Moore, USA, 1972
Miniature, flowering summer to autumn. The blooms have neat roundelay form, being made up of many small petals in light yellow with crimson edging; a cheerful sight. Small glossy leaves cover the compact plants of about 40x30cm (16x12in). 'Little Darling' x 'Westmont'. Plant this for small bed, front of border, container, exhibition, health, petite hedge (20cm-12in), small space; weatherproof.

MAIDEN'S BLUSH (Cuisse de Nymphe, Incarnata, La Royale, La Séduisante)
Europe, before 1738
Alba shrub, flowering in summer. Blush pink, bearing 8cm (3in) flowers of charming cupped form which look well against the typically grey-green Alba foliage. The plants grow tall, wide and are hardy and long lived; they may be found in old gardens where everything else has disappeared. 2.2x1.5m (7x5ft). Plant this for big border, fence, fragrance, health, big hedge (1.3m-4ft), naturalising, shrubbery, specimen plant, wall; weatherproof.

MAIGOLD
Kordes, Germany, 1953
Climber, flowering in early summer with some later bloom. The flowers are yellow, with hints of bronze evident in the slim elegant buds. The petals are large and open out wide to create a spectacular expanse of yellow on the prolific first flowering. This is one of

'MAIGOLD'

'MALCOLM SARGENT'

the first climbers to bloom, and sometimes the effort is such that the plants take a few weeks before re-flowering. Produces stiff arching stems, covered in prickles, with dark leathery leaves. 2.5x2.5m (8x8ft) or more. 'Poulsen's Pink' x 'Frühlingstag'. Plant this for high fence, fragrance, health, naturalising, pergola, big shrubbery (with pruning), low tree, high wall; weatherproof.

MAJORETTE (Meipiess)
Meilland, France, 1986

Floribunda cluster flowered bush, flowering summer to autumn. This is a remarkably free flowering rose, neat and compact in growth. The blooms are fairly small, carried in generous clusters, and open to show red petals with yellowish-white centres; on the back of the petals the two colours blend together. They are held upright on slim firm stems that bob in the breeze, making this a pretty and lively garden rose. 50x50cm (20x20in). 'Magic Carrousel' x ('Grumpy' x 'Scarletta'). Plant this for bed, border, container, compact hedge (40cm-16in) small space; weatherproof.

MALCOLM SARGENT (Harwharry, Natascha)
Harkness, England, 1988

Hybrid tea large flowered bush, remontant. Deep shining crimson, a warm and brilliant shade without magenta tones. The buds are neatly formed, urn-shaped, and make excellent buttonholes; they are often produced in large wide sprays, each stem being long enough to cut for flower arranging. Growth is rather rounded and shrublike, with plentiful dark glossy leaves. 90x90cm (3x3ft). 'Herbstfeuer' x 'Trumpeter'. GM Belfast PRIZE Copenhagen. Named in memory of the celebrated English conductor to help raise funds for the Malcolm Sargent Cancer Fund for Children. Plant this for bed, border, cutting, hedge (75cm-30in), weatherproof.

MANY HAPPY RETURNS (Harwanted, Prima)
Harkness, England, 1991

Shrub, flowering summer to autumn. Rose pink slender buds open into wide cupped blush-coloured flowers. They are very freely borne at different levels on the plant, and create a beautiful contrast with the dark glossy foliage. This makes a handsome and showy plant of neat spreading habit. 1x1.2m (3x4ft). 'Herbstfeuer' x 'Pearl Drift'. GM Geneva, PRIZE Geneva & Monza. Plant this for bed, border, health, hedge (1m-3ft), shrubbery, small specimen plant, spreading; weatherproof.

MARECHAL NIEL
Pradel, France, 1864

Noisette climber, flowering summer to autumn. This is a classic rose, famous for its long petalled high centred butter-yellow flowers, a wonderful novelty in 1864. The plant needs shelter, and is best grown trained overhead in a greenhouse after the manner of a vine. Since the flower stalks are weak, this method means the blooms can be readily admired. The flowering period extends over a long period, and because it starts early frost can easily affect it out of doors. Some say this should be grown with its roots outside the glasshouse, or it will not thrive. The plant at Askham Bryan College, near York, looks well enough despite being all enclosed, measuring 17m (55ft) long by an average of 2.5m (8ft) wide, with the drooping long leaves showing every sign of health. The parentage of this variety is uncertain. Maréchal Adolphe Niel (1802-69) was a hero in the French army at Sebastopol during the Crimean War, and was appointed Minister for War in 1867. Plant this for fragrance, sheltered SW high fence, glasshouse, rosarium, sheltered SW high wall.

MARGARET MERRIL
Harkness, England, 1977

Floribunda cluster flowered bush, flowering summer

'MANY HAPPY RETURNS'

to autumn. The flowers are blush, but often so pale as to appear white, with a cool satiny look about them, showing up to good effect against dark leathery leaves. They are attractive at every stage from bud to open flower, last well when cut, and have sweet pervasive fragrance. Upright grower, 90x60cm (3x2ft). ('Rudolph Timm' x 'Dedication') x 'Pascali'. FRAG Monza, New Zealand, RNRS, The Hague; GM Geneva, Rome; GSSP New Zealand; JMMGM RNRS; PRIZE Geneva. Named for the beauty counsellor to the makers of Oil of Ulay, who is actually a fictitious lady; three namesakes to date have come forward to plant and enjoy it as their own. Plant this for bed, border, cutting, fragrance, glasshouse, hedge (50cm-20in); weatherproof.

'MARGUERITE HILLING'

MARGARET THATCHER (Flamingo, Korflüg, Porcelain, Veronica)
Kordes, Germany, 1979

Hybrid tea large flowered bush, flowering summer to autumn. The elegant porcelain pink flowers are excellent for cutting, being carried singly on long stems. The variety is used in some countries for glasshouse growing, and out of doors the best blooms are to be seen after a spell of fine weather. 75x60cm (30x24in). Seedling x 'Lady Like'. Named for Britain's premier, being the second rose to honour her; the first, from Takatori of Japan in 1983, was a pinky red floribunda with blush stripes, but apparently this name was not registered, and the Kordes variety was introduced in the UK in 1985. Plant this for border, cutting, hedge (50cm-20in).

MARGO KOSTER
Koster, Holland, 1931

Polyantha cluster flowered bush, flowering summer to autumn. The clear salmon red colour and unusual shape made this little plant one of the favourite roses of the mid twentieth century. The flowers are petite, with the outer petals incurving to give them a globe-shape, like a trollius flower. They appear very freely over many weeks and last well when cut. The leaves are small and give thin cover by comparison with more recent roses. This, plus loss of vigour and an increasing tendency to revert to its red parent may account for its decline in favour in the UK, though it is still grown on several nurseries in USA. Certainly nothing else is quite like it. 40x30cm (15x12in). Sport of Dick Koster. Plant this for small bed, front of border, container, curiosity, cutting, small space; weatherproof.

MARGUERITE HILLING (Pink Nevada)
Hilling, England, 1959

Shrub, flowering in summer with some later bloom. This is a sport of 'Nevada' (q.v.) and resembles that rose in growth. The difference is in the colour of the flowers, which are a warm and positive shade of pink. The slender buds open into great wide flowers of seven or so petals. They seem to nestle against the leafy branches, which they almost hide, so profuse is the display in summertime. 2.2x2.2 (7x7ft). Plant this for big border, fence, huge hedge (1.5m-5ft), naturalising, shrubbery, specimen plant, spreading, wall; weatherproof.

'MARIE PAVIÉ'

MARIE PAVIE (Marie Pavic)
Alégatière, France, 1888
Polyantha cluster flowered bush, flowering summer to autumn. A historic survivor from the years when cluster flowered bushes of any sort were a novelty, and an especially valued one because it has some fragrance in its small blush white flowers. The stems have few prickles and the leaf is rich green and large in proportion to the plant. 40x40cm (15x15in). Plant this for border, fragrance, rosarium, small space.

MARIJKE KOOPMAN
Fryer, England, 1979
Hybrid tea large flowered bush, flowering summer to autumn. Long-petalled buds open into blooms of rich pink, held above the bushes on firm stems. Upright growth with noticeably large leaves to 1.1mx60cm (42x24in). GM Le Roeulx & The Hague. Named by the raiser in memory of his friends' daughter who had been the tragic victim of a car accident. Plant this for bed, border, exhibition, health; weatherproof.

MARION HARKNESS (Harkantabil)
Harkness, England, 1979
Hybrid tea large flowered bush, flowering summer to autumn. The beauty of this rose lies in the flamboyant flowers, a mixture of yellow and orange red. They are produced freely, opening cupped on dark leaved bushy plants. 75x60cm (30x24in). Seedling x 'Piccadilly'. Named for a senior member of the raiser's family to mark the centenary of the firm's foundation. Plant this for bed, border, cutting, hedge (50cm-20in); weatherproof.

MARJORIE FAIR (Red Ballerina, Red Yesterday)
Harkness, England, 1978
Polyantha shrub, flowering summer to autumn. The massive trusses of small wine red flowers with white eyes make this an eye-catching rose. The foliage is glossy and very dense, and it associates well with 'Ballerina' from which it was bred; the pollen parent was 'Baby Faurax'. 1.2x1.2m (4x4ft). ADR, GM Baden-Baden, Rome, Scandinavia, PRIZE Copenhagen, Paris. Named in memory of a friend of

'MARIJKE KOOPMAN'

'MARION HARKNESS'

MARY ROSE (Ausmary)
Austin, England, 1983
Shrub, flowering summer to autumn. The flowers have many petals, and the outer ones reflex while the inner ones incurve, creating a pretty old-fashioned looking flower. The colour is a warm shade of deep rose pink. Growth is vigorous, bushy but irregular, and leafy. 1.2mx90cm (4x3ft). Seedling x 'The Friar'. Named for the Mary Rose Trust, which worked to recover Henry VIII's flagship from the Solent where it had lain for over 400 years. Plant this for border, low fence, fragrance, shrubbery.

MASQUERADE
Boerner, USA, 1949
Floribunda cluster flowered bush, flowering summer to autumn. This was the talk of the rose world when first introduced, for it brought the "colour change" factor, hitherto seen in old Chinese roses of diffident growth, into the mainstream of garden usage. The flowers open yellow, then change colour to pink and finally a rather hard shade of red, all colours being present together in the large clusters. Despite the brashness of the final stages, the novelty appeal made this one of the world's most popular roses after World War II, and it was planted in beds and hedges by the million. Its popularity only declined when more subtle colour changes became evident in varieties bred from it, but it is still in demand for its vigour, freedom of bloom and general good behaviour, though virus has been a problem in some countries. 90x75cm (36x30in). 'Goldilocks' x 'Holiday'. GM NRS. Plant this for

the raiser. Plant this for large bed, border, exhibition, low fence, health, hedge (90cm-3ft), shrubbery, small specimen plant, spreading; weatherproof.

MARLENA
Kordes, Germany, 1964
Floribunda cluster flowered bush, flowering summer to autumn. This grows below average height, and covers itself with medium sized cupped flowers of rich dark crimson, lightened with patches of paler crimson. The compact plants are well furnished with dark green leaves. 45x45cm (18x18in). 'Gertrud Westphal' x 'Lilli Marlene'. ADR, GM Baden-Baden & Belfast. Plant this for small bed, border, low hedge (40cm-15in), small space; weatherproof.

MARQUISE BOCCELLA – see **JACQUES CARTIER**

MARY DONALDSON (Canana, Lady Donaldson)
Cant, England, 1984
Hybrid tea large flowered bush, flowering summer to autumn. Bears a good succession of salmony pink blooms of medium size on sturdy plants; they have classic high centred form, and may appear one to a stem or in clusters of a few flowers together, so that sometimes it is offered as a floribunda. Growth is upright, with large glossy leaves, 90x60cm (3x2ft). 'English Miss' x seedling. Named at the suggestion of the Worshipful Company of Gardeners to honour the first lady to become Lord Mayor of London. Plant this for bed, border, cutting, fragrance, health, hedge (50cm-18in); weatherproof.

MARY HAYLEY BELL (Korparau)
Kordes, Germany, 1989
Shrub, flowering summer to autumn. Makes a shrubby, dense plant with many shoots bearing dark pink rosette style blooms. The plant is rarely without flower through the season. Spiky grower, with plenty of bright leaves, to 90cmx1.2m (3x4ft). 'Zwergkönig 78' x seedling. GM & PIT RNRS. Named for the distinguished playwright and wife of actor Sir John Mills. Plant this for sizeable bed, border, fragrance, health, hedge (1m-3ft), shrubbery, spreading; weatherproof.

'MARY ROSE'

'MATANGI'

bed, border, hedge (60cm-2ft), rosarium; weatherproof.

CLG MASQUERADE
Dillon, England, 1958
Floribunda cluster flowered climber, flowering in summer with some later bloom. This climbing sport of the bush form is vigorous and colourful. Dead-heading will speed up the production of the next crop of flower when the first flush is over. Grows up to 3x4m (10x12ft). Plant this for fence, health, pergola, pillar, wall; weatherproof.

MATANGI (Macman)
McGredy, New Zealand, 1974
Floribunda cluster flowered bush, flowering summer to autumn. This variety brings refinement into the "painted rose" strain pioneered by Sam McGredy. The flowers are rich orange red with a silvery white eye and silvery reverse, very beautiful and striking, and they are borne freely against a background of abundant dark glossy leaves. The habit is neat, making this an excellent bedding rose. 90x60cm (3x2ft). Seedling x 'Picasso'. GM Belfast, Portland, RNRS & Rome, PIT RNRS. The name is the Maori word for "breeze" and also a village name; and a ship of that name was one of the first to bring members of the forces home after World War II; in the breeder's words, it means different things to different people. Plant this for bed, border, curiosity, exhibition, health, hedge (50cm-20in); weatherproof.

MATTHIAS MEILLAND (Meifolio)
Meilland, France, 1985
Floribunda cluster flowered bush, flowering summer to autumn. The colour of this rose is scarlet, dusky and bright , and the clusters of eight or so blooms display this brilliance boldly against a leafy background of shiny leaves. Growth is short, somewhat uneven, 75x60cm (30x24in). ('Mme. C. Sauvage' x 'Fashion') x ('Poppy Flash' x 'Parador'). Plant this for bed, border, hedge (50cm-20in); weatherproof.

MAX GRAF
Bowditch, USA, 1919
Rugosa hybrid ground cover rose, flowering in summer. This has been a universal favourite among landscape gardeners for many years, because it carpets the ground with healthy glossy leaves so densely that most summer weeds are smothered. The flowers are bright pink, paler towards the petal base, with golden stamens. As it does not set seed there is no need to trim off dead heads, which makes it particularly useful where easy garden maintenance is required. Long thought to be sterile, it showed that was not completely so by producing two seedlings, from one of which Kordes was able to breed the R. kordesii line of hardy shrubs and climbers. From them has come an improvement in the foliage of many newer roses, which is one of the most noticeable rose breeding achievements of recent years. We have much to thank 'Max Graf' for, and though its origin is obscure, it is thought to be R. rugosa x R. wichuraiana. 60cmx2.5m (2x8ft). Plant this for big border, ground covering, health; weatherproof.

MAY QUEEN
Manda, USA, 1898
Rambler, summer flowering. Bears rosy pink flowers in great profusion during the earlier part of summer. The blooms are of medium size, very prettily formed with many petals, opening quartered with an old-fashioned look about them. They are produced on short stems, and look beautiful garlanding the branches against a background of plentiful glossy leaves. The stems are flexible making this easy to train. 4mx3m (12x10ft). R. wichuraiana x 'Champion of the World'. Plant this for fence, health, naturalising, pergola, pillar, wall; weatherproof.

MEG
Gosset, England, 1954
Climber, flowering summer to autumn. The long slender buds are a rich reddish apricot, and open to wide apricot pink flowers of great beauty, showing prominent red stamens. The early flowering is prolific, and autumn bloom sporadic. Needs dead-heading to prevent the formation of large hips and encourage new flowering shoots. The plant makes vigorous growth with stiff prickly arching stems. 4x4m (12x12ft). Believed to be 'Paul's Lemon Pillar' x 'Mme. Butterfly'. GM St. Albans. Raised by Dr A.C.V. Gosset, a keen amateur rosarian from Liphook, Hants. Plant this for high fence, fragrance, health, naturalising, pergola, tree, high wall; weatherproof.

MELODY MAKER (Dicqueen)
Dickson, N. Ireland, 1991
Floribunda cluster flowered bush, flowering summer to autumn. Orange red flowers of hybrid tea shape are

'MEG' – UNUSUALLY PALE DUE TO HOT SUNNY WEATHER.

borne in clusters of up to twenty blooms. They have a silvery lining to the petals and the full blooms are outstanding, well displayed against a background of abundant dark foliage. 75x60 (30x24in). Seedling of 'Anisley Dickson'. ROTY. Plant this for bed, border, health, hedge (50cm-20in); weatherproof.

MEMENTO (Dicbar)
Dickson, N. Ireland, 1978
Floribunda cluster flowered bush, flowering summer to autumn. This is one of the best bedding roses ever raised, because of its even habit, freedom of bloom and good health. The colour is somewhere between salmon red and cherry pink, and this rather indeterminate shade may explain why it has never become as popular as it deserves to be. The blooms are neatly formed, well spaced in the cluster and make a marvellous show, whatever the weather. 75x60cm (30x24in). 'Bangor' x 'Korbell'. GM Belfast. Plant this for bed, border, exhibition, health, hedge (50cm-20in); weatherproof.

MERCEDES (Merko, Merkor)
Kordes, Germany, 1975
Floribunda cluster-flowered bush, flowering summer to autumn. This is included as a famous example of a rose grown for commercial cut flower use, and has flowers of intensely deep bright red and regular petal form; they open and hold their shape for many days. Some of the most intensive glasshouse production for the world's markets is done in Israel. According to Eliahu Bezalel, a leading grower, farmers working to maximum efficiency can harvest more than two million flowers per acre per year. An inert growing medium, such as volcanic stones, rockwool or dune sand is preferred to fertile soil, because the feeding can be scientifically controlled by means of a computer, with timings set for watering and the use of liquid fertiliser according to a planned programme;

'MELODY MAKER'

the use of inert medium also means that if mistakes occur and harmful salts build up, they can easily be flushed out by watering, and feeding can then resume. Most roses seen in florists' shops will have come from Israel, Colombia, Mexico, Kenya, southern Europe and other lands where sunshine is a natural asset. Very rarely are any of them fragrant, and this perhaps explains the origin of the fallacy that modern roses have lost their fragrance. The truth is that the waxy-coated petals that cut flower roses need if they are to travel without being bruised prevent the scent glands from functioning. As far as garden roses are

'MEMENTO'

concerned, scented varieties are available today just as they always have been, and it is simply a matter of selecting the right ones from the many that are available. Rose lovers find fragrant roses cut from the garden immeasurably more enjoyable than scentless ones produced for market. 'Mercedes' was bred from 'Anabell' x seedling, and is intended for large-scale glasshouse growers.

MERMAID
Paul, England, 1918
Climber, flowering summer to autumn. Five large yellow petals opening wide to disclose amber stamens comprise a flower of classic beauty. This rose was a sensation from the moment of its introduction, and the breeder was most fortunate to conjure it out of *R. bracteata*, which has shown few signs of willingness to pass on its genes in helpful ways. The flowers nestle against the leaves and appear at different levels on the plant for months on end. Their yellow colour pales to cream before the petals drop, leaving behind a circle of glowing stamens to be enjoyed for a few hours before they darken. The leaves are distinctive, red before they unfold to appear as polished, yellowish green oval leaflets. The stems are reddish-brown, apt to break off when being trained in place unless treated gently, and armed with vicious hooked prickles. 'Mermaid' has been described as "awkward on land" because of its reluctance to get established; once it settles down it grows very strongly, and if space permits it should be sited where it can develop naturally, since it is at its best when left to romp unpruned. Branches often look dead and should not be removed in haste, for they can show surprising powers of regeneration. Up to 6-9m (20-30ft). *R. bracteata* x a Tea rose. GM NRS. Plant this for high fence, health, naturalising, high wall; weatherproof.

MICHELE MEILLAND
Meilland, France, 1945
Hybrid tea large flowered bush, flowering summer to autumn. Produces long stemmed light pink flowers, with exquisite young flower form, perfect for cutting. The good foliage and vigour were early indications of the improvements that would come into roses thanks to genes from 'Peace'. 90x60cm (3x2ft). 'Joanna Hill' x 'Peace'. Plant this for bed, border, cutting, glasshouse, health, hedge (50cm-20in).

MINILIGHTS (Dicmoppet)
Dickson, N. Ireland, 1988
Patio or dwarf cluster flowered bush, flowering summer to autumn. Bears flowers like little yellow potentillas on short spreading plants, full of bright shiny leaves. An absolute charmer, and an important advance, because prostrate growing yellows that keep on flowering are badly needed in the rose garden. 25x50cm (10x20in). 'White Spray' x 'Bright Smile'. Plant this for small bed, front of border, container, curiosity, small space; weatherproof.

MINI METRO (Finstar, Rufin)
De Ruiter, Holland, 1980
Miniature, flowering summer to autumn. Orange red, a bright and pretty colour. Growth is bushy and upright. 40x35cm (16x14in). 'Minuette' x seedling. Plant this for small bed, front of border, container, petite hedge (30cm-12in), small space; weatherproof.

MISCHIEF
McGredy, N. Ireland, 1961
Hybrid tea large flowered bush, flowering summer to autumn. The large pointed flowers of this rose are seen in many gardens and at shows, for it is one of the commercial successes of the postwar years, and widely grown even after thirty years in commerce, despite some liability to rust. The colour is often said to be coral-salmon, a imprecise description which suggests that catalogue writers are not sure what to call it. This may be because the tints alter according to the time of

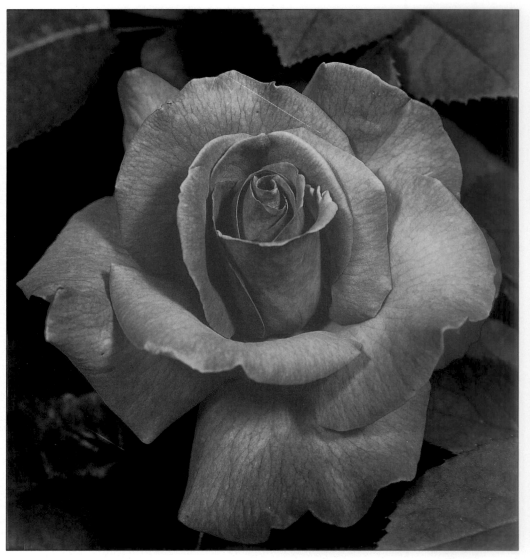

'MISCHIEF'

year, admitting more pink in summer and more orange in the autumn. It is beautiful always. Growth is upright and strong, to 90x60cm (3x2ft) or more. 'Peace' x 'Spartan'. GM NRS & Portland, PIT NRS. While this was being staged by the raiser at a show, Maj-Gen Frank Naylor, later RNRS President, suggested it be called 'Mischief'. Sam McGredy accepted this as a good idea, and only found out afterwards that it was the name of the General's dog. Plant this for bed, border, cutting, exhibition, fragrance, hedge (60cm-2ft); weatherproof.

MISTER LINCOLN
Swim & Weeks, USA, 1964
Hybrid tea large flowered bush, flowering summer to autumn. This makes an upright plant, bearing attractive velvety dark red buds which hold their colour tone well as they open to cup-shaped flowers. They are carried on strong stems and are useful to cut. The growth is too lanky to be ideal for bedding, and the tough leathery leaves have a rather dull appearance. 1mx60cm (40x24in). 'Chrysler Imperial' x 'Charles Mallerin'. AARS. Named for the sixteenth US President. Plant this for border, exhibition.

MODERN ART (Poulart, Prince de Monaco)
Poulsen, Denmark, 1983
Hybrid tea large flowered bush, flowering summer to autumn. The strikingly coloured salmon pink and white flowers have dark "painted" markings towards the petal edges, spreading as the flowers age. They have great beauty, especially on the first blooming. The habit is rather open and sprawling, foliage dark green. 75x60cm (30x24in). GM Rome. Plant this for border, curiosity, cutting.

MOJAVE
Swim, USA, 1954
Hybrid tea large flowered bush, flowering summer to

autumn. At the time of its introduction this was a sensation, being a healthy, free flowering rose in orange tones. Today, by comparison with better foliaged and more fully petalled roses, it looks thin and fleeting. The colour is orange salmon with veins of orange red running through, sometimes flushed with cyclamen pink. The neat slim buds are most appealing, held invitingly on long smooth stems, perfect for cutting. They open into loose-petalled shaggy looking flowers, though what they lack in form they make up for in colour. The plants grow narrow and gaunt, with sparse foliage. 75x50cm (30x20in). 'Charlotte Armstrong' x 'Signora'. AARS, GM Geneva & Paris. Takes its name from the Mojave Desert to the NE of Los Angeles, famous for its vivid orange sunsets. Plant this for border, cutting; weatherproof.

MONTEZUMA
Swim, USA 1955
Hybrid tea large flowered bush, flowering summer to autumn. The good points about this rose are vigour and health. The colour is a strange shade of salmon red, with a metallic quality about it as the flowers open and the colour lightens, at which point they take on a dull and artificial look. They also fail to open and show rain markings in wet spells. This makes a substantial plant, growing strongly with plenty of foliage up to 1.5mx90cm (5x3ft). 'Fandango' x 'Floradora'. GM Geneva, NRS, Portland. The name is that of Montezuma II (1466-1520), last Aztec emperor. Strange to relate, another rose called 'Aztec' came from the same breeder at the same time and bore perfectly formed large flowers in pale scarlet. The breeder's agents tested both, and there is no doubt that 'Aztec' was the finer flower, but sadly the plant was weak. If the flower of 'Aztec' had been on a vigorous plant like 'Montezuma' it could have been the sensation of the 1950s. Plant this for big bed, border,

exhibition, tall hedge (60cm- 2ft), pillar – but only in a warm climate or with protection from rain.

MOONLIGHT
Pemberton, England, 1913
Hybrid musk shrub, flowering summer to autumn. The breeder's catalogue for 1916 accurately describes this as having "wood and foliage dark claret red, in charming contrast to the moonlight colour of the flowers". The blooms are small, white with a lemon flush, carried in big clusters and opening flat with prominent yellow-to-pink stamens. The raiser's additional comment that this is "not liable to mildew" was rather optimistic, for the red young shoots may well be affected in the autumn. 1.2x1.2m (4x4ft). 'Trier' x 'Sulphurea'. GM Belfast, Dublin & NRS. Plant this for big bed, border, low fence, fragrance, hedge (1m-40in), shrubbery; weatherproof.

MORNING JEWEL
Cocker, Scotland, 1968
Climber, flowering summer to autumn. Bright pink flowers of medium size make a sparkling contrast with the shiny clean looking leaves. The blooms are carried in clusters and the first flush provides as spectacular a sight as any in the rose garden. There is

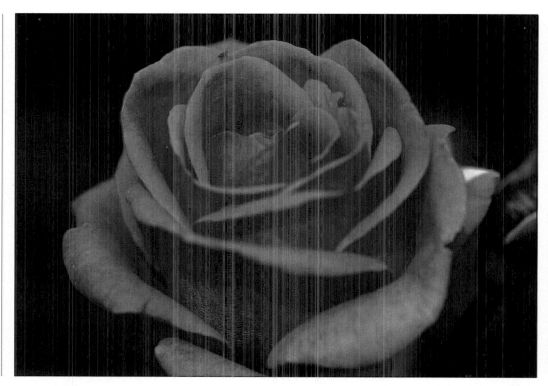

'MONTEZUMA'

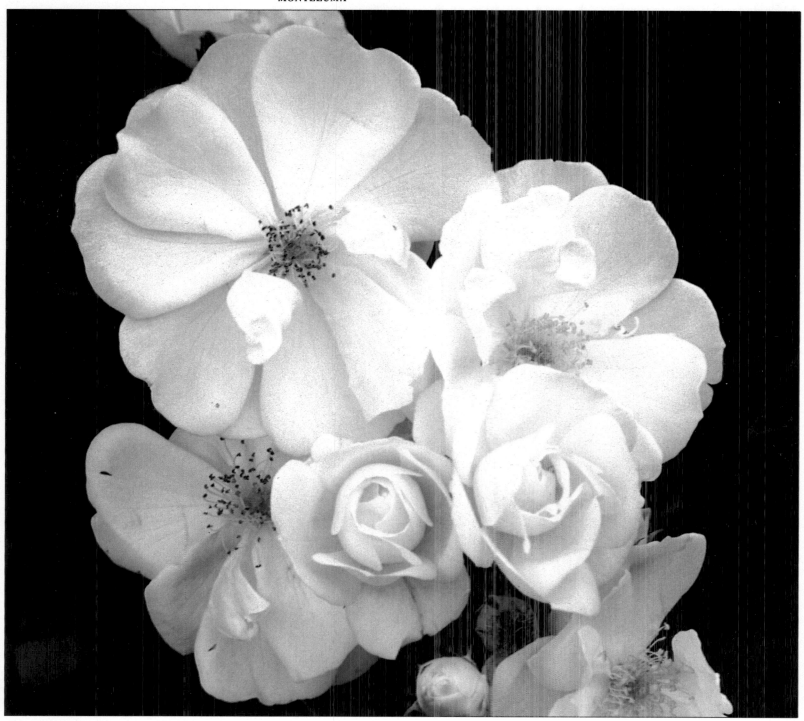

'MOONLIGHT'

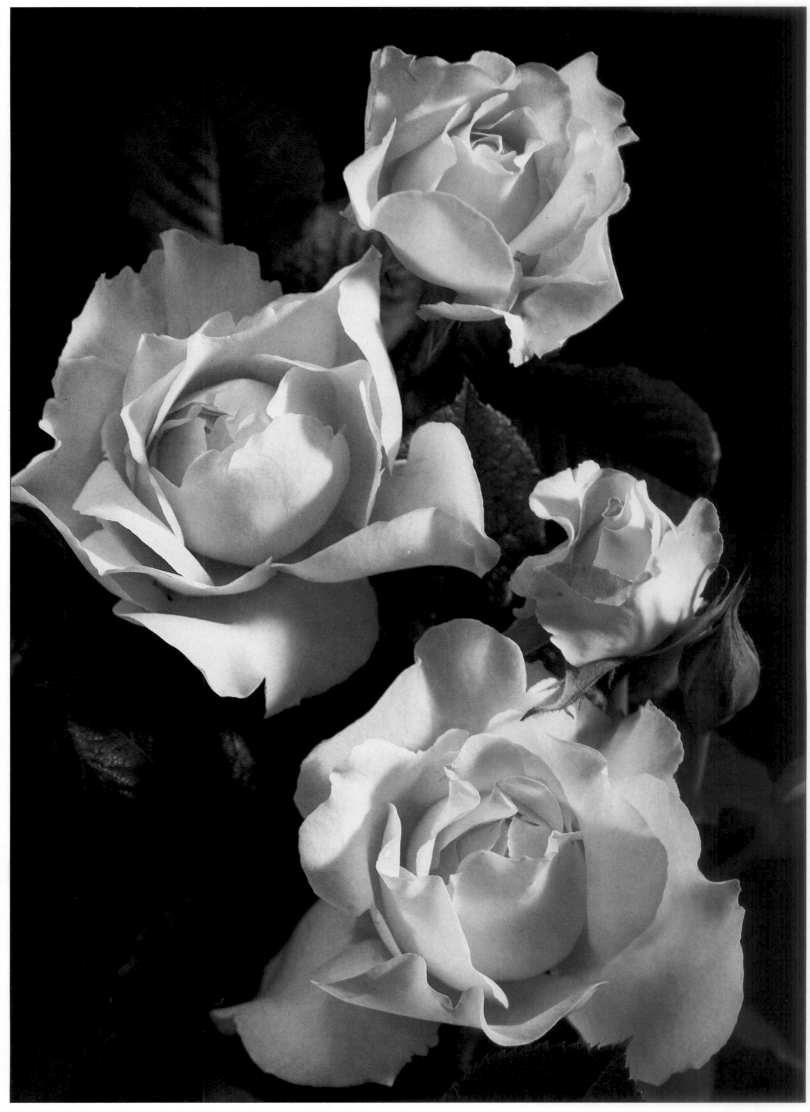

'MOUNTBATTEN'

then a pause while the plant gathers strength to flower again. The excellent health record of this rose makes it especially valuable for those difficult, awkward wall sites. It will extend up to 4x2.5m (12x8ft) but can be pruned as necessary to fit smaller areas. 'New Dawn' x 'Red Dandy'. Plant this for fence, fragrance, health, pillar, wall, including difficult positions; weatherproof.

MOUNTBATTEN (Harmantelle)
Harkness, England, 1982

Floribunda cluster flowered bush/shrub, flowering summer to autumn. Round yellow buds, tight with petals, open into large scented blooms, the petals reflexing and then incurving to create flowers of interest and changing beauty at every stage. The habit is handsome, shrublike and dense. The leaves are crisp, tough looking and plentiful, and usually persist well into winter. 1.2mx80cm (48x32in). 'Peer Gynt' x [('Anne Cocker' x 'Arthur Bell') x 'Southampton']. GM Courtrai & Orleans, GR The Hague, PRIZE Belfast, Courtrai & Lyon, ROTY. Named to honour the memory of Earl Mountbatten of Burma. Plant this for large bed, border, low fence, fragrance, health, hedge (60cm-24in), low pillar, shrubbery, specimen plant, low wall; weatherproof.

MOUSSELINE
Moreau-Robert, France, 1881

Moss shrub, flowering in summer, maybe some later bloom. The flowers are blush, with many petals, opening rather flat but raised in the centre, with a pleasing regular round outline. There is moss present but not a lot of it. A distinctive feature of this unassuming rose is the shape of the leaflets, like the bowl of a teaspoon. Makes a twiggy plant to about 1x1m (40x40in). Said by some to be the same as 'Alfred de Dalmas' of 1855, but this is not certain. Plant this for border, fragrance, shrubbery.

MOYESII – see R. moyesii.

MR E.E. GREENWELL
Harkness, England, 1978

Floribunda cluster flowered bush, flowering summer to autumn. The rosy salmon blooms open wide from red buds, and are well spaced in their clusters to give

'MOUSSELINE' OR 'ALFRED DE DALMAS'

maximum colour effect. It is one of the best bedding varieties for continuity of bloom. As with 'Memento', its qualities have not brought it the public favour it deserves, perhaps due to the colour not being popular for massed beds, and certainly not helped by the awkward name. Neat compact growth, dark foliage, 60x60cm (2x2ft). 'Jove' x 'City of Leeds'. Named in memory of a former President of the N. Yorks Young Farmers' Clubs. Plant this for bed, border, health, hedge (50cm-20in); weatherproof.

MRS ANTHONY WATERER
Waterer, England, 1898

Rugosa shrub, flowering in summer, with some later flower. This is a rough looking, coarse leaved plant which is now probably outmoded in the age of improved ground cover roses. It has served generations of gardeners well with its dense weed- suppressing growth and tolerance of less than ideal conditions. The flowers are reddish purple, loosely double, carried in clusters, and lie back among the leaves in a way that is restful and pleasing to the eye. There is good fragrance. Spreading, 1.2x2.2m (4x7ft). R. rugosa x 'Général Jacqueminot'. Plant this for large bed, border, low fence, fragrance, health, wide hedge (1.3m-52in), shrubbery, spreading; weatherproof.

MRS HARKNESS (Paul's Early Blush)
Harkness, England, 1893

Hybrid perpetual bush, flowering in summer, with some later bloom. Bears blush pink flowers of good size, well filled with petals. They are arranged in the confused fashion common to many older roses, and open wide to display their beauty, maintaining a pleasing rounded outline. The plant grows upright, with a covering of soft green leaves. 90x90cm (3x3ft). Sport of 'Heinrich Schultheis'. It is on record that two sports occurred simultaneously, one in Yorkshire and one in Herts., on the Harkness and Paul nurseries respectively. They were introduced in 1893 under different names. Both sometimes revert to the parent form (a pink rose) and there is a striped sport also, introduced in 1897 as 'Merrie England'. It is probable that the Yorkshire sport was named in memory of Mary Harkness (1826-1881), mother of John Harkness the discoverer. Plant this for border, fragrance, rosarium.

MRS JOHN LAING
Bennett, England, 1887

Hybrid perpetual bush, flowering in summer, with some later bloom. This is a historic rose, the result of a planned programme of breeding by Henry Bennett. The pointed buds open to wide round flowers of some forty-five petals arranged with beautiful symmetry, combining size, elegance and grace, thus foreshowing the qualities of the future hybrid teas. The bush grows strongly with ample light green foliage. 90x75cm (36x30in). Seedling of 'François Michelin'. GM NRS. Plant this for bed, border, fragrance, hedge (60cm-2ft), rosarium; weatherproof.

'MR E. E. GREENWELL'

'MRS OAKLEY FISHER'

MRS. OAKLEY FISHER

B.R.Cant, England, 1921

Variously described as a hybrid tea or floribunda bush, or as a shrub, flowering summer to autumn. This rose is an anomaly, one of a handful still in commerce of a group of five-petalled hybrid teas introduced before and after World War I. It survives by reason of the beautiful colour. The buds are rich orange with red flushes, and open to display flowers of buff-copper, with gold-to-red stamens in their hearts. Although the stems are frail in appearance and the reddish foliage thin, this is an enduring plant, and can be kept small or allowed to form a shrub. 75x75cm (30x30in) or more up to 1.5x1.5m (5x5ft). Plant this for border, curiosity, fragrance, rosarium.

MRS. SAM McGREDY

McGredy, N. Ireland, 1929

Hybrid tea large flowered bush, flowering summer to autumn. This was one of the most popular garden roses before the second world war, by reason of the colour – coppery pink in the fully open bloom, but with rich red veining in the urn shaped bud and young flower. Such a colour was unequalled before, and one could say it has not been surpassed in all the years since. In form too the flowers are exquisite, with high centres and petals parting slowly to reveal the inner depths. The plant and foliage do not match this standard, being thin wooded and sparse respectively, though the young leaf is pretty with lustrous dark red tints. 75x60cm (30x24in). ('Donald Macdonald' x 'Golden Emblem') x (seedling x 'The Queen Alexandra Rose'). GM NRS. Named for Ruth, the wife of Sam McGredy III. Plant this for border, rosarium; weatherproof.

CLG MRS. SAM McGREDY (Geneviève Genest)

Buisman, Holland, 1937

Hybrid tea large flowered climber, flowering in summer with some autumn bloom. The climbing form of 'Mrs Sam McGredy' has commendable vigour; the foliage cover is quite good though the plant may become bare at the base, and the stiff stems need a structure high enough to train them on. 3x3m (10x10ft) or more. Plant this for high fence, high wall; weatherproof.

MULLARD JUBILEE (Electron)

McGredy, N. Ireland, 1970

Hybrid tea large flowered bush, flowering summer to autumn. This bears large full-petalled flowers of a warm shade of deep rose pink, though sometimes it will produce smaller flowers in clusters. It has the qualities required of a good garden rose – quick to drop the old petals cleanly, leafy in habit, good in all weathers; some fragrance too. 75x60cm (30x24in). 'Paddy McGredy' x 'Prima Ballerina'. AARS, GM Belfast, The Hague, Portland & RNRS. Named by the breeder for the Mullard company. Plant this for bed, border, fragrance, hedge (50cm-20in); weatherproof.

MUTABILIS (Tipo Ideale)

from China, pre-1894

China bush/shrub/climber, flowering summer to autumn. This is one of the most remarkable roses ever, yet its origin is unknown. It is thought to be the 'Tipo Ideale' rose depicted by Redouté, and was growing in Italy in the 1890s. It has the characteristics of a Chinese garden rose in its pointed shiny leaves, plum coloured wood and long-petalled flowers. The buds open orange-yellow, and as the flowers age they change colour to ochre yellow, pink and finally slate-purple. In Graham Thomas's words, "the countless blossoms resemble flights of butterflies".[3] Although it is hardy, it is best to site it away from cold spring winds; on a sheltered wall it can go up to 3x1.5m (10x5ft), and in the open makes a shrubby plant 1.2mx90cm (4x3ft) or more. Named by the Swiss alpine gardener (Henri Corrévon) who had received it as a gift from Italy. Plant this for border, curiosity, fence, glasshouse, pillar, rosarium, shrubbery, wall.

3 In *Shrub Roses of Today*, (Dent 1974)

MY JOY

Wood, England, 1976

Hybrid tea large flowered bush, flowering summer to autumn. This pink rose is a sport of 'Red Devil' with the same big blooms, high centres and wonderful lasting qualities. The broad petals make it a fine exhibitors' rose, which is the chief reason for its cultivation. It will not stand too much rain. Upright, robust growth. 1mx75cm (40x30in). Discovered by Len Wood, President of the RNRS 1987/88, who named it for his wife. Plant this for exhibition.

NATHALIE NYPELS

Leenders, Holland, 1919

Floribunda cluster flowered bush, flowering summer to autumn. This is an unassuming little flower, pink and pretty enough and with no apparent special distinction, yet it is still being grown long after more famous roses of its era have disappeared. It makes a hardy and long lived plant, always seems to be in flower, and the restful clear colour makes it a useful companion in mixed borders, since it never clashes or looks out of place. The leaf is of the China type, pointed and shiny, and the habit is neat. 75x60cm (30x24in). 'Orleans Rose' x ('Comtesse du Cayla' x *R. foetida bicolor*'). Plant this for bed, border, health, hedge (50cm-20in); weatherproof.

NATIONAL TRUST (Bad Nauheim)

McGredy, N. Ireland, 1970

Hybrid tea large flowered bush, flowering summer to

'NATIONAL TRUST'

autumn. This is a useful dark red rose because of its short neat habit, in contrast to the legginess of most in this colour. The flowers are full of petals, of pleasing regular form, hold their heads up, and keep a good clear colour tone. The plants are bushy and well furnished with dark leaves. 60x60cm (2x2ft). 'Evelyn Fison' x 'King of Hearts'. Introduced in the National Trust's 75th anniversary year. Plant this for bed, border, hedge (50cm-20in); weatherproof.

NEVADA
Dot, Spain, 1927

Shrub, flowering in summer, with a few later blooms. One of the treats of summer is to see 'Nevada' festooned with creamy white semi-double flowers, opening wide to 10cm (4in) or more across and borne all along the branches. Although it is a big plant, the flowering is so generous that stems and foliage are almost lost from sight. Has dark, rather smooth wood, a vigorous branching habit, and plentiful light green foliage sweeping to the ground. 2x2m (7x7ft). Seedling of 'La Giralda'; the pollen parent is often cited as *R. moyesii*, but this seems improbable and a Scotch rose has been suggested as more likely. Plant this for huge bed, big border, fence, fragrance, majestic hedge (1.5m-5ft), naturalising, shrubbery, specimen plant, spreading, wall; weatherproof.

NEW DAWN (Everblooming Dr van Fleet, The New Dawn)
Somerset Roses, USA, 1930

Climber, flowering summer to autumn. The story of the discovery of this rose and its importance as a channel of *R. wichuraiana's* genes has been told in Chapter One. As a garden plant it is one of the most satisfying of all varieties, because it has no faults. The pretty blush flowers open whatever the weather, they have one of the sweetest scents, they keep blooming for weeks, the stems are pliable for training, the leaves shiny, attractive and rarely touched by ailments, and the whole plant has a pleasurable airy effect that makes you feel the world is a better place; what more can we ask of a rose than that? It can be kept as a 1.2x1.5m (4x5ft) bush by pruning, or trained up to 5x4m (15x12ft), and is one of the best to try on

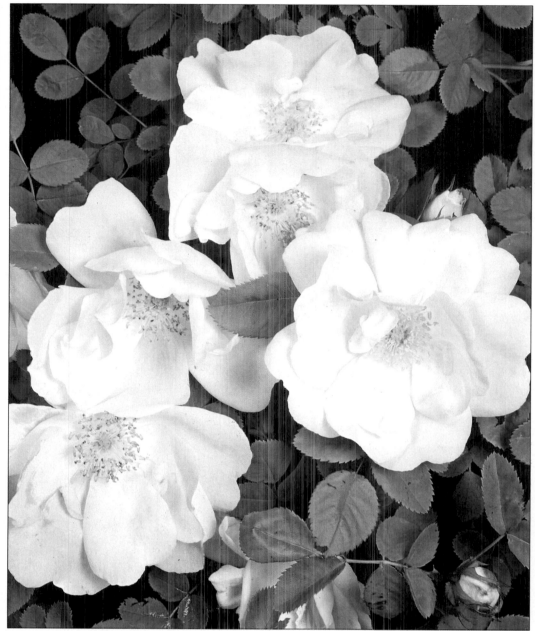

'NEVADA'

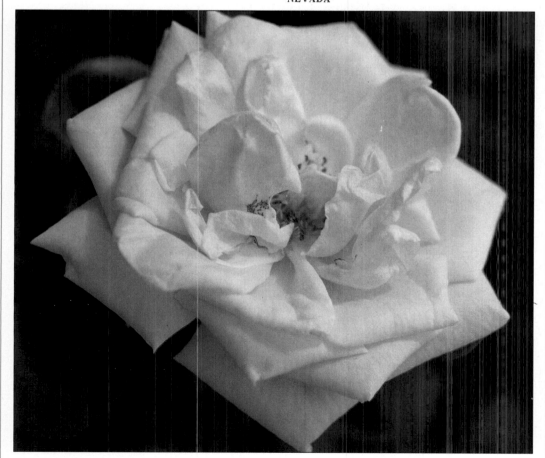

'NEW DAWN'

difficult wall sites. Sport of 'Dr W. van Fleet'. Plant this for large bed and border, with pruning; fence, fragrance, health, big hedge (1.2m-4ft), and prune hard into the young wood each year), naturalising, pergola, pillar, shrubbery (with pruning), tree, wall; weatherproof.

NEW PENNY
Moore, USA, 1962

Miniature rose, flowering summer to autumn. The flowers are somewhere between orange red and coppery pink in colour, of neat regular form, and freely borne over a long period on petite shiny leaved bushes. 25x25cm (10x10in). *(R. wichuraiana x Floradora)* x seedling. Plant this for container, glasshouse, health, small space; weatherproof.

NEWS
LeGrice, England, 1968

Floribunda cluster flowered bush, flowering summer to autumn. The beetroot-purple colour of the flowers was a great novelty when this was introduced, and it is still one of the best to grow in what is admittedly not a very popular rose colour. The blooms are quite large (8cm-3in) and open cupped, so the colour impact is striking. The growth is upright and semi-glossy leaves clothe the plant well. 60x50cm (24x20in). The breeder crossed 'Lilac Charm' with the Gallica rose 'Tuscany Superb' to obtain this, and did well to get a seedling able to repeat its bloom from such parentage. GM RNRS. Plant this for bed, border, curiosity, hedge (45cm-18in); weatherproof.

NIGEL HAWTHORNE (Harquibbler)
Harkness, England, 1989
Persica hybrid shrub, flowering in summer. When asked what type of rose he would wish to bear his name, Nigel Hawthorne said: "I am going to be a bit of a problem, because the kind of roses I like are unperfect roses". The rose he chose is only "unperfect" in the sense that the period of flowering is brief, because it is a first generation cross from *R. persica*. In other respects it is distinctive and remarkable. The five-petalled flowers are a rare shade of pale salmon, marked with red at the petal base, and they are carried on wiry stems with wrinkled rich green leaves. The plant makes a hummocky prickly shrublet, 60x75cm (24x30in). Bred from *R. persica* and the rugosa rose 'Harvest Home', this being the first record of a union between the genes of those two species. Plant this for border, curiosity, health, rosarium.

NIPHETOS
Bougère, France, 1843
Tea bush, flowering summer to autumn. The attraction of the lemon-white flowers lies in their elegant pointed bud form, much prized in the mid nineteenth century when such a feature was uncommon. This beauty was not often maintained in the open flowers, because the softness of the petal easily caused collapse or bruising, but this did not stop it being widely grown as a glasshouse rose for decorative use. The leaves are light green and pointed. 90x75cm (3x2ft). The name comes from the Greek for "snowy". Plant this for fragrance, glasshouse, rosarium.

CLG NIPHETOS
Keynes, Williams & Co. England, 1889
Tea climber, flowering summer to autumn. This is the vigorous climbing sport of 'Niphetos' which is most often seen today under glass, where weak necks cause the blooms to bow. This brings them conveniently into view for those who pass below. It can be grown on a very sheltered wall out of doors. 3x3m (10x10ft). Plant this for fragrance, glasshouse, rosarium, warm frost-free wall.

NORFOLK (Poulfolk)
Poulsen, Denmark, 1990
Ground cover shrublet, flowering summer to autumn. There is a great need for ground covering roses in yellow, and this newcomer is a step in that direction. It bears clusters of bright yellow double blooms on dense leafy bushes which grow compactly to about 45x60cm (18x24in). Plant this for small bed, front of border, container, fragrance, ground covering, small space; weatherproof.

NOZOMI (Heideröslein)
Onodera, Japan, 1968
Creeping patio or ground cover rose, flowering for several weeks in summer. The petite clematis-like flowers are a reminder of the guileless beauty that a mere five petals can command. They are white to blush and borne along the creeping stems on short stems, the effect being as if many garlands have been strewn upon the ground. This rose looks delightful where it can trail down, as on the top of a wall. It can be grown up against a wall as a miniature climber, to about 1.5x1.5m (5x5ft). The stems can be trimmed back if they exceed the space available when it is used in other ways. 'Fairy Princess' x 'Sweet Fairy'. 'Nozomi', meaning "hope" is a girl's name in Japan, and this pretty rose honours the memory of the breeder's four year-old niece; she was travelling from Manchuria to rejoin her family in Japan after the end of World War II, but tragically died before she could complete the journey home. Plant this for bed, front of border, sizeable container, curiosity, low fence, ground covering, health, naturalising, pillar, rosarium, front of shrubbery, smallish space, specimen plant, low wall, weeping; weatherproof.

NUITS DE YOUNG (Old Black)
Laffay, France, 1845
Moss shrub, flowering in summer. The attraction of this rose lies in the flowers, which are intensely dark, a mixture of deep maroon and rich purple-red. They are rather small, with stiff flat petals, borne on springy stems with brownish moss, rough to the touch. Upright grower, sparsely foliaged, and frankly no great beauty as a plant. 1.2x1m (4x3ft). The name seems strange, and Graham Thomas has suggested it is called after the morality poem *Night Thoughts on Life, Death & Immortality* by Edward Young, which was published 1742-45 and was famous in its day. Perhaps its most memorable line is "Procrastination is the thief of time". Plant this for border, curiosity, fragrance.

OFFICINALIS – see *R.gallica officinalis*

OLD BLUSH (Common Blush, Common Monthly, Old Pink Daily, Old Pink Monthly, Parsons' Pink China)
Ancient Chinese garden rose
China bush/shrub, flowering summer to autumn. This is the plant that caused a sensation throughout the western world from the 1750s onwards, when it is said to have reached Europe. The pretty rose pink flowers are borne in clusters of cupped, rather loosely petalled roses. They keep flowering in cycles of growth and bloom for several months until winter dormancy forces them to rest. It is this remontancy which made their genes so valuable in the development of roses in the century ahead. The leaves are pointed, shiny and handsome, and the plant grows to about 1mx80cm (36x30in), or larger in warmer climates such as that of Bermuda, where it is capable of reaching several feet into a tree or up against a wall. Plant this for bed, border, rosarium; weatherproof.

OLD PINK MOSS – see COMMON MOSS

OLIVE (Harpillar)
Harkness, England, 1982
Floribunda cluster flowered bush, flowering summer to autumn. The blooms are large, neatly formed with pointed centres, in a rich oxblood red colour; the outer petals often exhibit waved edges. Late season blooms are particularly fine and last for days when cut. Growth is uneven, as some shoots grow tall, making this suitable to grow on a short pillar as well as in bush form. The leaves are large, dark and glossy. 1mx60cm (40x24in). Seedling x 'Dublin Bay'. PRIZE Geneva. Named for Olive Scotchmer (née Harkness) for her 85th birthday. Plant this for border, cutting, low pillar; weatherproof.

OLYMPIAD (Macauck)
McGredy, New Zealand, 1984
Hybrid tea large flowered bush, flowering summer to autumn. Deep red, with long furled buds opening into shapely blooms which hold their petals stiffly. The

'OLIVE'

'OLYMPIAD'

colour holds its tone well without fading, though the petal tips may burn in strong sun. Grows upright and bushy to 90x60cm (3x2ft). 'Red Planet' x 'Pharaoh'. AARS, GM Portland. This was named as the official rose for the Olympic Games. Plant this for bed, border, cutting, hedge (50cm-20in).

OMAR KHAYYAM
Ancient Persian garden rose
Damask shrub, flowering in summer. This curious rose produces small fat buds containing many small pink petals, which open out in a confused loosely quartered fashion. The leaves are small, pale and rather downy and the plant forms a twiggy, prickly bush about 90x90cm (3x3ft). Stock is said to have come from Persia in the form of seed from the poet's tomb at Nashipur, and a bush raised from this was planted in 1893 on the grave of Edward Fitzgerald, translator of the *Rubáiyát*, at Boulge in Suffolk. Plant this for border, curiosity, fragrance, rosarium.

OPHELIA
Introduced by Wm. Paul, England, 1912
Hybrid tea large flowered bush, flowering summer to autumn. The creamy blush flowers of this sweet scented rose are among the loveliest one could wish to see. The young petal tips reflex to reveal pink tints within, and though they open rather fast, a pleasing rounded outline is maintained until petal fall. This has long been a natural choice for bridal bouquets and buttonholes. The stems and foliage are thin by modern standards, so it is best grown in a border with shorter plants in front. 90x60cm (3x2ft). The origin of

'Ophelia' is a mystery; Paul's nursery believed it might have come as a mislabelled item with plants ordered from France. What a gift of the gods! It gave rise to numerous sports and features many times in the family trees of modern roses. Plant this for border, cutting, fragrance, glasshouse, rosarium; weatherproof.

ORANGEADE
McGredy, N. Ireland, 1959
Floribunda cluster flowered bush, flowering summer to autumn. At the time of its introduction this was the hottest colour in roses, a bright orangey red so brilliant that it almost hurt the eyes. The flowers open wide, showing golden stamens. It is less widely grown now as there are others with better health records. The leaves are dark and semi-glossy. 75x60cm (30x24in). 'Orange Sweetheart' x 'Independence'. GM NRS & Portland. Plant this for bed, border, hedge (50cm-20in).

ORANGE SENSATION
De Ruiter, Holland, 1961
Floribunda cluster flowered bush, flowering summer to autumn. The colour is light vermilion red, more restful than others in this range. The flowers are cupped, fairly full and of medium size. They hold their colour tone and look pretty at every stage. There is a fruity, rather sharp scent. Growth is bushy and spreading, with plenty of light foliage. 70x60cm

(28x24in). 'Amor' x 'Fashion'. GM NRS, GR The Hague. Plant this for bed, border, fragrance, hedge (50cm-20in); weatherproof.

ORANGE SUNBLAZE (Meijikatar, Sunblaze)
Meilland, France, 1981
Miniature, flowering summer to autumn. The colour makes you stop and look; it is an intensely dark and bright scarlet, not orange in the fruity sense. The plant grows sturdily with petite pointed leaflets and maintains a good succession of tiny rosette type blooms. 30x30cm (12x12in). Plant this for very small bed, front of border, container, small space; weatherproof.

CLG ORANGE SUNBLAZE (Clg Orange
Meillandina, Meijikatarsar)
Meilland, France, 1986
Climbing miniature, flowering summer to autumn. This sport of the above is a welcome novelty. It flowers over a long period unlike some earlier climbing miniatures, giving brilliant colour up the stems to about 1.5x1.2m (5x4ft). GM Monza & Rome, PRIŻE Monza. Plant this for sizeable container, low fence, low pillar, low wall; weatherproof.

ORANGE TRIUMPH
Kordes, Germany, 1937
Polyantha or floribunda cluster flowered bush, flowering summer to autumn. This is a historic rose

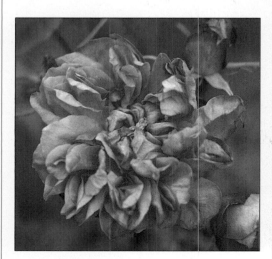

'OMAR KHAYYÁM'

'ORANGEADE'

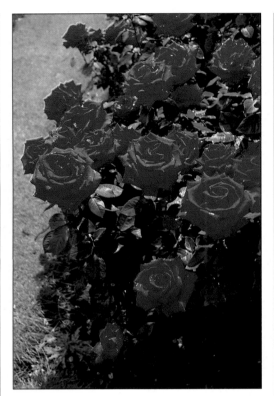

'PACEMAKER'

both because of its own plant qualities and for the value of its genes in further breeding. The flowers have no orange in them except to the imagination, being salmon red, small and filled with petals. They open cupped in great heads of bloom and last a long time on the plant. The plant grows upright with strong stems and was for many years one of the most popular floribundas because of its hardiness and ease of cultivation. 1.2mx75cm (48x30in). 'Eva' x 'Solarium'. GM NRS. Plant this for border, health, hedge (60cm-2ft); weatherproof.

PACEMAKER (Harnoble)
Harkness, England, 1981
Hybrid tea large flowered bush, flowering summer to autumn. Deep pink fragrant flowers are produced with a freedom that is surprising in view of their size and quality. The plants grow bushy, with a good covering of glossy leaves. 75x60cm (30x24in). 'Red Planet' x 'Wendy Cussons'. GM Belfast. This was named for the British Heart Foundation which benefited from the initial sale of plants. Plant this for bed, border, fragrance, hedge (50cm-20in).

PADDY McGREDY
McGredy, N. Ireland, 1962
Floribunda cluster flowered bush, flowering summer to autumn. This bears rose red flowers of classic hybrid tea form in clusters on a short plant. For that reason its introduction was hailed as something of a breakthrough in the story of rose development, as combining in one plant the best qualities of hybrid teas and floribundas. It also caused debate about classifying roses, but that issue was nothing new and remains contentious after thirty years. Today it is taken for granted that flowers of 'Paddy McGredy' quality should appear on cluster flowering bushes, and that is a measure of the quiet revolution breeders have brought about. 50x50cm (20x20in). 'Spartan' x 'Tzigane'. GM NRS. Named for the sister of Sam McGredy IV. Plant this for small bed, front of border, short hedge (45cm-18in).

PAINTED MOON (Dicpaint)
Dickson, N. Ireland, 1990
Hybrid tea large flowered bush, flowering summer to autumn. The flowers of this rose undergo an extraordinary colour change. Petals which start yellow turn pink from the tips, then the pink deepens to red, until finally they are more or less totally crimson. The flowers are carried in wide sprays so that several of

them open at the same time, and the colour effect is startling. Upright and leafy, 75x60cm (30x24in). 'Bonfire Night' x 'Silver Jubilee'. Plant this for bed, border, curiosity, fragrance, health, hedge (50cm-20in).

PALLAS (Harvestal)
Harkness, England, 1989
Miniature, flowering summer to autumn. The flowers are only up to 4cm (1.5in) across, but are remarkably structured, accommodating sixty narrow petals in the apricot buff rosettes. The first flowering is so prolific that you can scarcely see the ground beneath the plants. Petite grower, 25x25cm (10x10in). 'Clarissa' x 'New Penny'. Plant this for very small bed, front of border, container, health, small space.

PANDORA (Harwinner)
Harkness, England, 1989
Miniature, flowering summer to autumn. This bears creamy to white rosettes, sometimes with a hundred tiny petals, beautifully proportioned and nestling against a background of shiny dark leaves. Low and spreading, 30x38 (12x15in). 'Clarissa' x 'Darling Flame'. Plant this for small bed, front of border, container, health, petite hedge (30cm-12in), small space; weatherproof.

PAPA MEILLAND
Meilland, France, 1963
Hybrid tea large flowered bush, flowering summer to autumn.. This is a wonderful rose at its best, carrying high centred dark crimson flowers on strong stems, full of heady fragrance, and capable of winning prizes at the shows. It also attracts mildew and dies back in winter. The best place for it is the cutting garden. Upright grower, with large leathery leaves, 90x60cm (3x2ft). 'Chrysler Imperial' x 'Charles Mallerin'. GM Baden- Baden. Bred by Alain Meilland and named for his grandfather Antoine (1884-1971). Plant this for border, cutting, exhibition, fragrance.

PARADISE (Burning Sky, Wezeip)
Weeks, USA, 1978
Hybrid tea large flowered bush, flowering summer to

autumn. The colour of this rose is unusual and beautiful, silvery lavender with ruby red towards the petal edges. The blooms are long petalled in bud, open fairly fast and repeat well. It suits warmer climates which help bring out the colour contrast, but not cool wet conditions as found in Britain. 90x60cm (3x2ft). 'Swarthmore' x seedling. AARS. Plant this in warm climates for bed, border, curiosity, cutting, fragrance; and in Britain, for glasshouse.

PARKDIREKTOR RIGGERS
Kordes, Germany, 1957
Climber, flowering summer to autumn. Produces big clusters with up to fifty flowers of middling size. The blooms are rich deep crimson and open out with waved rather rigid petals, showing the stamens. The growth is very vigorous, with stiffly branching stems and dark leaves, to 4x2.5m (12x8ft) or more. *R. kordesii* x 'Our Princess'. ADR. Plant this for high fence, pergola, high wall; weatherproof.

PARSONS' PINK CHINA – see **OLD BLUSH**

PASCALI (Blanche Pasca, Lenip)
Lens, Belgium, 1963
Hybrid tea large flowered bush, flowering summer to autumn. The attractive flowers are white with hints of cream. The urn- shaped buds reflex their petal tips in a delightful way, and as the flowers open they maintain a consistently high quality in all weathers. It is difficult to think of a better white rose for the garden, even after nearly thirty years in commerce. The growth is upright, and the leaves dark, somewhat sparse. 75x60cm (30x24in). 'Queen Elizabeth' x 'White Butterfly'. AARS, GM The Hague & Portland. Plant this for bed, border, cutting, health; weatherproof.

PAUL'S HIMALAYAN MUSK (Paul's Himalayan Rambler)
G. Paul, England, 1916
Climber, flowering in summer. This is beautiful for three weeks or so when it bears a cloud of blossom, made up of countless tiny fluffy rosettes of blush pink with a dash of lilac in them. It has drooping leaves and thorny shoots which latch on to anything within reach

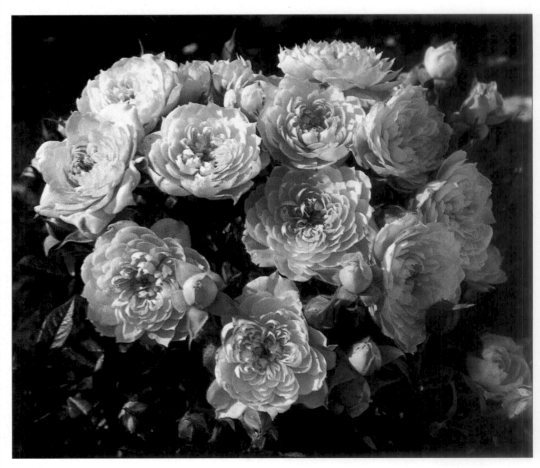

'PALLAS'

to gain support; and the reach is extensive, for it is one of the rose world's most rampageous members, capable of covering 9x9m (30x30ft). Its origin is a mystery. Plant this for fragrance, naturalising, large tree.

PAUL NEYRON
Levet, France, 1869
Hybrid perpetual shrub, flowering in summer and with some autumn bloom. Bears large rose pink flowers in a deep warm shade. There is an air of opulence in the casual way its fifty ruffled petals are disposed. The growth is strong to 1.5x1.2m (5x4ft). 'Victor Verdier' x 'Anna de Diesbach'. Plant this for border, low fence, shrubbery.

PAUL SHIRVILLE (Harqueterwife, Heart Throb)
Harkness, England 1983
Hybrid tea large flowered bush, flowering summer to autumn. Has fragrant high centred blooms of classic form, in a pretty shade of rosy salmon pink. The plants are more spreading in growth than most hybrid teas, giving them a shrublike effect, and are covered in dark shiny foliage. 75x75cm (30x30in). 'Compassion' x 'Mischief'. GR Courtrai, FRAG New Zealand, RNRS. Named for a noted design engineer, whose friends made the arrangements as a surprise retirement present; in New Zealand it is sold as 'Heart Throb' in aid of The National Heart Foundation. Plant this for bed, border, fragrance, hedge (60cm-2ft); weatherproof.

PAUL'S LEMON PILLAR
Paul, England, 1915
Climber, flowering in summer. The lemon colour is that of the pith, not the skin, and almost white. The flowers are very large and full, beautifully formed with many broad petals. Growth is stiff and upright, with a somewhat meagre covering of large leaves, to 5x3m (15x10ft). 'Frau Karl Druschki' x 'Maréchal

'PAUL NEYRON'

Niel'. GM NRS. Plant this for exhibition, high fence, fragrance, high wall; the stems need to be kept tied in as the heavy flowers can easily be damaged if blown about in high winds.

PAUL'S SCARLET CLIMBER
Paul, England, 1915
Climber, flowering in summer, with sometimes a few late blooms. The bright red clusters of this rose were a familiar sight up to the 1950s, when it had been the number one choice in red climbers for many years. It was popular because of the spectacular summer bloom, when much of the foliage was hidden under a mass of vivid colour. Makes long arching shoots, very leafy but prone to mildew, and extending to 3x3m (10x10ft) or more if space permits. Seedling of 'Paul's Carmine Pillar'. GM NRS & Paris. Plant this for fence, naturalising, pergola, pillar, tree; weatherproof.

'PAUL SHIRVILLE'

PEACE (Gioia, Gloria Dei, Mme. A. Meilland)
Meilland, France, 1942
Hybrid tea large flowered bush, flowering summer to autumn. This famous rose set new standards of excellence in vigour and beauty, but especially in foliage, for it showed that bush roses can be attractive to the eye even when not in flower. The blooms are yellow flushed pink, full and rounded in form, opening whatever the weather. Large bright leaves clothe the shrublike plants almost to the ground. 1.2x90cm (4x3ft). Seedling x 'Margaret McGredy'. AARS, GM NRS & Portland, GR The Hague. The intention of the raiser was to name this for his mother, but its release in USA coincided with the end of World War II, and commercial pressures dictated otherwise. Plant this for bed, border, cutting, exhibition, health, hedge (75cm-30in), shrubbery, specimen plant; weatherproof.

PEACHES 'N CREAM
Woolcock, USA, 1976
Miniature, flowering summer to autumn. The pretty flowers of this peach pink rose are rounded and full of petals, like hybrid teas greatly reduced in scale. It needs sunshine and dry conditions to open, and in Britain is best grown under glass to produce blooms suitable for showing. 35x35cm (15x15in). 'Little Darling' x 'Magic Wand'. Plant this in Britain for exhibition, glasshouse.

PEARL DRIFT (Leggab)
LeGrice, England, 1980
Shrub, flowering summer to autumn. This makes a spreading plant, very graceful, with blush flowers 11cm (4in) across in clusters, opening wide to show the stamens, looking clean, classy and beautiful at every stage. The leaves are plentiful, dark and shiny, on 75cmx1m (30x42in) plants. 'Mermaid' (a difficult rose to breed with) is the seed parent, crossed with 'New Dawn'. Plant this for sizeable bed, border, fragrance, health, hedge (90cm-3ft), shrubbery; weatherproof.

PEAUDOUCE (Dicjana, Elina)
Dickson, N. Ireland, 1985
Hybrid tea large flowered bush, flowering summer to autumn. A splendid garden rose, with big perfectly formed blooms of lemon white with lemon yellow in the centre. They are carried one to a stem, making this good for cutting, and contrast beautifully against a background of large dark leaves. 1mx75cm (40x30in). 'Nana Mouskouri' x 'Lolita'. ADR, GSSP New Zealand. Plant this for bed, border, cutting, exhibition, health, hedge (60cm-2ft); weatherproof.

PEEK A BOO (Brass Ring, Dicgrow)
Dickson, N. Ireland, 1981
Patio or dwarf cluster flowered bush, flowering summer to autumn. Bears petite flowers in large sprays on a compact cushiony plant. They have many small petals, and open from apricot urn- shaped buds into pink rosettes. The bushes are covered with many small dark narrow leaflets. 45x45cm (18x18in). 'Memento' x 'Nozomi'. Plant this for small bed, front of border, container, low hedge (40cm-16in), small space; weatherproof.

PEER GYNT
Kordes, Germany, 1968
Hybrid tea large flowered bush, flowering summer to

'PEEK A BOO'

'PEER GYNT'

PENELOPE
Pemberton, England, 1924

Hybrid musk shrub, flowering summer to autumn. The shell pink blooms are beautifully formed, cupped at first, then opening flat to show their yellow stamens. They are carried in graceful well spaced sprays. This is the most popular and enduring of the hybrid musks by reason of its freedom of bloom, neat spreading habit and clean dark foliage. 1x1m (40x40in). GM NRS. Plant this for large bed, border, cutting, exhibition, low fence, fragrance, health, hedge (80cm-32in), shrubbery, small specimen plant, spreading, low wall; weatherproof.

PENTHOUSE (Macnauru, Macsatur, West Coast)
McGredy, New Zealand, 1986

Hybrid tea large flowered bush, flowering summer to autumn. Produces large blooms in a middling shade of pink, with scalloped petal edges on well-foliaged plants. The growth may be uneven, to 90x60 (3x2ft). GM Baden-Baden. Plant this for bed, border, exhibition, hedge (50cm-20in); weatherproof.

PERFECTA
Kordes, Germany, 1957

Hybrid tea large flowered bush, flowering summer to autumn. The flowers can be so flawless in fine weather that they look artificial. The petals are blush edged reddish pink, and form high pointed blooms that last well when cut at the half-open stage. They are likely to spoil in rainy weather. Dark leaved upright plants to 75x60cm (3x2ft). 'Spek's Yellow' x 'Karl Herbst'. GM NRS & Portland. Plant this for border, exhibition, health.

PERLA DE ALCANADA (Baby Crimson)
Dot, Spain, 1944

Miniature, flowering summer to autumn. This is being superseded by newer sorts, but for many years it was the best deep red, and a fine example of what miniature roses can provide, with flowers, leaves, stems and general habit all reduced in scale. It bears dark petite rosettes, on compact plants, and is rarely out of flower for months on end. The plants are tough

and enduring, and covered with hundreds of tiny leaflets. 30x40cm (12-16in). Plant this for container, health, small space; weatherproof.

PERLE DES JARDINS
Levet, France, 1874

Tea bush, flowering summer to autumn. The light yellow flowers of this old rose are elegant in the young flower, and it was much valued for cutting a century ago. For this either a warm climate or glasshouse cultivation were required, for as the Rev. Foster-Meillar observed, it is "a Rose of shocking bad manners" due to early blooms of promise being malformed by cold spring weather. When they do come out they are splendidly set off against a background of dark leaves on vigorous plants. 1.2m x90cm (4x3ft). Seedling of 'Mme. Falcot'. Plant this in a warm climate for border, fragrance, low wall, and in cooler climates for fragrance, glasshouse and a very sheltered wall.

PERLE D'OR (Yellow Cécile Brunner)
Rambaud, France, 1883

Polyantha or china type bush, flowering summer to autumn. This is like an ochre yellow version of 'Cécile Brunner', with petite buds which open honey-pink deepening to pale apricot in the centre. The shoots are thin and the whole plant has a spindly appearance that belies its toughness. The leaves are dark and shiny, and the bush can attain 1.2x1m (4x3ft) or more. Thought to be raised from a polyantha x 'Mme. Falcot'. Plant this for border, cutting, low fence, health, low wall; weatherproof.

PERNILLE POULSEN
Poulsen, Denmark, 1965

Floribunda cluster flowered bush, flowering summer to autumn. Bears clusters of salmon pink flowers, elegantly formed in the bud stage, and opening out to show a warm expanse of colour. It is noted for flowering early and continuing late. The plants are well furnished with pointed light green leaves. 60x60cm (2x2ft). 'Ma Perkins' x 'Columbine'. Named by the raiser for his daughter. Plant for bed, border, exhibition, hedge (50cm-20in); weatherproof.

autumn. The full-petalled flowers are yellow, with the tips edged pinky red. They are large and rounded in form, and sometimes produced in clusters. The plants grow vigorously, with rich green foliage, to 80x60cm (32x24in). 'Colour Wonder' x 'Golden Giant'. GM Belfast. Plant this for bed, border, health, hedge (50cm-20in); weatherproof.

'PERLE DES JARDINS'

'PETIT FOUR'

'PHOENIX'

PETITE DE HOLLANDE (Normandica, Petite Junon de Hollande, Pompon des Dames)
Origin unknown, pre-1838
Provence or centifolia shrub, flowering in summer. This is an ancient form of the Cabbage rose, with the many-petalled rose pink blooms charmingly reduced in scale. They are borne in clusters very freely, and have deeper pink tints in the centre of the flowers. Bushy growth, 1x1m (40x40in). Plant this for border, fragrance, hedge (90cm-3ft), rosarium, front of shrubbery.

PETIT FOUR (Interfour)
Ilsink, Holland, 1982
Patio or dwarf cluster flowered bush, flowering summer to autumn. This rose makes a neat cushiony bush, covered with small (4cm-1.5in) flowers that open wide, showing a confection of pink and white shades. It is rarely without some flower all through the season. The leaves are small, bright and plentiful. 40x40cm (16x16in). 'Marlena' seedling x seedling. Plant this for small bed, front of border, health, low hedge (38cm-15in), small space; weatherproof.

PHEASANT (Heidekönigin, Kordapt, Palissade Rose)
Kordes, Germany, 1985
Ground cover, flowering in summer. Bears small double blooms in deep rose pink on creeping stems. The plant is well furnished with small glossy leaves, and will sprawl up to 3m (10ft) wide, but with a height of only about 50cm (20in). 'Zwergkönig '78' x seedling of *R. wichuraiana*. Plant this for front of big border, ground covering, health, front of shrubbery; weatherproof.

PHOENIX (Harvee)
Harkness, England, 1989
Miniature bush, flowering summer to autumn. Bears blood red rosettes, prettily formed with layers of narrow ogee-shaped petals, revealing orange highlights as they open. Grows compactly, with many tiny leaflets, to 40x40cm (15x15in). 'Clarissa' x ('Wee Man' x seedling). Plant this for small bed, front of border, container, health, petite hedge (36cm-14in), small space; weatherproof.

PHYLLIS BIDE
Bide, England, 1923
Polyantha climber, flowering summer to autumn. A very distinctive rose, with conical hearts to the young flowers. They are small, borne in clusters, and open with a subtle blend of fawn pink and yellow. This is a modest grower, putting more of its energy into flower production, which is all to the benefit of the gardener. It has narrow, shiny leaves and branching growth to 2.5x1.5m (8x5ft), or it can be trimmed and grown as a shrub. 'Perle d'Or' x a Noisette; 'William Allen Richardson' has been suggested as a more likely pollen parent than 'Gloire de Dijon' which is usually cited. GM NRS. Plant this for border (as shrub), fence, pillar, shrubbery, wall; weatherproof.

PICCADILLY
McGredy, N. Ireland, 1959
Hybrid tea large flowered bush, flowering summer to autumn. This rose is loved for its bright flowers, scarlet with yellow on the undersides, which are borne with amazing freedom and consistently good high centred form. The plants are bushy, making many shoots, and covered with dark lustrous leaves. 80x60cm (32x24in). 'McGredy's Yellow' x 'Karl Herbst'. GM Madrid & Rome. Plant this for bed, border, exhibition, hedge (50cm-20in); weatherproof.

PICCOLO (Tanolokip)
Tantau, Germany, 1984
Floribunda or dwarf cluster flowered bush, flowering summer to autumn. Neat buds open to somewhat loose flowers in bright tomato red, which are held

'PICCADILLY'

'Temple Bells'. Plant this for border, low fence, ground covering, health, front of shrubbery; weatherproof.

PINK FAVOURITE
Von Abrams, USA, 1956
Hybrid tea large flowered bush, flowering summer to autumn. The assets of this pink rose are good size, clear colour, perfect high-centred form, freedom of flower, shiny foliage and splendid health. Some people but not all detect fragrance too. The leaves are unusual, long, shining and light green. 75x60cm (30x24in). 'Juno' x ('Georg Arends' x 'New Dawn'). GM Portland. Plant this for bed, border, exhibition, fragrance?, health; weatherproof.

PINK GROOTENDORST
Grootendorst, Holland, 1923
Rugosa hybrid shrub, flowering summer to autumn. Clusters of small bright rose pink flowers are produced freely and with scarcely a break for several months. They have distinctive serrated or frilled petals like a dianthus. These dainty flowers are borne on a plant that entirely lacks their charm, having upright rather chunky growth with light coarse foliage and prickly stems. 1.3x1m (54x42in). Sport of the deep red 'F.J. Grootendorst', which is similar in all respects save colour. Plant this for border, curiosity, health, rosarium, shrubbery; weatherproof.

PINK PARFAIT
Swim, USA, 1960
Floribunda cluster flowered bush, flowering summer to autumn. The petals display many shades of pink – rose, salmon, orange and blush among them, melding into a pleasing light shade as the flowers mature. The buds are urn-shaped, neatly furled, and make splendid buttonholes. This is a free flowering garden rose of even growth and leafy habit, 75x60cm (30x24in). 'First Love' x 'Pinocchio'. AARS, GM Baden-Baden, NRS, Portland. Plant this for bed, border, cutting, exhibition, health, hedge (50cm-20in); weatherproof.

PINK PERPETUE
Gregory, England, 1965
Climber, flowering summer to autumn. Bears clusters of deep pink flowers, carmine on the petal reverse. They are of regular cupped form, and produced freely

close to the dark glossy leaves. 50x50cm (20x20in). Plant this for small bed, front of border, low hedge (45cm-8in), small space; weatherproof.

PINK BELLS (Poulbells)
Poulsen, Denmark, 1983
Ground cover shrub, flowering in summer. The flowers are a cheerful bright rose pink, and space themselves neatly over a mound of small dark leaflets. Vigorous growth to 75cmx1.5m (30x60in). 'Mini-Foul' x

'PINK GROOTENDORST'

'PINK PERPETUE'

'POLAR STAR'

'PORTLAND ROSE'

over many weeks, giving excellent garden value. The leaves are leathery and cover the plant well. Like many modern climbers, this can be pruned as necessary to fit the space available, and can attain 2.8x2.5m (9x8ft). 'Danse du Feu' x 'New Dawn'. Plant this for fence, pillar, wall, including exposed walls; weatherproof.

POLAR STAR (Polarstern, Tanlarpost)
Tantau, Germany, 1982
Hybrid tea large flowered bush, flowering summer to autumn. The flowers of this rose are very large, pointed, and borne on long stems. The leaves are large and dark green but somewhat sparse. 90x60 (40x24in). ROTY. Plant this for border, exhibition.

POLLY
Beckwith, England, 1927
Hybrid tea large flowered bush, flowering summer to autumn. This would be introduced as a cluster flowered rose today, for the creamy-blush blooms are no larger than those of many modern floribundas, and are frequently carried in wide sprays. They are exquisitely formed, with the petals coiled in such a way that as they part they reveal golden depths to the flower. The plants have a branching habit, with spindly wood and foliage that looks thin by modern standards. 60x50cm (24x20in). 'Ophelia' seedling x 'Mme. Colette Martinet'. Plant this for border, fragrance, glasshouse.

POMPON DE PARIS – see **ROULETII**

CLG POMPON DE PARIS
Origin not known
Climbing miniature, flowering in summer. This is delightful because it flowers early. The rose red flowers are daintily formed, cupped, rounded and well filled with many petals. It can extend to 4x2.5m (12x8ft) and needs a strong structure as the stems bear a fair weight of leafy side growths. Presumed to be a climbing sport of 'Pompon de Paris'. Plant this for rosarium, wall.

PORTLAND ROSE (Duchess of Portland, Paestana)
from Italy, ca.1800?
The historic importance of this rose as being perhaps

the first recorded hybrid between varieties of east and west has been described in Chapter One. Whether what is offered today is the true original is hard to say, but it answers the general description, bearing deep crimson-pink single blooms in summer and sometimes in autumn, with yellow stamens. Plant this for border, rosarium.

POT O' GOLD (Dicdivine)
Dickson, N. Ireland, 1980
Hybrid tea large flowered bush, flowering summer to autumn. The flowers are decorative, that is to say they are not over- large, but of a size perfect for the flower arranger. They are clear yellow with a touch of old

gold, and borne freely on spreading well foliaged plants. The late autumn bloom is especially good. 75x60cm (30x24in). 'Eurorose' x 'Whisky Mac'. PRIZE UK (BARB). Plant this for bed, border, cutting, fragrance, hedge (50cm- 20in); weatherproof.

POUR TOI (Para Ti, Wendy)
Dot, Spain, 1946
Miniature, flowering summer to autumn. This was another of Pedro Dot's highly successful introductions in the 1940s. The tiny buds and flowers with their cool creamy petals contrast beautifully with the dark leaves. 25x25cm (10x10in). 'Eduardo Toda' x 'Pompon de Paris'. Plant this for container, small space.

'POLLY'

'POT O' GOLD'

PRECIOUS PLATINUM (Opa Pötschke, Red Star)
Dickson, N. Ireland, 1974
Hybrid tea large flowered, bush, flowering summer to autumn. One of the best bright crimson roses, with a sheen to the petals that catches the eye from afar. The flowers are shapely and full of petals. Makes a vigorous bushy plant with plenty of glossy foliage, 90x65cm (36x26in). 'Red Planet' x 'Franklin Englemann'. The rather puzzling name for a red rose came about because it was sponsored by Johnson Matthey, refiners of precious metals. Plant this for bed, border, health, hedge (60cm-24in); weatherproof.

PRESIDENT DE SEZE (Mme. Hébert)
Before 1836
Gallica shrub, flowering in summer. The flowers are large, of beautiful colour, and with intricate petal folds. Of all the old roses this is one of the most pleasurable. The centre of the flower is deep magenta, graduating towards the lilac pink of the outer petals. The plant is vigorous, trouble free and long lived. With gallicas, it is a sound idea to plant deep, as members of this group readily throw up their own suckers. 1.2x1.2m (4x4ft). Plant this for border, curiosity, low fence, fragrance, health, shrubbery; weatherproof.

PRETTY POLLY (Meitonje)
Meilland, France, 1988
Patio or dwarf cluster flowered bush, flowering summer to autumn. This makes a leafy shrublet, covered with a good succession of small rose pink flowers. They are pretty, with rows of petals neatly arranged. Dense rounded growth, 40x45cm (16x18in). 'Coppélia 76' x 'Magic Carrousel'. GM & PIT RNRS. Plant this for small bed, front of border, container, health, low hedge (40cm-16in), small space; weatherproof.

PRIDE OF MALDON (Harwonder)
Harkness, England, 1991
Floribunda cluster flowered bush, flowering summer to autumn. This colourful rose bears semi double flowers, vivid orange on the inside of the petals and yellow on the reverse. They are carried in clusters and make a brilliant display against dark lustrous foliage.

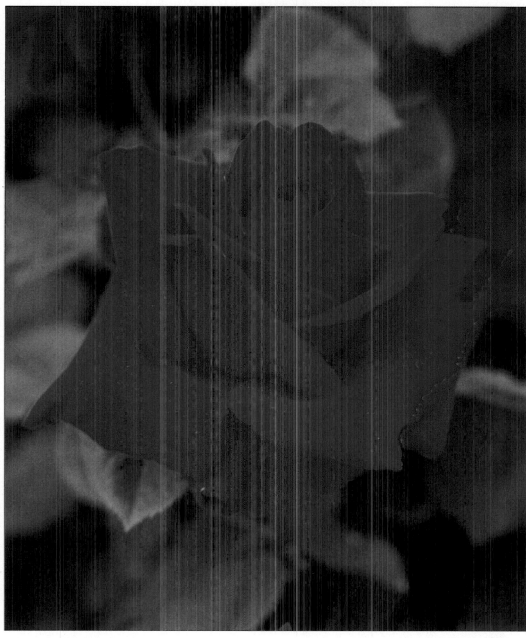

'PRECIOUS PLATINUM'

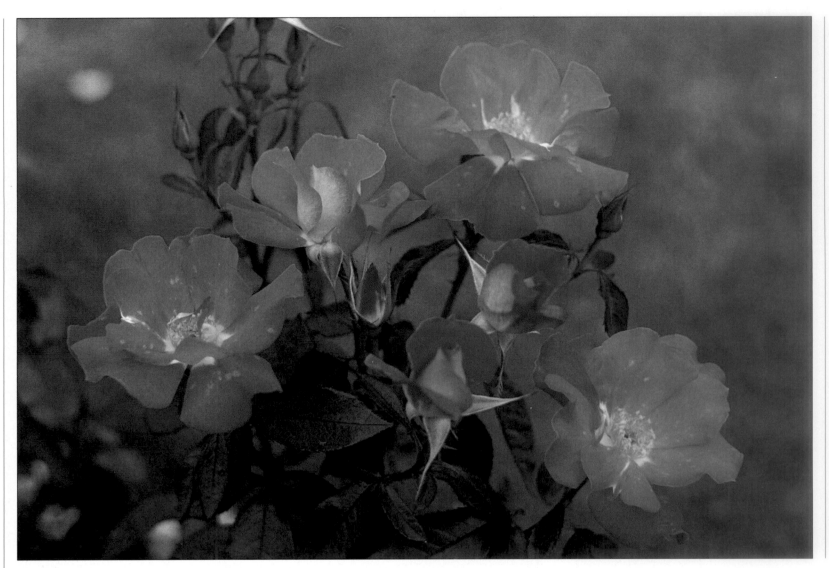

'PRIDE OF MALDON'

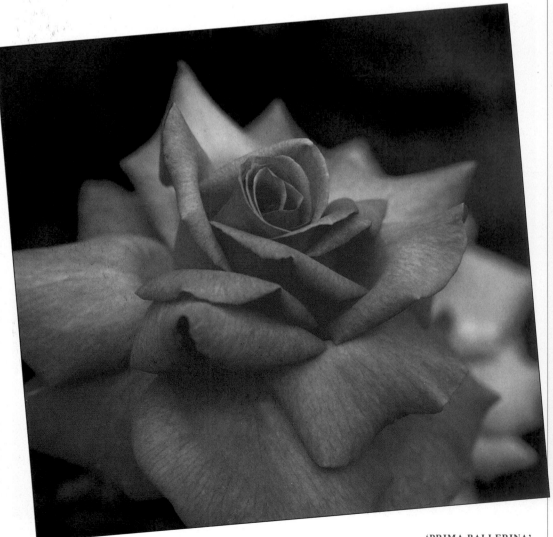

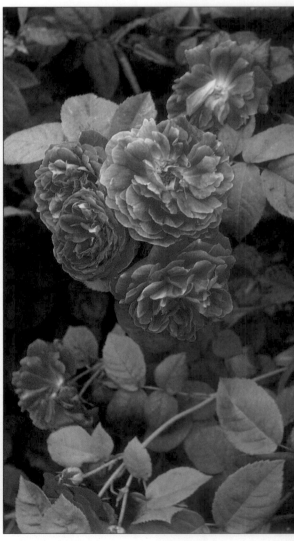

'PRIMA BALLERINA' 'PRINCE CHARLES'

172

75x60cm (30x24in). 'Southampton' x 'Wandering Minstrel'. Named to commemorate the millennium of the Essex town of Maldon, scene of an epic battle between Vikings and Saxons in 991 AD. Plant this for bed, border, health, hedge (50cm-20in); weatherproof.

PRIMA BALLERINA
Tantau, Germany, 1957
Hybrid tea large flowered bush, flowering summer to autumn. For years this was the best deep pink garden rose, loved for its fragrance and pretty high-centred blooms in a warm shade of deep rose pink. It is still widely grown though no longer the trouble free rose it was. 1mx60cm (40x24in). Seedling x 'Peace'. Plant this for border, fragrance; weatherproof.

PRINCE CAMILLE DE ROHAN (La Rosière)
Verdier, France, 1861
Hybrid perpetual bush, flowering in summer with possible later bloom. This rose has faults but is notable for its remarkable flowers, made up of a hundred or so overlapping blackish maroon petals with a dash of chestnut-brown. They have been described as "so dark as to be dull". The plant itself is undistinguished, with weak flower stems and disease prone leaves. 1x1m (40x40in). It maybe derived from 'Général Jacqueminot' x 'Géant des Batailles'. Plant this for border (preferably away from other roses), curiosity, fragrance.

PRINCE CHARLES
1842
Bourbon shrub, flowering in summer. This is a mixture of purple and crimson, lightening to lilac- red as the blooms age, and showing white at the petal base. The flowers are fairly full, usually borne in clusters, sometimes singly, and open loosely with crinkled petals, showing streaky vein marks. Grows to 1.5x1.2m (5x4ft) with nearly thornless stems. Plant

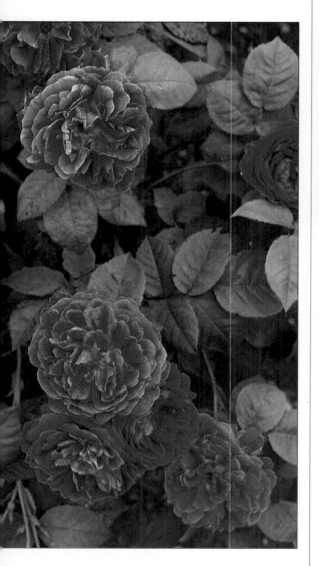

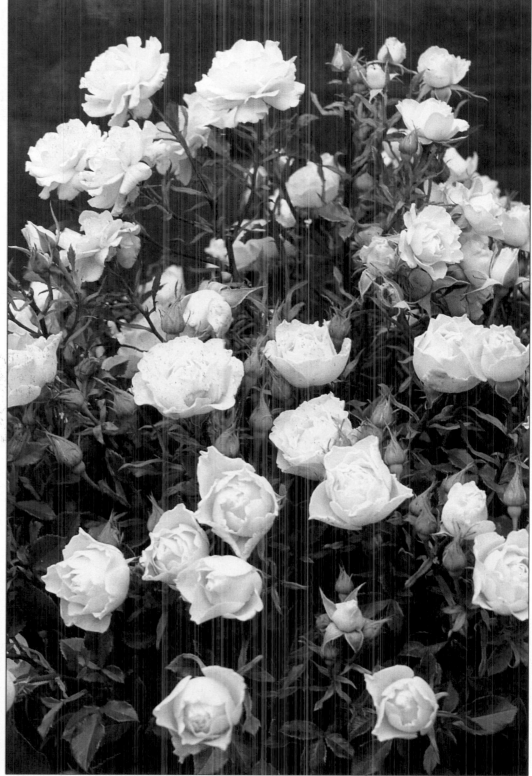

'PRINCESS ALICE

this for sizeable border, low fence, shrubbery, low wall.

PRINCESS ALICE (Hartanna, Zonta Rose)
Harkness, England, 1985
Floribunda cluster flowered bush, flowering summer to autumn. Bears clear yellow flowers in large clusters, with each flower neatly spaced to form a natural floral bouquet. They are carried on strong stems, good to cut and show. The plants grow upright, rather tall and narrow, 1mx60cm (40x24in), with healthy foliage. 'Judy Garland' x 'Anne Harkness'. GM Dublin, PRIZE Orleans. Named for HRH Princess Alice, Duchess of Gloucester, who has created a beautiful garden at Barnwell in Northants. Plant this for border, cutting, exhibition, health, upright hedge (50cm-20in); weatherproof.

PRINCESSE DE MONACO (Meimagarmic, Preference)
Meilland, France, 1982
Hybrid tea bush rose, flowering summer to autumn.

The large full blooms are enlivened with pretty tints of pinky red around the petal edges. They need dry conditions to open, so this variety is best in a warm climate. Attractive dark foliage and strong growth to 1mx80cm (40x32in). 'Ambassador' x 'Peace'. Named in memory of HSH Princess Grace of Monaco, who was active in encouraging others to share her love of roses. Plant this in warm climates for bed, border, fragrance, health, hedge (75cm-30in).

PRINCESS MICHAEL OF KENT (Harlightly)
Harkness, England, 1981
Floribunda cluster flowered bush, flowering summer to autumn. Bears well-shaped full petalled flowers, sizeable in proportion to the short bushy plants. They are canary yellow, rounded in form, hold the colour and drop their petals cleanly. The autumn blooms are particularly fine. Neat habit, with healthy glossy leaves, 50x50cm (20x20in). 'Manx Queen' x 'Alexander'. PRIZE Orleans. Named for HRH Princess Michael of Kent on the occasion of her opening the Lakeland Show, 1979. Plant this for bed,

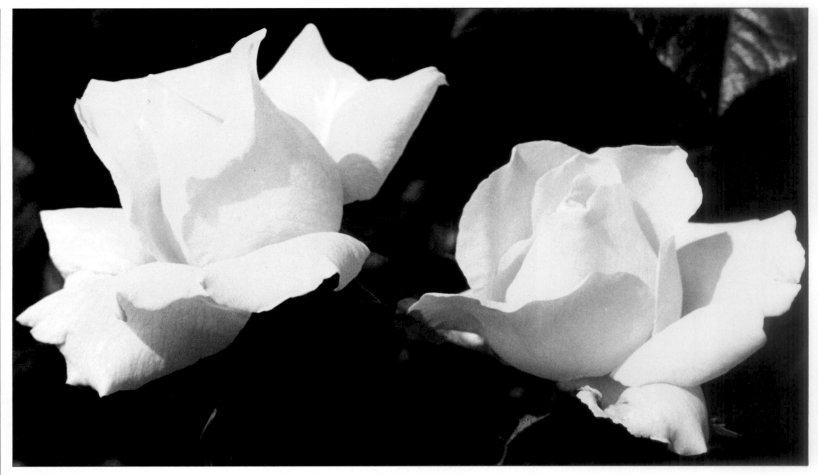

'PRINCESS MICHAEL OF KENT'

border, fragrance, health, low hedge (40cm-16in); weatherproof.

PRISCILLA BURTON (Macrat)
Meilland, New Zealand, 1978
Floribunda or cluster flowered bush, flowering summer to autumn. The colour is striking, rich carmine splashed with white, and darker markings towards the petal rims. The flowers open wide so they display this eye-catching mixture to the best advantage. The leaves are dark and glossy, though not proof against blackspot. Grows upright and bushy to 75x60cm

(30x24in). 'Old Master' x seedling. GM & PIT RNRS. Named for the wife of the chairman of the Fisons company. Plant this for bed, border, curiosity, exhibition.

PRISTINE (Jacpico)
Warriner, USA, 1978
Hybrid tea large flowered bush, flowering summer to autumn. The flowers are ivory with a hint of blush, large and well formed with overlapping petals, reminiscent of camellias. They stand out among dark leaves and stems on vigorous bushing plants,

1mx75cm (40x30in). 'White Masterpiece' x 'First Prize'. FRAG RNRS, GM Portland. Plant this for bed, border, fragrance, health, hedge (60cm- 2ft); weatherproof.

PROSPERITY
Pemberton, England, 1919
Hybrid musk shrub, flowering summer to autumn. Covers itself in great sprays of small semi-double creamy white flowers in summer, followed by less spectacular displays later in the season. Dark glossy leaves make a good contrast with the pale blooms. The plants will grow big and spread out to 2x1.5m (6x5ft) or can be pruned to keep them more compact. 'Marie Jeanne' x 'Perle des Jardins'. Plant this for large bed, border, low fence, fragrance, health, substantial hedge (1.2m-4ft or closer if being pruned down), shrubbery; weatherproof.

QUAKER STAR (Dicperhaps)
Dickson, N. Ireland, 1991
Floribunda cluster flowered bush, flowering summer to autumn. The flowers are wine red with silvery highlights. The petals have a stiff structure, and open from pretty buds to hold a regular rounded form. The plants are bushy, well foliaged and neat in habit, to 70x50 (28x20in). 'Anisley Dickson' x seedling. Named for the Quaker movement's tercentenary year. Plant this for bed, border, health, hedge (45cm-18in); weatherproof.

QUATRE SAISONS (Autumn Damask, Four Seasons, *R. damascena* 'Bifera', *R. damascena semperflorens*, Rose of Castille)
Ancient
The origin of this rose is a mystery, but its importance in rose evolution is undoubted, for it was the only old rose in the west that gave a reliable show of autumn flower. It also gave its fragrance and vigour to play a major role in the development of nineteenth century roses. Forms of it have supplied the rose perfume industry with its raw material throughout recorded time. The flowers are a rather hard tone of pink, loosely formed, with many petals arranged in random fashion, borne in clusters on arching branches. The

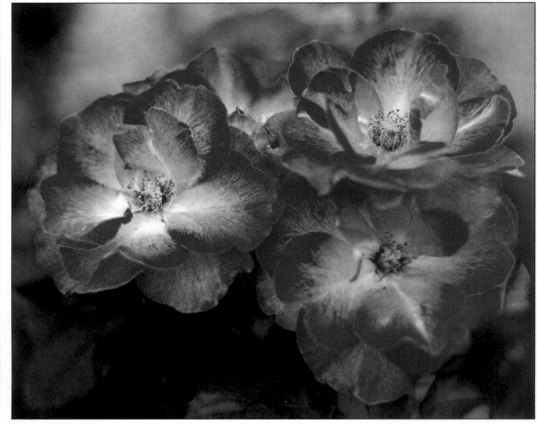

'PRISCILLA BURTON'

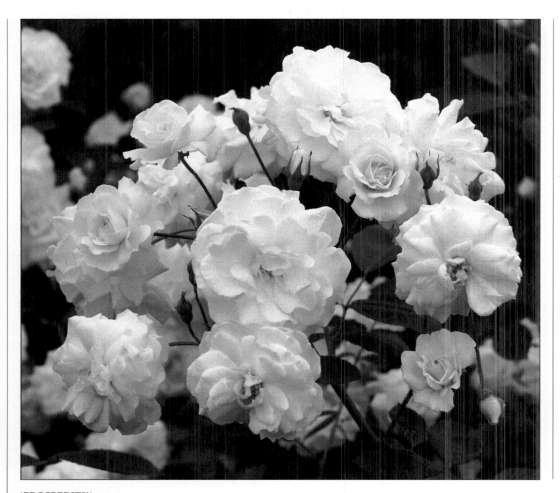

'PROSPERITY'

a substantial bloom. The leaves are large, dark, lustrous and plentiful. 90x60cm (3x2ft). 'Basildon Bond' x 'Silver Jubilee'. Named to mark the 250th anniversary of the maternity hospital established by Queen Charlotte, wife of George III. Plant this for bed, border, health, hedge (50cm-20in); weatherproof.

QUEEN ELIZABETH
Lammerts, USA, 1954
Floribunda cluster flowered bush/shrub, flowering summer to autumn. This is the cyclamen pink tall rose seen everywhere as a stalwart enduring plant, bearing clusters of sizeable blooms. It is a rose with no faults, unless one counts the legginess that results if it is left unpruned; shoots on such a plant have been found to exceed fifteen feet in length. It should be pruned annually three to four feet below the height required, and can be kept on this basis to 1.5-2.2m (5-7ft). 'Charlotte Armstrong' x 'Floradora'. AARS, GM American Rose Society, NRS & Portland, GR The Hague, PIT NRS. Named in 1952 to commemorate the accession of Queen Elizabeth II. Plant this for tall bed, border, cutting, exhibition, health, tall hedge (90cm-3ft), pillar; weatherproof.

RADOX BOUQUET (Harmusky, Rosika)
Harkness, England, 1981
Floribunda cluster flowered bush, flowering summer to autumn. The fully petalled rose pink flowers and rich fragrance call to mind the old centifolia roses, but the plant wears the modern dress of handsome glossy leaves. Makes a somewhat upright shrubby plant to 90x60cm (3x2ft). ('Alec's Red' x 'Piccadilly') x

'QUATRE SAISONS BLANC MOUSSEUX'

plant grows rather untidily to 1.2mx90cm (4x3ft). The autumn show of bloom is by no means generous. Plant this for border, fragrance, health, rosarium.

QUATRE SAISONS BLANC MOUSSEUX
(Perpetual White Moss, Rosier de Thionville)
Before 1848
This is a sport of the 'Quatre Saisons', in which the petal colour has changed to white, and the prickles to a multitude of bristles, resulting in the "mossy" effect. This is an interesting double sporting, and reversions to the non-mossy pink parent form have been observed. 1.2mx90cm (4x3ft). Plant this for border, fragrance, health, rosarium.

QUEEN CHARLOTTE (Harubondee)
Harkness, England, 1989
Hybrid tea large flowered bush, flowering summer to autumn. The flowers are light salmon pink with red shading, beautifully formed with high centres. There are only 23 petals but they are broad enough to form

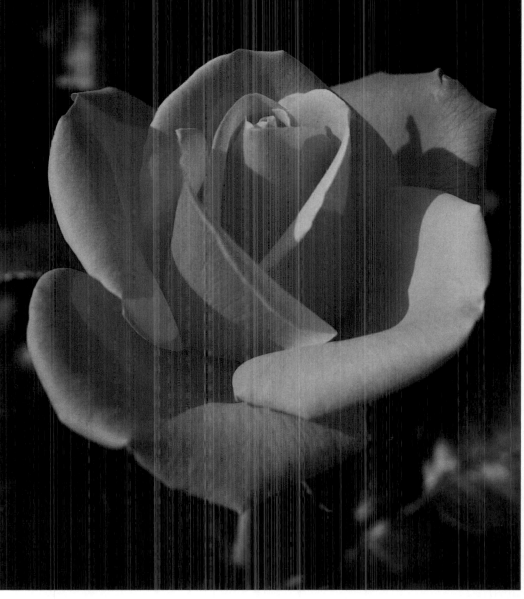

'QUEEN CHARLOTTE'

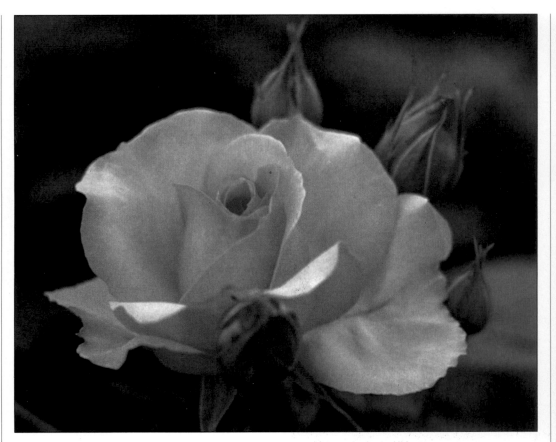

'RADOX BOUQUET'

('Southampton' x seedling). FRAG Belfast & Geneva. Plant this for bed, border, cutting, fragrance, hedge (50cm-20in).

RAMBLING RECTOR
Unknown origin, before 1912
Rambler, flowering in summer. This bears masses of small creamy to white semi-double flowers in big clusters, and grows rampantly to 6x6m (20x20ft). Graham Thomas describes it as "impenetrable, unprunable, overpowering". It is thought there is some *R. multiflora* in it. Plant this for health, naturalising, pergola, tree; weatherproof.

RAMONA (Red Cherokee)
Dietrich & Turner, USA, 1913
Climber, flowering in early summer. The flowers have an oriental look, opening flat, 10cm (4in) across, like a carmine clematis flower, pale in the centre, with gold stamens. The back of the petal is a subdued greyish rose. This is a beauty but needs shelter in Britain. Growth is rather stiff to 2.5x3m (8x10ft), and the foliage is sparse. It sported from 'Anemone' or

'Pink Cherokee', which is similar except that the flowers are silvery pink, and whose parents were probably *R. laevigata* x a Tea rose. Plant this for sheltered wall.

RAUBRITTER
Kordes, Germany, 1936
Shrub, flowering in summer. This is a very distinctive rose. The flowers are deep rose pink and made up of many small petals which seem reluctant to part. When they do so, they remain incurved forming tight little balls. They are carried in large clusters giving a bold display of colour, and because of their weight, they are bowed towards the ground. 'Raubritter' makes a sprawling plant, with tough wrinkled leaves, up to 90cmx2m (3x6ft). 'Daisy Hill' x 'Solarium'. Plant this for border, low fence, shrubbery, spreading plant – it looks attractive beside a pool; weatherproof.

RAY OF SUNSHINE (Cocclare)
Cocker, Scotland, 1988
Patio or dwarf cluster flowered bush, flowering summer to autumn. The bright yellow flowers open

'RED BLANKET'

cupped, showing their stamens, a cheerful sight against the short glossy leaved plants. 40x45cm (15x18in). 'Korresia' x seedling. Named for The Sunshine Fund for Blind Babies & Young People. Plant this for small bed, front of border, container, petite hedge (40cm-15in) small space; weatherproof.

REBECCA CLAIRE
Law, England, 1986
Hybrid tea large flowered bush, flowering summer to autumn. The colour is a subtle blending of light pink and pinkish orange, with veining on the outer petals. Grows rather upright to 90x60cm (3x2ft). 'Blessings' x 'Redgold'. FRAG & GM & PIT, RNRS. Plant this for border, fragrance; weatherproof.

RED ACE (Amanda, Amruda)
De Ruiter, Holland, 1979
Miniature bush, flowering summer to autumn. Bears dark red flowers with a velvety glow to them, on upright compact plants with semi glossy foliage. 35x30cm (14x12in). 'Scarletta' x seedling. Plant this for tiny bed, front of border, container, exhibition, small space.

RED BELLS (Poulred)
Poulsen, Denmark, 1983
Ground cover shrub, flowering in summer. This is the red counterpart to 'Pink Bells' (q.v.) which it resembles except for the geranium lake colour; the deeper colour does not make such a pretty contrast with the leaves. 'Mini-Poul' x 'Temple Bells'. 70cmx1.5m (28x60in).

'RAMBLING RECTOR'

'RED RASCAL'

'RED DEVIL'

Plant this for border, ground covering, health, front of shrubbery; weatherproof.

RED BLANKET (Intercell)
Ilsink, Holland, 1979
Shrub, flowering summer to autumn. This bears wide clusters of flowers in a bold shade of rose red, warm and inviting, paling to white towards the base of the petals. The semi-double blooms open cupped to flat, giving a good display. Grows into a leafy spreading plant, 75cmx1.2m (30x48in). 'Yesterday' x seedling. Plant this for sizeable bed, border, health, hedge (90cm-3ft), front of shrubbery, spreading plant; weatherproof.

RED DEVIL (Coeur d'Amour)
Dickson, N. Ireland, 1967
Hybrid tea large flowered bush, flowering summer to autumn. The huge light rose scarlet flowers are easily damaged by rain, but exhibitors know that given protection it is capable of winning best bloom many times in the course of a showing season. 1mx75cm (40x30in). 'Silver Lining' x a seedling of 'Prima Ballerina'. Named for the Parachute Regiment. Plant this for exhibition.

REDGOLD (Rouge et Or)
Dickson, N. Ireland, 1971
Floribunda cluster flowered bush, flowering summer to autumn. This bears sizeable blooms, which flaunt their yellow-edged-red petals to good effect. Upright grower to 90x60cm (3x2ft). Seedling x 'Piccadilly'.

AARS, GM Portland. Plant this for border, hedge (50cm-20in).

RED PLANET
Dickson, N. Ireland, 1970
Hybrid tea large flowered bush, flowering summer to autumn. Produces bright deep crimson flowers with freedom on strong well spread bushes. It is strange that this rose did not become more popular after winning the top RNRS award; it has good plant qualities. 90x60cm (3x2ft). 'Red Devil' x ('Brilliant' x seedling). GM & PIT RNRS. Plant this for bed, border, health, hedge (50cm-20in); weatherproof.

RED RASCAL (Jacbed)
Warriner, USA, 1985
Patio or dwarf cluster flowered bush, flowering summer to autumn. This bright red scarlet crimson has a satiny sheen to its petals. The buds are very neat and pretty, like petite hybrid teas, and open with stiff petals to hold a rounded outline, with gold stamens at their hearts. They make excellent buttonholes. Leafy and spreading to 40x45cm (15x18in). Plant this for small bed, front of border, container, cutting, health, small hedge (40cm-15in), small space; weatherproof.

REGENSBERG (Buffalo Bill, Macyoumis, Young Mistress)
McGredy, New Zealand, 1979
Floribunda cluster flowered bush, flowering summer to autumn. The petals are a positive shade of pink with white at the edges and the centres, sometimes lighter

'REGENSBERG'

pink according to the season. The plants carry so many flowers that the colour effect at its best is most spectacular; the petals open wide to make the most of it. The growth is low, not far off the "dwarf" category, and well spread, 40x50cm (16x20in). 'Geoff Boycott' x 'Old Master'. GM Baden-Baden. Plant this for low bed, front of border, container, curiosity, low hedge (45cm-18in), small space; weatherproof.

REINE VICTORIA (La Reine Victoria)
Schwartz, France, 1872
Bourbon shrub, flowering in summer with some later bloom. The buds are fat and rounded, opening to show a beautiful petal arrangement in the cupped flowers. The colour is deepish pink. Growth is tall and lax, 2x1.2m (6x4ft). Plant this with support for border, open low fence, fragrance, pillar, shrubbery (with support).

REMEMBER ME (Cocdestin)
Cocker, Scotland, 1984
Hybrid tea large flowered bush, flowering summer to autumn. The colour is remarkable, deep coppery orange irradiated with yellow. The flowers are neatly formed, not large, often borne several together in wide sprays but on stems long enough for cutting. The leaves are plentiful, so much so that they seem to jostle for space. Habit upright and narrow, 90x60cm (3x2ft). 'Alexander' x 'Silver Jubilee'. GM & PRIZE, Belfast. Named for the Not Forgotten Association. Plant this for bed, border, health, hedge (50cm-20in); weatherproof.

RISE 'N SHINE (Golden Sunblaze)
Moore, USA, 1977
Miniature bush, flowering summer to autumn. Long petalled buds open to full flowers like small scale hybrid teas. The yellow colour is deep and holds its tone. Bushy and upright to 45x40cm (18x15in). 'Little Darling' x 'Yellow Magic'. Plant this for small bed, front of border, container, small space.

RITTER VON BARMSTEDE
Kordes, Germany, 1959
Climber, flowering summer to autumn. This gives colour impact in the garden by weight of numbers, for there can be up to forty 5cm (2in) blooms in a single truss. They are deep rose pink and carried on strong stems against a background of shiny leaves. 3x2.2m (10x7ft). *R. kordesii* x seedling. Plant this for fence, health, naturalising, pillar, shrubbery (if kept trimmed), wall; weatherproof.

ROBERT LE DIABLE
Origin and date unknown
Provence or centifolia shrub, flowering in summer. The petals of this strange rose are a mix of purples, violets, and slate-greys, with highlights and veinings

'REMEMBER ME'

of cerise and scarlet. They are at their best in dry warm weather. The flower form is unusual, prompting speculation that gallica or china roses may be in the parentage. Lax growth, with narrow dark leaves, to 90x90cm (3x3ft). Plant this for border, curiosity, fragrance, rosarium.

ROBIN HOOD
Pemberton, England, 1927
Polyantha shrub, flowering summer to autumn. This rose of uninspiring colour was used by Kordes and became the progenitor of many famous modern roses. It has great qualities of vigour, freedom of bloom and remontancy. The small flowers are a dull cherry red, and their presence by the score in dense clusters does nothing to enliven them. The plants are well foliaged and grow upright with stiff stems to 1.2mx90cm (4x3ft). Seedling x 'Miss Edith Cavell'. Plant this for border, health, hedge (75cm-30in); weatherproof.

ROBIN REDBREAST (Interrob)
Ilsink, Holland, 1983
Patio or dwarf cluster flowered shrublet, flowering summer to autumn. This low grower bears large mops of currant red flowers with whitish-yellow eyes on its short stems, creating a wonderful sight on their first opening. The dead heads need to be cut off for the sake of appearances and to encourage the next cycle of bloom. The growth is spreading and dense, not always even, to 45x60cm (18x24in). Seedling x 'Eye Paint'. Plant this for bed, border, container, compact ground cover, small space; weatherproof.

ROB ROY
Cocker, Scotland, 1971
Floribunda cluster flowered bush, flowering summer to autumn. The buds of this crimson scarlet rose are high centred and elongated like small scale hybrid teas. They open somewhat loosely, in open clusters, maintaining a good clear colour tone. The plants are upright and reasonably leafy to 90x60cm (3x2ft). 'Evelyn Fison' x 'Wendy Cussons'. Plant this for bed, border, cutting for buttonholes, hedge (50cm-20in); weatherproof.

ROBUSTA (Korgosa)
Kordes, Germany, 1979
Rugosa hybrid shrub, flowering summer to autumn. As the name suggests, this is a tough looking rose, with stout prickly stems and rough leathery leaves. The flowers are wine red with white at the base. They are five-petalled, of good size (6cm-2.5in across) and

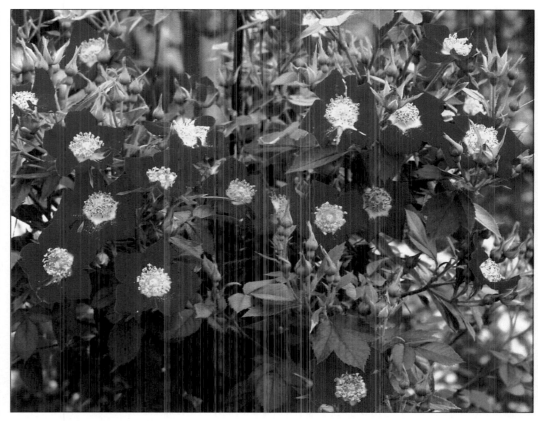

'ROBIN REDBREAST'

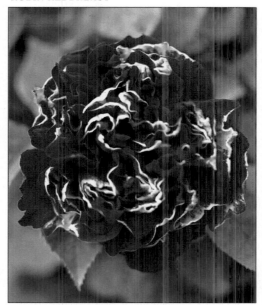

'ROGER LAMBELIN'

open cupped with wavy edges. The continuity of flower is well maintained. 1.5x1m (60x40in). Seedling of *R. rugosa*. ADR. Plant this for border, hedge (80cm-32in), shrubbery; weatherproof.

ROCHESTER CATHEDRAL (Harroffen)
Harkness, England, 1987
Shrub, flowering summer to autumn. The flowers are rose red to pink, a warm shade, with many layers of petals. They open flat displaying a pretty array of petal tips. The plant grows with a spreading habit, 90cmx1.2m (3x4ft). Seedling x 'Frank Naylor'. Named to mark the centenary of the appointment of Reynolds Hole (first President of the National Rose Society) to be Dean of Rochester. Plant this for border, hedge (1m-40in), shrubbery; weatherproof.

ROGER LAMBELIN
Schwartz, France, 1890
Hybrid perpetual shrub, flowering in summer with possible later bloom. This has deep crimson purple

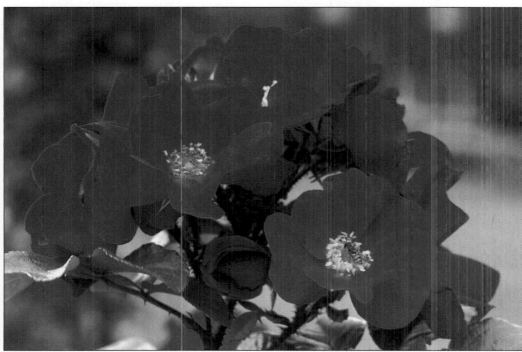

'ROBUSTA'

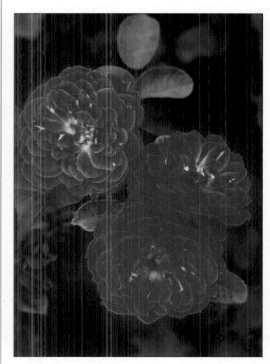

'ROCHESTER CATHEDRAL'

flowers with a narrow band of white along the petal edges, giving a most curious and eye-catching effect. It is a sport, probably of 'Prince Camille de Rohan' (q.v.) which it resembles in growth. Requires good soil to show the flowers at their best. Plant this for border (away from other roses for preference on account of its liability to rust), curiosity, fragrance.

R. x alba 'Maxima' (Great White Rose, Jacobite Rose, Maxima, White Rose of York)
Very ancient
Shrub, flowering in summer. Grows strong and upright, with big clusters of blush buds opening to cupped white flowers on grey-green leaved stems, to 2x1.5m (6x5ft). Not a true species but so old that it has become naturalised. Plant this for fragrance, health, enormous hedge (1.5m-5ft), naturalising, rosarium, shrubbery, specimen plant, wall; weatherproof.

R. x alba 'Semi-plena'
Ancient, before 1600
Shrub rose, flowering in summer. This is a sport of the above, and similar except that the blooms are semi-double, borne in smaller clusters, and open rather flat showing golden stamens. It also gives a show of hips in the autumn. Plant this for fragrance, health, hips, naturalising, rosarium, shrubbery, specimen plant; weatherproof.

R. banksiae normalis
To Europe from China 1884 or earlier
Species climber, flowering in summer. Bears close clusters of five-petalled white flowers in great profusion on rampant plants that can spread to 13m (40ft) or more. The stems have few prickles and the small narrow leaves almost evergreen. Grows wild in central to western China, usually in valleys by streams and rocky places. This is known as 'Mu-Hsiang' to the Chinese, meaning wood-smoke, because of the visual effect of so many blooms during its short season. They have a violet scent. This is not often seen in cultivation; where space permits it can be naturalised in sites not liable to spring frosts.

R. banksiae alba-plena
From Canton to Kew 1807
Species hybrid climber, flowering in summer. The double white form of the above, which it resembles in other respects. In Yunnan it is used for hedges, and in Arizona it is the "Tombstone Rose" of record size. It is cultivated and does well in warmer climates, needing protection from frost in Britain. Named for the wife of Sir Joseph Banks, director of the gardens at Kew.

R. banksiae lutea (Banksian Yellow)
From China to London 1824
Species hybrid climber, flowering in summer. This is a many-petalled yellow form with pretty rosette-like blooms, and grows like the above. There seem to be various strains and doubtless they are the result of selection by generations of Chinese gardeners. Of all in this group this is the hardiest and the one generally cultivated, easily reaching 5x2.5m (15x8ft). It will thrive out of doors given a site where frost does not nip the flowering shoots in springtime, such as a wall facing away from the rising sun. "Lutea" is Latin for yellow.

R. banksiae lutescens
From China to Italy before 1870
Species hybrid climber, flowering in summer. A single light yellow form, with larger flowers than the above and some scent, seen in cultivation in China but not found in the wild. The double yellow probably came about as a sport from this. It can be used in the same way in the garden.

ROSABELL (Cocceleste)
Cocker, Scotland, 1988
Patio or dwarf cluster flowered bush, flowering summer to autumn. The flowers are bright rose pink, and it is perhaps unique among modern dwarf roses in bearing quartered flowers, full of short petals in "old-fashioned" style. Leafy, spreading growth to 40x45cm (15x18in). Seedling x 'Darling Flame'. Plant this for small bed, front of border, container, small space; weatherproof.

R. bracteata (Chickasaw Rose, Macartney Rose)
From China to England 1793, to USA by 1799
Species climber, flowering summer to autumn. This grows wild in SE China and Taiwan, preferring dry sites. It bears 10cm (4in) creamy white flowers composed of five silky-textured petals with prominent

orange yellow stamens. Of wild roses it is one of the most beautiful. The shiny leaves add distinction, and tufts of small leaflets, known as bracts, lie close to the blooms and give the reason for its Latin name. Growth is upright and arching to 3m (10ft) or more, and the suckering habit means it can spread wide. As the plant is tender, it is best grown in warmer climates. It grows wild in SE USA and a place where it has room to naturalise without becoming a nuisance will show it at its best, deserving Graham Thomas's description "aristocratic and altogether splendid". In Bermuda, where it suckers all over the place, they have a less grand title for it: "the Fried Egg".

R. chinensis semperflorens (Belfield, Slater's Crimson China)
From Calcutta to England 1790
China shrub, flowering summer to autumn. The story of how this came to England is told in Chapter One. It was thought to have become extinct until 1953, when the American rosarian Richard Thomson on a visit to Bermuda noticed a rose at a house called Belfield, and that is now considered to be a true plant of the variety. It has red five-petalled flowers on slender stems and grows slowly to 1x1m (40x40in) in Bermuda's favourable climate. Plant this in a warm climate for border, curiosity, low fence, rosarium, low wall; and in cooler climates for the same purposes in sheltered locations, or under glass.

R. chinensis spontanea
Western China
Species climber, flowering in summer. This bears five-petalled pink flowers which deepen as they age to become crimson, up to 6cm (2.5in) across. The colour change has been noted as being more rapid and intense on plants at lower altitudes, dry west-facing slopes being the preferred habitat. The plants can clamber through trees up to 3m (10ft) but are usually shorter. Because it lives in parts of China little explored by botanists, this species has for many years a mystery; it was described in the *Gardeners' Chronicle* by Dr Augustine Henry of the Chinese Maritime Customs in 1902, eighteen years after he saw it at Ichang in Hupeh. Seed was collected by E.H. Wilson, but the next scientific report and the first photographs were not obtained until 1983, when Mr Mikinori Ogisu of Japan was engaged in botanical work for the University of Szechuan and found plants growing several hundred miles west of the previous location. This is assumed to be an important ancestor of Chinese garden roses and hence of most roses in the world today.

R. clinophylla (R. involucra)
From India to Europe by 1817
Species shrub, flowering in late spring. This is remarkable for its habitat, in swampy ground and by water from the Ganges plain eastwards to Bangladesh and Burma; it has been called "the only really tropical species of India". The plant has white flowers like those of *R. bracteata* to which it is related. The flowers are worn and used as offerings in religious ceremonies in India. It also has brittle stems like *R. bracteata*, but differs in its habitat and more slender shoots. The name is derived from a tendency of the long narrow leaflets to bend, from Gk. *clinein* to lean, and *phullon* leaf. Can reach 3m (10ft) in height and extent. Breeders in India have noted the valuable potential of this rose, since it is beautiful, produces seed readily and has the unique ability to thrive in wet ground in a warm climate. Pioneering work has been done by M.S. Viraraghavan and S.P. Banerjee. If they succeed, could it bring roses into the world of water gardening?

R. ecae
From Afghanistan to England, 1880
Species shrub, flowering in summer. The buttercup-like deep yellow flowers are small, only 2cm (1in) across, but the brilliance of their colour makes them stand out against the ferny light green leaves and wine

ROSA BANKSIAE ALBA-PLENA

'ROSA CHINENSIS' – AN EARLY FORM OF THE CHINA ROSE?

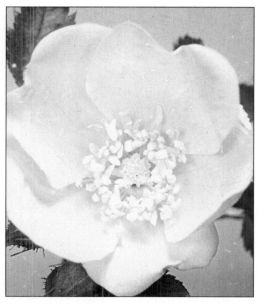

ROSA FOETIDA OR 'AUSTRIAN YELLOW'

red stems. They caught the eye of Surgeon-Major Aitchison, serving on a commission to delimit the borders of Afghanistan in 1880. He brought it home and gave it the initials of Emily Carmichael Aitchison, his wife. Its habitat is the rocky sloping ground which abounds in the frontier lands of Central Asia, from the Caspian east towards China. E.F. Allen used this in breeding 'Golden Chersonese'. It grows with a wiry, erect habit to 1.5x1.2m (5x4ft). Plant this for border, musk fragrance, rosarium, shrubbery; avoid sites exposed to cold spring wind and frost.

R. elegantula
From NW China to Europe, c.1900
Species shrub, flowering in summer. This may or may not be the same as *R. farreri* from the same region, but the pretty name justifies its inclusion, and derives from the dainty filigree effect of its tiny leaflets, the petite flowers with their gold centres, and the fine coating of red bristles on its stems. The flowers are pink to white, and the plant grows 90cm-3m (3-10ft) in height and 2m (6ft) across. Reginald Farrer (1880-1920) was a noted plant collector and obtained seed from plants near the border with Mongolia.

R. farreri persetosa (Threepenny Bit Rose)
Introduced after 1914
Species seedling shrub, flowering in summer. Has deeper pink flowers than the above, of which it is a selected form, and the one generally cultivated today. It is similar in leaf and flower and normally grows up to 2x2m (6x6ft). Plant this for big border, curiosity, rosarium, shrubbery; weatherproof.

R. fedtschenkoana
Central Asia to Europe, ca.1875
Species or species hybrid shrub, flowering summer to autumn. This is noted for its finely toothed grey leaves, attractive red bristles on the young stems and rather ghostly looking white flowers. These open flat with yellow centres, and are borne sparingly on big plants over a long period. The shrub makes a dense leafy plant to 2.2x2.2m (7x7ft) and will sucker in all directions so it needs careful siting. No one is quite

sure if it is the original species or a hybrid with perhaps the similar *R. beggeriana*. Plant this for health, naturalising, rosarium, big shrubbery, spreading; weatherproof.

R. foetida (Austrian Briar, Austrian Yellow, *R. lutea*)
From Turkey to W Europe, 16th century
Species hybrid, flowering in early summer. Bears bright yellow five petalled flowers freely if fleetingly along chocolate brown branches. The scent is variously described as sickly sweet, strong and disagreeable, "like the leaf maggot found in soft fruit", and more kindly as "an acceptable warm aroma" when heated by the sun. The taste is welcomed in Iraq, where the petals are used for making jam. In gardens this will achieve 1.5x1.5m (5x5ft), and will probably attract blackspot. It is naturalised in E and Central Asia in hedges, scrubland and rocky slopes. It is believed to be an ancient natural hybrid, possibly first brought to Europe via N Africa and Spain in the 13th century, and widely grown from 1550 onwards. The old species name was *R. lutea*, meaning yellow, which was changed to *R. foetida* in reference to the controversial fragrance. 'Austrian Yellow' seems to have been applied because of links with that part of Europe on its journey westwards; it was of course a sensational colour in those days. Plant this for border, rosarium, shrubbery. There may be die-back and early frost damage, so a sheltered site suits it best; prune spent wood only.

R. foetida bicolor (Austrian Copper, Rose Capucine)
From W Asia to Europe, 16th century
Species hybrid, flowering in early summer. Presumed to be a sport of *R. foetida*, which it resembles except

ROSA FARRERI PERSETOSA OR 'THREEPENNY BIT ROSE'

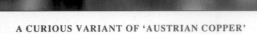

A CURIOUS VARIANT OF 'AUSTRIAN COPPER'

later bloom. The silky-textured lemony-white flowers have long petals and open 10-12cm (4-5in) across, as large as any species rose, showing deep orange stamens. The blooms are sometimes pink, and the related form *R. gigantea erubescens* has quite a dark pink tone, giving rise to the conviction that in one or other of these we have the ancestor of the blush and yellow tea roses; both forms possess the light spicy "tea" fragrance. The long leaves are a handsome pale shining green. These roses seem most at home in moist warm conditions, on forest edges, by streams and scrambling through other vegetation, which they can do over a range of 16m (50ft) or even more. In less favourable sites the growth may only reach 2mx2m

ROSA FOETIDA BICOLOR OR 'AUSTRIAN COPPER'

that the inside petal surface shows vivid orange scarlet instead of yellow colouring. The petal reverse stays yellow, giving the bicolour effect. This usually grows to 1.5x1.5m (5x5ft) but a big specimen in an English village garden was said to be "as big as a small haystack, and a blaze like one of Turner's sunsets".[4] Reversions to the parent form occur, giving rise to curious halfway variations. This rose may have been known in Asia as early as the 12th century. Plant this for border, rosarium, shrubbery; the same cautions apply as with *R. foetida*.

R. foetida persiana (Persian Yellow)
From Iran to England by 1836
Species hybrid, flowering in early summer. This is the important ancestor of modern yellow roses brought to England by Sir Henry Willock and used by Pernet-Ducher as recounted in Chapter One. It is bright yellow with double flowers, otherwise not unlike *R. foetida*, of which it may be a sport; another possibility is that it came from *R. hemispherica*. The first known record of it is thought to be a 17th century piece of embroidery work from Isfahan. It will form a rather gaunt shrub to 1.5x1.2m (5x4ft). Plant this for border, rosarium, shrubbery; the notes regarding blackspot and pruning remain as for *R. foetida*.

R. gallica (French Rose)
Ancient Species
Shrub, flowering in summer. Walter de la Mare could have had this in mind when he penned the often quoted lines "Oh, no man knows Through what wild centuries Roves back the rose". Certainly it is true of *R. gallica*, and the mystery extends to space as well as time, for it may have travelled from east to west or vice versa. The five petalled flowers are reddish pink, admitting much variation from rose pink to near crimson, and are quite large for a species bush, opening flat to 6cm (2.5in) across, with some scent. The blooming period extends for some weeks. The leaflets are darkish green, dull and stiff, and the stems wiry and upright with many twiggy branches, to 1x1m (40x40in), though the freely suckering habit enables the species to colonise a much wider area. The value of this rose and its semi-double form below

for medicine, cosmetics, hygiene, decoration, religion and even cooking is referred to elsewhere in these pages, as is their great importance in rose history. Plant this for border, fragrance, hedge (90cm-3ft), rosarium; weatherproof. Plant deep to let it sucker naturally.

R. gallica officinalis (Apothecary's Rose, Double French Rose, Red Rose of Lancaster, Rose of Provins)
Before 1600
Gallica shrub, flowering in summer. This is a finer form of *R. gallica* well worth garden space, with larger and more fully petalled flowers, and a neater bushy habit, 80x90cm (32x36in). The fact that it has five names speaks of its antiquity, though the first two are translations of each other, officinal being defined in the dictionary as "pertaining to a pharmacist". The Lancaster connection led to its becoming the badge of England, while the townsfolk of Provins built their economy on its cosmetic properties, and were not slow to publicise their source of wealth; in 1770 it is recorded that they prepared a bed of petals of this rose for Marie-Antoinette to rest on in the course of her journey to marry the Dauphin. Plant this for bed, border, fragrance, hedge (80cm-32in), rosarium, front of shrubbery; weatherproof.

R. gallica versicolor (Rosa Mundi)
late 16th century?
Gallica shrub, flowering in summer. A sport of *R. gallica officinalis* with portions of the colour pigment missing, resulting in bizarre streaks and stripes all over the petals. Occasionally a flower or branch reverts to the parent form, which this rose resembles in all respects save colour. Its antiquity is disputed, some believing there is a connection with "Fair Rosamond", mistress of Henry II, who died in 1176. It is difficult to see how so remarkable a rose could have gone unremarked until the 1580s if it really had existed such a long time before. An English source says it was a novelty in Norwich in the 1620s. Plant this for bed, border, curiosity, fragrance, hedge (80cm-32in), rosarium, front of shrubbery; weatherproof.

R. gigantea
SW China to NE Burma, to England 1889
Species climber, flowering in summer, with some

ROSA GALLICA VERSICOLOR OR 'ROSA MUNDI'

(6x6ft). As these roses embody six great virtues – health, beauty, vigour, scent, good foliage, and remontancy – further direct use in breeding seems worthwhile. The results have not so far been encouraging, because of a serious drawback; they are not hardy in cooler drier climates. Plant this in compatible climates for fragrance, naturalising, high wall; in Britain it needs a big wall and protection from frost to give it a chance.

R. glauca (*R. rubrifolia*)
SE Europe; cultivated early 19th cent.
Species shrub, flowering in summer. Grown in gardens for its arching red stems with their purplish leaves, and for the bunches of round red hips in autumn. The flowers are reddish pink, starry and fleeting. The natural habitat is mountain country across Europe from the Pyrenees to Poland and Albania, and it is said to prefer drier ground and partial shade for best results. Growth is leafy, upright and branching to 2.2x1.5m (7x5ft). The name *glauca* means covered with a powdery bloom, which truly describes the look of the leaves; many will think the old name *rubrifolia* equally apt and a lot more gracious on the ear. Plant this for border, curiosity, cutting (for flower arrangements), big hedge (1.3m-54in), hips, rosarium, shrubbery, specimen plant; weatherproof.

R. hemisphaerica (Sulphur Rose, Yellow Provence Rose)
From Turkey to Holland, ca.1601
Species hybrid bush, flowering in summer. Greenish yellow buds unfold into sulphur yellow flowers, with many broad petals. These stick to one another in damp weather, causing the flowers to ball. When they do open, they hold a cupped form, so that seen from the side they have the appearance of half a sphere, which explains the reason for the name. Growth is lax, with blue green leaves, 90cm-2m (3-6ft). Double yellow roses mentioned in Calcutta in 1503 may be the first reference to this rose, which came to Europe via an exhibition in Vienna. It took three attempts before it could be induced to grow in England, finally coming in 1695 direct from Turkey. It is not known in the wild. Plant this for glasshouse, rosarium.

R. hemisphaerica var. Rapinii
Is thought to be the original wild form, from which *R. hemisphaerica* sported. It bears single bright yellow flowers on bristly shrubby plants, happiest on dry slopes and roadsides from Turkey to Armenia. It is cultivated there, but needs the heat and drought of those areas to thrive, and has rarely proved successful when transplanted.

R. hugonis (Father Hugo's Rose, Golden Rose of China)
From China to Kew 1899
Species seedling shrub, flowering in early summer. The flowers are primrose yellow, 5cm (2in) across, and have a way of crinkling up, perhaps due to cold weather, when they should be opening out. For this reason the plant is less spectacular than 'Canary Bird', but it was hyped by the US introducers under a brilliant selling name and has had a good measure of attention ever since. The plants are big with ferny leaves and arching twiggy branches, to 2.2x2m (8x6ft) or more. The stock came from seed sent to Kew by the Rev. Hugh Scallan, after whom it was named by Hemsley, Keeper of the Herbarium, in 1905. Plant this for big border, health, huge hedge (1.5m-5ft), naturalising, shrubbery, specimen plant.

R. kokanica
Native to Central Asia
Species, flowering in summer. Little seems to be known of this wild rose, which occurs in remote regions of Afghanistan and northeast across the Russo-Chinese frontiers, preferring rocky slopes and stony places for its habitat. Bright yellow flowers, 5cm

(2in) across are borne on red-stemmed shrubby plants. The leaves are small and liable to blackspot. It needs dry hot weather, and even in its homeland it sometimes fails to bloom following cool summers. As one of the few possible ancestors of *R. foetida* it deserves attention.

R. laevigata (Camellia Rose, Cherokee Rose, Golden Cherry)
From China to Europe ca.1698
Species climber, flowering in summer. This white rose has a waxy sheen to the petals, and as they open out wide its beauty is enhanced by golden stamens, giving a very serene overall effect. Growth is very vigorous, the hooked branches capable of clambering 10m (30ft) or more. The handsome lustrous leaves give the plant its name, from the Latin levigare meaning "to make smooth". In China, where it occurs wild by streams and in rocky places over a wide area, this rose has long been cultivated under the name 'Chin Ting Tzu' or 'Golden Cherry', so called from the hips. It appears in a herbal of 1406 AD. When it reached USA it rapidly naturalised itself, and is today the emblem of the state of Georgia. It may suit Georgia but it won't do in Britain, being too tender to withstand cool springs, and too big to be a practical subject under glass.

R. moschata
From Italy to England by 1540
Species or species hybrid climber, flowering late summer to autumn. This is another mystery rose, not found growing in the wild despite the species designation. Perhaps it was an ancient natural hybrid. The flowers are white, single or semi double, borne in big clusters and with a cool look about them. They have a pleasant musky fragrance, especially good at evening time. The leaves are purplish green, and the stems also are dark, and not very strong looking but capable of extending to 3x3m (10x10ft). A reference

by John Amble, connected with a monastery in southern England, states that *R. moschata* was introduced to Britain from Spain about 1521. Others say Thomas Cromwell caused it to be sent from Italy, where he spent several years before returning to England in 1513. It was listed by John Gerarde in 1597. Then in the middle of the nineteenth century *R. moschata* unaccountably disappeared. In 1840 Thomas Rivers wrote: "The White Musk Rose is one of the oldest inhabitants of our gardens, and probably more widely spread over the face of the earth than any other rose."[5] In Mrs Gaskell's novel *My Lady Ludlow*, published in 1859, occurs this line of dialogue: "That is the old Musk Rose, Shakespeare's Musk rose, which is dying out through the Kingdom now."[6] Leaving aside the Shakespeare reference, which is almost certainly in error, this shows a very strange decline within the space of twenty years. After many years of searching, Graham Thomas rediscovered the true stock of *R. moschata* in 1963, growing at Myddelton House, near Waltham Cross in Herts., and was able to re-introduce it into cultivation. Plant this for S, SW or W fence, fragrance, rosarium, S, SW or W wall.

R. moyesii
From W China to England 1894
Species shrub, flowering in summer. There are many forms of this rose, some coloured wine red, others rose-red, others rose pink, and they are found growing at fairly high altitude in mountain country in western China. In all cases the flowers open flat, 7cm (2.5in) across, with prominent creamy yellow stamens. The stems that bear them are vigorous and arching, capable of reaching 4x3m (12x10ft). Their strength is well tested when the hips are formed, for they are large and

5 In *The Rose Amateur's Guide*

6 Quoted from G.S. Thomas, *Climbing Roses Old and New*, (Dent 1978)

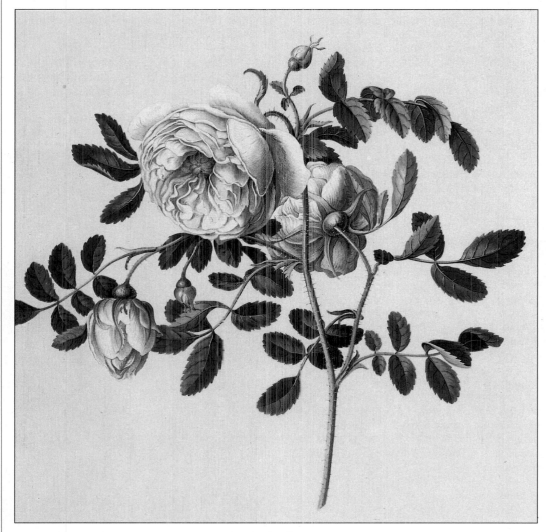

ROSA HEMISPHAERICA AS ILLUSTRATED BY REDOUTÉ.

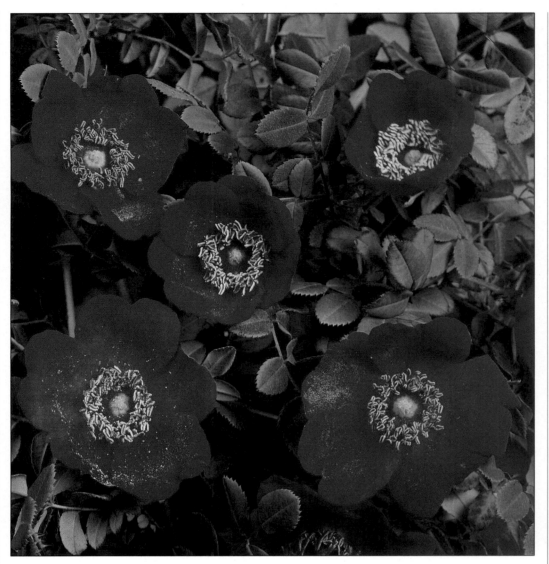

ROSA MOYESII

heavy, shaped like upturned pitchers and very decorative as they ripen to a rich bright scarlet; "like little red flagons ... nature's perfect pendants" is Jack Harkness's description. The leaves look out of place, sparse and small in proportion to the plant, but they are unusual in their rounded form and in having thirteen leaflets. Variants of *R. moyesii* in cultivation include *R. moyesii fargesii*, pinky red; 'Highdownensis', more elegant in growth; 'Wintoniensis', with paler flowers and good hips; 'Geranium', red, splendid for orange hips; and 'Sealing Wax', deep pink, also with excellent hips. The plant hunter E.H. Wilson named this species for his host at The China Inland Mission, the Rev. J. Moyes. Plant this for large border, health, hips, naturalising, rosarium, shrubbery; weatherproof.

R. multiflora
From Japan to France, 1862

Species climber, flowering in summer. For a brief period in summer, the plants, big as they are, seem lost in a cloud of blossom, as dense pyramidical corymbs push out towards the light. Each flower is tiny, about 1.5cm or less than an inch across, and the general effect is of a giant bramble bush covered in bloom. The flowers soon fall, and without them the plant is uninspiring, with dull foliage and a thicket of prickly stems. In USA they say it is "horse high, bull strong and goat tight". As a garden plant it is not worth space save perhaps for naturalising in a wild garden or growing up a tree. Its importance in rose development has been explored in Chapter One; coarse it may be, but we owe it thanks for its beautiful descendants.

R. palustris (Swamp Rose)
In cultivation USA 1726

Species shrub, flowering in summer. As its name implies, the natural habitat of this rose is marshy land, where it flourishes in parts of East & Central North America from Nova Scotia to Florida. The flowers are pink, 5cm (2in) across and borne in clusters. The plants grow in broad clumps from 90cm (3ft) to 2.5m (8ft) tall, depending on the environment, with reddish stems and hooked prickles. This rose is not generally planted in gardens, but is important, along with *R. clinophylla*, in showing that some rose roots can tolerate and indeed thrive in wet ground.

R. persica (Barberry Rose, Hulthemia persica)
From Iran to France ca.1788

Species shrublet, flowering in summer. This differs from all other roses in the appearance of the leaves and flowers. The leaves are bluish green and "simple", which means they are not divided into a number of leaflets like the other species. The small flowers are as vivid a yellow as can be imagined with a patch of deep scarlet at the base of each of their five petals, and no other rose apart from its own descendants displays this colour factor. The stems are springy and wiry, often growing from suckers which can spread several feet below the soil. It is not surprising that botanists have long been uncertain whether to call this item a rose or not. It has proved capable of being bred with roses, and now stands with the rest of the family like a sort of loose cousin, sole representative of the *HULTHEMOSA* branch. It is rarely seen outside its native haunts, the steppe and desert regions of Iran, Afghanistan and the adjacent lands of Russia, where it is abundant enough in places to be cut for fuel or cattle fodder. The only successful means of propagation is from seed, and that does not germinate easily. It requires a warm and dry environment, and an airy glasshouse where it can naturalise and put out its suckering shoots has worked well at Hitchin, Herts. There Jack Harkness has raised many seedlings over the past twenty years in attempts to harness the unique qualities of *R. persica* into serving gardeners' needs. Seedlings in commerce include 'Euphrates', 'Nigel Hawthorne' and 'Tigris', described above and below, and all exhibiting the "red eye".

R. pimpinellifolia (Altaica, Burnet Rose, *R. spinosissima*, Scotch Rose)
Cultivated by 16th century

Species shrublet, flowering in summer. The bristly stems and small dark ferny leaflets are a familiar sight around the coasts of Britain, capable of colonising sand dunes and growing along the cliffs. The flowers open like saucers, nearly always creamy, but markings of pink, yellow and purple can be found. They have sweet hay fragrance. In exposed places the plants stay dwarf and creeping, but will grow to 90cmx1.2m (3x4ft) or more with shelter. The hips are large, round and purple-black. There are many forms around the world, for the range extends through Europe to the Caspian, in Siberia, and it naturalised itself in N. America some three centuries ago. A well known one, much used in landscape schemes, is the 2x1.2m

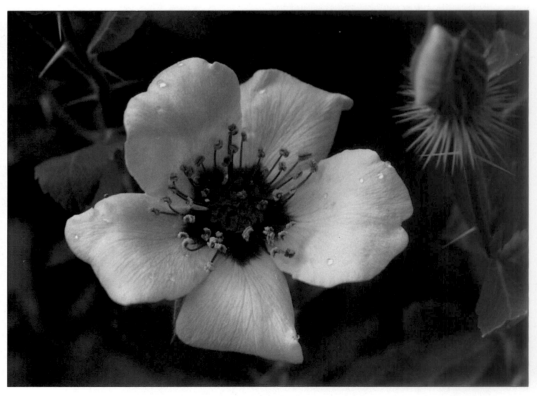

ROSA PERSICA – NOTE THE CURIOUS BRISTLY BUD.

(6x4ft) *R. pimpinellifolia altaica*, in pale creamy yellow, introduced from the Altai Mountains in 1818. Another yellow of similar growth is *R. pimpinellifolia hispida*, and these two were used by Kordes to give 'Maigold' and other hardy roses which have had many influences on subsequent breeding work. 'Dunwichensis' is another form in creamy white, forming an attractive free flowering low mound, 65cmx1.2m (26x48in). Scores of garden varieties were selected from the 1790s onwards, and around 1830 they reached their greatest popularity. The coming of remontant roses with more civilised growth habits soon ousted all but a handful. Those remaining include 'William III' and 'Williams' Double Yellow' (q.v.).

R. primula (Incense Rose)
From Samarkand 1910
Species seedling shrub, flowering in early summer. The incense comes from the aromatic foliage, made up of small shiny leaflets, often fifteen of them to the leaf. Both stems and hips are reddish brown, and the flowers pale primrose, quite small at 3cm (1.2in) across. Raised from seed collected by the botanist F.N. Meyer. Its native range extends from Turkestan to N China, and it grows on average 1.2x1.2m (4x4ft). In Latin, *primula* means "little first one". Plant this for border, curiosity, fragrance, hips, rosarium, shrubbery. It sometimes languishes and dies for no apparent reason; perhaps it misses the drier air of its natural habitat. On account of its fragrant foliage it would be an interesting to use in breeding work.

R. x richardii (Holy Rose, R. sancta, St John's Rose)
Introduced from Ethiopia ca.1895
Species hybrid shrub, flowering in summer. The flowers are blush, opening wide to 6cm (2.5in) with beautiful gold stamens. They are carried on short upright bushes to about 75x90cm (30x36in). This plant appears to be an ancient natural hybrid, selected and grown on for its beauty, and passed on perhaps through early Christian fathers from the Yemen or

Syria to Ethiopia. There it has been cherished for centuries and linked to religious rites, though it may be in peril, for Krüssmann reports that "In 1920 a monk stated that the 'Holy Rose' was to be found at Mau-Tsada, a mountain village at 2427m (8000ft) in Northern Ethiopia. Formerly, this rose grew wherever there was a church, but today virtually the only remaining plants are those few in Mau-Tsada. Those flowers not eaten by the local goats are collected by the priests and mixed with incense." Plant this for border, curiosity, rosarium; and to preserve an endangered item.

R. roxburghii (Burr Rose, Chestnut Rose, Chinquapin Rose, Hoi-tong-hong)
From Calcutta to England 1824
Species hybrid, flowering in summer. This is the cultivated full-petalled form of *R. roxburghii normalis*, a stiff growing and vigorous bright pink species from S and W China. Among its curious features are the prickly buds, resembling the casing on a chestnut and giving that nickname to the cultivated plant. The blooms of *R. roxburghii* are pink with a lilac tone, fairly large (6cm-2.5in) across and made up of many narrow petals. They are on short stems and nestle against a background of handsome foliage, with up to fifteen spruce leaflets neatly arranged along the leaf stalk. It grows to 2x2m (6x6ft). William Roxburgh brought this from Canton to Calcutta around 1814 to be grown in the Botanic Gardens before continuing its journey to the west. Plant this for health, naturalising, shrubbery.

R. rugosa (Hama-nasu, Hedgehog Rose, Japanese Rose, Kiska Rose, Ramanas Rose)
From Japan to Europe 1796 & later
Species shrub, flowering summer to autumn. This is one of the finest species of them all. The five petalled

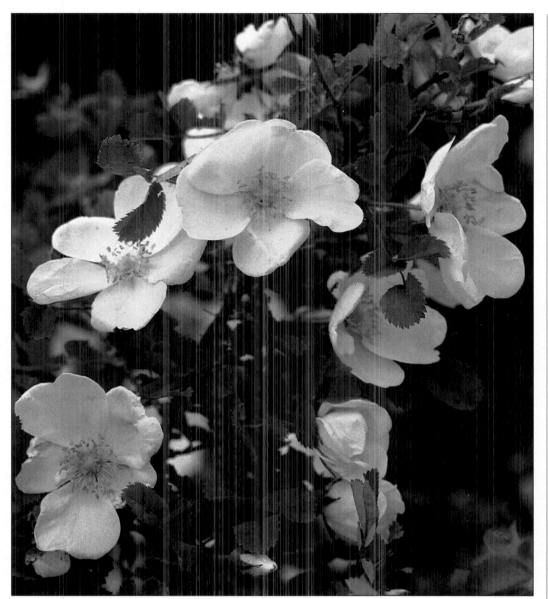

ROSA PIMPINELLIFOLIA HISPIDA

flowers are large, up to 9cm (3.5in) across, with clove fragrance, opening wide to show their stamens. They appear from early summer to late autumn and rarely is an established plant without at least one bloom in all that time. The stems are covered in fine prickles, quite soft when they are young, and the large leaves are leathery and very wrinkled – which is what the

word *rugosa* means. In habit the plant could hardly be improved, for it has a rounded graceful outline and the foliage clothes it nearly to the ground. Then there are the hips, shaped and coloured like small tomatoes, among the most decorative in the world of roses. Add hardiness, tolerance of less than ideal conditions and resistance to fungus troubles to the list, and the reason

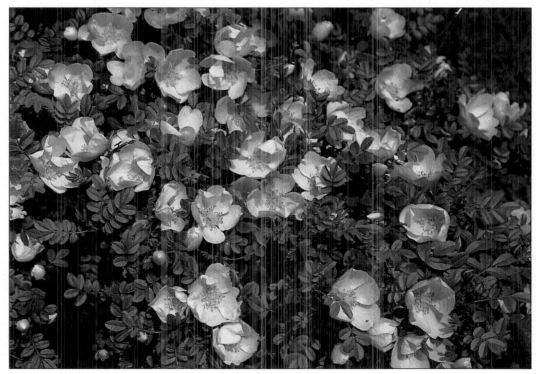

ROSA PRIMULA OR 'INCENSE ROSE'

for the value of this rose is plain. Attempts to breed with it have been less successful than one might expect, for the flowers on its seedlings lack refinement, and resistance to disease is sometimes lost. It does however have closely related garden forms in pink, purple and white, all of which are vigorous and healthy:

R. rugosa rugosa which is violet-carmine and considered as the original, 1.5x1.5m (5x5ft).

R. rugosa alba, white, a slightly larger plant, 1.8x1.8 (6x6ft).

R. rugosa rubra, wine red, making a beautiful contrast with the yellow stamens. This is likely to reach 1.5x1.5m (5x5ft), though the heights of all in this group will be less in exposed places.

R. rugosa scabrosa is a puzzle, for it turned up on the Harkness nursery from an unknown source. After being grown on and admired for some years, it was introduced in 1950. The name means "rough" in reference to the leaves, but there is nothing common about the single wide mauve-red blooms, with their dusty yellow stamens making a stunning contrast. It grows strongly to 1.5x1.5m (5x5ft).

Although described as the 'Japanese Rose', *R. rugosa* also occurs along the coastal regions of N China, Korea and Siberia, and naturalises itself in USA and Europe. It was anciently in cultivation in China and Japan, where the petals were mixed with camphor and musk and used for perfume. The first introduction into Europe failed to take off; people's eyes were fixed on the daintier offerings among the Chinese garden roses. A second launch in 1845 succeeded. Plant the Rugosa roses for large bed, border, low fence, fragrance, health, hedge (1.2m-4ft), hips, naturalising, shrubbery, specimen plant, spreading, low wall; weatherproof.

R. sericea (Silk Rose)
Discovered in the Himalayas 1822

Species shrub, flowering in summer. This is one of a small family of plants found through N India, Nepal, Burma and into W China, which are similar in bearing dainty white flowers on formidable thickety plants with pretty fernlike leaflets, rather as though nature had pieced together a set of unmatched parts. The flowers are frequently four-petalled, a unique feature among species roses where five is the norm. The Latin *sericeus* means "silky" and refers to the smooth hairs underneath the leaves.

R. sericea pteracantha is the form most often seen in gardens, and the addition to the name signifies "winged prickles", which cover the long arching stems and are beautiful when young, because light shines through them, giving a reddish glow. It may seem impossible for a rose thorn to be larger than a rose leaf; a look at this variety will prove that it can be so. These roses are stalwart growers to around 2.5x2.2m (8x7ft). Plant them for health, naturalising, rosarium, shrubbery; weatherproof.

R. stellata (Gooseberry Rose)
From New Mexico 1902

Species bush, flowering in summer. This strange little rose has deep rose purple flowers with a dusty yellow ring of stamens, tiny deeply toothed leaflets – said to be the smallest of any rose – and a fuzz of minute hairs covering the stems. It grows in arid regions, exposed to both heat and cold, and survives by suckering, making a wiry thicket up to 6cm (2ft) high.

R. stellata mirifica (Sacramento Rose)
From New Mexico, Texas, Arizona 1916

This form of the above is the one most likely to be found in gardens. It makes a larger plant, up to 90x90cm (3x3ft), growing in a tangle of thin wiry stems, with strawberry-like leaflets and beautifully

ROSA RUGOSA SCABROSA

ROSA SERICEA PTERACANTHA

colourful flowers, that seem to welcome England's grey skies despite the very different nature of their homeland. The Latin *stellata* means starry, in reference to the structure of the plants' fine hairs, and *mirifica* means wonderful; the names are rather nonsensical, because the hairs on *R. stellata* are more numerous and worthy of wonder than those on its relative. Plant this for border, curiosity, health, rosarium, front of shrubbery; weatherproof.

R. virginiana
From Virginia to Europe 1724

Species shrub, flowering in summer. This was the first American species mentioned in Europe, being described by Parkinson as early as 1640. It attracted notice by its shining green leaves, graceful rounded habit and bright pink 5cm (2in) flowers, set close against the foliage, which lead on to persistent ruby hips in autumn. Native to eastern USA and Canada, where it makes 2m (6ft) suckering thickets and does well on sandy soil. Allow space of about 1.2x1.5m (4x5ft) in the garden. Plant this for border, health, wide hedge (1.2m-4ft), hips, naturalising, rosarium, shrubbery, spreading; weatherproof.

ROSA SERICEA OR 'SILK ROSE'

R. xanthina (Huang Tz'u Mei)
From China to USA 1907

Species hybrid shrub, flowering in early summer. This rose is not a true species, for the flowers have many petals. It is a garden form cultivated in China since before 1800, and must have been greatly prized, since it makes a handsome and beautiful plant. The blooms are a cheerful yellow, 5cm (2in) across, and open cupped to flat, displaying their narrow petals at different levels against ferny decorative foliage. The leaf cover is dense, and the plant makes a commanding shrub up to 2.5x2.5m (8x8ft) with a graceful rounded outline.

R. xanthina spontanea
From China to USA 1909

Species shrub, flowering in early summer. This is the wild form, with single bright yellow flowers, not unlike 'Canary Bird' (q.v.) which must be derived from it and which is a finer garden plant. Plant these for big border, fragrance, health, giant hedge (2m-6ft), naturalising, rosarium, shrubbery, specimen plant, spreading; weatherproof.

ROSE DU ROI (Lee's Crimson Perpetual)
Souchet, France, 1815

Portland shrub, flowering summer to autumn. The flowers are red shaded violet, and this was a sensation in the early 19th century not just because of its rich colour but by reason of its long period of bloom. It is semi double, very likely raised from the 'Portland Rose' (q.v.), and became a progenitor of the hybrid perpetuals, so it is important in rose history. It is important also in showing how the rose as a plant was

'ROSE GAUJARD'

rising in the social scale in the period that saw its birth. In 1812 the gardener at the imperial palace of St Cloud, M. Souchet, observed with delight the richly coloured flower on his new seedling. The palace administrator was Comte Lelieur, and he decreed it should bear his name as 'Rose Lelieur'. Not long afterwards Louis XVIII returned from exile, and a member of his household changed the name to 'Rose du Roi'. That had to be amended to 'Rose de l'Empereur' when Napoleon escaped from Elba, reverting back to 'Rose du Roi' after Waterloo! The plant grows to 90x90cm (3x3ft) with clear green, slightly fluted foliage. Plant this for border, fragrance, rosarium, front of shrubbery.

ROSE GAUJARD
Gaujard, France, 1957

Hybrid tea large flowered bush, flowering summer to autumn. Bears high centred blooms, full of petals which are plum red on the inside and blush to silvery white on the reverse, thus creating a bicolour effect. It is common to find a split or cleavage in the centre of a flower where the petals have formed a double whorl. The plant is well furnished with dark shiny leaves and grows vigorously to 90x60cm (3x2ft). 'Peace' x seedling of 'Opera'. GM NRS. Plant this for bed, border, cutting, exhibition, health, hedge (50cm-20in); weatherproof.

ROSE-MARIE VIAUD
Igoult, France, 1924

Climber, flowering in summer. The attraction of this rose is its rich purple red colour, embracing tones from cerise and lilac to greyish violet as the flowers fade. They are borne in sprays of full petalled small rosettes on vigorous plants up to 5x2.5m (15x8ft). Seedling of 'Veilchenblau'. Plant this for fence, fragrance, health, naturalising, pergola, pillar, tree, wall; weatherproof.

ROSEMARY HARKNESS (Harrowbond)
Harkness, England, 1985

Hybrid tea large flowered bush, flowering summer to autumn. The fragrant flowers are of medium size,

'ROSE-MARIE VIAUD'

'ROSEMARY HARKNESS'

'ROSERAIE DE L'HAŸ'

opening from urn-shaped buds to hold a pretty rounded form. The colours are a blend of orange yellow and orange salmon, lightening as the blooms age. Growth is leafy and spreading, more shrublike than is usual with hybrid teas, well covered with glossy dark foliage, reddish when young. 80x80cm (32x32in). 'Compassion' x ('Basildon Bond' x 'Grandpa Dickson'). FRAG, GM & PRIZE Belfast. Named for Rosemary Stewart (née Harkness), the author's younger daughter. Plant this for bed, border, fragrance, hedge (70cm-28in); weatherproof.

ROSEMARY ROSE
De Ruiter, Holland, 1955
Floribunda cluster flowered bush, flowering summer to autumn. The flowers are prettily formed like camellias, in a kindly shade of clear rose carmine. They are carried in big sprays, heavier sometimes than the stems can bear, against a background of reddish leaves, and appear very freely over a long period. There may be seasonal mildew. Makes a spreading plant, 60x65cm (24x26in). 'Grüss an Teplitz' x seedling. GM NRS & Rome. Named for Rosemary McCarthy (née Gregory), daughter of Walter Gregory of Nottingham, whose firm introduced the rose. Plant this for bed, border, fragrance, hedge (55cm-22in).

ROSERAIE DE L'HAY
Cochet-Cochet, France, 1901
Rugosa shrub, flowering summer to autumn. The colour of the flowers has been described as "outrageous purple", being rich crimson purple in bud and admitting some magenta as they age. The large (11cm-5in) full petalled blooms stand out magnificently against a rich green backcloth of tough healthy Rugosa leaves, have strong fragrance, and repeat their bloom well. Some years they are followed by large red hips, but this is not usual. Makes a rounded handsome plant to 2.2x2m (7x6ft). Plant this for huge bed, large border,

curiosity, fragrance, health, great hedge (1.5m-5ft), naturalising, shrubbery, specimen plant, spreading; weatherproof.

ROSETTE DELIZY
Nabonnand, France, 1922
Tea bush, flowering summer to autumn. This rose is rather like St Paul, as one "born out of due time", for

it appeared when the Tea roses had had their day and been overtaken by the hardier hybrid teas. The pretty pointed blooms are a blend of yellow and pink, about 8cm (3in) across, and very freely borne over several months in warmer climates, where it is vigorous enough to achieve tree-like growth of 4x2m (12x6ft) if not kept short by pruning. 'Gén. Galiéni' x 'Comtesse Bardi'. Plant this in warm climate for bed, border, cutting, health, wall; weatherproof.

ROSINA (Josephine Wheatcroft, Yellow Sweetheart)
Dot, Spain, 1951
Miniature bush, flowering summer to autumn. Bright yellow, bearing semi double flowers of pretty shape freely for many months; a plant blooming in May was observed to continue through to January with very few breaks. The leaves are petite and plentiful. Bushy, 45x30cm (15x12in). 'Eduardo Toda' x 'Rouletii'. Plant this for front of border, container, small space; weatherproof.

ROSY CUSHION (Interall)
Ilsink, Holland, 1979
Shrub, flowering summer to autumn. The flowers are pink with ivory hearts, opening like a host of shallow saucers. The colour impact is splendid, and the bush

'ROSETTE DELIZY'

'ROSY CUSHION'

grows wide with plentiful dark shiny foliage to 90cmx1.2m (3x4ft). 'Yesterday' x seedling. Plant this for sizeable bed, border, fragrance, hedge (90cm-3ft), front of shrubbery, small specimen plant, spreading; weatherproof.

ROSY FUTURE (Harwaderox)
Harkness, England, 1991
Patio or dwarf floribunda bush, flowering summer to autumn. The flowers are warm rose red, urn shaped in bud, and open to a pretty shape showing the petal tips. The novelty lies in its sweet fragrance, inherited from the seed parent 'Radox Bouquet', while the pollen parent, 'Anna Ford', has passed on the gifts of petite dark healthy foliage and continuity of bloom. 55x45cm

(22x18in). 'Anna Ford' x 'Radox Bouquet' GM Courtrai. Named as the result of a competition on behalf of The Cardinal Hume Centre Trust, which provides a refuge for young people in London, and received the proceeds from initial sales. Plant this for bed, border, container, fragrance, low hedge (40cm-16in), small space; weatherproof.

ROSY MANTLE
Cocker, Scotland, 1968
Climber, flowering summer to autumn. Bears large well formed fragrant flowers with high centres in a kind shade of rosy salmon pink. They maintain an excellent continuity of flower. The leaves are dark, not as plentiful as one could wish. Vigorous stiff

growth to 3x2.5m (10x8ft). 'New Dawn' x 'Prima Ballerina'. Plant this for fence, fragrance, health, pillar, wall; weatherproof.

ROULETII (Pompon de Paris, *R. chinensis minima*, Roulettii)
Correvon, Switzerland, 1922
Miniature bush, flowering summer to autumn. Mystery surrounds this little rose. It was noted growing in a pot by Dr Roulet of the Swiss Army on a visit to the resort of Mauborget, overlooking Lake Neuchâtel, towards the end of the first World War. He described it as being only 5cm (2in) high and covered in bloom. Henri Correvon of Geneva heard his story and went to see the rose for himself, only to find that a fire had destroyed all trace of it. The searchers were directed

'ROULETII' OR 'POMPON DE PARIS'

to the nearby village of Onnens, and there they found it. What was it, where did it come from and why was it important? The last part is easy to answer; without it we would not have the Miniature roses of today, for they are all descendants of 'Rouletii'. It is thought to be a form of a dwarf garden rose from India or China, miniaturised by several decades spent in poor Swiss potting soil. One guess is that the original stock could have come from the garden of Augustus de Callonde (1778-1841), Professor of Botany at Geneva, who made a special study of rose species, and refers to something called *R. indica humilis* ("the humble Indian rose"), not now known to us.[7] Others say it is a dwarfed form of 'Pompon de Paris', known since the 1830s but subsequently lost except in today's climbing form (q.v.). The rose itself is tiny with double dark pink blooms and looks insignificant beside its showier

'ROSY FUTURE' BRINGS FRAGRANCE INTO PATIO ROSES.

7 See Fisher, *The Companion to Roses*, (Viking 1986) on whose research this account is based

'ROYAL WILLIAM'

descendants. Bushy, 20x20cm (8x8in). It can be planted for container, rosarium and small space, especially suited for a rockery.

ROYAL GOLD
Morey, USA, 1957
Climber, flowering summer to autumn. The flowers are full, large, deep golden yellow and beautifully formed. Unfortunately the plant does not do them justice, being stiff, with sparse virus-prone foliage, somewhat tender and showing reluctance to grow with any sense of urgency, serious handicaps for a would-be climbing rose. Given time and a warm site it will make some 2.5x2m (8x6ft). 'Clg Goldilocks' x 'Lydia'. Plant this in sheltered site for fence, fragrance, pillar, wall.

ROYAL HIGHNESS (Königliche Hoheit)
Swim & Weeks, USA, 1962
Hybrid tea large flowered bush, flowering summer to autumn. Produces elegant pointed blooms of great size, which maintain their high centres as they open, making them wonderful for showing. They may spoil in rain. Grows vigorous and upright with dark foliage to 1mx70cm (40x27in). 'Virgo' x 'Peace'. AARS, GM Madrid & Portland, PRIZE ARS. Plant this for tall bed, border, cutting, exhibition, fragrance, tall hedge (60cm-24in).

ROYAL WILLIAM (Duftzauber '84, Fragrant Charm '84, Korzaun)
Kordes, Germany, 1984
Hybrid tea large flowered bush, flowering summer to autumn. A deep crimson rose with stamina, bearing large blooms freely on vigorous bushy plants. The flowers vary in size and quality according to season, and at their best have beautiful form and hold their colour. 90x60cm (3x2ft). 'Feuerzauber' x seedling. ROTY. Commemorates the coming of King William III to England in 1688. Plant this for bed, border, fragrance, hedge (50cm-20in).

RUBY WEDDING
Gregory, England, 1979
Hybrid tea large flowered bush, flowering summer to autumn. Good features of this rose are the colour, clear ruby crimson without magenta tones, and freedom of flower. The blooms themselves are of medium size and pleasing form. The habit is rather open and blackspot may be a problem. 75x60cm (30x24in). 'Mayflower' x seedling. Arrangements to name this for a furrier's wife fell through when payment was offered in furs, an idea that did not appeal to the raiser. A new name had to be chosen quickly as the rose was due for introduction, and one of Gregory's office girls suggested 'Ruby Wedding'; let's hope she received a bonus, for the bushes have

been selling like hot cakes as anniversary presents ever since. Plant this for border; weatherproof.

RUGUL (Tapis Jaune, Guletta)
De Ruiter, Holland, 1973
Patio or dwarf cluster flowered bush, flowering summer to autumn. A splendid little garden rose, with cheerful bright yellow flowers nestling against shining petite green leaves. The blooms open flat with about twenty petals, and they look larger than they are because of the small size of the plants. Compact growth, 30x45cm (12x15in). 'Rosy Jewel' x 'Allgold'. Plant this for small bed, front of border, container, health, tiny hedge (30cm-12in), small space; weatherproof.

SAFRANO
Beauregard, France, 1839
Tea bush, flowering summer to autumn. The elegant beauty of the pale apricot blooms warms the heart today; no wonder it was a sensation in its early years, bringing tea rose shape and fragrance into Europe's gardens; as far as England was concerned, greenhouses were more suitable, for this graceful rose is tender, and though it can be grown outside with shelter, the flowers are much finer under glass. The high pointed buds unfurl, keeping their shape to the halfway stage and then opening quickly to loose semi double blooms,

9cm (3.5in) across. The leaves are pointed, shiny, rather sparse. 90x90cm (3x3ft). Plant this in warm climates for border, fragrance, rosarium; and in cooler countries under glass.

SAGA
Harkness, England 1974

Shrub rose or florishrub, flowering summer to autumn. Like 'Nevada' but on a small scale, this rose crams itself with flower in summertime, and goes one better by repeating the bloom at intervals through the growing season. The flowers are white with pretty buff tints, opening out with few petals to 9cm (3.5in). Dark leaves clothe the bush nearly to the ground. Growth is bushy, 1x1m (40x40in). 'Rudolph Timm' x ('Chanelle' x 'Piccadilly'). Plant this for large bed, border, health, hedge (90cm-3ft), shrubbery, small specimen plant; weatherproof.

ST BONIFACE (Kormatt)
Kordes, Germany 1980

Floribunda cluster flowered bush, flowering summer to autumn. The flowers are bright orangey red, neatly formed with many petals. They are carried in clusters on short bushy plants with plentiful dark shiny leaves. 60x60cm (2x2ft). 'Diablotin' x 'Träumerei'. Boniface lived ca. 675-755, and left his native England in 718 never to return, to preach the gospel in Germany and Holland, where he died by heathen sword. It is said that "he is much better remembered in Germany than among his fellow countrymen",[8] so it is appropriate that his rose was raised in the land for which he gave his life. Plant this for bed, border, health, low hedge (50cm-20in); weatherproof.

ST BRUNO (Lanpipe)
Hallows, England, 1985

Floribunda cluster flowered bush, flowering summer to autumn. Amber yellow sizeable 35-petalled flowers are carried in wide sprays. They are beautifully formed like small hybrid teas, and have refreshing fragrance. The habit is open and uneven, averaging 60x60cm (24x24in). 'Arthur Bell' x 'Zambra'. FRAG RNRS. Named for a well known brand of pipe tobacco. Plant this for border, fragrance, hedge (50cm-20in); weatherproof.

8 Attwater, *The Penguin Dictionary of Saints*, 1965

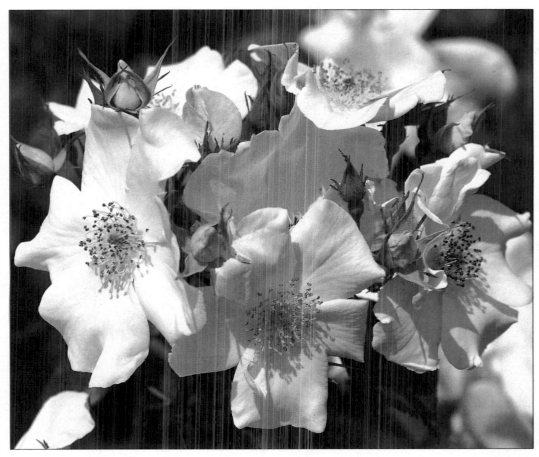

'SALLY HOLMES'

ST HELENA (Canlish)
Cant, England, 1983

Floribunda cluster flowered bush, flowering summer to autumn. The flowers are prettily formed with 20 large petals in a clear and even tone of lilac pink. The overall habit is even, with the foliage not plentiful but large enough to give good cover. 60x60cm (2x2ft). 'Jubiliant' x 'Prima Ballerina'. Named to raise funds for St Helena's Hospice in Colchester which opened in 1985. By happy chance it was also in time for the 150th birthday celebrations of the island of St Helena as a Crown Colony in 1984, where plants were sent to bloom in the anniversary year. Plant this for bed, border, hedge (50cm-20in); weatherproof.

SALLY HOLMES
Holmes, England, 1976

Shrub rose, flowering summer to autumn. This rose is recognisable by its spikes of creamy white five-petalled flowers thickly clustered on lofty stems. There can be few lovelier sights on a calm summer's day, especially when viewed against a dark background. In rough weather the heavy stems thrash about, so a place away from prevailing winds is best. Tall commanding plants with dark glossy leaves, up to 2mx90cm (6x3ft). 'Ivory Fashion' x 'Ballerina'. CM Baden-Baden. Plant this for rear of border, curiosity, exhibition, fragrance, pillar, shrubbery.

'RUGUL'

'SAMARITAN'

SAMARITAN (Harverag)
Harkness, England, 1992
Floribunda cluster flowered bush, flowering summer to autumn. Pointed apricot buds, like small scale hybrid teas, give no expectation of what follows. The flowers open with a very strange petal-crammed shape, all muddled and quartered in old fashioned style. The basic colour is a warm shade of apricot, with yellow and pink tints, edged with tomato red as the petals age. The leaves are glossy and plentiful and the habit bushy to 80x60cm (32x24in). 'Silver Jubilee' x 'Dr A.J. Verhage'. Named for the organisation which works to aid those who for a variety of reasons seek its help and counsel. Plant this for bed, border, curiosity, fragrance, hedge (50cm-20in); weatherproof.

SANDER'S WHITE RAMBLER
Introduced 1912
Rambler, summer flowering. Small white rosettes cluster together on pendulous stems amid a wealth of small polished leaflets. This is a plant that gives the gardener good measure in all departments, including fragrance. It makes vigorous trailing growth to 4x4m (12x12ft) if space allows. If older stems are cut out regularly it can be grown as a tall pillar. The origin of this lovely rose is uncertain. It is said to have turned up in a box of flowers consigned to a Belgian orchid grower named Sander, who was persuaded by a British visitor to introduce it into commerce. It seems extraordinary that two of the century's most precious and enduring roses – this one and 'Ophelia' – were both introduced as foundlings in the same year of 1912. Plant this for fence, fragrance, health, naturalising, pergola, pillar (with pruning), tree, weeping; weatherproof.

SANDRINGHAM CENTENARY
Wisbech Plant Co. England, 1981
Hybrid tea large flowered bush, flowering summer to autumn. Rather like a taller 'Mischief' with high-centred salmon pink flowers of excellent form on long stems. The flowers are borne very freely on dark leaved vigorous plants to 1.2mx75cm (48x30in).

'Queen Elizabeth' x 'Baccara'. Named in connection with the centenary of Sandringham Show in Norfolk. Plant this for border, cutting, health, tall hedge (60cm-24in), pillar; weatherproof.

SARABANDE
Meilland, France, 1957
Floribunda cluster flowered bush, flowering summer

'SANDER'S WHITE RAMBLER'

to autumn. The clusters of vivid orange red roses showing bright yellow stamens were a dazzling novelty in their time. The plant has dark bright leaves and a low spreading habit, 45x50cm (18x24in). 'Cocorico' x 'Moulin Rouge'. AARS, GM Geneva, Paris, Portland & Rome. Plant this for bed, border, hedge (46cm-20in); weatherproof.

SARAH VAN FLEET
Van Fleet, USA, 1926
Rugosa hybrid shrub, flowering summer to autumn. This is a big plant, bearing rather loose shallow-cupped flowers of fair size. They are light pink with a cool almost bluish tone, carried freely in clusters in summer and good again in autumn. The leaves are wrinkled and leathery with bronze tints when young and give good cover; in other respects the plant differs from the typical Rugosas, being stiffer with tall stems. 2.5x1.5m (8x5ft). Plant this for rear of big border, fragrance, health, huge hedge (1.2m-4ft), naturalising, shrubbery, specimen plant, spreading; weatherproof.

SAVOY HOTEL (Harvintage)
Harkness, England, 1989
Hybrid tea large flowered bush, flowering summer to autumn. The colour of this rose is light pink, but surprisingly vibrant for such a subtle shade. This is explained by the fact that the reverse side of the petal is a deeper pink, and as the large flowers expand, the darker tints catch the eye. The blooms are large, well formed and last for days when cut. The foliage is strong and dark green, the plant bushy and vigorous to 90x60cm (32x24in). 'Silver Jubilee' x 'Amber Queen'. GM Dublin. Named to mark the centenary of London's Savoy Hotel. Plant this for bed, border, cutting, health. Hedge (50cm-20in); weatherproof.

SCARLET QUEEN ELIZABETH
Dickson, N. Ireland, 1963
Floribunda cluster flowered bush, flowering summer to autumn. This is a seedling of 'Queen Elizabeth' and being tall and vigorous it could be used in the garden in similar ways. In fact it lacks its famous

parent's grace and harmony, bearing loosely formed scarlet flowers in close heads at the top of stiff and awkward looking stems. Upright, 1.2mx60cm (4x2ft). ('Korona' x seedling) x 'Queen Elizabeth'. GR The Hague. Plant this for border, tall hedge (50cm-20in).

SCENTED AIR
Dickson, N. Ireland, 1965

Floribunda cluster flowered bush, flowering summer to autumn. This seems to have suffered the same fate as another fine Dickson rose, 'Memento', in being a splendid bedding rose overlooked because of its not so popular colour. It is deep salmon pink, with large flowers for a Floribunda, and sweet fragrance. The first flowering is very prolific, and continuity good. The leaves are healthy, in fact everything is there, included a splendid name. Sturdy even growth to 90x60cm (32x24in). 'Spartan' seedling x 'Queen Elizabeth'. GM Belfast & The Hague. Plant this for bed, border, fragrance, health, hedge (50cm-20in); weatherproof.

SCHARLACHGLUT (Scarlet Fire, Scarlet Glow)
Kordes, Germany, 1952

Shrub rose, flowering in summer. All eyes turn to this in summertime when the buds open to flaunt the crimson scarlet single flowers with golden stamens. They are borne very freely, and as they measure up to 12cm (5in) across, the colour impact is tremendous. It needs lots of space, being capable of covering 3x1.8m (10x6ft), though not always in the directions the gardener desires. Pear-shaped hips follow the flowers. Bred from 'Poinsettia' x 'Alika' (which is a red Gallica rose). Plant this for large-scale border,

'SARAH VAN FLEET'

'SCENTED AIR'

193

'SCHARLACHGLUT' OR 'SCARLET FIRE'

fence, hips, naturalising, shrubbery, to clamber into tree; weatherproof.

SCHNEEZWERG (Snow Dwarf)
Lambert, Germany, 1912
Rugosa hybrid shrub, flowering summer to autumn. Opinion is divided on this one, some finding it beautiful and others utilitarian. The white semi double flowers with gold stamens are pretty enough, and they are borne over several months. The leaf cover is dense and the growth vigorous and even to 1.2x1.5m (4x5ft). Orange hips appear but they are rather small to have much colour impact. Plant this for border, health, hips, shrubbery, spreading; weatherproof.

SCHOOLGIRL
McGredy, N. Ireland, 1964
Climber, flowering summer to autumn. Large blooms of beautiful form and deep apricot colour, which is rare in climbers, have ensured this rose's popularity. The growth is vigorous and stiff and foliage rather sparse. 3x2.5m (10x8ft). 'Coral Dawn' x 'Belle Blonde'. Plant this for fence, fragrance, pillar, wall; weatherproof.

SCOTTISH SPECIAL (Cocdapple)
Cocker, Scotland, 1987
Patio or dwarf cluster flowered bush, flowering summer to autumn. The flowers are delightful, with many narrow petals which open flat to display pretty shades of apple-blossom pink and peach. The blooms are on short stems, nestling among the leaves on low cushion type plants. 40x45cm (15x18in). 'Wee Man' x 'Darling Flame'. The Scottish Special is a Housing

'SCHNEEZWERG' OR 'SNOW DWARF'

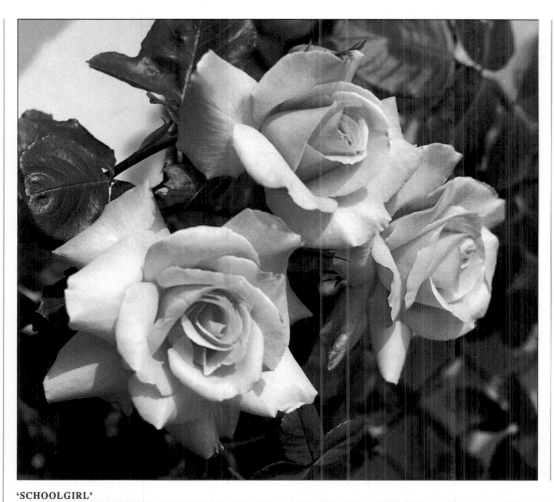

'SCHOOLGIRL'

Association and the rose marks its Golden Jubilee. Plant this for small bed, front of border, container, small hedge (40cm-15in), small space; weatherproof.

SEAFARER (Hartilion)
Harkness, England, 1986
Floribunda cluster flowered bush, flowering summer to autumn. The flowers open cupped, showing dark orange red with vivid orange tints, an unusual and lively combination. They are carried on firm short stems above bushy dark-leaved plants, 50x50cm (20x20in). 'Amy Brown' x 'Judy Garland'. This was launched to mark the work of The Marine Society, whose founder, Jonas Hanway, died in 1786. Plant this for bed, border, health, hedge (45cm-18in), small space; weatherproof.

SEAGULL
Pritchard, USA, 1907
Climbing polyantha or wild rose rambler, flowering in summer. This is rather like a civilised version of *R. multiflora*, with large trusses of gold-centred white flowers wafting their fragrance on the air. The plant is capable of reaching 6x4m (20x12ft) in time. Plant this for fence, fragrance, health, naturalising, pergola, tree, wall; weatherproof.

SEXY REXY (Heckenzauber, Macrexy)
McGredy, New Zealand, 1984
Floribunda cluster flowered bush, flowering summer to autumn. This is a delightful rose in shape and colour. It is rose pink, and the flowers open with many petals like camelias. They are carried on strong

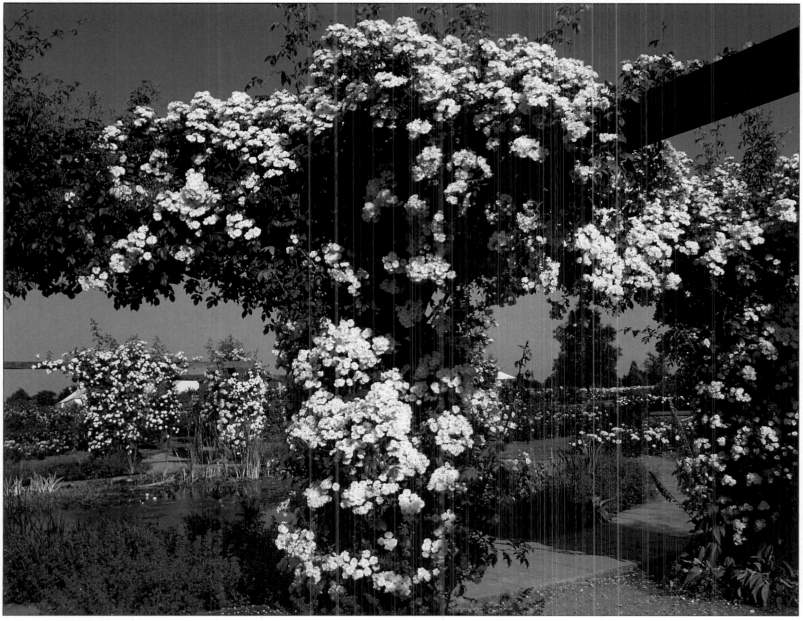

'SEAGULL' IN THE GARDENS OF THE ROSE, ST ALBANS.

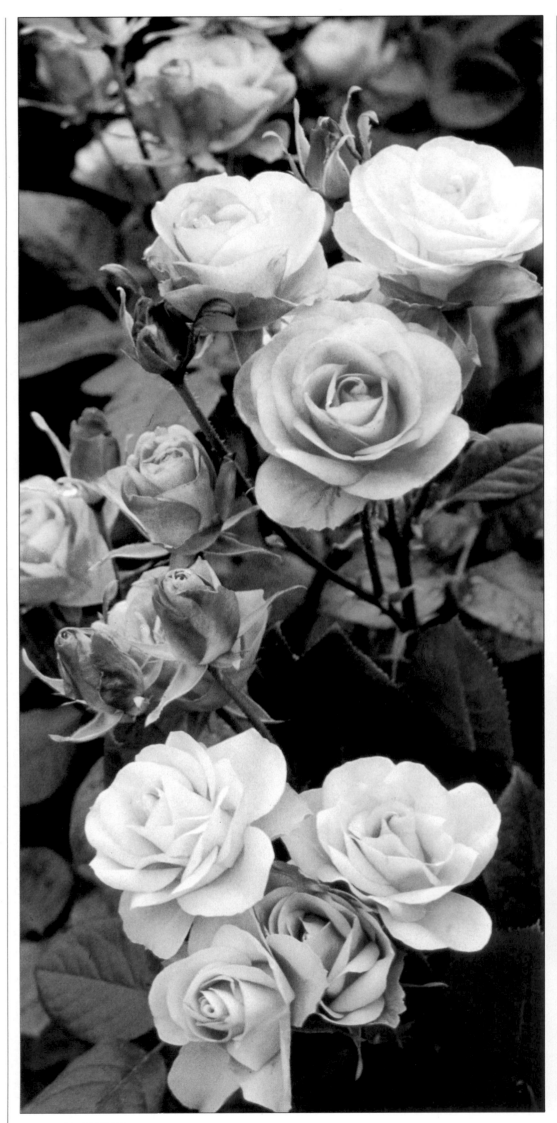

'SHEILA MACQUEEN'

stems in large heads of bloom, held close to the foliage on plants of even bushy habit. 70x60cm (28x24in). 'Seaspray' x 'Dreaming'. GM & PRIZE Glasgow, GSSP New Zealand. Plant this for bed, border, hedge (50cm-20in).

SHEILA MacQUEEN (Harwotnext)
Harkness, England, 1988
Floribunda cluster flowered bush, flowering summer to autumn. The reason for growing this is to obtain uniquely coloured rose sprays for decoration. The flowers are chartreuse green, often with touches of ginger and apricot, and last well when cut. The plant is upright with sparse foliage, 85x50cm (34x20in). 'Greensleeves' x 'Letchworth Garden City'. Mrs Sheila Macqueen selected this to bear her name, recognising its appeal to flower arrangers. Plant this for curiosity, cutting; weatherproof.

SHEILA'S PERFUME (Harsherry)
Sheridan, England, 1985
Floribunda cluster flowered bush, flowering summer to autumn. A cheerful red and yellow bicolour, with well formed flowers which are large for a floribunda; indeed this rose can easily pass as a hybrid tea, and gives excellent garden value. The leaves are plentiful, dark and lustrous and it grows neatly and strongly to 75x60cm (30x24in). 'Peer Gynt' x ['Daily Sketch' x ('Paddy McGredy' x 'Prima Ballerina')]. FRAG & PRIZE Glasgow & RNRS. One of the finest roses raised by an amateur in recent years, and named for his wife. Plant this for bed, border, fragrance, health, hedge (50cm-20in); weatherproof.

SHIRE COUNTY (Harsamy)
Harkness, England, 1989
Hybrid tea large flowered bush, flowering summer and autumn. The colours are a blend of primrose, peach and salmon, deepening as the blooms expand. They are large and full, cupped as they open, sometimes quartered in old rose style. The plant grows with a rather open habit to 75x60cm (30x24in). 'Amy Brown' x 'Bonfire Night'. Named for the centenary of the Association of County Councils and the Herts. County Council. Plant this for bed, border, fragrance, health; weatherproof.

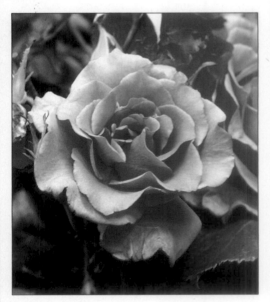

'SHOCKING BLUE'

SHOCKING BLUE (Korblue)
Kordes, Germany, 1974.
Floribunda cluster flowered bush, flowering summer to autumn. The flowers are rich lilac mauve, well formed with many petals and carried in wide sprays. They have good fragrance. Such a rose deserves to be popular, but the colour is not everyone's choice, and does not stand out against the dark foliage. Bushy, 75x60cm (30x24in). Seedling x 'Silver Star'. Plant this for bed, border, fragrance, hedge (50cm-20in).

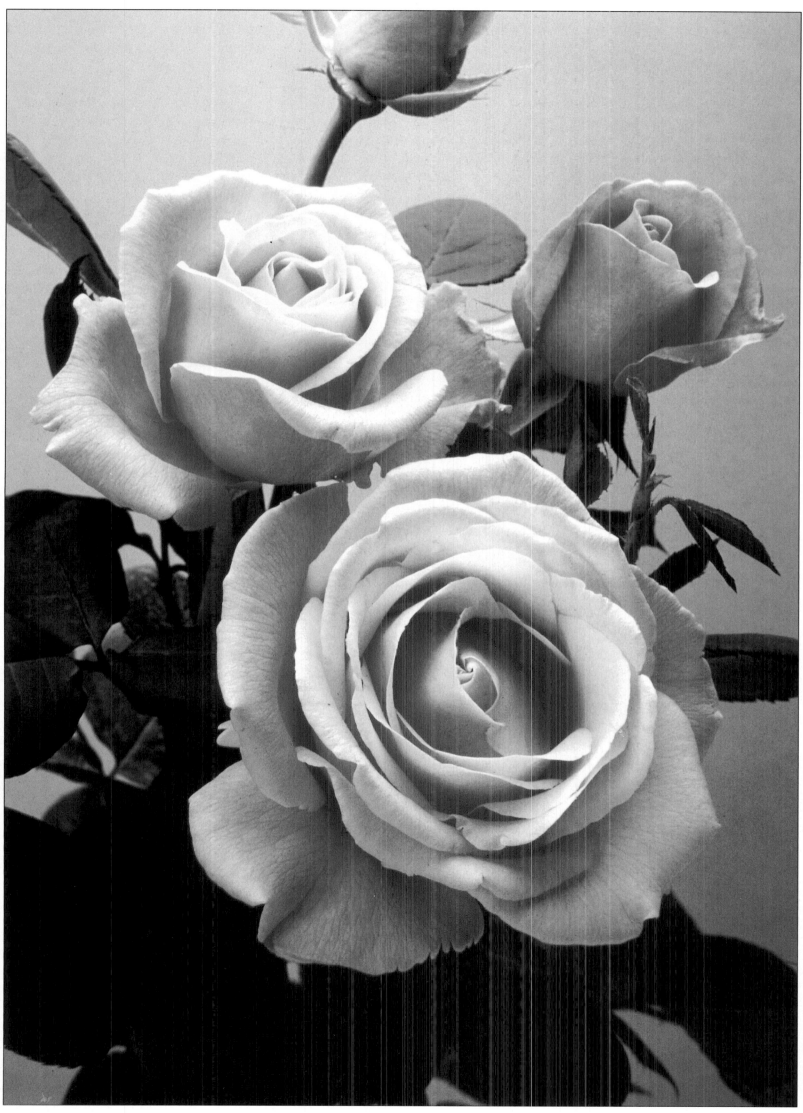

'SHIRE COUNTY'

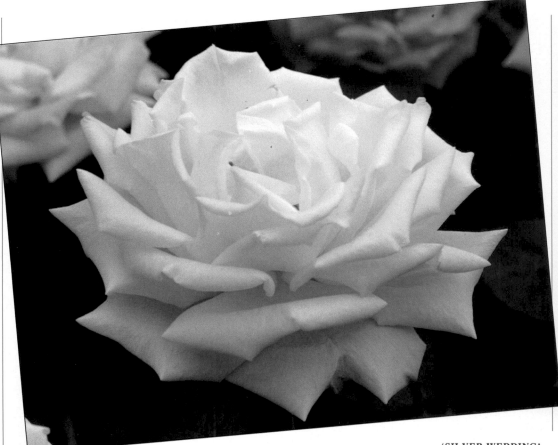

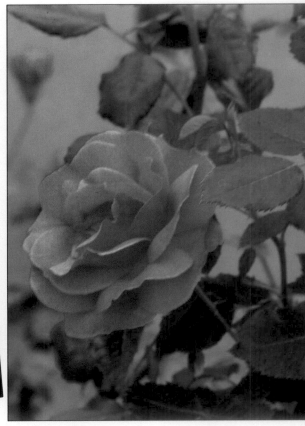

'SILVER WEDDING' 'SHOT SILK'

SHOT SILK

Dickson, N. Ireland, 1924

Hybrid tea large flowered bush, flowering summer to autumn. A fragrant old favourite with an inspired name, for there is something silky about the texture of the petals, and, allowing for some poetic licence, one may describe them as shot through with a mixture of orange, salmon, pink and yellow shades. In its heyday this was planted everywhere, and the healthy glossy leaves must have seemed novel in a rose of such colouring at the time. It looks thin in both flower and foliage beside the roses of today. Short, upright, 50x45cm (20x18in). Seedling of 'Hugh Dickson' x 'Sunstar'. GM NRS. Plant this for border, fragrance; weatherproof.

CLG SHOT SILK

Knight, Australia, 1931

Hybrid tea large flowered climber, flowering in summer and sometimes later. A sport of the bush form which is still worth growing as there are few climbers in this colour range. It will extend to 3x2.5m (10x8ft) or more. Plant this for fence, fragrance, health, pergola, wall; weatherproof.

SILVER JUBILEE

Cocker, Scotland, 1978

Hybrid tea large flowered bush, flowering summer to autumn. This has become famous for the beauty of its high centred peach and salmon flowers, whose perfect combination of elegance and size reflects all that is superlative in the modern hybrid tea. Only scent is missing from the qualities required; everything else is here – form, freedom of bloom, pretty colour, plentiful leaf, stamina and vigour. 1x60cm (40x24in). Seedling x 'Mischief'. GM Belfast, RNRS, Portland; JMMGM, RNRS. Named to mark Elizabeth II's twenty-five years as Queen. Plant this for bed, border, cutting, exhibition, health, hedge (50cm-20in); weatherproof.

SILVER WEDDING

Gregory, England, 1976

Hybrid tea large flowered bush, flowering summer to autumn. The flowers are pearly or creamy white, round and full, often carried in open sprays. They open to show pretty form, though in wet spells the petals may stick and the flowers spoil. Bushy habit, with dark foliage that sets off the colour of the

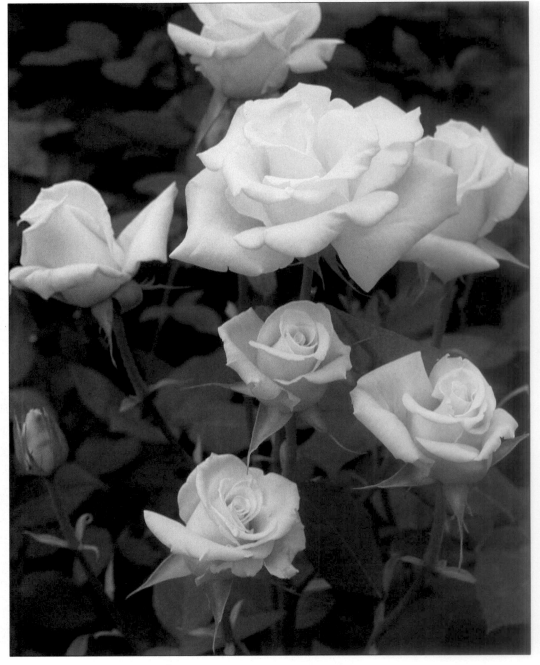

'SIMBA' OR 'HELMUT SCHMIDT'

198

blooms, 60x60cm (24x24in). This is a popular rose for anniversary gifts. Plant this for bed, border, health, hedge (50cm-20in).

SIR WALTER RALEIGH (Ausspry)
Austin, England, 1985
Shrub rose, flowering summer to autumn. The flower has been likened to a tree peony, being full of petals, cupped in form and admitting to view the golden stamens in the centre. The colour is clear warm pink, and the plants grow with large leaves to about 1.2x1.2m (48x48in). Named to commemorate the founding of the first English speaking colony in America. Plant this for border, low fence, fragrance, pillar, shrubbery, low wall.

SIMBA (Goldsmith, Helmut Schmidt. Korbelma)
Kordes, Germany, 1981
Hybrid tea large flowered bush, flowering summer to autumn. The yellow flowers of this rose are among the most perfectly formed of any in the colour. They are held up to view on firm stems on short attractive plants, and will last well when cut. 70x55cm (28x22in). 'Korgold' x seedling. GM Courtrai & Geneva. Plant this for bed, border, cutting, glasshouse, health, hedge (45cm-18in); weatherproof.

SLATER'S CRIMSON CHINA – see *R. chinensis semperflorens*

'SMITH'S PARISH'

SMITH'S PARISH (?Five-coloured Rose)
Bermudian mystery rose
China or Tea shrub, flowering summer to autumn. Rosarians in Bermuda have much to enjoy, not least the hospitable welcome from members of the world's smallest national Rose Society. They act as custodians of some of the rarest varieties in the world, evidently of Chinese origin, including 'Emmy Gray' and 'Belfield' to which reference already has been made.

'SIR WALTER RALEIGH'

'Smith's Parish' is named from the locality where it was found. It bears small (4cm-1.5in) blooms which open loosely, and some of them are white, some streaked pinky red, some rose pink and some deep red, all out at the same time. The plants can grow as open bushes up to nearly 2x1.5m (6x5ft) with pale leaves. In 1984 it was noted by Charles A. Walker Jr on a visit from the USA, and the results of his subsequent research suggest it could be the 'Five-coloured Rose' found at Ning-Po by Robert Fortune in 1844, considered to be the only striped Tea rose, and long thought lost.

SNOWBALL (Angelita, Macangel)
McGredy, New Zealand, 1984
Miniature bush, flowering summer to autumn. This creeping little rose has very double white flowers like fluffy rosettes, 3cm (1.5in) across. The plant is exceedingly compact, full of tiny bright green leaflets. 20x30cm (8x12in). 'Moana' x 'Snow Carpet'. Plant this for container, very small space; weatherproof.

SNOW CARPET (Maccarpe)
McGredy, New Zealand, 1980
Miniature ground cover rose, flowering in summer, with some later bloom. The small pompon style flowers are white with a hint of cream, borne along creeping stems. It is a useful ground cover rose for very small spaces, with minuscule leaflets cramped together. 15x50cm (6x18in). 'New Penny' x 'Temple Bells'. GM Baden-Baden. Plant this for very small bed, front of border, container, small space, weeping; weatherproof.

SOLITAIRE (Macyefre)
McGredy, New Zealand, 1987
Hybrid tea large flowered bush, flowering summer to autumn. The blooms are indeed large, recalling 'Peace' in their general shape and colour, though the yellow in 'Solitaire' is brighter, and the pink flush more intense. In habit they differ, 'Solitaire' being more open in growth, with a tendency to put up over-tall stems. Well foliaged, 90cm-2m (3-6ft) tall, 1m (40in) wide. 'Freude' x 'Benson & Hedges Gold'. GM & PIT RNRS. Plant this for border, fragrance, health, pillar; weatherproof.

'SNOWBALL'

'SOLITAIRE'

SOUTHAMPTON (Susan Ann)
Harkness, England, 1972
Floribunda cluster flowered bush, flowering summer to autumn. This is a popular rose, helped by its kindly marmalade colour, refreshing fragrance and pretty form from pointed bud to open flower. The petals fall cleanly and the foliage is rich bright green and shiny. Though tall, it branches out well to make a handsome plant 1mx75cm (40x30in). ('Ann Elizabeth' x 'Allgold') x 'Yellow Cushion'. GM Belfast. Selected by the civic authority in Southampton to bear the name. Plant this for bed, border, exhibition, fragrance, health, hedge (60cm-24in); weatherproof.

SOUVENIR DE LA MALMAISON (Queen of Beauty and Fragrance)
Béluze, France, 1843
Bourbon shrub/climber, flowering in summer and with some autumn bloom. Bears some of the loveliest flowers imaginable when the sun shines; they are crammed with petals, cupped and rounded in outline, quartered within. When fully expanded they are flat and display scores of petal edges in their large flowers, 13cm (5in) across. The colour is blush white, deepening to blush pink in autumn. Growth can extend to 1.8x1.2m (6x4ft) on a light support, or more in a sunnier climate, where it can be seen at its best. The flowers may fail to open in wet seasons. Thought to be raised from 'Mme. Desprez' crossed with a Tea rose. Plant this for sizeable border, low fence, fragrance, pillar, rosarium, shrubbery.

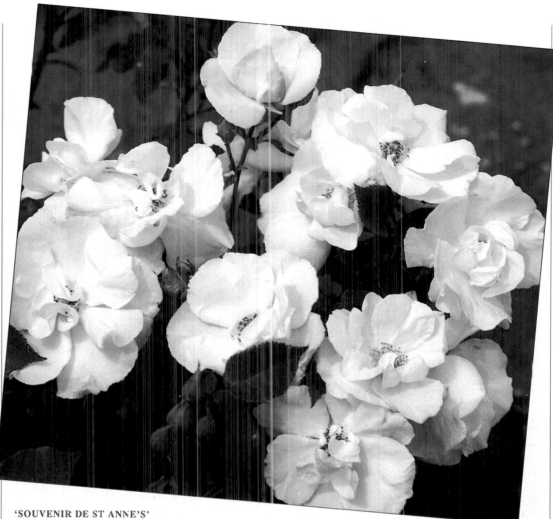

'SOUVENIR DE ST ANNE'S'

'STANWELL PERPETUAL'

SOUVENIR DE ST. ANNE'S

Introduced by Hilling, England 1950

Bourbon shrub, flowering summer to autumn. This is a sport of 'Souvenir de la Malmaison' above, discovered at St Anne's near Dublin before 1916. It resembles the parent except that the creamy-blush flowers are almost single, opening wide to 8cm (3in) across. They are borne on a substantial mound of a plant up to 2.2x.2.2m (7x7ft). This rose has an air of breeding, which is fitting since we owe its preservation to Lady Ardilaun from whose garden it came, and Lady Moore in Dublin who grew it on. Graham Thomas was instrumental in getting it introduced. Plant this for big border, fragrance, naturalising, shrubbery, spreading plant.

STACEY SUE

Moore, USA, 1976

Miniature bush, flowering summer to autumn. The search for perfection is always on but this rose comes near it. The flowers are rose pink, formed with many petals into dainty rosettes, presented to view in neatly spaced clusters, and nicely in proportion to the leaves and stems. Low and bushy, 35x35cm (15x15in). 'Ellen Poulsen' x 'Fairy Princess'. Plant this for small bed, front of border, health, petite hedge (30cm-12in), small space; weatherproof.

STANWELL PERPETUAL

Lee, England, 1838

Scotch hybrid shrub, flowering summer to autumn. This is a charming rose, with blush flowers 7cm (3in)

across opening out flat, showing many petals "folded and arranged in the most complicated way, to give an impression of artless simplicity".[9] Unusually for a Scotch rose, it repeats its flower. The leaves are small and undistinguished yet form a curiously restful background to the sweet flowers. Will grow to 1x1.2m (40x48in) or more if supported. A Damask rose is thought to be in the parentage to account for the remontant bloom. Plant this for border, low fence, fragrance, health, low pillar, shrubbery; weatherproof.

STAR CHILD (Dicmadder)
Dickson, N. Ireland, 1988
Patio or dwarf cluster flowered bush, flowering summer to autumn. The flowers are orange scarlet with ivory at the bases of its twelve petals, creating a star formation as you look down into the open bloom.

Chief' x ('Little Darling' x 'Ferdinand Pichard'), the last named being a striped hybrid perpetual. Plant this for front of border, curiosity, small space; weatherproof.

STERLING SILVER
Fisher, USA, 1957
Hybrid tea large flowered bush, flowering summer to autumn. This has many merits but a fatal flaw. The good points are colour, which is lilac, neat regular flower form, upright stems, long vase life and fragrance. The problem is that it will not thrive in the open in cool climates; the colour turns a lifeless grey and stems die back in winter. Upright growth, with sparse foliage, to 75x50cm (30x20in) in cool climates, bigger in warm ones. Seedling x 'Peace'. Plant this in warm climates for border, cutting, fragrance; and in

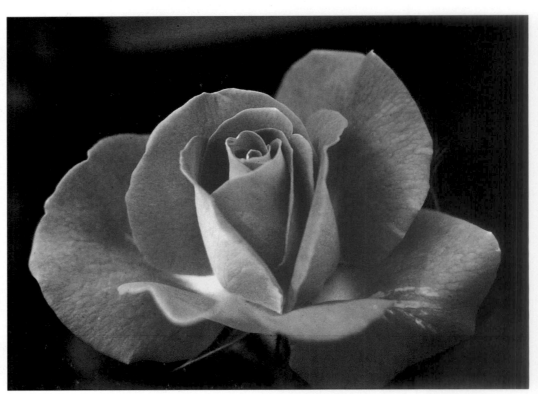

'SUFFOLK'

cool climates grow it under glass for superb roses to cut.

SUE LAWLEY (Macspash, Spanish Shawl)
McGredy, New Zealand, 1980
Floribunda cluster flowered bush, flowering summer to autumn. The open flowers are wonderfully eye-catching, as each petal is a warm shade of red in the centre, graduating to blush around the margins and at the base, and with some darker crayoning marks. The colour pattern varies according to season, but is

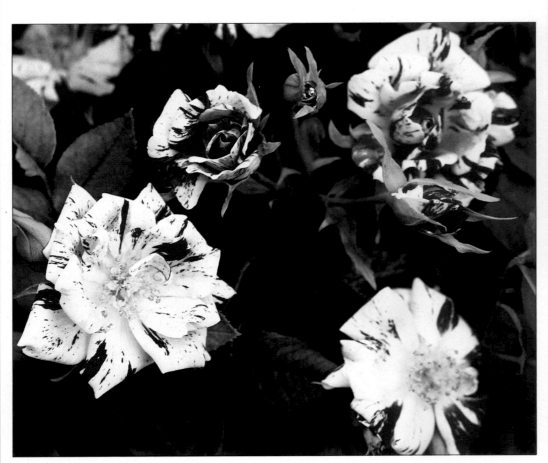

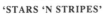

'STARS 'N STRIPES'

The plant is well foliaged with glossy leaves, and grows as a neat bush to 45x40cm (18x15in). 'Eye Paint' x seedling. GM Dublin & Tokyo. Plant this for small bed, front of border, container, health, low hedge (36cm-13in), small space; weatherproof.

STARINA (Meigabi)
Meilland, France, 1965
Miniature bush, flowering summer to autumn. The flowers are formed like small hybrid teas in a clear orange red, on neat well behaved plants with mid-green shiny foliage. 35x35cm (15x15in). ('Dany Robin' x 'Fire King') x 'Perla de Montserrat'. ADR, GM Japan. Plant this for small bed, front of border, container, cutting, exhibition, health, petite hedge (30cm-12in), small space; weatherproof.

STARS 'N STRIPES
Moore, USA, 1975
Miniature bush, flowering summer to autumn. The flowers show bizarre stripes of blush white and strawberry red, and are large in proportion to the plant, with ragged form. It is a curious item and important for bringing novelty into the Miniatures, but not everyone's favourite. Bushy but uneven, averaging 30x35cm (12x15in). Bred from 'Little

9 Jack Harkness, *Roses*, (Dent 1978)

'SUE RYDER'

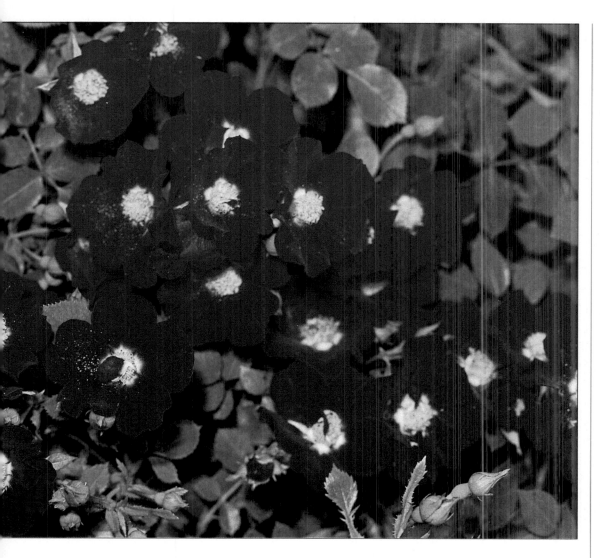

The flowers are rich bright scarlet with golden stamens, borne freely on low spreading plants with small shiny leaves. 45x90cm (18x36in). Plant this for bed, border, container, ground covering, front of shrubbery; weatherproof.

SUMA (Harsuma)
Onodera, Japan, 1989
Ground cover shrub, flowering summer to autumn. This makes a truly creeping plant, pushing its reddish leaves along the surface of the ground, to be followed by clusters of little red rosettes. Established plants build up on this base to form a low hummock, or a short climber if supported. In autumn the small dark leaves take on a burnished crimson effect like that of Virginia creeper. 45cmx1m (18x40in). Seedling of 'Nozomi'. Named by the Japanese raiser after a town in his country that is used as a popular resort. Plant this for low bed, front of border, container, curiosity, low fence, ground covering, health, small space, low wall; weatherproof.

SUMMER DREAM (Frymaxicot)
Fryer, England, 1989
Floribunda cluster flowered bush, flowering summer to autumn. Bears full petalled peach apricot flowers in close clusters, giving a good display of refreshing colour on upright bushy plants, 90x60cm (36x24in). Plant this for bed, border, fragrance; weatherproof.

SUMMER SUNSHINE
Swim, USA, 1962
Hybrid tea large flowered bush, flowering summer to autumn. This has flowers of beautiful pointed form and shining bright yellow colour, with refreshing fragrance. There has perhaps never been a lovelier yellow hybrid tea as far as the blooms are concerned, but the plant is a disappointment, being short of foliage, rather splayed in habit, and none too vigorous. 75x60cm (30x24in). 'Buccaneer' x 'Lemon Chiffon'. Plant this for border, fragrance; weatherproof.

SUMMER WINE (Korizont)
Kordes, Germany, 1985
Climber, flowering summer to autumn. The open flowers have great beauty, being coral pink with red stamens, which are enhanced by yellow shading at the petal base. The plant grows upright and bushy with large leaves to 3x2m (10x6ft). Plant this for fence, fragrance, health, pillar, wall; weatherproof.

always pretty, and reflects the influence of 'Frühlingsmorgen' in the complex parentage. Bushy, 60x60cm (24x24in). GSSP New Zealand. Named for the television celebrity. Plant this for bed, border, curiosity, hedge (50cm-20in); weatherproof.

SUE RYDER (Harlino)
Harkness, England, 1983
Floribunda cluster flowered bush, flowering summer to autumn. This makes a sturdy upright plant, capable of bearing very large flower trusses of colourful well formed flowers. They are a gentle blend of salmon red and amber yellow. The leaves are shiny and give good coverage. 90x60cm (36x24in). 'Southampton' x seedling. Named for Lady Ryder of Warsaw CMG OBE, and sold to aid the Sue Ryder Foundation. Plant this for bed, border, health, hedge (50cm-20in); weatherproof.

SUFFOLK (Bassino, Kormixal)
Kordes, Germany, 1988
Ground cover shrub, flowering summer to autumn.

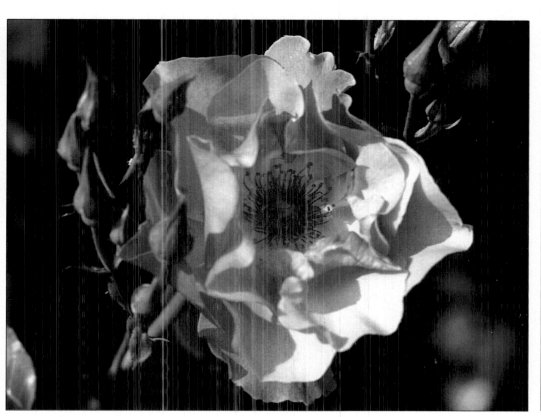

'SUMMER SUNSHINE'

'SUMMER WINE'

SUNBLEST (Landora)
Tantau, Germany, 1970
Hybrid tea large flowered bush, flowering summer to autumn. This is clear yellow, with bright flowers of no great size but good form. They are borne freely on upright plants with ample shiny foliage. These are qualities which make it one of the best for a bed. 90x60cm (34x24in). Seedling x 'King's Ransom'. GM Japan & New Zealand. Plant this for bed, border, cutting, health, hedge (50cm-24in); weatherproof.

SUPER STAR (Tanorstar, Tropicana)
Tantau, Germany, 1960
Hybrid tea large flowered bush, flowering summer to autumn. When this was introduced, the beautiful vermilion colour and shapely form of the big flowers caused a sensation. It can still produce superb blooms, but the plant leaves much to be desired, being uneven in growth, with small dull leaves which mildew spores enjoy. It is no longer the brightest in its colour range, largely due to its own merits as a parent. 1mx75cm (40x30in). Bred from two seedlings, one out of 'Alpine Glow', the other from 'Peace'. AARS, GM ARS, NRS, Portland. The raiser intended to call it 'Ilse Tantau' after his wife, but the introducers in the USA sought to change it for business reasons to 'Super Star'; that name was challenged because another US firm was called Star Roses, and though 'Super Star' is used in Europe, in America it is 'Tropicana'. Plant this for border, cutting; weatherproof.

SURREY (Korlanum, Sommerwind, Vent d'Eté)
Kordes, Germany, 1985
Shrub, flowering summer to autumn. This has an interesting habit, forming a dense mound covered in leaves and adorned with scores of clear pink flowers.

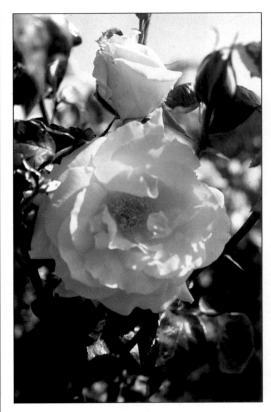

'SUNBLEST'

They are on the small side, about 6cm (2.5in) across with twenty or so ruffled petals, and neatly spaced on the plant. 75cmx2m (30x80in). 'The Fairy' x seedling. GM Baden-Baden, Genoa, NRS, PRIZE Genoa, Lyon, Paris. Plant this for border, low fence, fragrance, ground covering, health, front of shrubbery, spreading; weatherproof.

SUTTER'S GOLD
Swim, USA 1950
Hybrid tea large flowered bush, flowering summer to autumn. Treasured for its fruity fragrance, sweet and sharp. The buds are elegantly furled like those of an old Tea rose, and the long petals open loosely in much the same way. The colour is a pretty melange of golden orange overlaid with red, paling to more subdued tones before the petals fall. This delightful rose would be widely grown were it not for its failure to produce more stems and leaves; it looks gaunt and does not make the grade of plant that nurserymen like to send for their customers to plant. 90x60cm (36x24in). 'Charlotte Armstrong' x 'Signora'. AARS, FRAG USA, GM Geneva, Paris, Portland. Commemorates the discovery of gold in California on the estate of John Sutter (1803-1880), who was a naturalised Mexican born in Germany of Swiss parents. We are told that after gold was found "squatters, cattle thieves and miners robbed him of his land"[10] and although he received a pension the gold rush was of little benefit to him. Plant this for border, fragrance, health; weatherproof.

CLG SUTTER'S GOLD
Weeks, USA 1950
Hybrid tea large flowered climber, flowering in summer. This is a climbing sport which is unfortunately not remontant but well worth growing on a wall where there is room for its stiff branches to be stretched out; while it is in bloom it is most prolific. 3.5x2.5m (12x8ft). It is remarkable to see a sport introduced the same year as its parent and from an apparently different source, and the explanation is that Swim and Weeks were colleagues working for

10 These details are given in *White Rose News* for November 1979

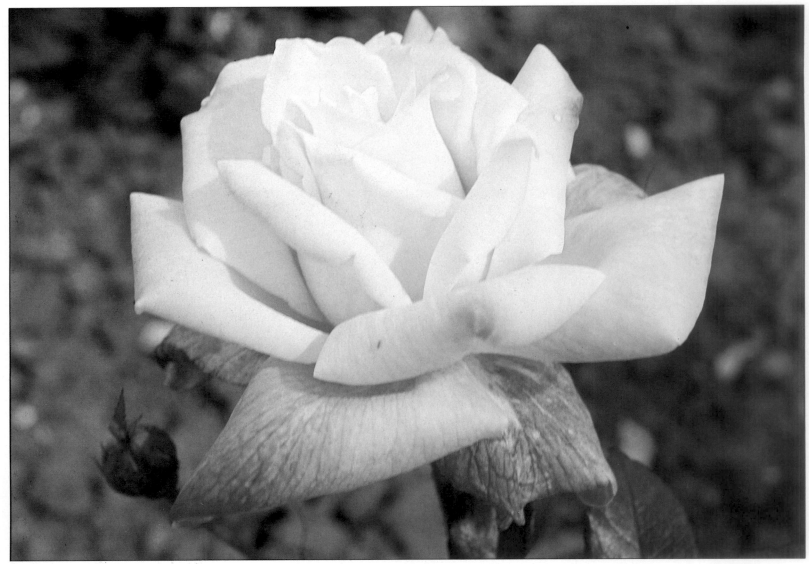

'SUTTER'S GOLD'

Armstrong's Nurseries in California. Weeks evidently noticed the sport on Swim's seedling at a very early stage. Plant this for high fence, fragrance, health, high wall – it is desirable to plant something in front to hide the bare stems below; weatherproof.

SWEET DREAM (Fryminicot)
Fryer, England, 1988
Patio or dwarf cluster flowered bush, flowering summer to autumn. In appearance resembles 'Summer Dream' above, but the clusters of gentle apricot flowers are on a smaller scale. The little blooms have great charm, being packed with petals and often quartered. Neat upright growth, 40x35cm (16x14in). ROTY. Plant this for small bed, front of border, container, health, small hedge (30cm-12in), small space; weatherproof.

SWEETHEART (Cocapeer)
Cocker, Scotland, 1980
Hybrid tea large flowered bush, flowering summer to autumn. The flowers can be enormous, with over fifty broad petals forming high-centred blooms on firm upright stems. They are a warm and kindly shade of rose pink, and fragrant. This is a beauty which should

be better known. Well foliaged, 90x60cm (36x24in). 'Peer Gynt' x ('Fragrant Cloud' x 'Gay Gordons'). FRAG Belfast. Plant this for bed, border, exhibition, fragrance, health, hedge (50cm-20in); commendably weatherproof considering the size of the flowers.

SWEET JULIET (Ausleap)
Austin, England, 1989
Shrub, flowering in summer and autumn. Apricot shrub roses are scarce. The blooms of this one are fairly large, cupped in form, opening to show a confused formation in the petals in the manner of older roses, with deeper apricot in the heart of the flower, paling towards the edges. The plants grow to 1mx90cm (40x35in). Bred from 'Graham Thomas'. Plant this for border, fragrance, shrubbery.

SWEET MAGIC (Dicmagic)
Dickson, N. Ireland, 1987
Patio or dwarf cluster flowered bush, flowering summer to autumn. A rare colour for a dwarf rose, rich orange with golden tints, taking some pink flushes as the blooms age. The flowers are small and well formed, opening wide from pretty pointed buds. Leaves, stems and flowers are all of a scale, making

this like a petite replica of the floribundas. Makes a neat rounded leafy bush, 40x40cm (15x15in). 'Peek a Boo' x 'Bright Smile'. ROTY. Plant this for small bed, front of border, container, health, petite hedge (32cm-13in), small space; weatherproof.

SWEET PROMISE (Sonia, Sonia Meilland)
Meilland, France, 1973
Hybrid tea large flowered bush, flowering summer to autumn. The rosy salmon flowers are of modest size, perfectly formed with true hearts, and maintain their neat shape and impeccable outline as they open. For these reasons the rose has long been a favourite for cut flower growers, and sold by the million to satisfy that market. In the garden it is easily upset by rain or cold, so it is not well suited to being grown outdoors in Britain. Grows upright with dark leaves to 90x60cm (34x24in). 'Zambra' x ('Baccará' x 'Message'). Plant this in warm climate for bed, border, cutting, health, hedge (50cm-20in); and in Britain under glass for cutting.

SYMPATHIE
Kordes, Germany, 1964
Climber, flowering from summer to autumn. Bears

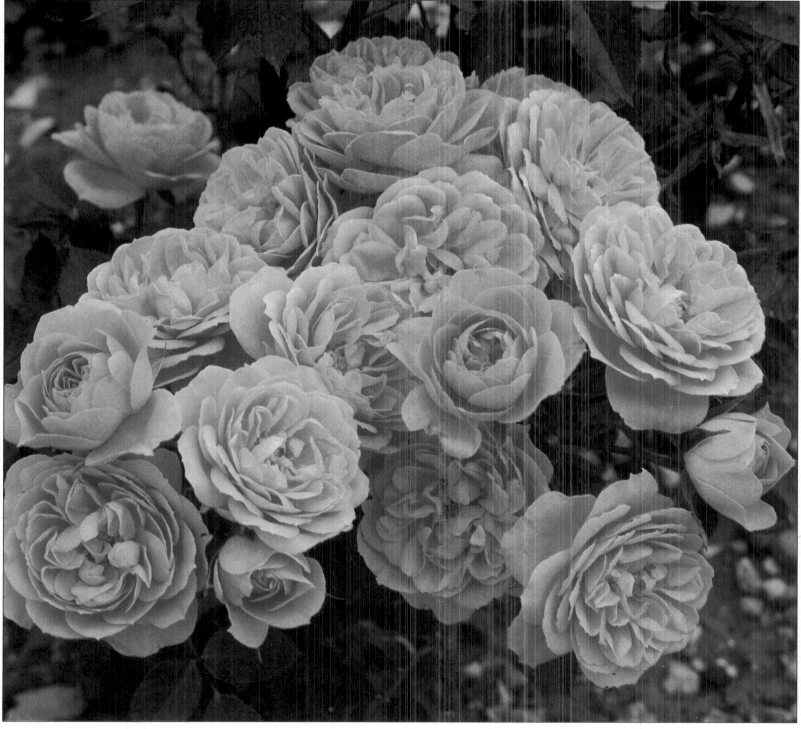

'SWEET DREAM'

'TANGO'

clusters of rich blood flowers, cupped in form and opening out to 10cm (4in) across. The colour is intense and shows up beautifully against a background of rich shiny foliage. The mid-season blooming can be sparse and indifferent, but it comes good again in autumn. Up to 5x3m (15x10ft). 'Wilhelm Hansmann' x 'Don Juan'. Plant this for fence, pergola, wall; weatherproof.

TALL STORY (Dickooky)
Dickson, N. Ireland, 1984
Shrub rose, flowering summer to autumn. Often listed as a ground covering rose, but it grows higher than that description would imply. The blooms have a glorious cool creamy look, like new butter from the dairy. They are neatly formed, carried in sprays at different levels on the plant, and impervious to bad weather. Plentifully foliaged with light glossy leaves, 75cmx1.2m (30x48in). 'Korresia' x 'Yesterday'. Plant this for sizeable bed, border, cutting, fragrance, low fence, ground covering, health, hedge (1m-40in), shrubbery, small specimen plant, spreading, low wall; weatherproof.

TANGO (Macfirwal, Rock 'n Roll)
McGredy, New Zealand, 1989
Floribunda cluster flowered bush, flowering summer to autumn. A novel colour, orange red over most of the petal area, with yellowish edging at the petal tips and in the centre of the blooms. This looks to be a splendid addition to the "handpainted" roses developed from 'Picasso', with vigour and health. Bushy leafy growth to 75x60in (30x24in). GM RNRS. Plant this for bed, border, curiosity, health, hedge (50cm-20in); weatherproof.

TEAR DROP (Dicomo)
Dickson, N. Ireland, 1989
Patio or dwarf cluster flowered bush, flowering summer to autumn. Blush white; small narrow-petalled flowers open flat, displaying golden hearts. There is an air of innocence about them that invokes a response as you admire their simple beauty. The plants are round like dinner plates, and very short so

that the flowers are only a few inches off the ground. 40x40cm (15x15in). Plant this for tiny bed, front of border, container, health, very small space; weatherproof.

TEQUILA SUNRISE (Dicobey)
Dickson, N. Ireland, 1989
Hybrid tea large flowered bush, flowering summer to autumn. The blooms are yellow with vivid touches of scarlet towards the petal edges, and are produced with remarkable freedom to make a colourful show. They

last well and are set off by glossy green foliage on bushy plants, 75x60cm (30x24in). 'Bonfire Night' x 'Freedom'. GM RNRS, Rome & The Hague, PRIZE Baden-Baden. Plant this for bed, border, cutting, health, hedge (50cm-24in).

THE FAIRY
Bentall, England, 1932
Polyantha shrub, flowering summer to autumn. This variety begins to flower later than most roses, but makes up for it with a splendid show of dainty pink

'TEQUILA SUNRISE'

'TEAR DROP'

rosettes for weeks on end until the frosts of winter compel it to take a rest. The plants are attractive even when not in bloom, forming round cushions of bright green pointed leaves. This is a cheerful rose to have around. 60x60cm (2x2ft) or more if not pruned. 'Paul Crampel' x 'Lady Gay'. Plant this for bed, border, container, cutting, health, small space, small specimen plant, spreading; weatherproof.

THE TIMES (Carl Philip, Christian IV, Korpeahn, Mariandel, The Times)
Kordes, Germany, 1984
Floribunda cluster flowered bush, flowering summer to autumn. Dark crimson, an excellent deep colour and lovely when sun lights up the petals, neatly arrayed around dusty yellow stamens. This variety has a curious flat topped appearance, because leaves and flower clusters are unusually even in their growth, nestling alongside one another; this puts in it the front rank as a rose for bedding. Grows to 60x75cm (24x30in) with dark lustrous foliage. 'Tornado' x 'Redgold'. GM & PIT, RNRS. Named to celebrate the bicentenary of the famous newspaper. Plant this for bed, border, exhibition, health, hedge (60cm-24in); weatherproof.

THISBE
Pemberton, England, 1918
Hybrid musk shrub, flowering summer to autumn. The flowers are borne close together in the cluster, so that in full bloom the effect is of a fluffy cloud of chamois yellow. They open rosette-style with many small petals, amber stamens and pleasing fragrance. Growth is bushy with pointed narrow leaflets to 1.2x1.2m (4x4ft). Said to be 'Marie Jeanne' x 'Perle des Jardins'.

TIGRIS (Harprier)
Harkness, England, 1985
Persica hybrid shrub, flowering in summer. The flowers are canary yellow, with a red eye at the base of the petals which becomes more apparent as they unfold. When fully open they are the shape of powder puffs about 3cm (1in) across. The plant is curious,

'THE TIMES'

'THISBE'

'TIGRIS'

like a low spreading thornbush with many wiry stems. Cushiony growth, 45x60cm (18x24in). Bred from *R. persica* x 'Trier', and believed to be the first hardy Persica hybrid introduced in commerce. Plant this for border, curiosity, health, rosarium, small space; weatherproof.

TOPSI

Tantau, Germany, 1972
Floribunda cluster flowered bush, flowering summer to autumn. Recently described as a "tantalising,

dazzling charmer", for the good reasons that it is beautiful but apt to die on you. The colour is as vivid an orange red as can be imagined, and the flowers open out wide to show it off. They are borne in clusters on very short stubby plants, and give a great display through the flowering season, unless rendered leafless through blackspot. Perhaps too much energy is channelled into the flower and not enough new wood made against the risk of dieback. The Topsy of *Uncle Tom's Cabin* said she just "grow'd"; the problem with this 'Topsi' is that in some gardens she just

doesn't. The plants have a squat habit, with proportionately large leaves, 40x40cm (15x15in). 'Fragrant Cloud' x 'Signalfeuer'. GM & PIT RNRS. Plant this for bed, front of border, small space; weatherproof.

TOUR DE MALAKOFF

Soupert & Notting, Luxembourg, 1856
Provence or centifolia shrub, flowering in summer. The flowers are, in a word, purplish. Examine them closely and shades of lilac, magenta, violet and grey can be seen through the life of the cupped 13cm (5in) full petalled flowers. The leaves are smooth and the branches lax, needing support to hold them up. Bourbon and gallica rose ancestry probably account for the unusual character of this rose. That it provokes strong feelings is evident from the recent verdicts of two experts: " ... some extra effort is more than worthwhile for the sake of the flowers ... It is a breathtaking transformation." "If you like to grow an arching shrub of wayward disposition and revolting colour, this is the one for you ... it starts up magenta, changes down to mauve pink, and finally meets its doom all greyed over in a proper spirit of ashes to ashes. I have written off Malakoff from my future itineraries; it must be an extraordinary place on this evidence."[11] The writer would certainly have found Malakoff uncomfortable in September 1855, when the tower was stormed by the French in their attack on Sebastopol in the Crimean War; an exploit of which the introducers of this rose were quick to take advantage. Plant this for border with support, low fence, fragrance, pillar, shrubbery with support, low wall.

TOY CLOWN

Moore, USA, 1966
Miniature bush, flowering summer to autumn. The

11 From M. Gibson, Shrub Roses, Climbers and Ramblers, (Collins 1981) and J. Harkness, Roses, (Dent 1978)

'TOPSI'

buds are urn shaped, like petite hybrid teas, and strikingly coloured, blush white rimmed with carmine. The open flowers are blush with pink. Bushy neat growth, 30x30cm (12x12in). 'Little Darling' x 'Magic Wand'. Plant this for container, small space.

TRIGINTIPETALA see KAZANLIK

TROIKA (Royal Dane)
Poulsen, Denmark, 1972
Hybrid tea bush, flowering summer to autumn. The good qualities of this rose are its warm colouring of orange-red with pink, the large high centred blooms of excellent form, good foliage, respectable fragrance and reasonable health. It makes a vigorous leafy plant to 90x75cm (36x30in). ['Super Star' x ('Baccará' x 'Princesse Astrid')] x 'Hanne'. *Troika* means a threesome in Russian, or a coach drawn by three horses. Plant this for bed, border, cutting, exhibition, fragrance, hedge (60cm-24in); weatherproof.

TRUMPETER (Mactru)
McGredy, New Zealand, 1978
Floribunda cluster flowered bush, flowering summer and autumn. Few roses can be considered perfect but this would surely be among them. It flowers freely with showy bright red flowers in clusters, and displays them on neat clean foliaged plants. A householder who had a few to try ordered four hundred more the next year, "to replace all my geraniums". 50x45cm (20x18in). 'Satchmo' x seedling. GM Portland, GSSP New Zealand. Plant this for bed, border, health, hedge (16cm-40in), small space; weatherproof.

TUSCANY SUPERB (?Double Velvet)
Origin uncertain
Gallica shrub, flowering in summer. Bears flowers of deepest crimson maroon, taking in purple as they age, and sometimes showing gold stamens if the petals part in time. It is a wonderful colour when illuminated by the sun. The plant grows vigorously to 1.2x1m

'TROIKA'

(4x3ft), and will increase readily by suckering. This is an improved form of 'Tuscany', and it is possible but not provable that these two roses are the 'Double Velvet' varieties mentioned in catalogues of the 1750s, and 'Tuscany' may even be the 'Velvet rose' of Gerarde's *Herbal*, whose 1596 description answers well, even to the fine prickles on the stems and the way the "floures grow at the top of the stalks, doubled with some yellow thrums in the midst, of a deepe and blacke red colour, resembling red crimson velvet...". It must have been the nearest to a true red rose in Europe before the advent of Chinese varieties. If 'Tuscany' came from Italy as the name suggests, a possible wild source of the colour may be *R. pendulina*, which in that region has been observed to produce fine red-purple forms. Plant this for border, curiosity, rosarium, shrubbery, spreading; weatherproof.

TYPHOON (Taifun)
Kordes, Germany, 1972
Hybrid tea large flowered bush, flowering summer to autumn. A cheerful combination of salmon with orange shading, made more delightful by the fragrance and a background of crisp dark green leaves. The flowers are large and well-formed, last well when cut, and the bushes have a neat habit to 75x60cm (30x24in). 'Dr. A.J. Verhage' x 'Colour Wonder'. It was perhaps unlucky to be introduced in the shadow of 'Just Joey', a highly successful rose in the same colour range, and has never achieved the popularity its merits deserve. Plant this for bed, border, cutting, fragrance, hedge (50cm-20in); weatherproof.

VALENTINE HEART (Dicogle)
Dickson, N. Ireland, 1990
Floribunda cluster flowered bush, flowering summer to autumn. This is a delightful rose, the palest of

'TYPHOON'

scarlets in bud, opening with blush pink on the inside of the petals. As you look within, the pale and deep pinks blend to give wonderful depth to the flowers. Neat in habit, leaf and bloom, 75x60cm (30x24in). 'Shona' x 'Pot o' Gold'. FRAG The Hague, GM Geneva. Plant this for bed, border, fragrance, health, hedge (50cm- 20in); weatherproof.

VARIEGATA DI BOLOGNA
Bonfiglioni, Italy, 1909
Bourbon shrub, flowering in summer with some later bloom. The attraction of this lies in the colour of the flowers, which are blush bizarrely striped with rosy purple. They have many petals, open cupped to about 8cm (3in) and are often quartered. The plant grows upright with branches that bend over, and it is easier to control if grown on a support. 2x1.3m (72x54in). Plant this for border, curiosity, fragrance, pillar, shrubbery.

VEILCHENBLAU (Blue Rambler, Blue Rosalie, Violet Blue)
Schmidt, Germany, 1909
Polyantha or multiflora climber or rambler, flowering in summer. This produces masses of violet rosettes with little streaks of white. They are borne in clusters and make a spectacular show, especially when lit up by early or late sun; too sunny a site takes some of the brilliance off the colour. Vigorous growth to 4x3m

'VALENTINE HEART'

'VARIEGATA DI BOLOGNA'

'VEILCHENBLAU'

(12x10ft), but easy to train. 'Crimson Rambler' x 'Erinnerung an Brod'. Plant this for fence, fragrance, health, naturalising, pergola, pillar, tree, wall; weatherproof.

VIRIDIFLORA (Green Rose, Lü E, *R. chinensis viridiflora*)
From China

Ancient China bush, flowering summer and autumn. The so-called flowers are green, bronzing as they age, with narrow petals; They are freakish, and not true flowers for no stigmas or stamens exist. In the bud stage they look pretty, and as a curiosity this has a place in the garden today as it did in old China, where it presumably sported from a garden rose. Since many other garden forms were sent from China it seems reasonable to suppose this one did too, but no such record exists. It emerges from the mists of speculation into the world of commerce in 1856, when an English nursery introduced it; the stock having come from USA! Plant this for curiosity, cutting (it lasts weeks), health, rosarium; weatherproof.

VIRGO
Mallerin, France, 1947

Hybrid tea large flowered bush, flowering summer to autumn. The long white blooms of this rose have delighted millions of rose lovers with their elegant form and purity of colour. The plant is apt to mildew and no longer has the stamina of earlier days. 60x50cm (24x20in). 'Blanche Mallerin' x 'Neige Parfum'. GM NRS. Plant this for cutting, glasshouse.

VOLUNTEER (Harquaker)
Harkness, England, 1986

Floribunda cluster flowered bush, flowering summer to autumn. This cheerful looking rose is yellow with flushes of pink. The blooms are formed like scaled down hybrid teas, and as the outer petals reflex the high centre is retained, creating a flower of neat proportions. The blooms are held close to the bright foliage which clothes the plants almost to the ground. 60x60cm (24x24in). 'Dame of Sark' x 'Silver Jubilee'. Named for VSO (Voluntary Service Overseas) and sold initially to aid their funds. Plant this for bed, border, health, hedge (50cm-20in); weatherproof.

'VIRGO'

'VOLUNTEER'

WANDERING MINSTREL (Daniel Gelin, Harquince)
Harkness, England, 1986

Floribunda cluster flowered bush, flowering summer to autumn. The flowers are a rich blend of orange-pink and yellow, hard to describe because the balance of colours changes according to the time of year. They are full-petalled, well formed and large for a floribunda, and show up well against a background of luxuriant deep green foliage. 75x60cm (30x24in). 'Dame of Sark' x 'Silver Jubilee'. Named appropriately for the balladeer and entertainer Roger Whittaker. Plant this for bed, border, health, hedge (50cm-20in); weatherproof.

WARM WELCOME (Chewizz)
Warner, England, 1991

Miniature climber, flowering summer to autumn. A recent development in roses is the appearance of varieties like this one, having small-scale flowers and leaves, blooming freely, and making climbers of restrained growth. The semi double flowers are orange vermilion with yellow at the petal base, borne in clusters at different levels on the plant, and making a colourful display. Dark foliage. 2.2x2.8m (7x9ft). GM & PIT RNRS. Plant this for fence, health, pillar, wall; weatherproof.

WARRIOR
LeGrice, England, 1978

Floribunda cluster flowered bush, flowering summer to autumn. This low grower has bright unfading

'WEDDING DAY'

'WARRIOR'

'WEE JOCK'

orange scarlet flowers, borne freely in clusters and quick to repeat their bloom; one could say it fulfils the role of the excellent 'Trumpeter' in a shorter version. Compact and leafy to 40x45cm (15x18in). 'City of Belfast' x 'Ronde Endiableé'. Plant this for bed, front of border, health, low hedge (40cm-15in), small space; weatherproof.

WEDDING DAY
Stern, England, 1950
Climber, flowering in summer. The individual flowers are small, but are carried in great heads of bloom to create a spectacular effect. The opening buds are creamy white and they age blush, but white is the effect created by the mass of flowers, apart from highlights of yellow from the stamens. Old flowers mottle before the petals fall. The plant puts out arching branches that can clamber into trees for 8m (25ft) and spread out to 4m (12ft) or more, pushing through the branches so that their shiny leaves can reach the light. Considered to be a seedling of *R. sinowilsonii*. Plant this for fragrance, health, naturalising, tree. It is sometimes grown against high fences and walls and on pergolas, but it is hard work keeping it tied in place and under control.

WEE JOCK (Cocabest)
Cocker, Scotland, 1980
Patio or dwarf cluster flowered bush, flowering summer to autumn. This makes a neat and compact cushion of a plant, bearing deep crimson flowers like small scale hybrid teas. They are perfect for small arrangements. The foliage is small, dark and plentiful. 45x45cm (15x15in). 'National Trust' x 'Wee Man'. Plant this for small bed, front of border, container, cutting, health, low hedge (40cm-12in), small space; weatherproof.

WENDY CUSSONS
Gregory, England, 1959
Hybrid tea large flowered bush, flowering summer to autumn. Buds of cherry red open to beautifully formed flowers of deep pink, a rich and strong colour. The blooms are large. high centred and fragrant, carried

on strong arching stems. This favourite of thirty years standing is still popular, and though it is said that the colour needs placing carefully in a planting scheme, in practice it goes well in quite unlikely contexts. Branching growth with dark green leaves to 1mx60cm (40x24in). Parentage may be 'Independence' x 'Eden Rose'. FRAG GM Rotterdam, GM & PIT NRS, Portland & Rome, GR The Hague. Plant this for bed,

border, cutting, exhibition, fragrance, hedge (50cm-20in); weatherproof.

WESTERLAND (Korwest)
Kordes, Germany, 1969
Shrub, flowering summer to autumn. The combination of rich apricot orange with yellow on the petal reverse is perhaps unique in shrub roses, which makes this

'WENDY CUSSONS'

'WESTERLAND'

fine variety all the more welcome. The scented blooms are loosely double and borne freely on a substantial leafy plant to 1.5x1m (60x40in). 'Friedrich Wörlein' x 'Circus'. ADR. Plant this for sizeable border, fragrance, health, big hedge (90cm-36in), pillar, shrubbery, specimen plant, low wall; weatherproof.

WHISKY MAC
Tantau, Germany, 1967
Hybrid tea large flowered bush, flowering summer to autumn. The author of *The Rose Expert* sums up the secret of success which made this golden apricot rose Britain's top selling hybrid tea: "a unique colour plus an attractive and unusual scent".[12] To that can be added its flower form, pretty, regular and admitting the eye into the depths of the bloom. It remains popular though seasonal mildew and some winter dieback weigh against it. Plant this for bed, border, cutting, fragrance.

WHITE BELLS (Poulwhite)
Poulsen, Denmark, 1983
Ground cover shrub, flowering in summer. The white counterpart of 'Pink Bells' (q.v.) which it resembles except that it has white flowers and may be expected to grow larger. 'Mini-Poul' x 'Temple Bells'. 80cmx2.2m (32x84in). Plant this for border, ground covering, health, front of shrubbery, spreading; weatherproof.

WHITE COCKADE
Cocker, Scotland, 1969
Large flowered climber, flowering summer to autumn. Probably the best white climbing rose for general garden use, having well formed flowers of good size and pure creamy white colour on sturdy dark-leaved plants. It does not grow with any sense of urgency, preferring to spend its energies on making extra

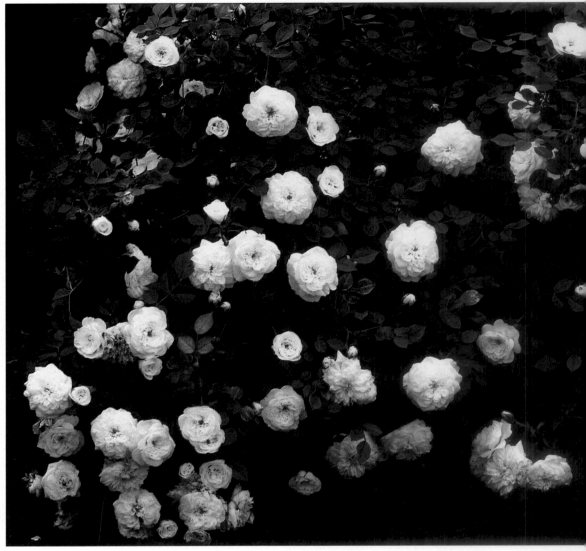

'WHITE BELLS'

12 Dr D.G. Hessayon, pbi 1988

blooms; that means it is excellent on an average sized garden wall or fence because it is easy to keep the growth under control. It can indeed be kept pruned and grown as a large bush. 2.2x1.5m (7x5ft) or more given time. 'New Dawn' x 'Circus'. Plant this for big border (if kept pruned), fence, health, hedge (if kept pruned), pillar, shrubbery, wall; weatherproof.

WHITE WINGS
Krebs, USA, 1947
Hybrid tea large flowered bush, flowering summer to autumn. The largeness of the flowers consists in their width and not their fullness, for they usually have just five petals, stretching out to form a bloom of great simplicity and beauty about 9cm (3.5in) across. The stamens are dark by contrast, rich reddish brown. Makes a bushy plant, not a quick grower, to 1mx75cm (40x30cm). 'Dainty Bess' x seedling. Plant this for border, fragrance.

WILLIAM III
Origin unknown
Scotch hybrid, flowering in early summer. A remarkable colour in which rich tones of magenta crimson mingle with those of plum and lilac in the small semi-double blooms. It produces many flowers within its brief season and the visual effect is unforgettable. The plants are short and will spread themselves by suckering, forming a thicket of tiny grey-green leaves and prickly stems, to 40x90cm (15x34in) in an open site. The origin of this interesting rose is not known. William III, a posthumous child, ruled Holland every day of his life from 1650-1702 and Britain from 1689-1702, and William III was king of the Netherlands 1849-1890. The heyday of the Scotch roses extended from the 1790s to the 1830s, the period within which one would expect such a rose to have been raised. In the absence of facts

'WILLIAM LOBB'

it is tempting to speculate that a Scottish nurseryman with Jacobite loyalties named it in a spirit of irony for the earlier William, who had ousted a Stuart king. The rose has the colour of a mole, and it was this creature that literally brought William to his deathbed, when his horse stumbled on a mole-ill in the park at Hampton Court. "The little gentleman in the velvet jacket" became a favourite Jacobite toast. Plant this for front of border, curiosity, fragrance, front of shrubbery, and any open site where it can make a clump on its own; weatherproof.

WILLIAM ALLEN RICHARDSON
Veuve Ducher, France, 1878
Noisette climber, flowering summer to autumn. The young buds can look as pretty as the roses on a wedding cake, like petite orange hybrid teas. They open loosely to yellowish apricot flowers about 7cm (3in) across. The plant is stiff in growth, with pleasing mid-green shiny leaves, capable in time of attaining

4x2.5m (12x8ft). A sport of 'Rêve d'Or'. Named for a Kentucky rosarian who had been corresponding with the raiser. Plant this for S, SW or W fence, fragrance, S, SW or W wall.

WILLIAM LOBB (Duchesse d'Istrie)
Laffay, France, 1855
Moss shrub, flowering in summer. Bears flowers 9cm (3.5in) across, well filled with petals of rich purple crimson, fading to lilac grey. Growth is vigorous, with long arching shoots that bow under the weight of bloom and need support if the plant is to look tidy. The leaves are dark and rather small. 2x2m (6x6ft). Plant this for big border (preferably with support), low fence, pillar.

WILLIAM SHAKESPEARE (Ausroyal)
Austin, England, 1987
Shrub, flowering summer to autumn. The young blooms are a wonderfully rich colour, dark crimson

'WILLIAM SHAKESPEARE'

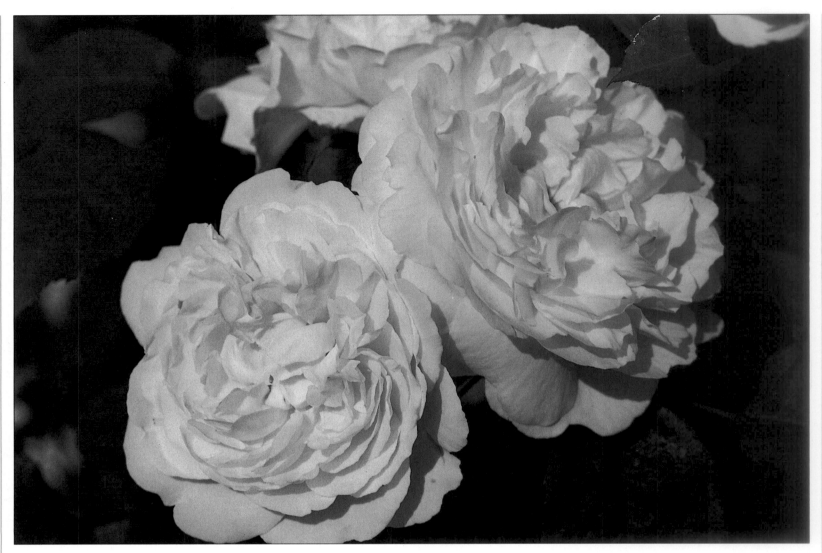

'WINCHESTER CATHEDRAL'

turning purple. They open cupped to flat in old fashioned style, with folded petals crowding their centres. Their weight is heavy for the stems, and in its general aspect neither habit nor foliage comes up to the high standard of the flowers. 1.2mx90cm (4x3ft). 'The Squire' x 'Mary Rose'. Plant this for border, curiosity, fragrance, shrubbery.

WINCHESTER CATHEDRAL (Auscat)
Austin, England, 1988
Shrub, flowering summer to autumn. This is white, sometimes with a hint of buff at the heart of a newly opened bloom. It has the same flower form and growth as 'Mary Rose' (q.v.) of which it is a sport. Named to benefit The Winchester Cathedral Trust. Plant this for border, low fence, fragrance, shrubbery.

WISHING (Dickerfuffle, Georgie Girl)
Dickson, N. Ireland, 1985
Floribunda cluster flowered bush, flowering summer to autumn. The blooms are neatly formed like small scale hybrid teas, and appear with remarkable freedom, giving a good display of pink to salmon roses. They are spaced in their spray at just the right intervals to provide an "all-over" blooming effect. The inside of the petal is darker in tone, giving depth to the flowers. Growth is short and compact, with small but plentiful foliage. 50x50cm (20x20in). 'Silver Jubilee' x 'Bright Smile'. Plant this for bed, border, hedge (45cm-18in), small space; weatherproof.

WOBURN ABBEY
Sidey & Cobley, England, 1962
Floribunda cluster flowered bush, flowering summer to autumn. This was something of a sensation in the early 1960s, being a golden orange floribunda in the days when the word "orange" in rose catalogues meant bright scarlet or even salmon. It bears somewhat crowded trusses of neat blooms on strong upright stems, well furnished with small shiny bright leaves.

After some years it became prone to rust. 90x60cm (3x2ft). 'Masquerade' x 'Fashion'. Sidey and Cobley were friends in the village of Earl Shilton, Leics., and at Sidey's request Cobley helped him make a few crosses to show how it was done. The parents they used were 'Masquerade' x 'Fashion', both raised by Boerner in USA, where the same cross had already

been tried thousands of times without comparable results. This romantic tale of village dabblers beating the big boys at their own game will enrich the dreams of all amateur breeders, who against the odds continue to produce surprises. Named with permission for the Duke of Bedford's family seat. Plant this for border, hedge 50cm-20in); weatherproof.

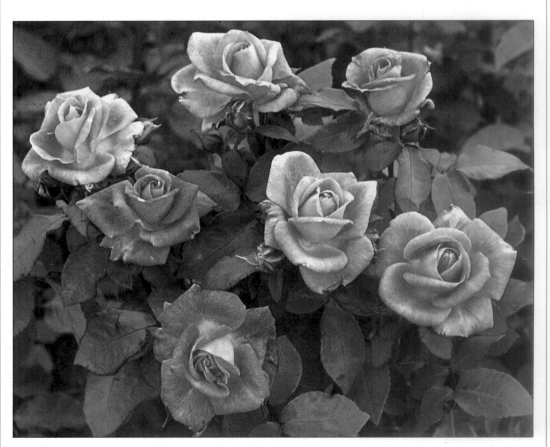

'WOBURN ABBEY'

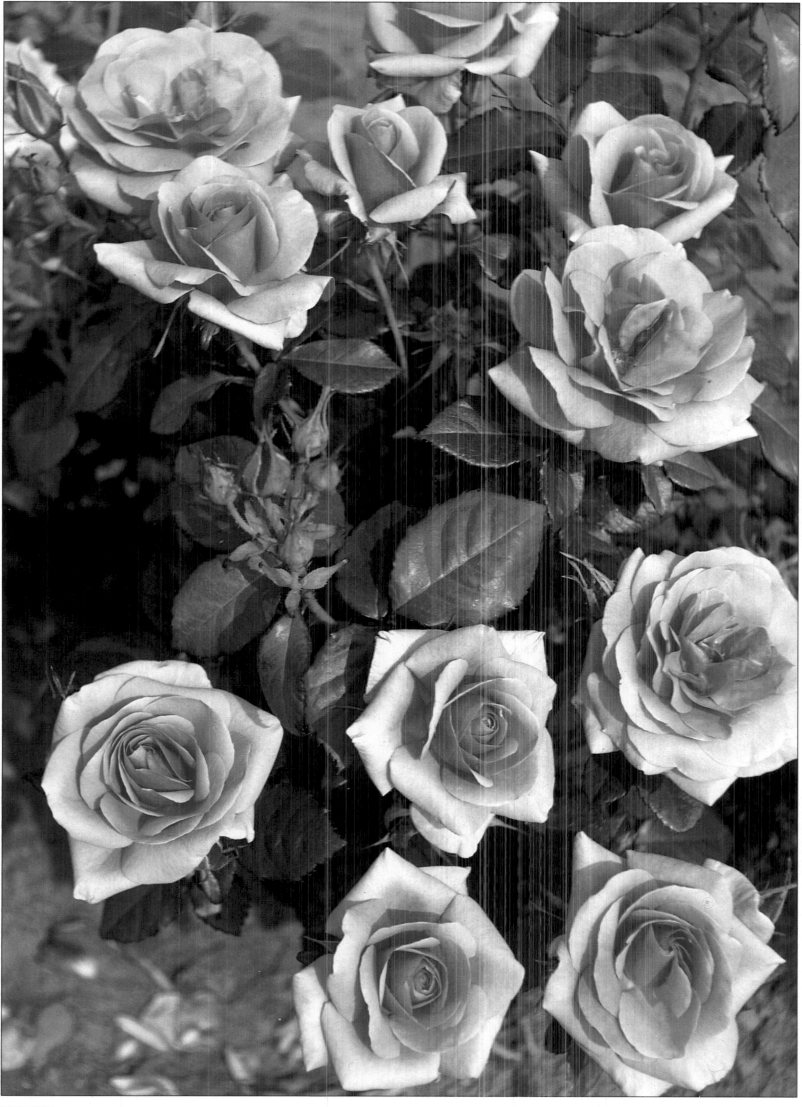

'WISHING'

XERXES (Harjames)
Harkness, England, 1989
Persica hybrid shrub, flowering in early summer. The brilliance of *R. persica* with its vivid yellow petals and their scarlet eyes is magnified in this hybrid, the result of crossing the species with the vigorous shrub 'Canary Bird'. The leaves are pretty, ferny and greyish green, and the stems red, so that even when not in bloom the bush looks ornamental. Upright growth to 1.2x1.2m (4x4ft). Plant this for border, curiosity, health, rosarium, shrubbery; weatherproof.

YELLOW DOLL
Moore, USA, 1962
Miniature bush, flowering summer to autumn. The petite blooms carry over fifty narrow petals and last well when cut, the bright yellow colour paling as they expand. They stand out well against the glossy pointed leaves. 'Golden Glow' x 'Zee'. Plant this for very small bed, front of border, container, cutting, exhibition, small space; weatherproof.

YESTERDAY (Tapis d'Orient)
Harkness, England, 1974
Polyantha shrub, flowering summer to autumn. This unusual and charming rose puts out dainty sprays of small (3cm-1.5in) flowers, lilac pink to rosy violet with yellow stamens, on spreading leafy plants. Longer spiky shoots appear, which can be trimmed back or allowed to grow, so that this versatile item may be kept compact to 60x60cm (2x2ft) or allowed to sprawl to 1.2x1.2m (4x4ft) or trained on a support up to 2x1.2m (6x4ft). In frost free Rome it grows as a pillar to 2.8m (9ft). It therefore has many applications in the garden, and is valuable for the continuity of bloom;

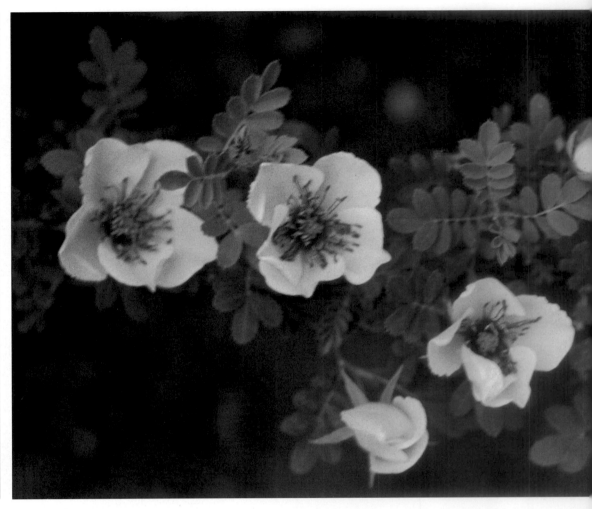

'XERXES'

'YESTERDAY'

new flowering shoots appear before the old ones have fully opened. ('Phyllis Bide' x 'Shepherd's Delight') x 'Ballerina'. ADR, GM Baden-Baden & Monza. Plant this for bed, border, container, cutting, low fence, fragrance, health, hedge (60cm-2ft), pillar, front of shrubbery, small space, specimen plant, spreading, low wall; weatherproof.

YORK & LANCASTER *(R. damascena versicolor)*
Before 1629
Damask shrub, flowering in summer. This bears a famous name, bestowed because of the unstable

'YORK & LANCASTER'

'ZÉPHIRINE DROUHIN'

colour of its flowers. Some are white and others pink, and often there is a mixture of the two, with a petal wholly or partly differing from its neighbours. The rose was not listed by Gerarde in 1597, and it is unlikely to have any historical link with the imagined events of the 1450s when peers are supposed to have plucked white and red roses off one bush, an improbable means of conducting the nation's business. The plant can grow to 2x2m (6x6ft) but it takes time and good soil to achieve that. The wood is twiggy and the leaves pale. Plant this for border, curiosity, fragrance, shrubbery.

YVONNE RABIER
Turbat, France, 1910
Patio or dwarf floribunda bush, flowering summer to autumn. Usually classed as a dwarf polyantha, this little rose was ahead of its time, for the petite hybrid tea type blooms on neat small-leaved bushes sit very well alongside the modern patio rose. Is it right to re-classify a rose? Arguments will continue for as long as the species is evolving, which surely means for ever. The blooms are ivory white, borne on leafy rounded plants and show themselves off to advantage against delightful shiny foliage. 50x50cm (20x20in).

R. wichuraiana x a polyantha. Plant this for small bed, front of border, container, fragrance, health, small hedge (45cm-15in) small space; weatherproof.

ZEPHIRINE DROUHIN (Thornless Rose)
Bizot, France, 1868
Bourbon climber or shrub, flowering in summer and with some later bloom. The good qualities of this rose have endeared it to generations of gardeners. The colour is deep pink, a warm and kindly tone, and the sweet scented flowers are pretty in bud, open with petals loosely disposed in an insouciant kind of way, drop them cleanly and proceed with the next cycle of bloom. It is one of the earliest climbers in flower and continues late, and at pruning time the smooth wood is pleasant to handle; though the occasional thorn is not unknown. It has its drawbacks, some liability to mildew, blackspot and rust being the chief among them, but it has survived for 120 years, remains a best selling rose, and seems to have plenty of vigour for the years ahead. Growth is open and arching, easy to train on a support, to 4x2.5m (12x8ft) or less if kept pruned. Plant this for border, fence, big hedge (1.5m-5ft), pergola, pillar, shrubbery, wall (but avoid a dry site); weatherproof.

bibliography

The following have been particularly useful among the many books that have been consulted, and are recommended for further reading.

Beales P., *Classic Roses* (Collins Harvil 1985)

Bermuda Rose Society., *Old Garden Roses in Bermuda* (1984)

Dobson B., *Combined Rose List 1989; Bev Dobsons Rose Letter*

Find That Rose!, Rose Growers Association 1989, ed. A. Pawsey

Fisher J., *The Companion to Roses* (Viking 1986)

Fletcher H.L.V., *The Rose Anthology* (Newnes 1963)

Gibson M., *Growing Roses* (Croom Helm 1984); *Shrub Roses, Climbers and Ramblers* (Collins 1981)

Griffiths T., *My World of Old Roses* (Whitcoulls 1983)

Harkness Jack, *Rose Classes* (Southwold 1989); *Roses* (Dent 1978); *The Makers of Heavenly Roses* (Souvenir Press 1985); *The World's Favourite Roses* (McGraw-Hill 1979)

Harkness John, *Practical Rose Growing* (Blackett 1898)

Hessayon D., *The Rose Expert* (pbi 1988)

Hole S.R., *A Book About Roses* (15th ed. Arnold 1896)

Indian Rose Annuals issued by the Indian Rose Federation

King R., *The Quest for Paradise* (Mayflower 1979)

Krüssmann G., *Roses* (Batsford 1982)

LeGrice E.B., *Rose Growing Complete* (Faber 1976)

Le Rougetel H., *A Heritage of Roses* (Unwin Hyman 1989)

Mattock M., *Roses* (Blandford 1980)

Mayhew/Pollard, *The Rose: Myth, Folklore and Legend* (New English Library 1979)

McGredy/Blake, *Look to the Rose* (Collins 1982)

Modern Roses 9 by The American Rose Society (ed. P. Haring)

Phillips R. and Rix M., *Roses* (Pan 1988)

Rose Annuals of the National Rose Society of New Zealand

Rose World, U.P. Rose Society, ed. J.P. Agarwal

Royal National Rose Society Annuals and other publications

Shepherd R.E., *History of the Rose* (Heyden 1978)

Thomas G.S., *Climbing Roses Old and New* (Dent 1978) *Shrub Roses of Today* (Dent 1974) *The Old Shrub Roses* (Dent 1979)

Warner C., *Climbing Roses* (Century 1987)

Young N., *The Complete Rosarian* (Gardens Book Club 1972)

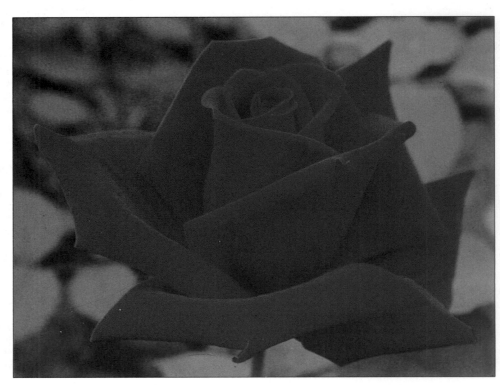

'ENA HARKNESS'

index

Picture page references are given first, in **bold** type.

picture credits

Tony Craddock: 158.
John Durdin: 26*tr*.
Dickson Nurseries Ltd: 72, 210*t*.
Jas. Cocker & Sons: 117*b*, 204*b*.
The Royal Society for the Protection of Birds: 80*b*.
Roger Phillips: 11*b*, 12*b*, 14*b*, 55*tr*, 99*t*.
Bill Shaw: 84*t*, 88*b*, 101*t*, 107*tr*, 124*tr*, 132*b*, 133*tl*.
R. Harkness & Co. Ltd: back cover *tl&bc*, 1, 6, 7, 43*t&bl*, 56*tr*, 61*b*, 135*tl*, 156, 187*t*, 197, 211*t*.
Colour Library Books Ltd: front cover *3rd row l&c, bc &br,* back cover *tr*, 70*t*, 135*b*, 161*t*, 169*t*, 184*t*, 219*tr*, 204*b*.
Betty Harkness: 25*b*, 49*b*, 57*t*, 108, 117*tl*, 124*b*, 127*b*, 138*t*, 155*t*, 191*b*, 196*l*, 203*bl*, 206*b*, 208*t*, 220.
Les Puskas: back cover *4th row l*, 35*b*, 38*t*, 87, 94*t*, 97*t*, 106*b*, 112*b*, 120*b*, 122*b*, 127*tl*, 130, 150, 162, 164, 166*b*, 177*tr*, 178*b*, 189*b*, 190, 198*b*, 205.
The Royal National Rose Society: 11*tl*, 27*cr*, 34*br*, 46*t*, 75*t*, 89*tr&b*, 114*b*, 118, 136, 137*l*, 148*t*, 152*t*, 160*b*, 177*b*, 181*tr*, 183, 185*b*, 186*tr*, 204*t*, 209*t*.
Peter Harkness: front cover *tl, tc&bl,* back cover *2nd row l, 3rd row, 4th row r, bl&br,* 10*b*, 11*tr*, 12*t*, 15*b*, 17*tl&tr*, 19*b*, 20*b*, 21, 23, 24*b*, 25*t*, 27*t&br*, 28, 29*tl&b*, 30*t*, 31*tl&b*, 33*cr*, 34*bl*, 35*tr*, 36*tr, cl&b*, 38*b*, 39*t*, 43*br*, 44*tr*, 45, 46*l&br*, 47, 48*t&br*, 49*tr*, 50*b*, 51*tl&b*, 52*tl*, 54*tr, bl&br*, 55*b*, 62, 63, 64*t*, 66*t*, 68, 69*t*, 70*b*, 71, 78*tl&r*, 79*cl*, 80*t*, 82*b*, 85*b*, 88*t*, 89*tl*, 90*b*, 91*t*, 92*b*, 93*tr&b*, 94*b*, 95*b*, 97*bl*, 98*b*, 99*b*, 100*tr*, 102*b*, 103, 104*tl&b*, 105*bl*, 106*tr*, 112*t*, 117*tr*, 119*tl*, 124*tl*, 125*t*, 129*b*, 131, 133*tr*, 135*tr*, 139, 140, 141*t*, 142*b*, 144*tl*, 147*t*, 151*t*, 163*bl*, 165, 167*b*, 168*b*, 171*tr&b*, 172*t*, 174, 175*bl&br*, 176*tl*, 179*c&br*, 180, 181*tl*, 182*tl&tr*, 188, 192*t*, 195*t*, 199*tr*, 200*b*, 202*b*, 206*t*, 207*tl&tr*, 211*b*, 216*b*, 217, 218*tr*.
Vincent Page: all other photographs.

The author and publishers acknowledge with thanks the kindness of all those who made their photographs available for use in order that the best selection could be made. Special thanks are due to Vincent Page, whose material has been used extensively throughout the book.